A HISTORY OF
WESTERN SCULPTURE
CONSULTANT EDITOR
JOHN POPE-HENNESSY

Medieval Sculpture

Other volumes in the series

Classical Sculpture
Author George M. A. Hanfmann

Sculpture
Renaissance to Rococo
Author Herbert Keutner

Sculpture
19th & 20th Centuries
Author Fred Licht

A HISTORY OF
WESTERN SCULPTURE

CONSULTANT EDITOR
JOHN POPE-HENNESSY

Medieval Sculpture

Roberto Salvini

NEW YORK GRAPHIC SOCIETY
GREENWICH, CONNECTICUT

© GEORGE RAINBIRD LTD 1969

This book was designed and produced by
George Rainbird Ltd
Marble Arch House
44 Edgware Road, London, W.2

Text translated from the Italian:
Introduction by Peter and Linda Murray
Notes by Eileen Ellenbogen

House editor: Jocelyn Selson
Picture research: Enid Gordon
Designers: Ronald Clark and George Sharp

Printed in Great Britain

Library of Congress Catalog Card Number 68–12365

IN MEMORY OF
MY FATHER AND MY MOTHER

ILLUSTRATION CREDITS

The publishers are greatly indebted to Professor Salvini for the loan of many photographs which would otherwise have been unobtainable. They acknowledge with gratitude the helpfulness and generosity of museums and photographers all over Europe in supplying photographs for this volume. Copyright owners are shown in italics. Small roman numerals indicate introduction pictures, large roman numerals colour plates. All other illustrations have arabic numerals.

AOSTA Professor Robert Berton (photo) 56, 57

BARCELONA *MAS* (photo) 4, 5, 79, 80, 81, 82, 84, 85, 86, 87, 88, 117, 239, 240, 241, 264, 293, 327, 339, 340

BERLIN *Dr Robert Oertel* 299 (photo Dr Ilsabe Oertel); *Staatliche Museen zu Berlin* 21

BOLOGNA *Instituto di Storia dell'Arte, University of Bologna* 151, 154 (photo Croci); *Villani* (photo) 329, 330

BONN *Rheinische Landesmuseum* 161

BUOCHS *Leonard von Matt* (photo) 41, 43, 67, 118, 128, 148, 149, 152, 274

CAMBRIDGE (Mass.) *Medieval Academy of America* v, ix

CASARSA *Elio Ciol* (photo) 8, 9

CLUNY *Musée du Farinier* 39

COLOGNE *Rheinisches Bildarchiv* (photo) 27, 166

CREMONA *Ente Provinciale per il Turismo* 76 (photo Fazioli), 289 (photo Negri)

DIJON *R. Remy* (photo) 325, 326

DUBLIN *Commissioners of Public Works in Ireland* (photo) 35; *National Museum of Ireland* 36, ii, iv, vii

FERRARA *Museo della Cattedrale* 93, 153

FLORENCE *Alinari* (photo) (*Mansell*, London) i, iii, viii, 6, 11, 19, 59, 95, 138, 139, 140, 141, 142, 147, 150, 156, 157, 190, 249, 250, 251, 252, 253, 254, 255, 256, 257, 258, 260, 270, 277, 278, 282, 284, 285, 287, 291, 316, 317, 318, 320, 356; *Edizioni Bencini e Sansoni* 33 (photo Guido Sansoni); *Scala* (photo) I, VI; *Soprintendenza alle Gallerie* ii

FRANKFURT/M *Dr Harald Busch* (photo) 32, 64, 171, 172

KÖNIGSTEIN-IM-TAUNUS *Karl Robert Langewiesche* 342

KRAKOW *Zaiks* (photo) 357

LA ROCHE-SUR-YON *Simonin* (photo) 114

LIÈGE *Vroonen* (photo) IV

LONDON *British Museum* and *George Rainbird, Ltd* (photo Derrick Witty) IX; *Carlton Studios* (photo) 303, 304; *Courtauld Institute* 227 (photo L. Stone), 228, 302, 332 (photo F. H. Crossley); *F. L. Kennett* (photo) 235, 262, 267, 268, 269, 272, 273, 281, 294, 305, 315, 345, 353, 359; *National Monuments Record* (photo) 38, 233; *Picturepoint* (photo) 301; *George Rainbird* III, V (photos Express News Agency), VIII (photo Mario Carrieri), II (photo Lalance), IV (photo Vroonen), 179, 231, 238, 328 (photos Picturepoint); *Victoria and Albert Museum* (photo) 37, 83; *Warburg Institute* 173, 175, 176, 177, 178 (photo Otto Fein), 34, 177, 226; *Westminster Dean and Chapter* 234, 237, 300, 333 (photos John Freeman); *Professor George Zarnecki* (Courtauld Institute) 174, 180, 225

ACKNOWLEDGEMENTS

I would like to express my deep gratitude to the editor, Mr John Pope-Hennessy, for selecting me as the author of this volume: this has given me an opportunity to sketch a history of Medieval sculpture from some unaccustomed and original viewpoints. I am much indebted to the publisher's editors: Mrs Enid Gordon, who took care of this book in its earliest phase, and especially Miss Jocelyn Selson who supervised progress throughout with great accuracy and intelligence, surmounting considerable problems. I offer my grateful thanks to my colleagues, Mr and Mrs Peter Murray, who assumed the responsibility for the translation, brilliantly overcoming the obstacles presented by an Italian text which was much complicated by my attempt to say as much as I could in the briefest possible way. I would also like to thank Mrs Ellenbogen for her work on the translation of the notes, and the Design Department of George Rainbird Ltd for their strikingly effective layout.

R. S.

CONTENTS

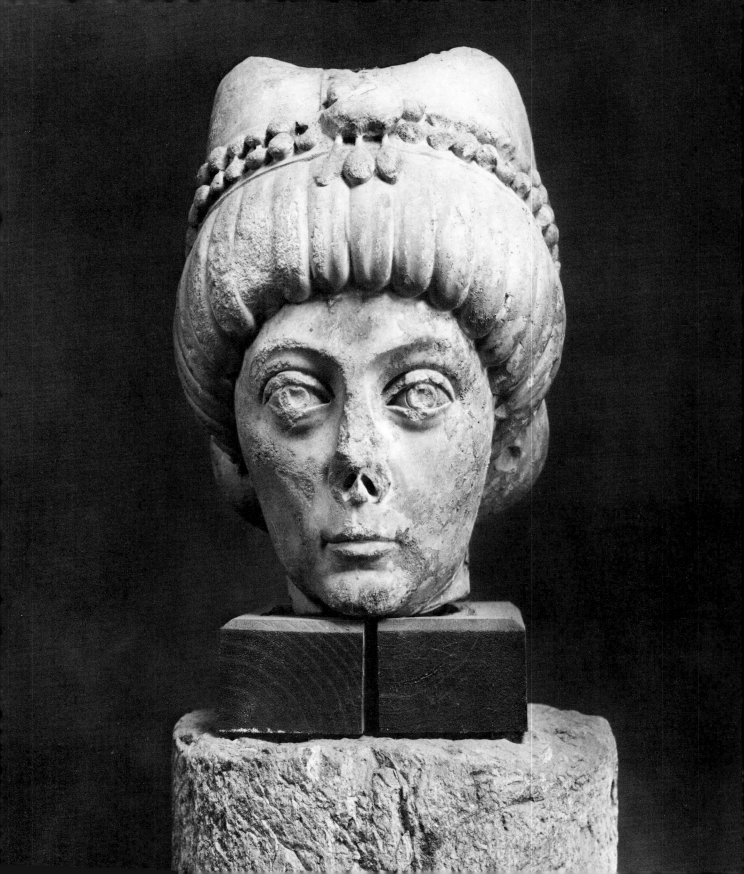

INTRODUCTION

The concept of the 'Middle Ages' was born between the fourteenth and the six-
teenth century in Florence, the creation of poets, artists, and critics. Petrarch and
Boccaccio, praising Giotto and Simone, had referred to an earlier long period
during which art 'had been buried' under the errors of those who preferred to
'charm the eyes of the ignorant' rather than to 'satisfy the intellect of the learned'.
At its moment of birth, Humanism reproached Medieval art for the preciousness
of its materials and the fascinating splendour of its colour, indulged in at the
expense of clarity of form. When, therefore, Leon Battista Alberti, on his return
from exile, acclaimed the architecture of Brunelleschi, the sculpture of Donatello,
Ghiberti, and Luca della Robbia, and the painting of Masaccio, as the birth of a new
art worthy to rival that of Antiquity, he not only founded the theory of the
Renaissance, but implicitly confirmed the idea of a long middle period – which
was also one of decadence – that had interposed its uniform greyness between the
luminosity of the Classical Age and the new light of modern art. Later on, Vasari
maintained that the causes of this long decadence were the devastations of the
barbarians and the aversion of Christianity for pagan art, and he defined the
moment when revival began as that which saw the renewed capacity to understand
and imitate the art of Antiquity.

The concept of the Middle Ages, therefore, came into being both as an historical
concept and a criterion – though a negative one – of aesthetic judgement. And it
was natural that the Renaissance, in the very act of identifying the highest aesthetic
ideal with Classicism, should also characterize the art of the Middle Ages as the
moment of greatest distance from Classical ideas and, hence, the lowest level in
quality that had ever been reached. Nowadays – ever since the Romantic move-
ment in fact – we no longer accept the clarity of Classical form as the only possible
artistic ideal, and we no longer have any reasons for regarding Medieval art with
either mistrust or disdain. Thus, progress in the historical sciences coupled with
the daring experiments of contemporary art have made it possible for us to
recognize and understand the unsurpassed grandeur of many works of Medieval
art, and the concept of decadence is no longer a valid one for the art of the Middle
Ages. But the theory that the Middle Ages was a period both distant and averse
from the ideals of Antiquity is now also being reconsidered. Certainly, as Hanfmann
wrote in the first volume of this history, 'the Classical ideal had deified the human
body; the Christians humiliated and mortified it. The Classical ideal was based on
organic comprehension of the nude; nudity became sinful to Christianity. The
Classical ideal saw the divine in the rhythm of nature; the Christian God was a
miracle, worked miracles, and was above the laws of nature.' This explains how
the men of the Renaissance saw in the art of the Middle Ages the very opposite of
Classicism and Antiquity. Yet not all Antique art was strictly 'Classical', and the
Middle Ages themselves were full of recollections, always different in form, of

i BYZANTINE SCULPTURE 6th century
Empress Theodora (?)
Milan, Museo del Castello Sforzesco

Classicism, and not without justification have some of its periods been described as 'renaissances'. The splendour of Antique civilization was often present in the minds of men and artists during the Middle Ages – sometimes like the mirage of a vanished beauty, sometimes like a noble model which it was worth trying to imitate or adapt to the exigencies of the new Christian ideal. And even when every memory of Classical form seems to have been wiped out, it is still possible to discover in the Antique world itself, even in its least Classical expressions, quite a few of the sources of the figurative vocabulary of the so-called 'Dark Ages'.

I am convinced that at least one of the possible methods of coming to grips with the bewildering variety and richness of facets of the art of this long middle period, and of finding a thread which will guide us through its labyrinthine story, lies in considering the development of Medieval art within the dialectic that sometimes aligns it with, and sometimes opposes it to Antique art. This point of view yields better results if we study – as we propose to do – the figurative language as some kind of parallel to the language of words, and treat both of them as manifestations linked to the structure, and to the social stratification, of the period. In so far as it is possible to comprehend the history of all Medieval art within this multi-faceted unity, it is certain that the parallel with linguistic and social changes is particularly clear in the case of sculpture.

Early Middle Ages: Pre-Romanesque Sculpture

The term 'pre-Romanesque', which appears as the heading of this section, is intended to have a different meaning from the sense in which it is generally used. 'Pre-Romanesque' is here understood not merely chronologically, to indicate all the art of the period which precedes that commonly called 'Romanesque'. It is intended to refer only to some of the artistic currents that can be isolated in sculpture from the seventh century to the middle and latter part of the eleventh century. It must be borne in mind that during the entire course of Roman Imperial art it is possible to distinguish – as has been more systematically demonstrated by Bianchi Bandinelli than by any other scholar – a cultivated current with a direct Hellenistic and sometimes even Classical derivation, and a popular current derived from the dialect of Italic Hellenism. Even in Rome this popular current is powerfully present, but it prevails decisively over the other in provincial sculpture. The two currents develop – though not without reciprocal interminglings – in two distinct social spheres. They find a perfect analogy in the typical bilingualism of the Roman world, where to the well-known literary Latin was opposed a vulgar tongue, which is fragmentarily known from the dialect expressions of some popular characters in comedies. It can be more fully reconstructed by working backwards from Romance languages, which, as is well known, derived far more from this provincial and vulgar Latin than from the noble language of literature. In the age of Diocletian there began a complex social upheaval characterized by the decay of the ancient senatorial aristocracy and the growth of humbler social classes, with the army expressing and compelling recognition of the demands of this lower social stratum. Thus, at the time of Constantine, the popular language of sculpture, formerly confined to the provinces and to small private monuments in Rome, conquered Imperial art. For this reason, the Constantinian reliefs were for long considered as the product of a profound decadence, until the new interpretation of

Riegl, who discovered in them the signs of a different will to form (*Kunstwollen*), in their search for a pictorial style and for new values in clarity of form and symmetry. But this was nourished by a long tradition of formal simplification and flattening, and expressionistic tendencies – exactly the tradition of provincial and popular Roman sculpture. Soon, the new social class which emerged from the military dictatorships assimiliated its own habits and tastes to those of the preceding aristocracy, while at the same time it turned, now that it was Christian, towards ideals of spiritual serenity which were to find artistic expression in the revived Classicism of the so-called 'Theodosian Renaissance'. Thus Early Christian sculpture developed once more from the basis of an aristocratic figurative language, and assumed quite patently noble aspects during the fifth and sixth centuries, when the cultural centre with the greatest prestige was transferred from Italy to Constantinople, where the governmental organization of the Empire of the East eventually became a theocratic absolutism.

For many centuries, the western Medieval world looked to Byzantine art as a supreme example of a civilization which was heir to Greco-Roman Classicism. Nevertheless, the popular elements were not entirely submerged during the Early Christian period, and one has only to remember the great stylistic diversity of many Roman and Ravennate sarcophagi, and the reappearance in so many of these of the formal simplifications and the use of flowing line, sometimes enlivened by expressionistic touches, to be convinced that a strong current of popular art continued to flow underneath the official current, just as the vulgar Latin tongue continued to develop in a sphere socially inferior to that documented by the revived Classical Latin of the Christian authors. From the second century onwards, the development of grand monumental and commemorative sculpture in Rome was accompanied by this provincial and popular Roman sculpture, whose humble language and common accent was frequently capable of great expressive force; to it may be attached the huge volume of figurative and more frequently ornamental sculpture of the seventh to the eleventh centuries in all the western provinces of the former Roman Empire. It is to this sculpture, which is very often – though wrongly – termed 'barbaric' that we intend to reserve the title 'pre-Romanesque', in the same way that the term 'pre-Romance' is used for the dialects which during these same centuries evolved in Italy, Gaul, and Hispania, and from which later the Romance languages were to be born in parallel with Romanesque art.

Its development, which on the whole displayed considerable unity and was generally lacking in any distinct regional characteristics, can be illustrated by a short series of examples belonging to different centuries and countries (1–17), chosen for preference from figurative sculpture. But it must not be forgotten that the majority of these works consist of marble and stone transennae, ciboria, and capitals, decorated with geometrical ornament, and in particular with interlacings, some of which have links with ornamental motifs used in barbaric jewellery or show the influence of Irish illumination and metalwork, but which, for the greater part, have evolved naturally from ornamentation typical of Late Roman sculpture. But it is quite clear that the origins of figure sculpture are also to be found in the stylistic forms of popular and provincial Roman sculpture, or in the tendency to transpose into simpler, more schematic expressions, and looser, more linear constructions, the highly complex language which provided the much admired models. These, until at least the eighth century, were to be found in Byzantine art – an art which, to the man of the Middle Ages, appeared both as the repository of the secrets of

Classical beauty, and as more suited, because of its highly abstract qualities, to represent the Christian ideals of the age. Two small figures in Ravenna (one shown in 2), though they derive their typology from Early Christian sarcophagi, clearly develop premises already proposed by provincial Roman sculpture of several centuries earlier (ii) while the small head in Milan (1) translates into a very much more humble language, though one richer in expressive values, the delicate refinement and contemplative spirit of the Byzantine marble of Theodora (i). On both sides of the Alps, the seventh century is by far the poorest in monuments, especially in dated works, but the relief of the two martyrs in the Hypogeum at Poitiers must date from then, while the Narbonne tomb slab (3) might even be as late as the eighth century, particularly since this last piece seems to have contacts with crude, very late Gallo-Roman sculpture, such as the two steles at Garin. The Narbonne tomb slab also presents certain stylistic affinities with Iberian reliefs like the capitals of S. Pedro de la Nave (4) and Quintanilla de las Viñas (5), and also with the Cividale reliefs (8, 9). Attempts have recently been made to explain this network of resemblances by referring them to a common source in certain Oriental, Balkan, Mesopotamian, and Coptic reliefs, whose influence is said to have reached Europe by several channels, one of which is supposed to have traversed North Africa, leapt the Straits of Gibraltar, and thus reached Spain. But this kind of explanation neither simplifies the problem nor appears convincing. While not excluding the possibility that Eastern influences – influences, that is, from Early Christian art of the Mediterranean basin and the art of the Byzantine provinces – might at some time have reached Western Europe, it is nevertheless preferable to identify the source of these, and other sculptures of the ancient Gaulish, Spanish, and Italian provinces, in Roman provincial sculpture, and to account for their differences as the result either of the effect of particular local conditions or of the sporadic intervention of other, possibly Eastern, influences. The affinities which link the works cited should not, however, be allowed to obscure their often very distinct individuality and their differences of artistic quality. The poverty of expression of the Narbonne tomb slab (3) may be contrasted with the expressive beauty of the S. Pedro de la Nave capital (4), where the tremulous movement of the serpentine folds of Daniel's tunic, the vibrant contours of the lions, the clear symmetry of the composition, and the Classical elegance of the frieze of the abacus, all suggest that the model was some Eastern-influenced provincial sculpture, and even perhaps Eastern stuffs. Despite its stylistic links, the relief at Quintanilla (5), with its sharp tensions of line in contours and folds, is very different. But this tension rises to real expressive vigour only in the Cividale reliefs of the Ratchis Altar (9), and in the transenna inscribed with the name of the Patriarch Sigvald (8), where the symbolic beasts confront each other with ferocious mien and savage force, which the artist renders with a rustic yet lucid simplicity of means. A level of elegance similar to that of the S. Pedro capital is also to be found in the sarcophagus of Theodota at Pavia (6), and, with a hurried rhythm and an undisciplined energy which results in the overcrowding of the composition in both figures and ornaments, in the slab of Lopicenus at Modena (7). Here the presence of a Byzantine influence working through a language of Roman provincial origin is evident. The stylistic current which produced its finest work in the Cividale reliefs was destined to have a long life indeed, if it is still to be recognized, speaking with a changed accent though with a substantially similar linguistic structure, in the eleventh century in a series of Dalmatian reliefs (11) and in a group

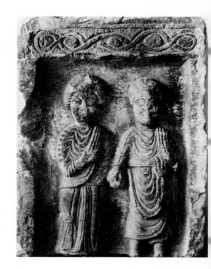

ii ROMAN PROVINCIAL SCULPTURE
4th century
Sepulchral Stele of husband and wife
Florence, Depots of the Uffizi Gallery

of sculptures of the so-called 'Pyrenean school' (12). Despite the flatness of their cutting, these works are the prelude to the emergence of Romanesque sculpture proper, because of the way in which they stress the significant areas of the architecture of which they form a part. Yet other, and perhaps more important, aspects of Romanesque sculpture are anticipated, though still in a dialect and vernacular tongue, in a few surviving Lombard pieces, like some of the capitals at Pavia (14) and Piacenza (13), and in the crypt of St Bénigne at Dijon; these last are probably Lombard if the church was in fact rebuilt at the end of the tenth century by William of Volpiano. During the eleventh century, French sculpture, while it develops in a coherent manner along the lines set by the preceding centuries, is the clear forerunner of the new formal energy of Romanesque sculpture, even if in Paris (17) it recalls the Pyrenean school, or in Tournus (15) and at St Benoît (16) it follows the Lombard forms of Piacenza (13), Pavia (14), and Dijon.

Early Middle Ages: Carolingian and Ottonian Sculpture

During the seventh and eighth centuries, sculpture, as well as all the other arts, was expressed in this vernacular tongue, except where, because the subject required more formal treatment, there was recourse to Byzantine art. The social structure of the barbaric kingdoms was still too close to the tribal and military organizations of the Age of Migrations for privileged classes to have been created on grounds other than ownership of land or cattle, or authority gained through prowess in battle. No class possessed any culture capable of influencing the language of word or form. The only art possible – Roman civilization and learning having been irreparably damaged – was that spontaneously developed from the popular current of Classical art, which assimilated any benefits to be derived from the sumptuary art of the barbarians, and which here and there reached unaccustomed heights under the influence of Byzantine art. But by the end of the eighth century, principally through the will of one great monarch, one of these barbarian kingdoms had become latinized, and, in competition with the surviving Roman state on the Bosphorus, transformed itself into an empire with vision and ambitions on a universal scale. With Charlemagne, the West regained a Classical culture in the literary and figurative arts – an Imperial culture deliberately fostered so as to legitimate a newly re-founded Roman Empire, which, after the failure of efforts to re-establish Imperial unity through marriage, should compete in pomp with the Empire in Constantinople. For these reasons the palace and chapel at Aachen were modelled, though with great originality as well, on monuments in Ravenna, the last capital of the Western Empire, and perhaps also in Byzantium. Thus, between the eighth and ninth centuries, there was born and diffused between France and the Rhineland, a new figurative language of high literary and courtly character – a typical Medieval Latin of the figurative arts. It was because of the survival within the Carolingian Empire, whose organization laid the foundations of feudal society, of that profound social division between master and servant which had characterized the first barbaric kingdoms, and also because of the decay of urban culture, that the rebirth of literary and figurative Latin remained confined to the Court and the hierarchy. However, just as the language of words continued its development

towards the future vernacular neo-Latin tongues, so there survived -- as has been shown in the preceding section – the 'pre-Romanesque' current in sculpture, even in the homelands of the courtly Carolingian art.

While stone and marble sculpture continued with only rare exceptions to express itself in the pre-Romanesque vernaculars, in architecture, in mural painting, and above all in book illumination, in sculpture in stucco, ivory and bone, bronze, metals, and in all manner of precious materials, Carolingian art was an art of great and vital character, with no trace of cold academicism; not only by virtue of the artists themselves, but also because the courtly civilization which they were called upon to express was not that of a luxurious and effete court, but a warlike and energetic society, possessed of a missionary religious spirit. Thus Carolingian art was one of pathos and vehemence of feeling, using large forms and a full and robust vocabulary. This concern for expressive content is also to be seen in the large number of ivories, mostly produced as book covers – a type of production linked, therefore, with the Emperor's programme of promoting literary culture – and based on the copying, and combining, and sometimes on the misinterpretation of Late Roman, Early Christian, and Byzantine models. This is not to imply that these works are lacking in vigorous, though not always obvious, touches of originality. For instance, in the cover of the Dagult Psalter in the Louvre, given by Charlemagne to Pope Hadrian I, about 795, the Classical forms of its Early Christian models are evoked with subtle tenderness of modulation, which appears to be the personal contribution of the Carolingian carver. In the most beautiful parts of the cover of the Lorsch Gospels (19), the multiple thin folds of the draperies sometimes enliven the images with the quiver of intense pathos so as to emphasize their luminous and transfigured faces. Elsewhere, as in the *Crucifixion* diptych, formerly in Berlin (destroyed in 1945), and in the *Holy Women at the Sepulchre* (Florence), there are effects of moving eloquence or powerful drama (as in the Darmstadt *Ascension*). Even in an ivory upon which a framework of precious stones appears to confer an atmosphere of aristocratic detachment - the cover of the Psalter of Charles the Bald (II) – the narrative develops with striking vivacity, in an almost tempestuous movement of line in composition and forms in powerful relief and strong chiaroscuro. Stone sculpture is limited practically to the decoration of capitals (Höchst, Lorsch, Fulda, Brescia, S. Pedro de Roda, etc.), with a borrowing of Classical motifs, sometimes in pictorially delicate terms, at other times in a simplified and massive handling suited to the grave austerity of the architecture. But the most important tasks were given to sculpture in stucco, not only because of the greater ease of working the material, but also because this could be painted to produce the most subtle and delicate effects, appropriate to the courtly nature of contemporary art. The amount of surviving work is small, because of the fragility of the material, and nearly all of it is in Ladinia – the territories immediately south of the Alps (the Grisons, Venosta, Friuli). The beautiful head at Malles, with its air of detachment and its pathetic nobility, and the superb choir of saints at Cividale (20) are masterpieces, stiff and strong, yet delicately pictorial in the tender passages of chiaroscuro and in their now vanished but probably once present polychromy. They remain on the periphery of the Carolingian world through their resemblance to hieratic Byzantine icons, and their probable derivation from Palmyrene prototypes. The small number of surviving bronzes have a more marked Classical quality: the doors of the Palatine Chapel in Aachen, with their vigorous lion heads on roundels decorated with palmettes; the famous and much discussed equestrian statuette from

I Vuolvinius and assistant *Scenes from the Life of Christ*, detail from the Golden Altar *c.* 850 Milan, S. Ambrogio

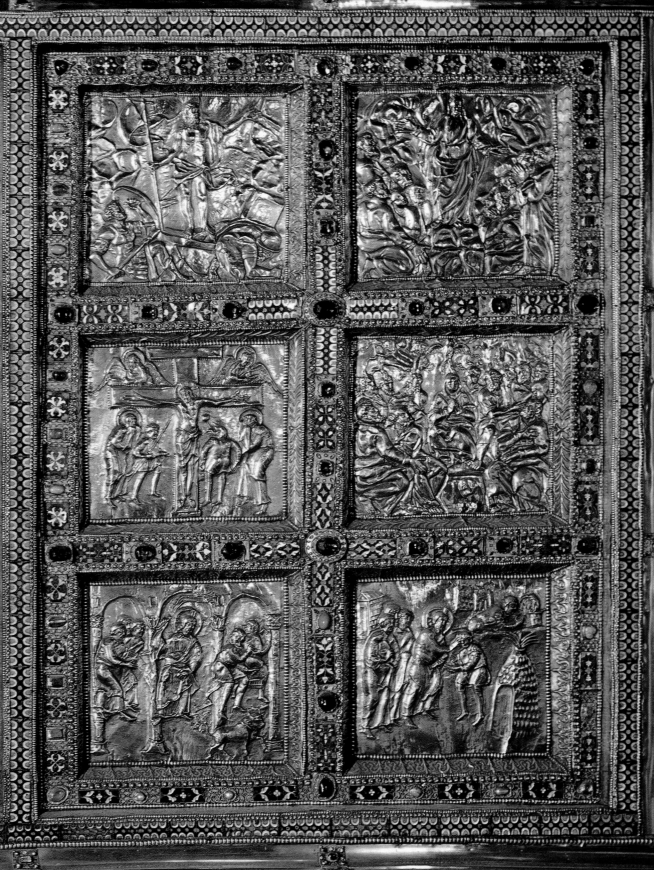

Metz (18), clearly inspired by the *Marcus Aurelius* now on the Campidoglio in Rome. But these deliberate echoes of Antique examples must not prevent us from recognizing the strong stylization, in the sense of the closed compactness of the form, which characterizes these works and renders them utterly distinct from any true Classical sculpture. The expressive quality of these bronzes is founded on a dialectic between idealizing Naturalism and the will to abstraction, analogous to that which translates the airy forms of S. Vitale in Ravenna into the block-like forms and geometric rigour of the Palatine Chapel in Aachen.

Entirely different forms are presented by sculpture in precious metal, beginning with the wonderful altar frontal of S. Ambrogio in Milan (I). Here, the link with Classical figure sculpture is primarily a matter of the concept of space, basically pictorial, and the modelling of the relief, no less pictorial. The rhythms of Roman art are re-created by a pictorial sensibility of an impressionistic type, which has its prime sources in Late Hellenistic art. The volume of the figures is in large part obtained by means of the play of light in the diffused glow of the precious metal. The same shafts of light that softly model the forms of the figures are reflected in the fragments of landscape, drawn in their turn according to the rules of a perspective illusionism derived from Romano-Hellenistic tradition. The movements and gestures of the figures in the glowing depths of an indeterminate and barely adumbrated space result in an intense narrative power, heightened by dramatic force, far from any kind of abstraction and air of solemnity, and prolific, rather, in naturalistic details in an atmosphere of pathetic emotion. Slightly later but equally precious works are the portable altar of Arnulf of Carinthia, and the cover of the Codex Aureus of St Emmeram, both in Munich. The Codex cover has thinner and more elongated figures with lively gestures, reducing the sense of depth in the backgrounds, and rendering the illusionistic perspective so summarily as to diminish it as a system.

The art of the British Isles cannot be included in the historical framework which we have sought to establish, since it has a development quite different from that on the Continent. The most astonishing creations are those of Irish illumination, though the same motifs also appear in stone and metal. There is no room for it in the distinction already outlined between literary Latin and the vernacular tongue, inasmuch as the figurative language of Ireland has its roots in Celtic, just as the language was written in oghamic characters. The island, never conquered by the Romans, for long preserved a social structure of tribal type, although the Irish may have learnt, through their contacts with Roman Britain, something of certain systems of fortification used in Hadrian's Wall. Their conversion to Christianity, rapid and pacific in the fifth century, did not provoke a rupture in the development of traditional artistic forms, since the missions of Palladius, Patrick, and Columba endeavoured to absorb rather than to destroy the symbols and monuments of the older religion. This explains why monumental Irish crosses often took the place of churches as signs of the meeting-places of the faithful, and were erected on steles, formerly functioning as altars of the pagan cults. Finally, this also explains how the ornamental motifs which became almost a lyrical abstraction – a kind of early 'Action Painting' – developed their local tradition without obvious outside influences (35-6). British art also is a thing apart, not only in those cases where it underwent Irish influence, but also where it is linked with Continental art through a common Classical descent. It presents an unusual phenomenon in that sculpture of very high quality dating from the seventh century (34), instead of developing

Illustration to Psalm 57: Cover of Charles the Bald's Psalter 860–70
Paris, Bibliothèque Nationale

the precedents of Roman art in Britain in the direction of a vernacular form, turned towards examples of more exalted origins, to be found in Italian Early Christian and Byzantine art. Celtic and Anglo-Saxon art could, therefore, contribute to the Carolingian Renaissance, while Alcuin of York and Pietro da Pisa instructed the Emperor and his Court in Classical culture. It is not surprising that in its turn the art of Britain in the ninth century reflected the Carolingian art of the Continent, as is demonstrated by the major sculptural work of the period, the Easby Cross (37).

Just as Carolingian art was not limited to the Rhineland and to France, but represented the illustrious language of the figurative arts for the whole of Western Europe, and was in contact in certain border zones with the no less illustrious language of Byzantine art, so Ottonian art, which represented the continuation or rather the energetic renewal of it, when in the first half of the tenth century, Otto I reconstituted the fragmented Carolingian Empire, was not, as is often said, a purely German phenomenon (even if it had its main centres in Germany), but leapt the frontiers of the Rhine, the Alps, and the Pyrenees, and even crossed the Channel, as is demonstrated by the Romsey Crucifix (38). Ottonian art presents perhaps more varied aspects than Carolingian art; on the one hand it is a vigorous revival of Late Antique and Early Christian Classicism, while on the other it renews, particularly after the marriage of Otto III with Theophano, the closest contacts with the world of Byzantine art. This is not surprising, as it fitted in very well with the cultural policies of the Empire, since the Empire of Constantinople was not considered less Roman than the Holy Roman Empire of the West. If the finest works of the Carolingian period were animated by an intensity of pathos, the Ottonian artists, and particularly the sculptors, made use of an even more vigorous expressionistic language, at least harsher, more rigid, and solemn, while it was no less illustrious and Classical. It is a grave error to consider, as is often done, the great Ottonian works of art as a direct road to Romanesque, or even as an initial phase of Romanesque proper. Above all, Ottonian art is not Romanesque in its techniques or in its preferred forms; it never appears in monumental sculpture tied to architecture as Romanesque was later to do; Ottonian sculpture was rarely in stone or marble, but usually in bronze, and productive of superb but small works of art in metal and ivory, or of larger carved reliefs in softer materials such as stucco or wood, inlaid with brilliant polychromy. It is not Romanesque in the structure of its language. The monumental wooden crucifix of Archbishop Gero in Cologne Cathedral (27), of about 970, is often considered as either Romanesque or of the prelude to Romanesque, because of its vigorous realism and the power of the relief. But its sculptural force and its expressionistic realism combine with the rhythmic harmony of the whole figure, Classical in its own way, and no less so than any Byzantine image. It shows no trace of the labour with which it has been carved out of inert matter, which is uncharacteristic of Romanesque sculpture. A form of narrative of Classical clarity, in the Early Christian tradition, is to be found in works in various materials and of various types during the whole extent of Ottonian art, from the tranquil compositions of the ivories from the Magdeburg Antependium, the bone situla of Archbishop Goffredo in Milan (from the last quarter of the tenth century), from the Trier situla and on to the stiff figures of the stuccoes on the ciborium in S. Ambrogio in Milan (end of the tenth century) and the rhythmic vivacity of the narrative in the small panels in the wooden doors at Cologne (26). Other ivories, from those by the Master of Echternach (21), of the end of the tenth century, to

those derived from them in S. Millàn de la Cogolla (22), show a more violent style, tense and linear, the abstraction and dynamism of which is precisely the opposite of the dense and heavy language of Romanesque sculpture. The feeling for space, too, should be considered. In Romanesque sculpture space either does not exist, or appears only vestigially as part of the plastic effect of the relief or of the figure, which tends to be treated as if it were freestanding. In Ottonian sculpture the space is still allied, through the effect of Carolingian tradition, with an impressionistic illusionism of Romano-Hellenistic origin. Thus, in the bronze doors of Augsburg Cathedral (24), the agile, quivering little figures floating about in the void of the large panels, evoke, through the highly pictorial links with the background, a sense of open and indefinite space, the last echo of the illusionism of Late Antique painting. Even a work so much more advanced and of such tremendous expressive force as the doors of Bishop Bernward at Hildesheim (III, 24), where the lively details have a surprising and exceptional effectiveness of relief, and where the concise narrative is expressed with unusual vehemence of action and gesture, is still conceived in an intensely pictorial language, and approaches in the fantastic foreshortenings of its oblique architecture the still living, if distant, memory of the illusionistic style of late antiquity. Ottonian art is never Romanesque in the aristocratic derivation of its language, nor in its social hinterland: the Imperial house, the great ecclesiastical dignitaries who were blood relations of the Emperor. From this stems also the not infrequent direct imitation, sometimes of Byzantine works as in several of the Milanese ivories of the end of the tenth century (for example the one of St Matthew in the British Museum), sometimes of Roman monuments, like the bronze column candlestick of Hildesheim (25).

One must not be misled in this matter by the existence of some cycles of sculptures in stone, or even in stucco, apparently linked to architectural monuments. Works such as the large figures, originally in niches (of which only a few heads survive), on the west front of St Pantaleon in Cologne; the three figures in high relief in polychromed stone round a portal at St Emmeram in Regensburg (30); the figure, also in a niche; from St Moritz at Münster in Westphalia; or the series of medallions of the Zodiac in the Abbey of Brauweiler (32), are not, and never were, an organic and interdependent whole with the building to which they belonged. These are large-scale versions of works of the minor arts. Thus, the *Christ* in Regensburg (30) is a powerful enlargement of the *Christ* in gold in the cover of the Uta Codex, while the figures beneath the arches derive from well-known types of Early Christian sarcophagi, and the composition of the stucco figures at Civate (33) does not differ substantially from the ivory relief inserted into the precious cover of the Gospels of Otto III. Works of this kind can never be placed on the same plane as sculpture which plays an active, even though elementary, role in the architecture, and, so to speak, pays the price of its functional use by renouncing the splendid isolation and the proud self-sufficiency which is proper to every work of Ottonian art. Functional sculpture has laboriously to work out a plastic language in constant dialectic with the forms and the architectonic logic of the monument of which it forms a part: examples are French sculptures like the *Crucifixion* on the façade of St Mesme at Chinon (beginning of the tenth century), and reliefs of uncertain date at Marcilhac, or the architraves of the Pyrenean school (12).

It is a question of two different languages, *pre-Romanesque* and of a vernacular type in these last monuments, *Ottonian*, aristocratic, and of *Latin* type in the German works mentioned above. But it would be a mistake to believe that this distinction

coincided with a geographical distinction. If in Germany as the centre of the Empire, art stemmed from aristocratic roots, in France and in Italy the two languages existed side by side, linked to different social circles. Thus, the pre-Romanesque Abbot of Tournus (15) may be contrasted with the Ottonian Abbot Isarn of Marseilles (31); to the pre-Romanesque capitals of Piacenza (13) and Pavia (14) may be opposed the Ottonian reliefs on the ciborium of S. Ambrogio in Milan, and of S. Pietro al Monte at Civate (33). On the other hand, despite great diversity of expressive accent (for which, ultimately, the personality of the artist is responsible), the bronze *Crucifix* of Werden (28) and, in the same place and of the same date, the stone figures of the nuns under arcades which formerly were part of a frontal, clearly belong to the same aristocratic language; each figure closed in its own rhythm, clear in its simple volume, and without any reference to their background, as abstract as a gold ground. That these could ever have taught anything to the great Romanesque sculptor Gislebertus of Autun (46–8, 50), as has been said, appears rather dubious; it is more likely to be a question of the phenomenon, of which more will be said later in the context of Romanesque art, of stylistic *attraction*.

It is therefore clear that Ottonian sculpture belongs to the aristocratic language of the Medieval figurative arts, while there continued to develop in parallel in those productions which we have defined as pre-Romanesque, a sculpture in a vernacular language, expressive of the lower classes of feudal society. Ottonian art extends beyond the chronological limits of the Imperial dynasty after which it is named, reaching almost to the end of the eleventh century. In its main centre, Germany, it lived on for a long time in the minor arts and exercised its influence also on the architecture and sculpture of the twelfth century, which thereafter took part in the new Romanesque civilization. In the Latin countries its survival was much weaker, since, being less tied to the Empire, they achieved from the end of the eleventh century onwards a very different social structure, freer and more articulate, which was favourable in the highest degree to the emergence and development of the radically new Romanesque art.

Romanesque Sculpture

The use of a single term (*roman* in French, *romanisch* in German), or of two closely related terms (*romanico* and *romanzo* in Italian, Romanesque and Romance in English), to refer both to the art of the twelfth century and to the neo-Latin language and literature existing in this same moment of time, is not to be attributed to a mere caprice of European languages. It reflects, even if confusedly, the realization that here we are confronted with two phenomena not only contemporaneous, but also in close parallel. This parallelism is confirmed by the fact that the major centres of Romanesque art are in fact the neo-Latin countries – France, Italy, and Spain – while in Germany true Romanesque art is only an imported phenomenon. In the middle of the extremes is England, where Romanesque art certainly has a greater originality and a greater development than in Germany, but is never the equal historically (apart from the aesthetic level of a few works) of Romanesque in France, Italy, and Spain; it occupies an intermediary position which has its counterpart in the field of linguistics, where, after the Norman Conquest in 1066, the old Anglo-Saxon stock had a vigorous Romance vocabulary grafted on to it.

Once this has been established, it is necessary to inquire if only briefly into the

historical significance of this parallelism between the figurative and the verbal languages, and to suggest for them a common root. The appearance in the last decade of the eleventh century of Romanesque sculpture (and architecture) in many of the neo-Latin regions of Europe testified by its grandiose creative outburst, not only to the advent of a great and new art and civilization, but also to the end – or the beginning of the end – of the figurative bilingualism of the Early Middle Ages. Romanesque sculpture was born of the modest though lively tradition of pre-Romanesque sculpture (in the sense in which the meaning of the term has already been defined), but in the effort of raising itself to its full dignity and expressive capacity it profited by the experiments made by courtly Carolingian and Ottonian art, or else turned back to Roman provincial sculpture, where it sought not the popular aspects but the reflections in it of the cultivated art of Antiquity. In the same period, Medieval bilingualism in verbal language also began to disappear, through the formation of Romance languages and dialects, and the emergence of neo-Latin literature. This is the moment of the 'Chanson de Roland', and 'El Cantar de mio Cid' is soon to appear; and if in Italy, for a number of reasons which do not concern us here, vernacular literature had not yet appeared, it is certain that in the spoken language the chief Italian dialects had already achieved distinct form and a consciousness of their common descent; this explains why a hundred years later they gave place to literary dialects which were clearly Italian. The Romance languages were born from the pre-Romance dialects, which derived in turn from vernacular Latin, but in the act of rising to literary dignity they adapted words from Classical and Church Latin, and on these modelled in part their syntax where the structure of the vernacular dialect appeared incapable of expressing the new requirements in meaning. The formative processes of the Romance languages are entirely analogous to those of Romanesque sculpture. In the verbal as well as in the figurative language, the typical bilingualism of the first centuries of the Middle Ages disappeared. The courtly Ottonian language survived only in precious cult objects, just as Latin survived only as an ecclesiastical, a scientific, and a legal language, while the old vernacular dialects became capable of a full range of expression.

This process of linguistic unification could only take place – verbally as well as formally – because the social order was undergoing great changes. It was no longer that of a feudal, rural society, divided into entirely distinct orders of landowner and serf, but was henceforth to be, or was already becoming, a society of urban type – cities administered autonomously by their bishops, emerging communes controlled by the citizens, or industrial settlements of the kind that arose round the great Benedictine abbeys reconstituted as houses of lay workers according to the new organization of monasteries as real business centres of production and exchange. The city, therefore, either as a bishopric or a commune, and the monasteries, could henceforward promote an open economy based on commerce, which replaced the old crop economy based on the consumption of produce *in situ*. A more open kind of society came into being, in a sense a more 'democratic' one, in which it was easier to pass from one class to another, and in which the middle classes grew ever more important in that they became the connective tissue of the whole society. This social fusion required a linguistic fusion, in the field of form as much as in the field of language, and brought about the birth of Romanesque art, and of the Romance languages and literatures.

The derivation of Romanesque sculpture from the tradition of vernacular pre-Romanesque of the Early Middle Ages is particularly evident in Lombardy, and,

within the limits of this book, can be illustrated by a comparison between capitals in Piacenza and Pavia of the tenth century (13, 14), and capitals from the crypt of the cathedral in Modena (51) of about 1099–100, or by comparing Parisian capitals of the eleventh century (17) with the reliefs on the portal of S. Fedele at Como (52). Against the late datings of S. Ambrogio in Milan, there is – besides many points about the history of its architecture which cannot be dealt with here – the circumstance that many motifs in the capitals of the Milanese basilica are to be found developed in S. Sigismondo at Rivolta d'Adda, a documented church built in the last decade of the eleventh century. But in the portal and the capitals of S. Ambrogio, the confusion of pre-Romanesque carving is resolved into an intense sculptural energy, the reliefs are organized logically according to the structure of the architecture; the forms acquire a greater nobility, their models being derived from Roman provincial sculpture. Most striking, among many impressive images, are the two heavy beasts of the portal (53), the two-tailed mermaid, the hunting scene, and the roaring lion of the pulpit (54) – figures redolent of great emotive tension, with strong overtones of meaning and relationships, so that although the conception of the figures is subordinate to the architectonic requirements, it stresses their harsh naturalism and ends by conferring on the structure of the pulpit itself an air of powerful and mysterious vitality. A note of much greater solemnity appears in the pulpit of S. Giulio d'Orta (55), so much so that one scholar has endeavoured to relate this masterpiece of the Como school to Ottonian sculpture. In no way does it derive from this source, but is one of the examples of the phenomenon of *attraction*; that is, of the attempts of a vernacular tongue developing from the unlearned tradition of the popular art of the Early Middle Ages to *equal* the exalted Ottonian Latin. In fact, compared with the geometrical volumes or the illusionistic pictorial quality of Ottonian art, there is here a close dialectical union between the architecture of the pulpit and its sculptural decoration. The figures have a physical quality expressive of the material, and the marvellous abstraction combines with a sense of secret and pulsating vitality.

The famous capitals at Cluny, of 1090–5 (39–41), are the most precious incunabulum of Burgundian art, and the warhorse of those who claim an Ottonian origin for Romanesque art. Their rhythmic refinement and delicate modelling are an effective counterpart to such late Ottonian sculpture as that of Brauweiler (32) or the Regensburg astrolabe. But their closeness to Ottonian taste lies in the rhythmical values of the composition, and is part of their syntactical structure, which has a melodic turn of phrase, and even of their choice of vocabulary. The forms, however, are different in substance and movement: the flattened Ottonian relief is opposed to a fullness of relief and modelling, while the link between figures and capitals is typically Romanesque, and finds its nearest precedent in the pictorial quality and concern for setting in composition, with pre-Romanesque sculpture of the eleventh century, such as the capitals of the narthex of St Benoît-sur-Loire (16). The forms here are the sources of the Cluny capitals, while their syntactical model is Ottonian sculpture, as in other cases it is Roman sculpture. Generally, the recourse to Ottonian models is a characteristic of Romanesque sculpture in monastic houses – of which Cluny is an example – and, ever within the scope of the new vernacular language, it gives them a more aristocratic tone, in harmony with the higher level of monastic culture. The position is quite different in Toulouse, where the Benedictine Abbey of St Sernin was situated in the heart of the city, capital of the Duchy of Aquitaine and its own county, which enjoyed full administrative autonomy, and

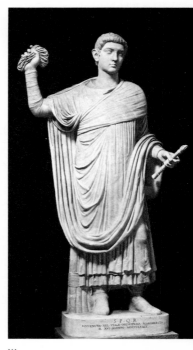

iii ROMAN OFFICIAL SCULPTURE
4th century
Consular Statue

was ruled by a body of consuls or *capitouls* elected by the mercantile townsmen. Here, in the sculpture on the altar signed by Bernard Gilduin (66) and in the series of *Apostle* figures (67), the inspiration from Ottonian ivories is balanced by that of late Roman consular figures (iii), while their origin is clearly in the reliefs of the Pyrenean school (12), as is particularly demonstrated by the *Christ* which accompanies the *Apostles*. Figures and capitals in the cloister at Moissac (68), and capitals in the Porte des Comtes at St Sernin in Toulouse (65) develop – about 1099–100 – the style of this first Languedoc school (or school of Aquitaine) in the direction of a richer plasticity and lay the foundations for the rise of the great Modenese sculptor Wiligelmo (69–73, 75). At Modena, however, the social conditions were definitely those of an urban society, and the formation of the Commune was under way. A contemporary chronicle, which tells the story of the contested translation of the body of S. Gimignano from the crypt of the old cathedral to the crypt of the new building in 1106, shows that the decisions with regard to the building of the cathedral and the translation and authentification of the relics (things which during the Middle Ages had a considerable political importance) were taken after heated discussions in a popular assembly, by the representatives of the clergy, the knights, and the citizens. It is, therefore, not surprising that in the very moment when the city was claiming autonomy from its feudal overlords, by appealing to its own Roman origins, Wiligelmo concentrated upon the Roman marbles (iv) which were being dug up in the ancient cemetery of Mutina. In the reliefs on sarcophagi, the sculptor saw Antique examples in a noble language which he was impelled to study so as to confer upon the new Romanesque idiom a precision of vocabulary and an eloquent clarity which should render it worthy of the language of antiquity. The most literal borrowings occur in the *Sons of Noah leaving the Ark* (last relief), in the funerary genii higher up on the façade, and in the two *Prophets* on the foundation-stone (73). Apart from these, Wiligelmo was able to draw from Antique sculpture useful ideas which helped him to make his style more dramatic than narrative, gave him his power of concentrating all one's attention on a meaningful gesture, so that the fatal and pregnant act should be expressed with distinctness and nobility. The direct influence of Wiligelmo is to be found in other sculpture in the cathedral at Modena (74), in the small foundation-stone of the Cathedral of Cremona (76) and, together with the influence from Languedoc, in the splendid *Prophets* by another sculptor, at Cremona (77), and in the pulpit of S. Nicóla at Bari (78).

According to some very widespread theories, the home of Romanesque is to be found in northern Spain. From here, Romanesque sculpture is said to have spread into southern France and into Italy. This theory appears improbable, firstly, when one considers that the social structure of the Christian kingdoms, founded upon a feudal type of organization and upon a military régime imposed by the needs of the wars of reconquest, did not offer, during the second half of the eleventh century, very favourable conditions for the birth of the Romanesque artistic language. The theory becomes definitely wrong when the dates upon which the argument is founded are critically examined. The point of departure for the claim that European Romanesque sculpture was born in Aragon, postulates that a capital with the story of St Sixtus in the cathedral at Jaca (81) was carved in 1063. In reality, 1063 is the date of an act of donation of King Ramiro I, in which it was laid down that the new church was to be vaulted, and was to have a tower over a portal – 'ubi jam incepimus aedificare' – which only establishes that a church had been begun, without any

iv ROMAN PROVINCIAL SCULPTURE
3rd century
Sepulchral 'genius' from Mutina
Carpi, Museo Civico

certainty that the actual church is that founded by Ramiro, and, even if this were true, that the capital in question belongs to the first phase of the construction. On the contrary, this capital (81) rather than having any right to be considered as a forerunner of the sculpture of Wiligelmo, is itself clearly derived from works of the school of the Modenese master such as the reliefs of the Portale dei Principi (74), and cannot therefore be earlier than about 1110. Moreover, in the same south doorway to which it belongs, the capital accompanies other capitals, like the one with the monkeys and the one with the wild men, which have the same type of swelling and sensuous forms as those on the Porte de Miègeville in Toulouse (90-1), which are certainly not earlier than 1110. Another argument often advanced to sustain the thesis of the precedence of Aragon over any other region in Europe is the sarcophagus of Doña Sancha (84), daughter of Ramiro and widow of the Count of Provence, who died in 1097 in the Nunnery of Santa Cruz de la Serós, leaving a will in favour of the convent. But this sarcophagus, which was placed in a chapel in the cloister, of much later date, before it was transferred together with the nuns to the Benedictine Convent in Jaca where it now is, was clearly executed some years after the death of their benefactress, since it is demonstrably derived from the Modenese Portale dei Principi, and from the Cremona foundation stone (76); that is, from monuments datable about 1110. The connections with Emilian works are confirmed by the reliefs at Vich (83), clearly inspired by examples of sculpture from the circle of Wiligelmo. Neither Aragon, therefore, nor Catalonia is the cradle of European Romanesque sculpture, as has, in fact, long been recognized by the majority of writers on the subject. The problem is, however, posed anew for the region of León, and it is generally agreed that priority goes to the sculpture in this area. It is usual to date at about 1060 the portico attached to the church of S. Isidoro in León, where some of the capitals (79–80) anticipate by some thirty or forty years the characteristics proper to the earliest Romanesque sculpture of Languedoc and Emilia. This date is supported only by the old church of S. Isidoro (the present one dating from the first half of the twelfth century), which was consecrated on the 21 December 1063, and which is documented by inscriptions as due to the munificence of Fernando I, King of Castile and León, and of his consort Doña Sancha, who died in 1063 and 1067 respectively, and it would be absurd to extend it – as all the experts wish to do – to the portico, disproportionately large, and with its cross-vaults of a far more developed architectonic style than that of the old church, which was very small and covered with a barrel-vault. The explanation sometimes given, that the portico was built on a more monumental scale after the acquisition of the relics of S. Isidoro, which occurred when the construction of the church was already well under way, might be valid for its dimensions, but not for the more advanced style of the architecture and the sculpture. As it is extremely unlikely that the capitals in question date from the seventh decade of the eleventh century, it is necessary to offer for the few surviving documents a different inter-pretation from the one generally accepted. The inscription on the tomb of the daughter of Ramiro and Sancha, Doña Urraca (d. 1101), mentions that she 'ampliavit ecclesiam istam': from this it has been deduced that she began the construction of the new church (the present one) of S. Isidoro, a work by Petrus Deustamben, which was consecrated in 1149. But no one has commented on the oddness, if this is the case, of the fact that the commemorative inscription only describes as an 'enlargement' what was in fact a complete reconstruction, even if only just begun, of the church. It is much more logical to believe that Doña Urraca

had enlarged, in the last decade of the century, the old church by the addition of the atrium or Pantéon de los Reyes, and that the church finished in 1149 was founded some time later. In the last years of the eleventh century these capitals (79–80) would have had nothing surprising about them, and – if one excludes the hypothesis of an unnatural anticipation – they would confirm instead the participation of Spanish sculpture in the formation of the Romanesque style, in full agreement and probably in direct contact with Languedoc and Emilia. The large heads under their heavy mane of hair stand out in full volume from the bodies, animated, but still adhering closely to the structure of the capital (79), the strong detachment of the figures from the background, the correspondence between the harshness of the carving and the rhythms of the composition determined by the scansion of three or four lines that carry the dramatic content (80) – all confirm the clear and close prelude to the capitals of the cloister at Moissac (finished in 1100), the reliefs of Wiligelmo (1100–6), and even premonitions of the rude and summary handling of the reliefs at Vich (83). The form and composition of the capitals, the type and decoration of the abaci are similar to those found in the cloister at Moissac (68), while the figures seem to be infused with a more intense force which already points in the direction of the sculpture of Wiligelmo. The slightly later date of his works in Modena should not be an obstacle to the dating and the thesis here advanced, since Modena shows Wiligelmo at the highest maturity of his style, and it is reasonable to suppose that he had earlier created masterpieces which have now disappeared. To return to Aragon, the capitals in the interior of the cathedral at Jaca, and those of the south portal (82), which can be dated about 1110 are the work of a great sculptor and of his shop. These too are not unaware of the art of Toulouse, but are largely inspired by Roman sculpture.

We must, therefore, conclude that Romanesque sculpture found in Spain a favourable territory for the great development which became possible through the organization of religious houses, but that it was not developed entirely from within the country, but was imported through the medium of the pilgrimages, which, along various routes, led to Compostela. This is confirmed by the sculpture of the lunette of S. Isidoro in León as well as by those in Santiago itself, which largely depend upon the second phase of the sculpture of Toulouse, represented by the Porte de Miègeville (90–1), and by the few pieces of sculpture from the façade of S. Sernin, and various other pieces culminating in the series of figures by the master Gilabertus (92). At S. Isidoro, the lunette of the Portal of the Lamb, and the figured friezes which surround it (86) – given the incredible date of about 1064 in a recent publication – derive their ductility and softness from Tolosan sculpture, as also does the lunette, full of lyrical tenderness, of the Portal of Forgiveness (85). Some of the figures in the Door of the Silversmiths (87–8) have been – and probably not without reason – attributed to the same master as the Porte de Miègeville (90–1).

The second school of Toulouse, and especially Master Gilabertus (92), exercised its influence on an Emilian sculptor deriving from Wiligelmo, Niccoló, working about 1120 in Piedmont (94), in 1135 at Ferrara (93), and somewhat later at Verona (95). A notable, though not great, artist, Niccoló enriches with softness and with pictorial passages the harsh plasticity of Wiligelmo, deriving from Tolosan sculpture involved rhythms and complex motifs of a mannerist taste such as those of the crossed legs; and when he uses narrative, he shows himself gifted with a lively sense of actuality and domestic intimacy. The art of Niccoló had an enormous influence in the surrounding regions, laying the foundations, among others, of the

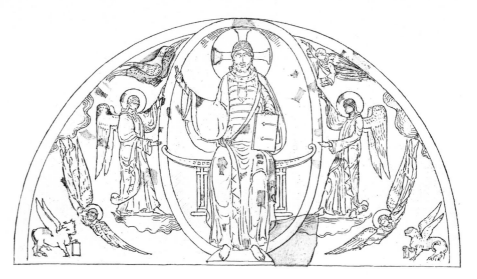

school of Piacenza (133–5), and still further afield. Thus, in Aragon, the beautiful capitals of the cloister of S. Juan de la Peña derive from him, and also those of the cloister of Gerona (121) in Catalonia, while one of his pupils worked even before 1140 at St Denis, from whence something of his style reached Lincoln (175–6). It is not impossible that he also contributed in some ways to the formation of the Provençal school of sculpture.

But now it is necessary to take up once more the story of sculpture in Burgundy, essential for the understanding of the successive developments of the Languedoc school, and that of the second phase of sculpture at Modena. Of the great portal of the Abbey of Cluny, erected about 1115, there remain only a few fragments (43), from which it may be deduced that one of the masters of the choir capitals (39) also worked on the portal. But from the reconstruction based on archeological data by Conant (v), it is evident that, under the influence of illumination, as well as of a particular type of Gaulish Early Christian sculpture, characterized by the spiritual elongation of the figures (vi), this sculpture laid the foundations of the famous tympana of Vézelay and Autun. Already, in the capitals of the nave at Vézelay (45), it is evident that there is continuity with those of the choir of Cluny; the little figures, nestling in the shadowed recesses between the foliage, sway with a lilting movement, reflected in the arched and spiralling lines that outline the folds of the draperies. The air of mystical exaltation which invests the grandiose figures of the tympanum (42, 44) makes Burgundian sculpture exactly the opposite of the earthly spirit and the feeling for the harshness of life that animate the Modenese creations of Wiligelmo (69–75). But it may be remarked that the feeling for nature and for the flesh is far from being absent from the images of the great anonymous Burgundian sculptor, who possessed a lively, fresh and sometimes even slightly sensuous feeling of tenderness for the body, which he expressed with touches of soft modelling, lengthening and refining the figures in a way that does not so much indicate abstraction, as the dissolution of the flesh in the exaltation of the spirit. There is a much more direct dependence on the destroyed portal at Cluny of the great sculptor Gislebertus, who signed the tympanum of the portal at Autun (46–8), and executed the major part of

26

the capitals of the church (50). He shows a refinement which becomes almost mannered, and which may in part have been suggested by the lost fresco paintings with which certain parts of Cluny were ornamented, and which we know only from surviving frescoes of the first decade of the twelfth century at Berzé-la-Ville. In comparison with Vézelay, the proportions of the figures are still more elongated, the relief even more subtle, while in the contours and the draperies the line has a simpler and more unified development, giving to the images an even softer movement, expressive of spiritual feeling. It would, however, be a mistake to interpret this language in terms of abstraction: just as in the architecture of the church there are frequent Classical motifs, like the pilasters, which are used for their ornamental effect, so in the capitals carved by Gislebertus, in those which are not entirely figurative, the foliage has a quality of naturalism not inferior to that of Antique capitals, except that this naturalism is pushed to an extraordinary refinement and preciousness. Similarly, in the figures the stylization is joined to a freshly naturalistic vision, so that the poetry springs not so much from the formal abstraction as from an initial abandonment to a vision of almost sensual naturalism, resolved in the purest of arabesques. This is expressed in the highest way in the wonderful figure of Eve (VIII), where a note of disturbing feminity is reached together with a spiritualized pictorial delicacy in the very sober modelling and in the rhythmic subtlety of the long, sinuous, and undulating line.

Although it is customary to deny this, the grandiose *Apocalyptic Christ* of the portal at Moissac (96–7), a masterpiece of the third phase of the Languedoc school (98–100), could not have been created – even admitting the influences from illumination – without a knowledge of the Cluny portal, and of the earlier parts of the sculpture at Vézelay and Autun. If its visionary quality might have been suggested by miniatures of the type of the *Apocalypse of St Severus*, the agitation and the extreme elongation of the figures cannot have been achieved without a knowledge of Burgundian sculpture. The great difference is that here the quivering line and the strongly pictorial quality have not overwhelmed, as happens in Burgundy, the plastic solidity of the figures, which break up the volumes and involve them in a powerful, rhythmical movement, infused with a pathos full of

27

pain and solemnity. Since the solidity of the figures is unaffected, they finally appear like men carried away by the storm winds of a transcending inspiration, which impel them forward and transform their movements into the rhythm of a sacred dance. This movement is shared not only by the *Prophets* on the door-jambs and the *trumeaux* at Moissac (97) and Souillac (98), but also by the Magi (99) who approach in a dancing measure to present their gifts to the Divine Child. What small touches of delicate and sensuous naturalism had been achieved by Burgundian sculpture were swallowed up in this rhythmic paroxysm, and only reappear in the *trumeau* at Souillac (100).

These important conjunctions were destined to diffuse the language of Burgundian and Languedoc sculpture far and wide, by virtue either of their intrinsic artistic merit, or of the very free articulation of the sculpture and its consequent ability to develop a decorative potential related to the ever varying architectural forms of the monuments of European Romanesque. Burgundian influence can be found in works of the Lombard school, as in the capitals of Parma Cathedral (59), while strong Burgundian and Languedoc influences modified very considerably the works of the followers of Wiligelmo, active for several decades at Modena after the (presumed) death of the master (101–5), giving rise to creations of the highest and most European type of Romanesque in Italy. But the influence of Burgundy and Languedoc is also patent in the huge production of sculpture in the regions of western France – in Poitou, the Saintonge, the Angoumois, the Middle Loire, and Anjou (106–7, 109, 112–14). Here, however, the profusion with which the reliefs are arranged in friezes one above the other on the church façades raises the very difficult problem of the relationship between Lombard sculpture of the Pavian phase (56–7, 58) on the one hand and Armenian sculpture of the tenth and eleventh centuries on the other. As in Pavia, and as earlier in Armenia, the sculpture is not limited to seconding the slow and powerful rhythms of the architecture, but develops and spreads over the walls like a climbing plant, or appears to rise out of the stone like a spontaneous mossy growth. The fact that Pavian sculpture remains closely tied to the preceding phases of Lombard sculpture in Como and Milan without absorbing anything from the greater softness and malleability introduced by Burgundian and Languedoc work, leads one to exclude the possibility of Pavian sculpture having derived from examples in the western regions of France, always closely connected with precedents in Burgundy and Aquitaine. The Armenian influences must, therefore, have reached Pavia first, and from there have passed into France. On the other hand, the presence on the fronts of a number of French churches in the west, besides the friezes with small figures like those in Pavia, of large figures and of arcades (106, 109), having closer analogies with work found in Armenia at Aghtamar or at Ani, appears to tip the balance in favour of a direct Armenian influence on France. The domical architecture which accompanies this congested vegetable-like sculpture is found in the Angoumois, in the Middle Loire, in the Limousin, but less frequently in Poitou (except Périgord, where St Front in Périgueux is a direct derivation from the church of the Holy Apostles in Constantinople and St Mark's in Venice), derives immediately from eastern Armenia and Georgia, through the cathedral at Cahors, which Bishop Géraud III planned with domes in 1112 after his return from a long journey in the East. If the recent hypothesis of Sanpaolesi, that the larger nave of S. Michele in Pavia was originally roofed with domes is accepted, as would seem reasonable, then two hypotheses remain open: that Pavia derived from French influence, or the

common descent from Armenian sources of both Pavia, and the group of domed churches in the Lot area (Cahors, Souillac) and the western regions of France. This is probably the most likely solution, because otherwise it would be impossible to explain the total absence in Pavian and Pavian-derived sculpture of those motifs of Aquitanian and Burgundian origin which had been absorbed into the sculpture of western France. However, despite the strangeness and contradiction of the geography that it appears to display, the domical architecture of Apulia is of French, and not Eastern, origin, because the sculpture which accompanies it (110), with its ramifications in Campania (111) and Sicily (108), presents clear derivations from the schools of western France. The sculpture of these regions of the Atlantic coast of France is as a whole very varied and picturesque, and one result of these characteristics is its rapid spread even into distant regions like southern Italy on the one hand and Spain on the other, where its influence was sometimes mixed with that emanating from Languedoc, Toulouse, and Emilia (115–22). Since the sculptors of Poitou and its adjoining regions were unable to compete in inspiration with the noble art of Vézelay, Autun, or Moissac, they concentrated on developing original details of a grotesque type, and thus reached what was perhaps the summit of their expression in the works of Master Gofridus at Chauvigny (114) and Marignac (113).

To return briefly to Lombard sculpture, to the early period of which we owe such a masterpiece as the oldest panels of the bronze doors of S. Zeno in Verona (VI), it is necessary to mention the ramifications towards the north-west in Germany, and especially in the Rhineland (60), as far as Scandinavia (61) and Saxony (64), and towards the north-east in Bavaria (63), as far afield as Carinthia (62), and in various other parts of Austria towards Hungary and Vienna, first of the earlier phase originating in Como and Milan, and then of the later one centred on Pavia. Another Lombard current was to penetrate by means of roving workshops into the mountainous regions of Auvergne and the French Massif Central (Bessuéjouls, Nant-en-Rouergue, Le Puy, Rozier-Côtes-d'Aurec in the Forez-Velay), preparing in part, through its decoration of simple village churches, for the important sculpture done later in Auvergne and territories near by (123, 124), which derived, however, from knowledge of Gallo-Roman sculpture.

With a delay of thirty or forty years in the earliest appearance of Romanesque art, Romanesque sculpture in Provence was derived from the forms established by Gilabertus of Toulouse, perhaps also on those of Niccolò of Ferrara, and certainly under the influence of provincial Roman sculpture (vii, viii), though quite a number of pieces have references to the third school of Languedoc. The sculptors of St Gilles (125–8), and their chief master, Brunus, studied Roman and Early Christian sarcophagi (and perhaps also the Gaulish Tarasque de Noves, at Avignon) with the same passionate interest with which Wiligelmo had studied the marbles from the Mutina necropolis. But the result is very different indeed. While in Modena the vigorous forms emerge from the background, yet seem to have difficulty in freeing themselves from the block (69–75), here the relief does not emerge from the stone, but has the quality of statues, strong and positive, eloquent and with heroic overtones. The friezes at Nîmes (132) are derived from St Gilles and, by a process of simplification, the sculpture at Arles (129–31). Outside the neighbouring region of the Dauphiné, the style of the Provençal figures spread and exercised a certain influence in Italy in the second half of the twelfth century. Traces of Provençal influence are to be found in the school of Piacenza (133–5), and Provence, especially Arles,

was the training-ground for Lombard workshops, which came from Campione, and were active in Modena, Milan, in the Grisons, and at Basle (136–7). Tuscan Romanesque was late in developing because in Tuscany the formation of the new type of civilization based on the communes was much slower, and because the architecture had remained tied to the aristocratic forms of the Classical tradition. The origins of Tuscan Romanesque are to be sought in St Gilles and in the older sculpture at Arles, certainly known to the Pisan Guglielmo (138–9) and to his pupils Gruamonte, Biduino, and Roberto, before the grafting of other, Byzantine, ideas on to the recent tradition influenced from Provence, gave rise to the exceptional and unusual art of Bonannus (VII, 140–2). Also, in Sicily, the centralized government of the Norman monarchy, its toleration of Islam in cultural matters as well as religious, and its orientation towards the Byzantine Empire, rendered it a not very fertile soil for the growth of Romanesque art. This arrived only as an imported style – imported, in fact, from Provence as can be seen from the tomb of Roger II (143), and the capitals of the cloisters in Cefalú (145) and Monreale (144). In the same way, the astonishing Classicism of Campanian sculpture, which until recently was explained as the reflowering of a hidden Classical current of very ancient origin, has now been restored by recent critics to its Provençal sources (146–7).

Provence was also the artistic homeland of Benedetto, one of the 'Antelami' masters – that is, a native of the Valle d'Intelvi in the Como region – who emerged from a workshop orientated, like his neighbours in Campione, towards Provence (cf. 131). Benedetto Antelami, however, has nothing of the great eloquence of the sculptors of St Gilles, or the somewhat academic refinement of those of Arles. Rather is he endowed with very delicate rhythmic feeling (148–9) and a contained

energy which infuses the marble with a new restless aspiration (150), so that he was receptive to ideas from the new sculpture of the Île-de-France (151–2, 154). With Antelami, therefore, there began a strong current of typical Late Romanesque, uniquely balanced between the traditional subservience to architecture and the laws imposed by the block of stone, and the new imaginative tendencies towards liberation from the architectonic context, and towards the 'process of individualization' which was to be the characteristic of Gothic art, by now in full flower in northern France. From Milan (155) to Ferrara (153) and Venice (157), with currents reaching from Dalmatia (158) to Lucca (156), in Arezzo and in the Marches, there develops the current emanating from Antelami during all the first half of the thirteenth century, thus separating Italy from the lively participation in the artistic life of France and Europe, which had lasted during the whole of the twelfth century.

After the middle of the twelfth century, and even earlier, the new Île-de-France school had been born. Its earliest artistic witness, the portico of the Abbey of St Denis near Paris, ready just in time for the consecration in 1140, has come down to us badly disfigured by nineteenth-century restorations, but the door-jambs make clear its derivation from the second school of Toulouse (that of Gilabertus), and of the works of Master Niccolò. This was also to be the source of the destroyed column-figures known to us only from an engraving by Montfaucon (ix), and from the few surviving heads. The recent hypothesis, according to which these figures were executed much later and are thus dependent upon Chartres, does not seem reasonable, because they occupy an intermediary position in the development of the 'type' between its first adumbration at Cremona (77), Toulouse (92), and Ferrara (93), and the final stage at Chartres (162, 164). The St Denis figures appear to have more movement than those at Chartres, and have not yet achieved their hieratic, archaic, quality. What is still original at St Denis is so closely linked to the Romanesque tradition as to make it impossible for it to be a projection into Gothic, as it is so

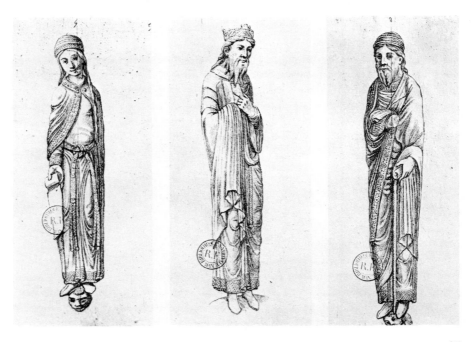

ix Column statues of St Denis as drawn by Bernard de Montfaucon

often said to be; even if the richness and the logical sequence of the programme drawn up by Abbot Suger is already on the lines of the complex, yet clear, Gothic iconography. The earliest of the Chartres masters appeared first at La-Charité-sur-Loire (159), and demonstrated that he had absorbed stylistic motifs from Burgundy and Provence. The various elements blended at Chartres (160) in an original poetic vision in the uncrowded relief and the clarity of the volumes. The famous column-statues (162, 164) and the reliefs connected with them (163, 165) are the work of other sculptors, under the unifying control of a great anonymous master; they stand as ancestors of Cathedral Gothic, but at the same time they are well within the ambit of the Romanesque because of their close adherence to the rhythm of the architecture. On the other hand, their graceful linear elaboration, with its musical overtones, holds these images – in so far as they reflect an inward spiritual life – within the world of sculpture.

The sculpture of Chartres had its echoes in Italy (151–4), in Germany (161, 166, perhaps also 172), where other rare but important works (170–1) seem rather to derive from the sculpture of western France, and in England. The wide acceptance in England of the Romanesque figurative language from the Continent – still visible despite the widespread destruction wrought by time and weather – is parallel to the infusion into the old Anglo-Saxon language of the new vocabulary used by the Normans, so that, despite certain very grand pieces of a solemn archaism (173), as a whole English sculpture is more clearly Romanesque than German sculpture. Sometimes it leans on western France (174, 177), but it attains its most powerful effects in an original re-elaboration of the language of St Denis and Chartres. Of this type are the reliefs at Lincoln (175–6), nicely balanced between the simple and solid world of Romanesque and the new sensibility and humanity of the earliest Gothic, so that it is possible to find in them, though without there being any direct contact, ideas that are a parallel to certain works of Benedetto Antelami. Thus, the reliefs and figures at Malmesbury (178–9) combine ideas from the sculpture of Saintonge and Chartres with a lively remembrance of the traditional expressiveness of Anglo-Saxon illumination; a great art, but one turned back upon its own past.

The new art of Gothic could never have come out of art of this kind, but rather from the revived archaism and the peaceful splendour of the Chartres figures (164), or from the moving and fearful solemnity of Antelami's figures (154), or from the new liveliness that runs through the figures at Oviedo (182), perhaps by Mateo, and those certainly by him in the Portico de la Gloria at Santiago (184). As happens later at Bamberg in the *Prophet* figures (211), the fervour for logic and the passion for dialectics of the rising Scholasticism are here given a new poetic expression.

Gothic Sculpture

The transition from Romanesque to Gothic sculpture is gradual, but the difficulty and controversy arise over fixing the moment in time. The actual break is certainly less than that which separates pre-Romanesque from Romanesque, and it is largely correct to adapt for sculpture the idea current in architectural history, that Gothic is the logical development of Romanesque premises. The critical point is generally fixed as being the Royal Portal at Chartres (162–5), in the middle of the

III *Adam and Eve after the Fall, the Expulsion and the condemnation to Labour* detail of door 1015 Hildesheim, Cathedral

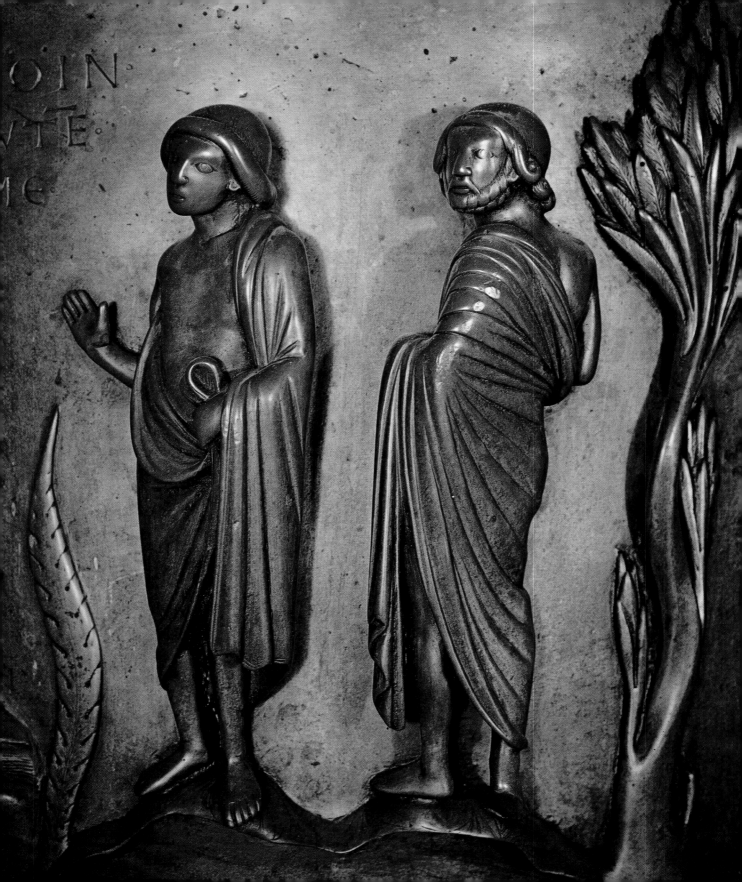

twelfth century, which, while it represents the unification and climax of the regional styles of French Romanesque, from Provence to Burgundy, also lays the foundations of one of the leading currents in the new style, 'Cathedral Gothic'. In Italy one may quote the case of Benedetto Antelami (150–4), a few decades later. He derives equally from Provençal Romanesque sculpture and from Chartres, and he, too, develops Romanesque ideas in the direction of Gothic.

If the transition is gradual, the differences between the two styles appear to shade into one another with infinite subtlety as soon as one attempts to define them, reducing to a common denominator a number of different and often conflicting aspects. From a purely formal point of view it may be said that the strict relationship with architecture is what changes the two forms. The subordination of sculpture to architecture, so much in evidence in the Romanesque period, has no place in the Gothic monuments. Figure sculpture no longer animates the elements of construction, such as capitals. These are no longer adorned with allegorical figures or whole narratives, but have motifs derived from plant forms, in harmony with that sense of a living organism which animates the architecture itself. Where there are figures they are isolated in the special zones created by niches or tabernacles. Sculptors continued to provide the adornment of portals and façades, but without subordinating themselves to the exigencies of the architecture to such an extent that, as not infrequently happened in the Romanesque period, the actual proportions of figures suffered major changes. Gothic figures tend to maintain their own rights, not rebelling against the architecture but freely accompanying it with their own special rhythms. The relief is no longer the favourite sculptural form, but is replaced by the statue in the round or a relief so high that it approaches the round, and, when it is necessary to approximate the relief form, as in the decoration of pilasters or plinths, the sculptors avoid continuous friezes or the casual, pictorial, type of arrangement in order to set off figures and scenes in defined panels and a geometric framework. This corresponds closely with the vivid organic and geometrical quality of Gothic architecture, and for the same reason, rather than stress the importance of the sculptural masses or the functional vitality of individual members by means of volume or chiaroscuro, the emphasis is given by a style which is based on the power of a harmonious quality of line to express the living organism of the building as a whole. Sculpture becomes more delicate, with graceful and undulating forms to go with the projecting and branching lines of a type of architecture which tended to reduce walls to a transparency, filtering the daylight through stained-glass windows to make a transcendental effect of coloured light, leaving the skeletal forms of the load-bearing members to express both the static forces and the spiritual tension of the building.

From the point of view of subject-matter, it is well known that Gothic iconography does not make any radical innovations by comparison with Romanesque, but it is on the whole richer, more organic, and more logical. It tends to reflect the ideas behind the great encyclopedias, those *Speculae* which are so typical of religious literature of the thirteenth century and which operated on a grand scale to make a rigid synthesis of history, morals, and dogma. Even as early as the triple Royal Portal at Chartres, which is still substantially Romanesque in style and still connected to the Romanesque tradition in iconography, there is a wider and more organic programme than is normal in Romanesque churches. There are prophets and patriarchs from the Old Testament in the series of column-statues (twenty-six in the original arrangement); the months and the signs of the Zodiac for the

V Rainer of·Huy
Two men awaiting baptism, detail of font 1107–18
Liège, St Barthélemy

33

intermediate colonettes; the entire story of Christ on the capitals; and the Apostles and the Ascension, the vision of the Apocalyptic Christ, and the Virgin in Glory, with scenes from her life on the architrave, in the three lunettes. It is in any case significant that this programme, organic enough in itself, seemed inadequate to the masters who, about 1200, undertook the reconstruction of the nave and choir, destroyed in the fire of 1194. Whether or not it was the intention from the beginning to retain the old façade, which had been spared by the fire, as in fact happened, the transept portals certainly repeat the iconographic scheme of the Royal Portal in a new, fuller, and more logically arranged version. The central portal of the north transept is dedicated to the Virgin and culminating in the lunette with her Coronation, preceded by the Dormition and Assumption in the architrave, clarifies the reference to the Old Testament, made in the Royal Portal by the statues of prophets and patriarchs. In the north transept this is done by the two distinct but convergent series of the human ancestors of the Virgin (and of Christ), under the form of the Tree of Jesse in the voussoirs, and of the spiritual forerunners of Christ (and of the Virgin) – Abraham, Moses, Samuel, David, Isaiah, Jeremiah, Simeon, John the Baptist – in the column-statues, adding at either end the two High Priests Melchisedek and Peter, to identify Christ with the Church. After 1220, when it was decided to add an extra portal on each side of the central one, the themes chosen for the sculpture were a logical extension of those on the central portal: scenes from the Life of the Virgin on the one side, and another series of the spiritual precursors of Christ on the other – Balaam, the Queen of Sheba, Solomon, Sirach, Judith, Joseph. On the architrave and tympanum of this door there are two histories prefiguring the two essential aspects of Christ – the Judgement of Solomon and the Patience of Job, standing for teaching and sacrifice. The central portal of the south transept also repeats one of the themes of the Royal Portal, that of the Apocalyptic Christ, although it is merged into the representation of the Last Judgement and accompanied by the series of the Apostles, each of whom is triumphing over his persecutor. Thus the north transept portal represents a synthesis of the prehistory of Christianity, while that on the other side presents, through the Apostles, Christianity in action, and, with the Last Judgement, its climax at the end of time. The theme of Christianity in action is further developed in those portals which were very soon added to the central one and devoted to martyrs and confessors respectively, arranged in rows of column-statues below the histories which occupy architrave and lunette respectively of the two portals, of St Stephen Protomartyr, and of St Nicholas of Bari and St Martin, representing those confessors who were notable for their charity.

This emphasis on doctrinal coherence in the drawing-up of the iconographic programmes cannot but be connected with the general tendency of contemporary theological thought which led to the compilation of the *Summae* and the *Specula Salvationis*. On the other hand, the strict logic and the spirit of geometry which inform both the iconography and the style of Gothic architecture and sculpture have led people to think of the rigorous system of Scholastic philosophy; and the analogy certainly gains in conviction when we recall that the centre – or, at least, one of the great centres – of this cultural and philosophical movement was Paris, where the great university was rising at the very moment when Notre-Dame and the new cathedral at Chartres were being built. There can hardly be any doubt that the rigorous intellectual quest for religious finality, the systematization of doctrine, the clarity of language in the interlinked parts of a syllogism, are all aspects of

Scholastic philosophy which seem to be reflected in the guiding principles of Gothic art. Even that current of thirteenth-century thought which sought to subordinate natural values to the transcendental, through geometry, finds its echo in Gothic art. It has often been noted that the method used by Villard de Honnecourt, and often demonstrated in his famous sketchbook, of mastering the forms of nature by deriving them from, or confining them within, geometrical figures corresponds closely to the statement of the contemporary philosopher Robert Grosseteste: 'omnes causae effectuum naturalium habent dari per lineas, angulos, et figuras . . . quoniam impossibile est scire naturalem philosophiam sine illis'. When one reflects that the earliest of the *Summae* and of the *Speculae*, beginning with the *Summa* by Alexander of Hales, *doctor irrefragabilis*, were not published until the great French cathedrals were in large part built and decorated, and that in general Scholasticism reached its full flowering only in the latter part of the thirteenth century, then it is evident that Gothic art has a clear priority. The methods of *Kunstgeschichte als Geistesgeschichte* have accustomed us to seek in the visual arts a reflection of the thought and 'spirit' of an age; but we ought always to remember that art is itself a *primary* means of expression of the human spirit and is not a surrogate or reflection of its other activities. For this reason it is not at all uncommon to find examples of times and places in which art seems to give clearer and more definite manifestations of feelings and thoughts that were certainly in the air, but which still awaited elaboration in literature or philosophy. In such cases we should not hesitate to recognize the creative stimulus of the arts outside the field of their own special figurative poetry, in the domain of thought and the general tendencies of culture and civilization. A striking example is furnished by Florence in the first decades of the Quattrocento: no philosopher, no writer, had, in the first thirty years of the century, expressed the new principles of the dignity and autonomy of man – the essence of Humanism – with the same force, decision, and clarity with which Brunelleschi from 1420 and Masaccio from 1427 had proclaimed them in the lucid spaces of the Ospedale degli Innocenti and on the walls of the Brancacci Chapel. To say this does not alter the fact that, later, it was Marsilio Ficino and Poliziano who provided allegorical and Neoplatonic material for Sandro Botticelli to turn into pictorial poetry. The Early Gothic period in northern France was one such moment, and it was the Gothic architecture and sculpture of the Île-de-France that had the merit of giving the first and most poetic expression to sentiments and ideas that, once crystallized in philosophy, gave the civilization of the age its character.

An iconographical peculiarity of the Judgement Portal at Chartres points, as Kidson has shown, to another salient aspect of Early Gothic. In this relief the angels, the Blessed, and the Damned, who, in Romanesque compositions of this type occupied the greater part of the lunette, are now confined to the voussoirs so as to leave much more room in the lunette for the figures of the Intercessors, Mary and St John: 'they introduce into these awe-inspiring proceedings a note of mercy'. On the *trumeau* there appears the figure of Christ, the *Beau-Dieu*, benignly blessing. In Romanesque Last Judgements the main emphasis was on the terrors of damnation, but here the accent is shifted towards hope and the promise of salvation. It may in part be due to the circumstance that Chartres, the earliest Gothic cathedral, had always been dedicated to the Virgin that the cult of Mary became increasingly important in the Gothic period: it is possible, when one considers the importance of Chartres as an example for the art of the epoch, although another, and more important, reason is to be found in the intercessory role which Christian thought

attributed to Mary. The emphasis given at the time to this aspect of the cult of the Mother of God corresponds to the attitude of the Church, which, more and more, interposed as mediator between Man and God and, again according to Kidson, corresponds to the increased faith of society in general in the Church, which, in the pontificate of Innocent III, reached the summit of its power and was convinced of its possession of all knowledge, which could be expounded synthetically in the written encyclopaedias of the *Summae* or the stone ones of the cathedrals. In this way Gothic art also became an expression of the increased prestige of the Church, and it may be possible to explain this in terms of the birth of Gothic in the Île-de-France. This was the personal domain of the King of France at the time of the earliest example of Gothic architecture, the choir of the Abbey of St Denis. From this arises the old, but still valid, definition of Gothic as the art of the French monarchy at the time of its first affirmation of power; confirmed by the fact that the Gothic region, at first a small island in a Romanesque sea, extended *pari passu* with the extension of the Capetian dominion from Louis VII to Philippe Auguste, who reconquered the northern provinces from the English and was the first king crowned on the hereditary principle. This society was returning to a deeper faith in the Church and was more unified than those outside, divided into feudal over-lordships, abbacies, and communes, and it was a monarchical system within which there was already arising the idea of a chivalrous and courtly society. It found itself facing a pope educated in France, who knew how to impose his own authority on the king in matrimonial questions and was to succeed in obtaining help from the same king against the Emperor Otto IV. Historical circumstances, therefore, favoured the acceptance on the part of the restricted society dependent on the monarchy of the spiritual guidance of the Church in the matter of salvation guaranteed by the protection of the Virgin. The cult of Mary was linked with the cult of Woman, characteristic of chivalry, while the overall tone of aristocracy in a monarchical society favoured the refinement of taste, the turning of the formal ideals of the epoch towards subtlety and sweetness. In harmony with this back-ground of an aristocratic and monarchical society the new figurative language was characterized not only by greater refinement than its predecessor had possessed, but also by a greater unity than the formal language of Romanesque art, which had had innumerable local varieties and had fermented, as it were, many dialects. Thus, to return to the parallel between the figurative arts and the spoken and written languages which has already helped to clarify the meaning and origins of Roman-esque art, it may be said that if Romanesque corresponds to the birth of the Romance languages and their dialects, Gothic represents a later and different phase of the same linguistic process – progressive linguistic unification by means of the imposition on a whole nation of the culturally and politically most important ver-naculars as a literary language. Political prestige assured the triumph of the *langue d'oïl* over the *langue d'oc* in France and later the prevalence in Spain of Castilian over Catalan, while literary prestige secured the hegemony of Tuscan over the other dialects of Italy and the *Mittelhochdeutsch* dialects of South Germany over the *Plattdeutsch* of the North, long before Luther coined modern German.

If we interpret Gothic in its early stages as the artistic language of the French monarchy it will also explain how, in contrast to Romanesque, which arose at the same time in many different centres in the neo-Latin countries, the progress of the Gothic style can be verified as a diffusion from a single centre which steadily eroded the Romanesque areas. Similarly, it will explain the differing rates of

diffusion in the various countries and regions. It was relatively slow in conquering the southern regions of France itself, which had for some time been separate from the kingdom of France and enjoyed different cultural and political conditions up to the time of the conquest of Languedoc (1215) and the Albigensian Crusade, which inflicted grave damage upon the cultural autonomy of Provence. Gothic was still slower in penetrating Italy, but, on the other hand, it rapidly reached the English monarchy and penetrated Germany rather less quickly but nevertheless with a deep and lasting effect on the country, broken up as it was into numerous feudal dominions, each of which was at least monarchical in tendency. Longer than any other country Italy retained all the varieties of Romanesque, and, as a parallel, the formation of a national literary language was long delayed. It was precisely here that some of the conditions favourable to the rise of Romanesque culture lasted longer than elsewhere, above all the socio-political system of the Communes. Here, too, one can see that the Gothic style was diffused more rapidly in those places where the Commune gave way to a Signoria – a régime more favourable to the establishment of a courtly and chivalrous culture – and, on the contrary, was more original and independent of the rest of Europe, more pre-Renaissance, where, as in Florence, bourgeois rule flourished throughout the Trecento.

Even though Senlis derives from Chartres, the profound difference which separates the scenes from the Lives of Mary and Jesus on the Royal Portal (159, 160) at Chartres from the two scenes of the Dormition and Assumption (187) on the architrave (below the *Coronation* lunette) of Senlis Cathedral, is what makes us think that it is here, about 1175, and not at Chartres about 1150, that we find the beginnings of Gothic sculpture. The histories at Chartres are still related in an atmosphere of modest reserve, although the accents are placed with great subtlety. At Senlis, on the other hand, in spite of the old-fashioned way in which the figures are contained within strictly limited rhythmic movements, the free-standing quality of the figures and their complete absorption into swirling linear patterns introduce accents of affecting and shy emotion into the scene, iconographically new, of the Assumption, which is interpreted as the awakening of the Virgin by a crowd of angels. The iconographical renewal goes hand-in-hand, therefore, with the stylistic one in a new intimacy of expressive accent. While elsewhere, as at Notre-Dame de Corbeil, the ideas of the Royal Portal were re-elaborated in a traditional, still largely Romanesque, way (cf. the figures of Solomon and the Queen of Sheba in the Louvre), and in the sculpture of the Portal of St Anne at Notre-Dame, Paris, before its reworking in the thirteenth century (189–90) the new spirit found very restrained expression, implicit, so to speak, in the sometimes harsh tension which affects rigidly archaic forms. The process of formal and psychological liberation begun at Senlis continued, in the last decade of the twelfth century, at Laon, to go on to the transept portals at Chartres. Nevertheless, it must be borne in mind that there were parallel influences, archaizing in a different sense: thus, the reliefs on the plinths of the portal of the cathedral at Sens, of about 1200, with the Liberal Arts and other allegories, though they can be called Gothic because of the freedom of their movement and loose relationship to their background, nevertheless benefit in their rich chiaroscuro and effects of modelling from the more pictorial aspects of the Romanesque tradition. In the first years of the thirteenth century the reliefs on the plinths of the Judgement Portal of Notre-Dame, Paris, derive from Sens. A little later, about 1210, the Portal of the Virgin at Notre-Dame, both in the great composition of the tympanum with its Dormition of the Virgin, so much more

restrained than the one at Senlis, and in the reliefs of the plinth and the *trumeau* (188), begins a new tendency later to be developed at Amiens. This has an almost academic clarity of form and attempts have been made to explain it in terms of Byzantine ivories. In its finest results it is animated by touches of sober naturalism and contained emotion that recall, perhaps not entirely by chance, the mature work of Benedetto Antelami. There is a different spirit in the transept portals of the renovated Cathedral of Chartres, built and carved in the first decade of the century. Here the column-statues are almost free-standing, and, with the harmonious play of their volumes and the delicate lines of the drapery folds, they seem to seek a new balance of forces. Based on a discreet use of Antique exemplars, they have something of the self-sufficiency of Classical statuary, while on the other hand their elongated and gently undulating forms harmonize with the vertical rhythms of the architecture: in this way they attain a high degree of naturalism without ever infringing their subordination to the striving for transcendence which underlies the tense and dynamic structure of the whole cathedral. Even the high reliefs of the architraves and tympana, such as the Dormition, Assumption, and Coronation of the Virgin, translate the passionate and lyrical style of Senlis (perhaps transmitted through Laon) into gentle and tranquil forms, not without pathos.

A quite different approach can be seen in Solomon's Portal, at the right of the north transept, where the dramatic pathos is increased in the *Judgement of Solomon*, just as much as in the stories of Tobias in the archivolts, by means of the fully realized three-dimensional quality of the figures and the variations in the narrative rhythm. In the Creation scenes (which belong to the porch added a little later to the three portals) the style reaches a rare climax of lyrical tenderness; as, for example, in *The Creation of Adam* (191), where, against all iconographic tradition, the figure of God the Father assumes the youthful and gentle expression appropriate to a Christ figure – an innovation which accords perfectly with stylistic needs. The caress with which he models the form of Adam is in keeping with the delicacy of light and shade and the fragile quality of the draperies. Among the last statues of this attached porch, such as the fascinating figure of Ste Modeste (192), we encounter a new spirit of Classical equilibrium, which is certainly connected with one of the masters of Rheims: it is sometimes supposed that such an intervention by Rheims masters at Chartres would be due to Villard de Honnecourt, who is said to have gone to Chartres after a period at Rheims. Equally late, but different in style, are the statues of the knightly saints Theodore and George (193), added with the extra porch of the left-hand portal of the south transept: they are particularly notable for the way in which their energetic naturalism and portrait-like quality is made to harmonize smoothly with the exalted idealism of the whole setting. At Rheims, where the iconographical programme is less coherent on account of changes made during the process of construction – as, for example, when the portals designed for the façade were adapted to the transept – French Gothic sculpture reaches its most 'Classical' moment. This is true in the literal and historical sense, for there is a breath of true Classical feeling and a clear reference to actual Classical models – though these, I think, are more likely to have been Roman works of the Augustan Age or of a Hellenizing type than, as is sometimes claimed, Greek works which are supposed to have been brought back from the Peloponnese by the French conquerors Geoffroy de Villehardouin and Guillaume de Champlitte, or by the Duke of Athens, Othon de la Roche. This is illustrated in the celebrated *Visitation* (201), but it is also true in the sense that there is a perfect balance between

the feeling for naturalism and the spirit of transcendence in the figures of the dead rising in the Last Judgement (202), with nudes that are almost sensual and yet highly spiritual, or in the perfect fusion between the feminity that is so vibrant in the figures of *Church* (199) and *Synagogue* and the calm which makes them suitable vehicles for their allegorical meaning, or, finally, in the balance maintained between individual portraiture and typological universalism – the youthful king in a knightly society – which characterizes the fascinating portrait of Philippe Auguste (200).

At Amiens, on the other hand, there is a stylistic variety which ranges from the painterly narrative intensity of the Judgement tympanum to the almost apathetic calm of many of the column-statues, including the Annunciation group; from the austere but merciful *Beau-Dieu* to the complacent preciosity of the *Vierge Dorée* (209) and the tympanum of the portal above, where the story of St Honoré and the *Crucifixion* above it are inspired by a great lyrical tenderness, while it is a fresh naturalism that animates the reliefs of the months (194) and those of the history of the prophets or the stories of the Virgin. Equal in its lyrical intensity and refinement of style to the most delicate sculpture at Amiens is the Nativity from the rood-screen at Chartres (203), but it has a greater reserve, and at Paris there is a vivacity full of sensibility in the reliefs of the portal by Jean de Chelles (195). The Nativity from the rood-screen at Chartres has its stylistic premises in some of the figures from the Judgement Portal of the south transept there, and it is from there that the stylistic current flows which leads quickly to the superb and highly finished figures at Strasbourg (196–8). This is probably the common source of the spiritual affinity which seems to connect *Church and Synagogue* at Strasbourg (196), with the *Nativity* at Chartres (203), much more than is the case with the same figures at Rheims (199). It is not possible to follow here in all its many variations the later complex development of French sculpture in the thirteenth century (204–5, 207, 210); it is sufficient to point to the exceptionally pathetic quality of the vigorously modelled reliefs from the rood-screen of Bourges (206), which seem, as Gnudi claims, to be close predecessors of certain aspects of the art of Nicola Pisano.

German Gothic sculpture was directly dependent upon French, but very soon elaborated new and highly original characteristics of its own. As early as the Golden Door of Freiberg Cathedral in Saxony, of about 1220–5, perhaps influenced by the minor arts of the Romanesque, the fundamentally French characteristics have grafted on to them an insistence on realism and a concern for the narrative unfolding of the story which combine to give a feeling of simple, domestic intimacy. The situation is different at Bamberg where there were at least two successive workshops engaged. The earlier of the two, active about 1220–5, was responsible for the Portal of Grace (*Gnadenpforte*), which is architecturally still Late Romanesque, and for the prophets in the east choir (211), which may relate to Provençal Romanesque, but are primarily characterized by the retention of the expressionistic excitement of Ottonian ivories and Ottonian and Romanesque illumination. In this case the Gothic spirit is attained by a different road from that taken in France, through a nucleus of a strongly plastic centre of emphasis, round which there builds up an independent linear system of harsh movements. The tense agitation culminates in the very strongly characterized heads. The same thing is to be seen in the series of Apostles and prophets on the left jamb of the Portal of the Princes (212); which is the work of another master of the same group. The great sculptor who is known as the Master of Bamberg (213–16) followed immediately afterwards;

he must certainly have come from Rheims and was either a pupil or admirer of the Master of the *Visitation* (201). The Classical poise of the French sculptor, however, gives way here to an intensely naturalistic vision in the sense that the artist obtains his unforgettable impression of nobility and spiritual firmness by accentuating the physical vitality and individuality of his creations. Nothing but a direct confrontation between the *Philippe Auguste* from Rheims and the *Rider of Bamberg* (200, 216) – probably the Emperor Henry II opposite a figure of Constantine which is lost or was never executed – can serve to bring home to us the differences of temperament and of historical setting which gave rise to the two figures. The image of the young King of France is half-way between individuality and the collective personality of the choir of sacred personages who are his companions, all of them part of the rhythm of the architecture around them; and again divided between his own individuality and that of the type he represents, the king of a Christian country and of a crusading people. The Bamberg emperor is also in an architectural setting, but this is not Gothic in the full sense of the term, since it retains the weight and massiveness of Romanesque, for the statue of the rider draws its life from the dialectic between the solid mass of the horse and the supple twist of the man, restrained in his turn by the baldachin overhead. The tension here is not, as at Rheims, between individualism and participation in a group ideal, but between will-power and personal, active domination and the resistance offered by the outside world, symbolized by the Romanesque gravity of the building. In the still feudal German monarchy there did not obtain that tranquil faith in King and Church which was the force behind the French monarchy. The Golden Door of Freiberg Cathedral in Saxony, where, as in the Portal of Grace at Bamberg, Gothic figures are set on the jambs of a portal which is still Late Romanesque of a Lombard type, and the *Foolish Virgins* at Magdeburg (219) are, together with the works of the Master of Bamberg, the stylistic precursors of the great Master of Naumburg and his shop (220–4). This is the culmination of thirteenth-century sculpture in Germany, and it still remains difficult, because of the uncertain dating, to define the relationship with Burgundian sculpture such as that of Semur-en-Auxois (210). Compact modelling of the volumes, shot through with an extreme tension in the linear composition, gives a dramatic freedom animated by a rather popular type of expressionism and at the same time a haughty and fierce power. These are qualities to be ascribed to the extraordinary personality of the artist, but they were made possible by the sharp contrasts in a society which was divided and tumultuous and far from the stability attained in France.

The thirteenth century in England presents original variations, but basically of the same type as their French models, and many works of high quality were produced as early as the first decade of the century. At first the influence of Chartres and its region is grafted on to massive and severe forms still linked to the Romanesque tradition (225–6), or produces variations of a more fantastic and unbridled sort, on the theme of the monstrous (227). After a very short time this genre evolves, without further reference to France, in two separate directions – the grotesque (233), and the humorous portrait adorned with ornaments and witty anthropomorphic use of the architectural elements, as in the corbels of Christ Church, Oxford (232), or those in the triforium of Westminster Abbey (234), which develop a type that appeared in the first decade of the century in the capitals of Wells Cathedral (228). A characteristic form of sculpture in Britain is the tomb-effigy carved in stone, with the figure of the dead man stretched out on a

V Nicholas of Verdun
 The Shrine of the Magi, detail *c.* 119
 Cologne, Cathedral

VI *Adam and Eve after the Fall, the Exp*
 sion, the Labour and the Crime of Ca
 detail of door, *c.* 1100
 Verona, San Zeno

VII Bonanus Pisanus
 The Flight into Egypt, detail of door
 c. 1190–95
 Pisa, Cathedral (Porta di S. Ranier

VIII *Eve c.* 1130
 Autun, Musée de la Cathédrale

 (*VI, VII, VIII overleaf*)

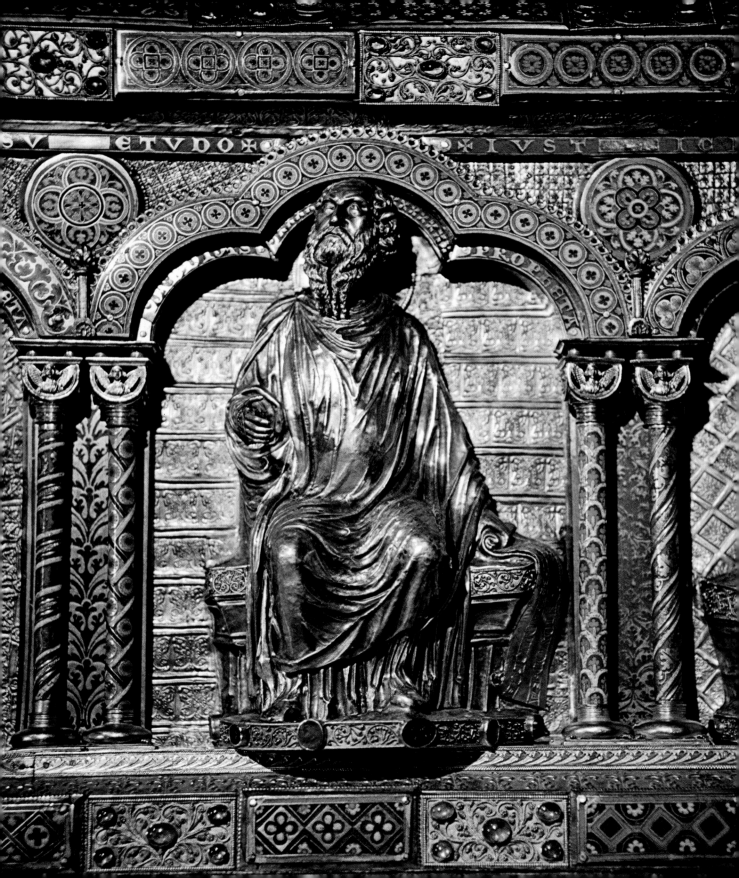

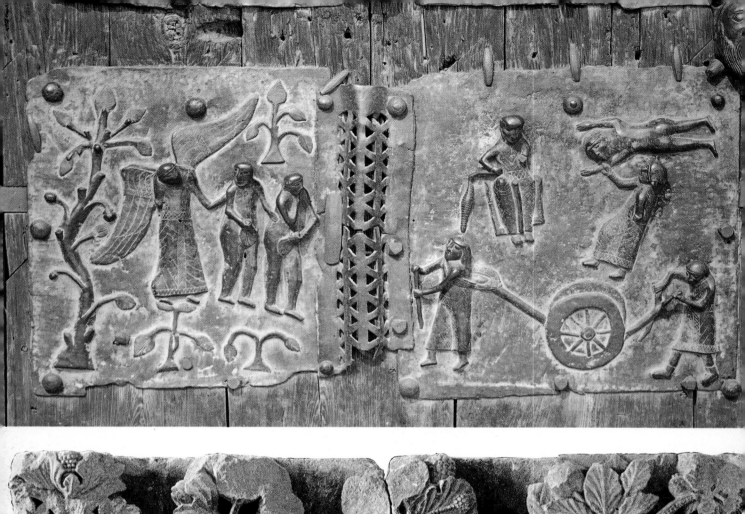

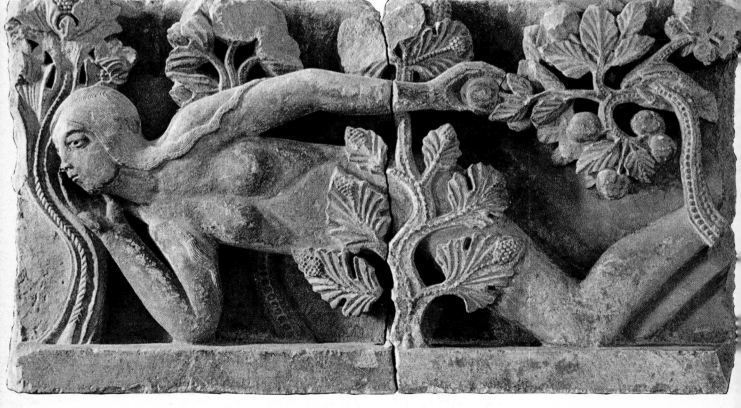

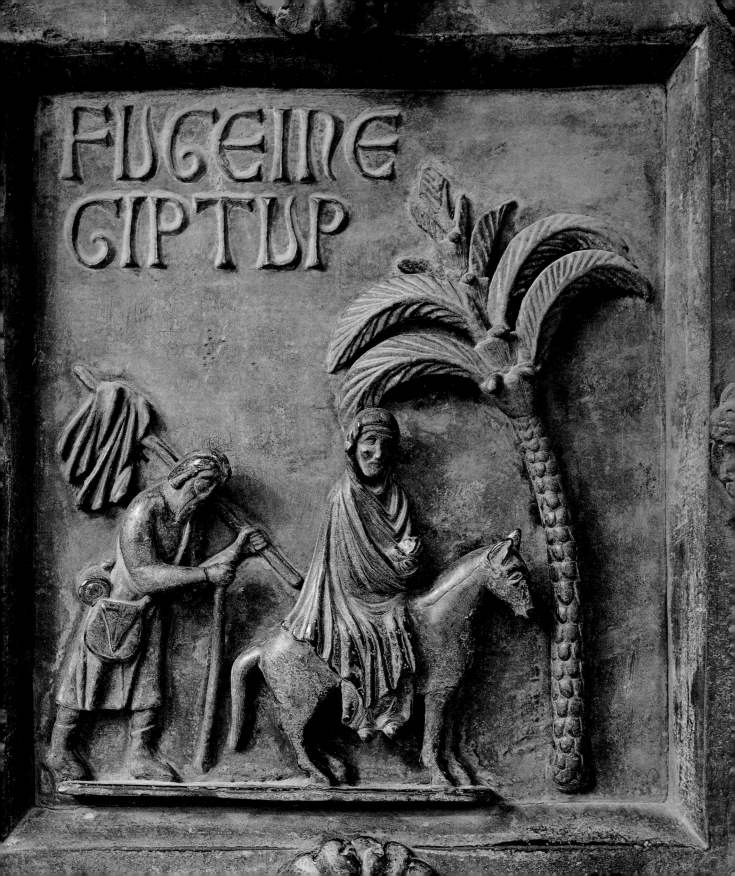

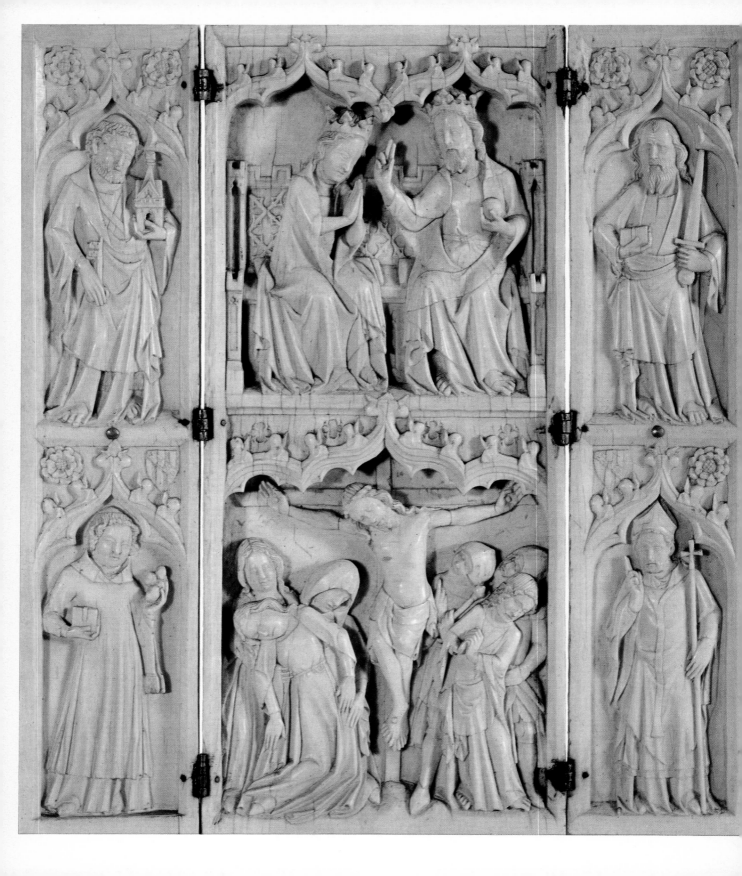

sarcophagus: the theme, already known in France, is no longer confined to the royal and aristocratic sphere, but passes into that of bishops and, above all, knights, both classes being then in the ascendant with the imposition on the monarchy of Magna Carta and the growth of parliamentary institutions. Certainly, the practical spirit of this class had some effect on such images, from that of Bishop Levericus at Wells to that of William Longespee at Salisbury (231), and from that of the unknown knight at Pershore up to that, of exceptional beauty, of the knight unsheathing his sword, at Dorchester (238): all are presented with a strong flavour of realism and almost brutal energy. They are much more alive than the precious series of royal tombs in Westminster Abbey, of gilded bronze, begun with the commission given by Edward I to William Torel for the monument to Eleanor of Castile (235). The sculpture of religious subjects on façades and portals follows more closely the examples of Paris and Amiens, though almost always with touches of originality, sometimes of a rather timidly archaic gentleness, as at Wells (229–30), at Winchester, or in the highly poetic head found among the ruins of Clarendon Palace (236), sometimes of a deeper lyricism in a vision of dream-like elegance, as in the portal of the Chapter House at Westminster Abbey (237).

Spanish sculpture is more closely linked to France, and some pieces may actually be the work of immigrant Frenchmen. Its greatest masterpiece is perhaps to be found in the work of the anonymous master, certainly a Spaniard, who, just after the middle of the century, carved the imposing images of Nuestra Señora la Blanca at León (239) and of Queen Violante at Burgos (241), with their feeling for breadth in the placing of the figures and a lively sense of the body and of the drapery.

Italian sculpture of the Duecento and Trecento needs a rather longer treatment, on account of the great diversity of its aspects and its richness in creative artists. So much variety, and the limited validity of the term Gothic, which, in Italy sometimes assumes a significance no more than obliquely related to its meaning in the other countries of Western Europe, are both the result of the absence of a unified movement in the peninsula as a whole and the lack of a political centre of force. In Italy the fragmentation into communes lasted for a long time and resulted in the formation of a society of urban, bourgeois states instead of a unified monarchy. Thus, the regional and local variations remained more active than elsewhere, while the need for unity – made plain by economic considerations – found some satisfaction, by a process of transference on to the plane of culture and imagination, in a complicated dialogue between the universalism of religion and a national sentiment rooted in the myth of a common Classical origin. Hence the 'Protorenaissance' and Classicizing elements in the art of such masters as Nicola Pisano and Arnolfo, and on the other hand, related to European Gothic, such varied masters as Giovanni Pisano, Andrea da Pontedera, and Lorenzo Maitani.

The earliest manifestation of Classicism, even though it is entwined with traits of Gothic and of the monastic architecture of the Cistercians, is of courtly inspiration and appears, before the middle of the thirteenth century, in South Italy under the inspiration of Frederick II (242–4). Brought up in this atmosphere of southern Classicism and on the Roman sculpture which Pisa then, as now, offers in large quantities, Nicola de Apulia, having become a Pisan citizen, chose the calm and noble forms of Classical art (x, xi) as those most suited to carry the message of Christian truths which he was expounding in his pulpits (245–50), in pursuance of a programme which made of the *ambone* a sort of synthetic encyclopedia of doctrine copied from the much vaster examples displayed in the huge French

The Coronation of the Virgin, the Crucifixion, the Saints Peter, Paul, Stephen and a Saint Bishop
c. 1340
London, British Museum

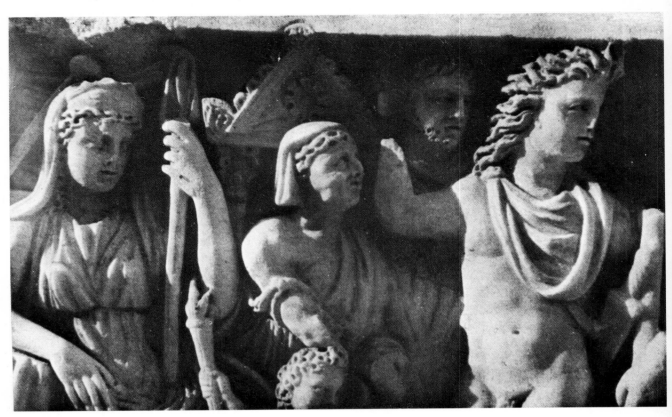

x Late antique sarcophagus, detail
Capua, Cathedral (crypt)

cathedrals. It is extremely characteristic of Italian civilization that such an idea should also be adapted, by the master responsible, to a secular work, put up as a symbol of the glory of a city (253–4). The spirit of Gothic art is not absent, nor is it limited to modifying the solemn Classical language with a few subtle and intimate inflections (249–50), or to introduce, through the work of pupils (251–2), decorative flourishes. It is present as the breath of life in even the most Classical scenes of the Pisa Pulpit (245–8), where it introduces into the Classicizing reliefs a sense of the organic growth of form. In this way, Nicola's Classicism, fertilized by the naturalistic sensibility of Gothic art, is inspired by a sense of pathos at the same time as it is engaged in re-evoking an admired grandeur. His pupil Arnolfo had a different sense of the Classic (250, 255–61), since his art was informed by Etruscan and Late Roman examples, allied to a linear tension derived from Gothic which he applied to forms of an almost neo-Romanesque solidity. This gives his figures a distant and unapproachable air – a kind of timeless detachment. To an interpretation of such strongly 'national' type, and as such a forerunner of the Renaissance, the kind of Gothic present in Nicola and Arnolfo is very soon counterbalanced by the entirely European attitudes of Giovanni Pisano (263, 265–70, 272). That, as a young man, after collaborating on the Siena pulpit (1268) and before working again with his father on the Perugia fountain (1277–8), Giovanni had travelled in France and perhaps even in Spain, is possible and perhaps probable. Among other things, the Madonna of the portal of Tarragona Cathedral,

a masterpiece by Bartolomé de Gerona (264), cannot be explained without a knowledge of youthful works by Giovanni. That he might have seen French ivories (262, 273–4) in Italy, which would have given him a knowledge either of the powerful, but still archaic, language of the Madonna in the Portal of the Coronation of the Virgin of Notre-Dame in Paris, or of the highly refined style of the statues in the Ste-Chapelle, is certain, even if too few pieces of this kind still remain in Italy. The varied aspects of French Gothic linearism are transformed by Giovanni Pisano into an extremely sharp tension, into jagged lines and movements of painful agitation, treated with a strong and pictorial chiaroscuro, which imposes its own dynamism on the volumes and the arrangements of his compositions. This feeling for deep and violent drama with an expressionistic quality, brings Giovanni close – on an ideal plane although his formal language is more elegant – to the expressionism of the Master of Naumburg (222). The position of Andrea da Pontedera (275–8, 281–2) is very unusual. Knowledgeable in French sculpture (and not only through his son Nino, but probably by means of goldsmith's works, or whalebone statuettes) he was, however, deeply affected by Giotto's full forms and measured movements. He thus achieved a highly personal language, in which the synthetizing clarity of his perception of the dramatic meaning of an event is accompanied by, and also based on, a very soft and harmonious treatment, so that the drama appears almost like a transparency seen through the lens of a serenely idyllic vision.

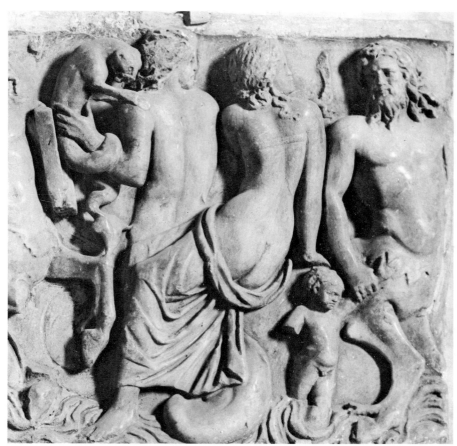

Roman relief with nereids
Siena, Museo del 'Opera del Duomo'

The elements of Gothic style reached Siena either through Giovanni Pisano or through the painting of Simone Martini and the Lorenzetti brothers. This was the case with Tino di Camaino (271) and also Lorenzo Maitani (284), who displays a knowledge of the tender French narrative sculpture of the early years of the Trecento, such as that of the delicate reliefs at St Étienne in Auxerre (283). In Florence, by the mid-century, sculpture was treading the beaten path of conservatism in a sort of neo-Gothicism, more or less nourished by Andrea Pisano, with Arnoldi (287) and other sculptors of the series of upper panels in the Campanile, and with Orcagna (285). In the south, meanwhile, an initial French influence (the tomb of Queen Isabella in the cathedral at Cosenza, of *c*. 1275) was replaced by a Tuscan influence through the immigration of Tino and other sculptors to Naples. Tuscan influences also reached Lombardy with the immigration of Giovanni di Balduccio (286), and the presence of works by Giovanni Pisano and Nino Pisano in the Veneto. But at the same time, in Lombardy and Verona, through works by the Campione Masters (288–9), who were the heirs of the tradition of this current (136–7), there appeared a language moulded from neo-Romanesque, and strengthened by a vigorous realism. From this framework comes the older of the Scaligeri tombs in Verona, that of Cangrande (291), uncertain in date and even more uncertain in its stylistic descent, but of the highest artistic value because of its imaginative transfiguration of the facts of reality, carefully studied and fully absorbed by the artist. It is a work which combines harsh realism with a courtly quality and can, therefore, stand as a symbol of the proud, active, and unscrupulous society of the Signorie of the fourteenth century.

French sculpture of this period is very rich, but overall much less important than it had been in the thirteenth century. Both in funerary art, with its centre at St Denis, and in the decoration of church façades and portals, it merely develops the implications of the work of the previous century, but with a strong tendency towards richer decoration, as in the north transept portal at Bordeaux (*c*. 1310), or towards a more intimate lyricism gained by delicacy of line and subtle pictorial effects, as in the reliefs on the outside of the choir chapels of Notre-Dame, about 1310–20, or in those of the façade of Auxerre Cathedral (283), while a more dramatic character is to be found in the reliefs of the choir enclosure of Notre-Dame at Paris. It was the type of standing Madonna on the *trumeaux* which was the starting-point for the series of statues of the Madonna, upright, holding the Child in her arms (279–80) as opposed to the other series of Madonna statues, derived from different sources, in which she is shown seated. By and large, French sculpture develops in the course of the fourteenth century towards an ever-increasing refinement, in monumental stone statues, in diptychs, statuettes, and small ivories (290): the exquisite products of a civilization already definitely 'courtly'.

Spanish sculpture of this period continued to develop, as in the previous century, under French influence, but not without some knowledge of Italian, and, especially, Tuscan, examples (293). German sculpture, on the other hand, though diverse in character and also less flourishing than it had been in the previous century, presents aspects of great originality, from the point of view both of style and iconography. Characteristic themes are those of the Crucifixion, which stress the physical suffering and start from the Crucifix – in itself 'expressionist' – at Naumburg and develop to the point reached by that extraordinary masterpiece of the early fourteenth century, the Gabel Crucifix in St Maria im Kapitol in Cologne, or the images of the Dead Christ (*Vesperbild*), an example of which is the famous group at Veste

Coburg. These are the favoured themes of German mysticism of the century, expressed in polychromatic wood-carvings for the most part, but also in other materials, even leather. At the opposite extreme are the *Andachtsbilder*, which are images – again usually in polychrome wood – intended to stimulate personal, silent, devotion, which are the expression of a tranquil and recollected religious sentiment (292, 294). Monumental sculpture, on the other hand, oscillates between drama of a bitter expressionism based on French examples, such as the Holy Sepulchre at Freiberg (298) and other works by the same sculptor (299), and a free fantasy such as the tympanum of the north portal of the Kapellenturm at Rottweil, and the echoing of French preciosity of the fourteenth century, with a dash of sensuality added, as in the series of statues for the cathedral at Cologne (295). A new accent, that of bourgeois realism, appears in the sculptors of the Parler circle about the middle of the century, just before they went to Bohemia where these ideas were more fully developed and added something distinctive to Gothic Court art of the International Style.

In England the new century saw the development of the themes and style already established in the thirteenth century. Monuments continue to play an important part and are influenced by France, as can be seen particularly – though not exclusively – in the Royal tombs in Westminster Abbey. The figure of the dead man is often carved in alabaster, but the baldachin has weepers and reliefs in stone, often, from the third decade of the century onwards, in a sketchy and free style, as in the tomb of Aymer de Valence (300). Sometimes, as in the alabaster figure of Edward II at Gloucester (302), the decorum implicit in funerary monuments and in the make-up of a court artist does not entirely extinguish the feeling of lively and realistic delineation of character. Towards the end of the century these monuments were executed in a still more precious material, gilded copper, which led to an intensification of the idealistic quality, confining the portrait-quality within the strict demands of style (305). In general, there was an increase in naturalism, even in sculpture which formed part of an architectural complex, until it reached heights of audacity in subjects traditionally lending themselves to the grotesque (301), and even in religious subjects – which are sometimes treated with a profane liveliness far from any possible French prototype (304). The production of small panels in ivory or alabaster is linked with French ivories, although the refinement of the models is transformed into popular humour and vivacity (303).

International Gothic

This, or the more descriptive 'Cosmopolitan Gothic', is the name given to a great and complex artistic movement which developed from the last decades of the fourteenth century and continued into the first of the fifteenth in the furthermost regions of Europe – from Paris to Flanders, from the Rhineland to Bohemia, from Spain to Italy, and even reached out to the British Isles. It has been correctly observed that the whole of the Gothic period – indeed the whole of the Middle Ages – was 'international' and that this last phase was no more so than the earlier periods, and so there has been an attempt to substitute some less generic term for it – for example, 'Court Art', the 'Soft Style' (*der weiche Stil*), or 'Florid Gothic' (*gotico fiorito*), which, in its architectural manifestations, is also called 'Flamboyant'. The first two of these descriptions, however, with their sociological or strictly

stylistic connotations, properly cover only some, partial, aspects of the complex of artistic currents, while the last, though covering a wider range of phenomena, still has the defect of putting the emphasis on only one of the multiple aspects of this art. All in all, it is probably just as well to retain the traditional and universally known term, with the proviso that 'International' in this context means an art movement without a fixed centre, one, in other words, that was diffused from several different places, so that it can sometimes be a difficult and controversial matter to decide precisely where the principal centres were. The difficulties multiply when it is sculpture that is under discussion, for this art, though affected by the movement, did not play a leading part. The characteristic arts of International Gothic are illumination, painting, both on panel and in fresco, tapestry, and all the minor arts; sculpture often followed the example of the sister arts, occasionally assuming the task of carrying to a maturer, more precise, expression certain aspects of the movement as a whole.

In explanation of this great phenomenon there have been various definitions and historical interpretations put forward, depending on the proposer's point of view and historical method. From a purely formal point of view, International Gothic has been considered as the extreme, almost automatic, development of the potentialities implicit in the linearism and colour of Gothic painting, towards a linearism, which is ever more calligraphic and remote from formal significance, and a colourism ever more splendid and lacking in chiaroscuro. The historical explanation has been provided by the late style of Simone Martini and of his pupils, such as Matteo Giovannetti, at Avignon, from whence the style was taken by French masters as far as Paris. From there it was diffused throughout Burgundy and Flanders on the one hand, and to Cologne and the Rhineland on the other. Because of the French education of the Emperor Charles IV and the time spent in Avignon by his learned Chancellor, Johann von Neumarkt, the Franco-Sienese Avignon style is supposed to have fertilized Bohemia, from whence it later reached out to Austria and southern Germany, and from there, by way of sea and river trade, it arrived in the Hanseatic cities and North Germany. This is an interpretation which certainly contains much truth. A closer study of the stylistic links would probably modify it in some ways and sharpen it in others, without destroying the main outlines: yet it is still not entirely satisfactory, since it leaves in obscurity the actual subject-matter expressed by these forms and it tells us nothing of the reasons which favoured the reception of this artistic movement in practically the whole of Western and Central Europe. Another explanation has also met with favour – the variety called *geistesgeschichtlich*, founded on the idea of the History of the Spirit. The fourteenth century saw the decline of the universal powers of the Middle Ages: the decline of the Papacy, exiled in Avignon and subject to pressure from the King of France, and, from 1378, divided by the Great Schism; and the decline of the Empire, where the kings of Bohemia, invested with the Imperial title, had virtually no authority outside the boundaries of their hereditary kingdom and vainly tried to restore the Imperial prestige by unfortunate expeditions into Italy. Even the French monarchy was weakened by the Hundred Years War against the English and by struggles against the Duke of Burgundy and other great lords. In the province of philosophy something similar was happening – the decline of Scholasticism and the abandonment of Thomism under the pressure of Occam's Nominalism. The grandiose edifice of universalist thought, mirrored in the arts by the great Gothic cathedrals, was visibly crumbling. As a result, deprived of the

support of the great truths and the universal institutions, the human spirit found itself in crisis and took the way out offered by escape into the refined and fabulous world of the International Gothic. This was a world of fable, of unreality, but different from the transcendentalism of the past and directed rather, under the influence of Nominalism (which depreciates universal concepts), towards the loving study of fragments of reality. By comparison with the strictly stylistic theory this has the advantage of explaining the way in which International Gothic artists seem to seize on isolated fragments of the natural world as well as purely ornamental forms: it also explains this latter fact, albeit in aesthetic terms such as 'play' or 'decoration', as an expression of a need to escape into an enchanted world. This 'escapist' interpretation is common to the sociological hypothesis. The upheavals due to war (France), to heresy and religious struggles (England with Wycliffe, Bohemia with Hus), to social unrest (the Ciompi revolt in Florence) – all these are said to have provoked in the ruling classes a sense of insecurity and fear, to which they reacted by flight into the artificial Paradises provided by the fabulous world of International Gothic. On the other hand, the efforts of the monarchs to consolidate their powers brought about, in Paris and in Prague, the formation of an official class, bourgeois in origin, which is then said to have set about appropriating the powers and functions formerly in the hands of the aristocracy. They took over the mode of life, ideals, and tastes of the aristocrats they were supplanting. The aristocrats themselves, pushed on to the sidelines of the monarchical system, are then said to have turned to a revival of feudal and knightly ideals. The cities, especially in Tuscany and North Italy, had a long tradition of urban civilization and were then or later ruled by a Commune or a Signoria, but, in either case, were in fact dominated by an ever-increasingly plutocratic and oligarchic middle class, which to a certain extent tried to 'legitimate' itself by acquiring those habits of life and thought, and those tastes which had once been the mark of the aristocracy. This social phenomenon is said to explain simultaneously the courtly and grand aspects of this art and its partial naturalism, nourished by the sense of the concrete possessed by the middle class. This hypothesis has the merit of offering a kind of compromise between the *Zeitgeist* and the objective fact of the work of art, but, like all sociological explanations of this kind, it leaves one wondering whether the patrons had any real control over the artist's style and ideas. Rather than conceive of the arts as the expression of the dominant classes of any epoch it is better to recall the particular type of mentality which is nourished by specific social conditions: attitude of mind, sentiment, taste, are all part of the human formation of an artist, and all pass through the filter which is his own individual imagination.

Each of the three hypotheses which have been outlined here has something to contribute to the elucidation of the International Style, but none has a monopoly of truth. Nor is this the place to attempt a synthesis of the three points of view, both for lack of space and because this is a book about sculpture, so we can do no more than draw attention to certain facts and some of the principal works of art. It seems likely that the Court element played a leading part, as far as sculpture is concerned, in the process of formation of the International Style, and especially in Paris and Prague. The Abbey of St Denis had long been a focal point of sepulchral sculpture, and, for obvious reasons connected with the monuments, of elaborated portraiture. The effigy of Charles V of France, executed by André Beauneveu before 1370 (309), is still inspired by a kind of compromise between the traditions of Cathedral Gothic in the quiet undulations of line in the draperies, and a new search for realism,

however limited by the exigencies of traditional idealism, in the head itself.

There is an admirable fusion of these two elements somewhat later, in the image of Catherine d'Alençon (310), once in the Chartreuse at Paris, under the guise of a most refined subtlety. The activities of the Parlers, which ensured the East–West link on the Cologne-Prague axis, early provided the premisses for at least one aspect of this style in the commemorative sculpture in Prague Cathedral, oscillating between a cheerful realism, which seems to employ motifs of block-like solidity, ultimately derived from Giotto but already assimilated into Bohemian painting (306), and a regression to idealization which is only partly offset by the naturalism combined with ornament of the costumes (307). The realistic side, even a certain sensuality, prevails in some of the busts in the choir (308), while an extreme of illusionism is reached at Mühlhausen (311), redeemed by the lightness of the linear rhythms and transformed into an enchanted vision. The transfiguring power of the linear rhythms, which ends by identifying the substance of the image with the courtly elegance of the gesture (312) or with more generalized human attitudes (314), is almost always to be found in works in the Parler tradition, in figures full of physical and spiritual vitality. The emphasis on portraiture, the aristocratic bearing of the figures, were certainly suggested by the particular requirements of Court art, and these same characteristics are to be found in the splendid series of the so-called Beautiful Madonnas, a type probably Bohemian in origin, but which was rapidly diffused throughout the German-speaking world (313). Even the mystic *Pietàs* (*Vesperbilder*: 315), which were already an established tradition in the German lands, abandon expressive and mystic exaltation in favour of confining grief within the amplitude of a quiet and elegant gesture.

But not all International Gothic comes from courts; if it is true that the workshops of Milan Cathedral were a focus in Lombardy for craftsmen from every country north of the Alps and a centre of diffusion of courtly modes which affected the sculpture as well as the drawings and illuminations of Giovannino de' Grassi, yet in Tuscany the mannered Gothic of the Late Trecento was revivified in the last decade of the century in the works of the decorators of the Porta della Mandorla of Florence Cathedral (316) – among whom there is, perhaps, to be recognized the young Jacopo della Quercia (*see* vol. III) – with their robust Classicism, which must surely be connected with the beginnings of Humanism. From 1401 the dominant style is related to International Gothic, but already containing Humanist motifs, in the work of Lorenzo Ghiberti (*see* vol. III); but Florentine sculptors emigrated to Venice, where, in the last years of the Trecento, a notable Venetian sculptor had framed his delicate and pictorial figures in thick vegetation suggestive of a fresh and fabulous Nature like that of the 'florid Gothic' (317). Yet the Florentine masters – one of whom is perhaps to be identified with Pietro Lamberti (318) – gave the stylistic principles of International Gothic an interpretation filled with restraint and inspired by a surprising spirit of Medieval Classicism. In the work of Venetians such as Pier Paolo dalle Masegne at Bologna (320) or Jacobello at Venice (319), a portrait-like realism of bourgeois origins joins forces with the portrait style of a courtly stamp, deriving more or less directly from France.

A position of his own is occupied by the greatest sculptor of the North at this period, Claus Sluter, Court Sculptor to the Duke of Burgundy. In his works, most of which date from the last decade of the fourteenth century, the portraits, over-coming all official rigidity, are charged with a vital intensity which is profoundly human, and the flowing Gothic line, allied to an unusual firmness of modelling and

intensity of pictorial effect, confers upon the *Prophets* and the figurines of the *Weepers* a pathos and dramatic grandeur which go far beyond the bounds of Gothic spirituality (321–6). These factors place Sluter on the same footing as a sculptor with a Gothic background, but of a fundamentally Renaissance cast of mind, such as Jacopo della Quercia, and it also makes it possible to appreciate – at a distance of fifty years – something of the formation of Niccolò dell'Arca (329, 330).

Fifteenth-century Naturalism and Late Gothic

It is only on account of long tradition and a convention still largely accepted that the phrase 'Late Gothic' is used to describe fifteenth-century art north of the Alps. In actual fact, the use of such a description would only be justified in terms of a formalist conception – which I do not share – in so far as the vocabulary of the figurative arts north of the Alps remains much the same as that of the preceding centuries, or at any rate does not conceal its Gothic origins. It is the syntax which is different, at least from the beginning of the fourth decade of the century; just as the things to be expressed, the outlook on the world, the social structure underlying it, are all different. They are so different from the International Gothic that use of the word 'Gothic' in this connection is not really justifiable, even though qualified as 'Late'; and it becomes absurd if it is permitted to give colour to the assumption that the fifteenth century in the North is quite different from the Italian Quattrocento, as if on either side of the Alps there lived, in the one century, peoples in two different stages of history – Italy in the springtime of the modern era and the Northerners in the autumn of the Middle Ages. Certainly we cannot extend to the North, in the fifteenth century, the concept of Renaissance, since this idea is inseparable from the concept of Humanism – that is, the cult of Antiquity and of Classical moderation. Although the North was ignorant of Humanism before the time of Erasmus this is no reason for pushing back its fifteenth-century civilization into the Middle Ages, or its art into Gothic. There is one aspect that is common to North and South, and it is called naturalism: the opening of the heart and mind to the nature of things, the certainty of the autonomy of Man and of the physical world. The sense of the importance of the reality of Nature and the things surrounding Man, the sense of the completeness and the autonomy of Man were not less vivid in France or Germany than they were during the Quattrocento in Italy. It was only that these same convictions and analogous sentiments have as background and as source in Italy a clearer philosophical consciousness, a rationalism and a clarity of historical vision which led to the complete recovery of the importance of ancient civilization for human society of all times, while in the North the reconquest of Man by himself was made more slowly and with greater difficulty by the tenacious and industrious application of Man's own technical capacity until it was transformed from technical skill to creative power. From this arises that feeling of rather strained craftsmanship which is characteristic of so much non-Italian (and especially German) art. It can easily be confounded with a survival of the Middle Ages, but this is not so, because it does not have that degree of high finish which is indispensable in works done for the glory of God, but is part of the creation of objects and images which are sufficient in themselves.

If this were not the case it would be impossible to explain the strength of

Flemish naturalistic influence in Britain (332–3) and elsewhere, or the vital optimism of French sculpture, influenced by the example of Sluter in Flanders, from the vigorous tomb-statues of Jacques Morel (331) to the powerful and sensual vitality of the late *Eve* at Albi (360). German figurative language breaks decisively with the flowery quality of International Gothic in the vigorous sculpture of Hans Multscher (334–6), where the echoes of Gothic linearism give at the same time an air of aristocratic idealism and a natural, human, strength. About the middle of the century, in the work of the wandering sculptor Nicolaus Gerhaert (338), and in the many works influenced by him (342), or in that of the Swabian Joerg Syrlin (341) Flemish naturalism is interpreted in terms of a pungent sense of portraiture, transmitting the feeling of complete trust in human energy and industry. In a different way, directed towards effects of sophisticated preciosity, still with a background of naturalism, there is the effect of Flemish influence in Spain (339, 340). In the second half of the century, side by side with apparently neo-Gothic phenomena which in fact celebrate the ability of Man to make nature conform to his own dynamism (343), there appears the strongly dramatic art of a Michael Pacher (346–9), which breaks up the texture and rhythm of the Gothic *Schnitzaltar* into an intense set of contrasted motifs, where the bodies take over the space and fill it with an irresistible pathos, which is uniquely human. Such a way of seeing appears to be at the opposite pole from the tranquil and secure vision of space which is characteristic of Italian Quattrocento art (which, incidentally, Pacher studied deeply in his other role as a painter), but arises from a consciousness of Man as a free agent, which is in no way inferior to, though completely different from, that of the Early Renaissance in Italy. The subtle sensibility, the profound lyricism, and the mystical excitement of Tilman Riemenschneider (350–3) are not a return to Gothic, except in so far as the measure with which stylistic motifs from that tradition, such as a subtle and living contour, lend themselves to the spiritualization of a strongly rendered naturalism in a climate of deep religious emotion. Germany was then in the throes of religious and social upheavals, which came to a head in the Reformation. The beginning of Riemenschneider's activity at Würzburg coincides with the fiery sermons of Geiler von Kaysersberg and with the burning of the heretic Hans Böhm, while the end of his career saw him implicated in the Peasants' Revolt. In this dramatic and turbulent time differing temperaments found diverse means of artistic expression, but all were impassioned, from the expressionistic fantasies of Bernt Notke (354) to the robust realism of an Adam Kraft (355) or the tormented and esoteric drama of Veit Stoss (356–9). All are the expression of minds profoundly committed to the struggles of their own time, preoccupied with the destiny of Man, the enormous gap which had opened by this time between them and that faith in universal values, which, in various forms, often dramatic, had sustained the men of the Middle Ages and had governed from afar, as a supreme aspiration, the art of that long span of time.

EARLY MIDDLE AGES

PRE-ROMANESQUE
SCULPTURE

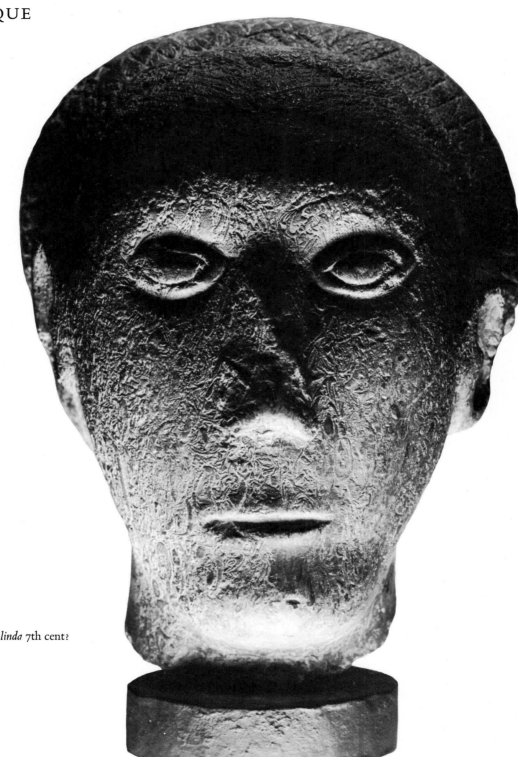

Head, believed to be of Theodolinda 7th cent?
Milan, Museo del Castello
Sforzesco

2 *Statuette of a saint* 7th cent.
Ravenna, Museo Nazionale

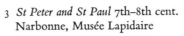

3 *St Peter and St Paul* 7th–8th cent.
Narbonne, Musée Lapidaire

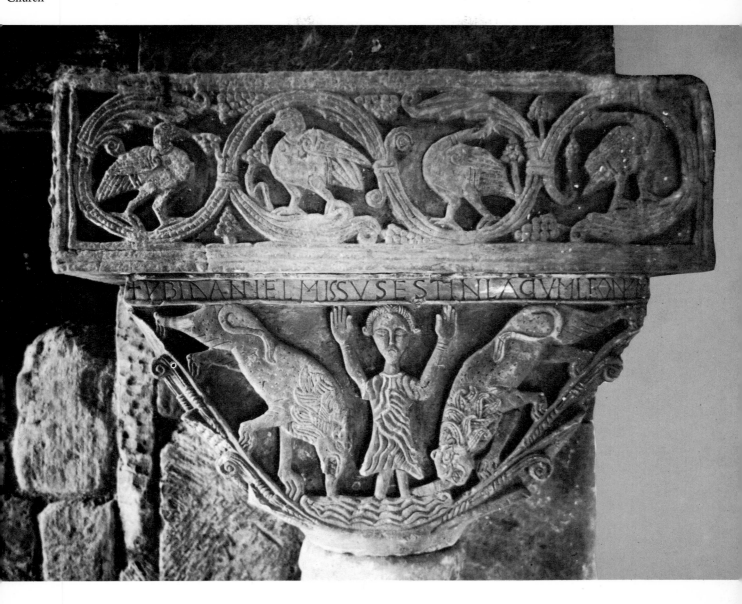

5 *Christ between two angels* 7th–8th cent.
Quintanilla de las Viñas (Burgos), Parish
Church

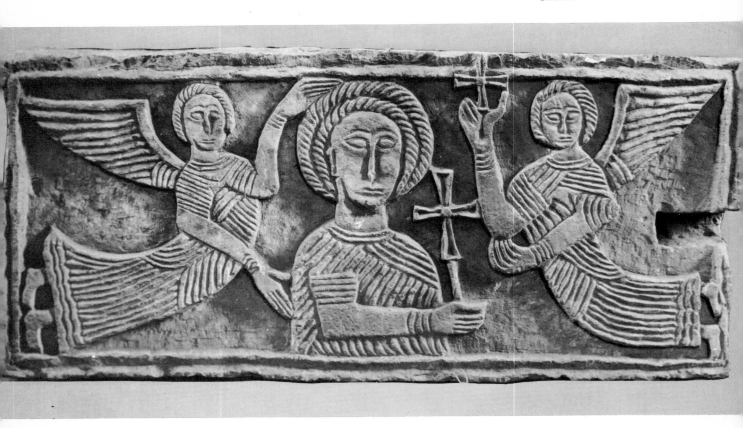

7 *Cross, flanked by peacocks, stags, and lions*
c. 750
Modena, Museo Lapidario del Duomo

Sarcophagus of Theodota c. 735
Pavia, Museo Civico Malaspina

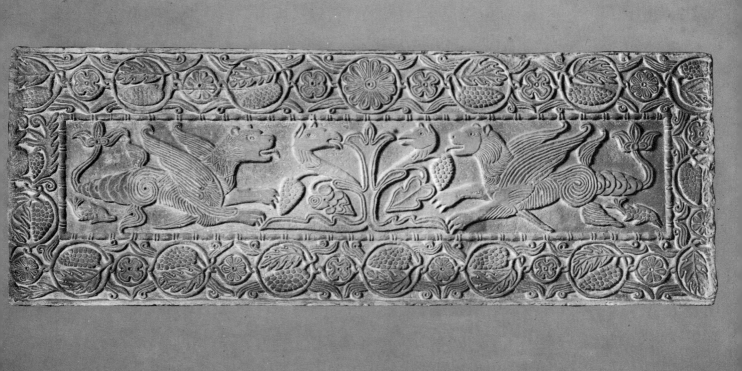

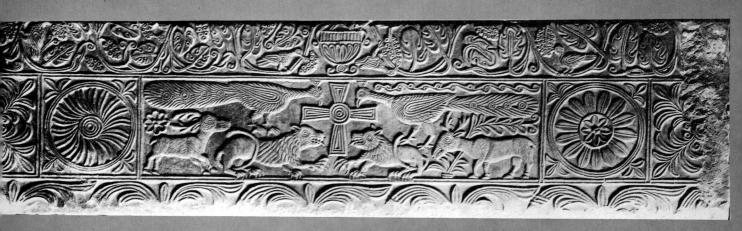

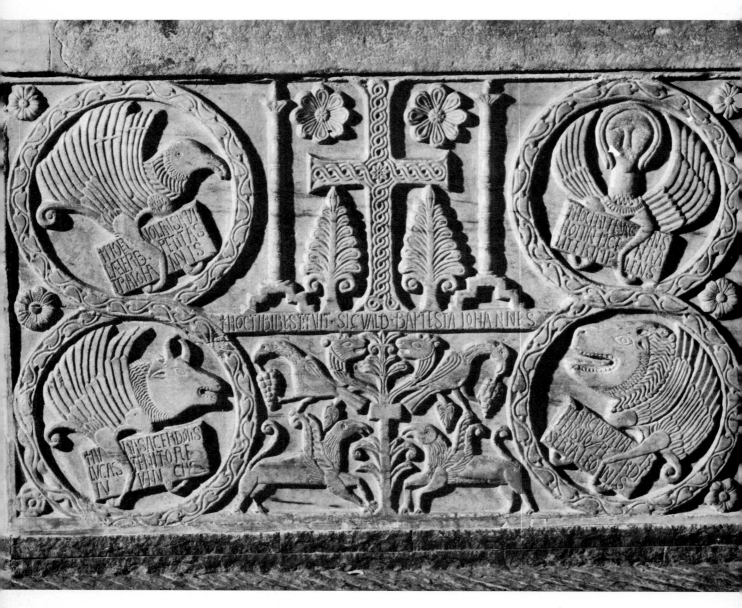

8 *Patriarch Sigvald's slab c. 737*
Cividale, Museo Cristiano

9 *The Adoration of the Magi c. 740*
Cividale, Museo Cristiano

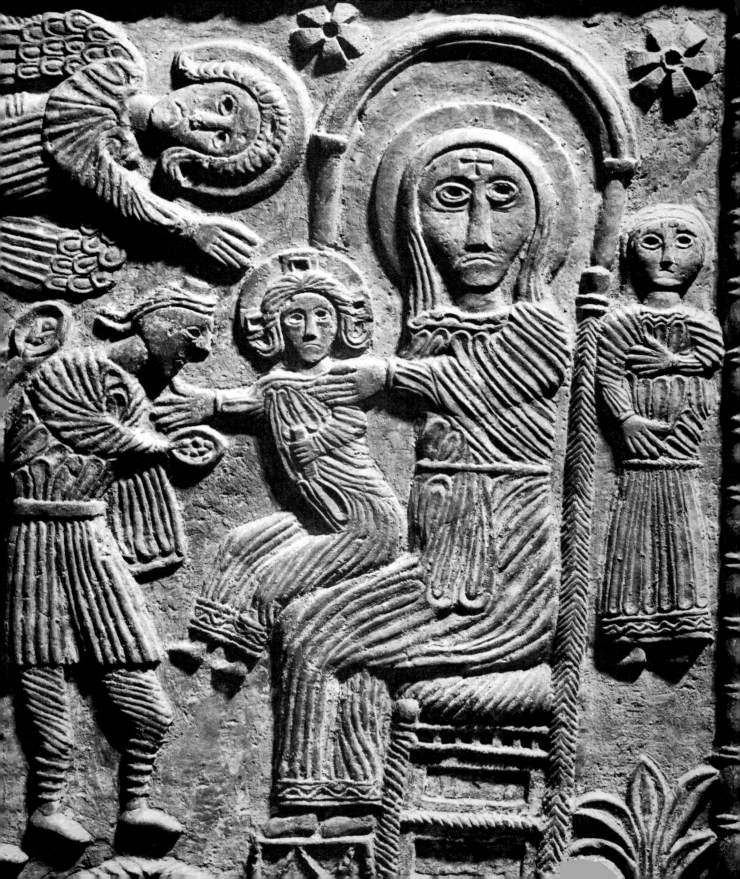

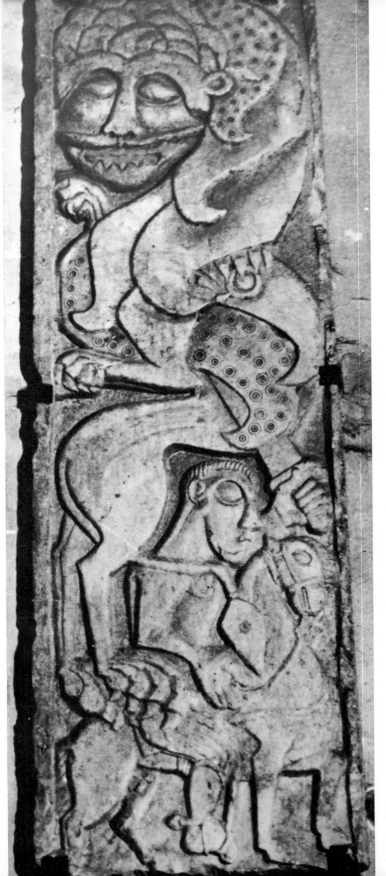

10 *Horseman slaying a dragon* 9th cent?
Aversa, Cathedral

11 *The Massacre of the Innocents and the
Flight into Egypt* first half 11th cent
Zara, Museo Medioevale di
S. Dona

12 *Christ in Majesty c.* 1020
St Genis-des-Fontaines (Eastern
Pyrenees), Church of St Genis

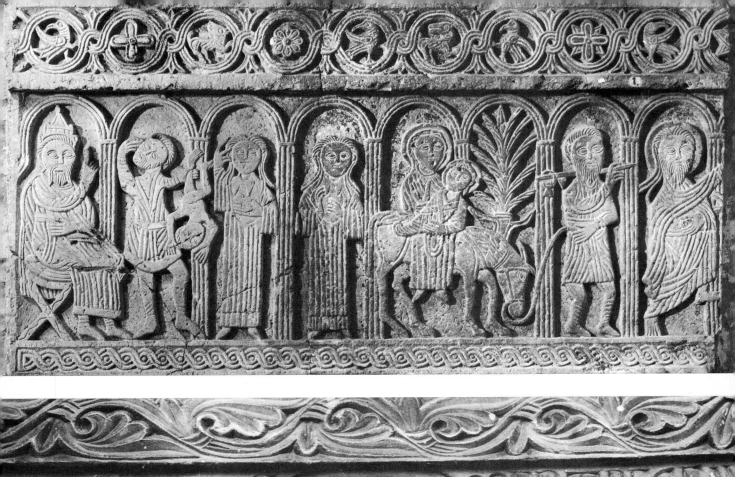

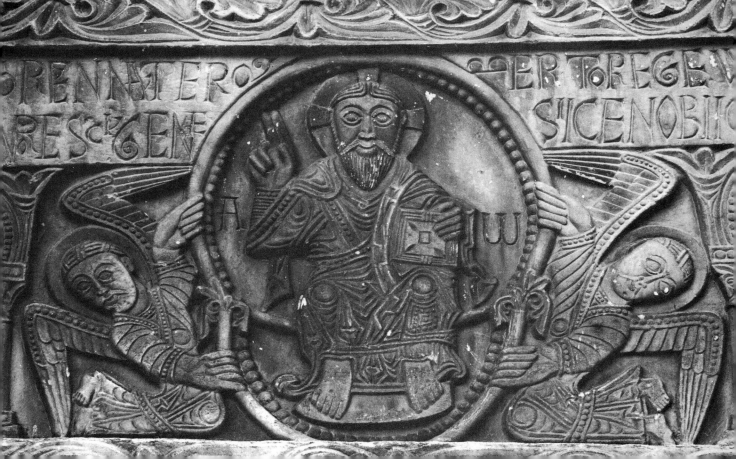

13 *Capital with four Atlas-figures c. 903–12*
Piacenza, S. Savino (crypt)

15 *Kneeling abbot c. 1030–40*
Tournus, St Philibert

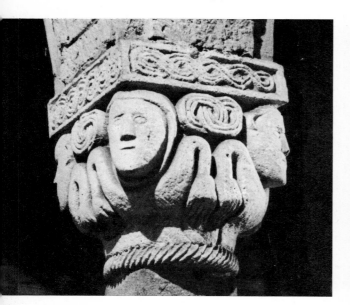

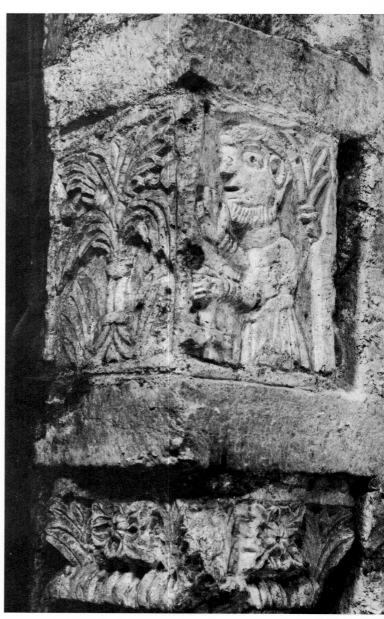

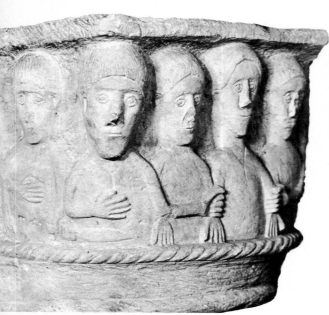

14 *Capital with portrait busts c. 912–24?*
Pavia, Museo Civico Malaspina

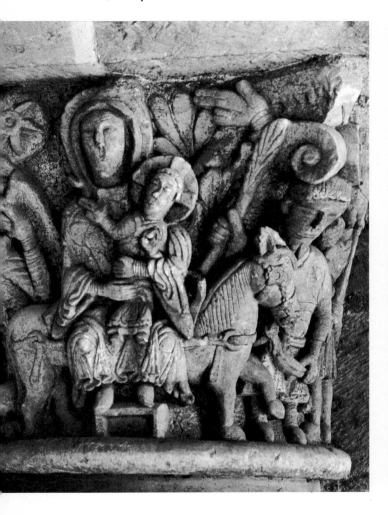

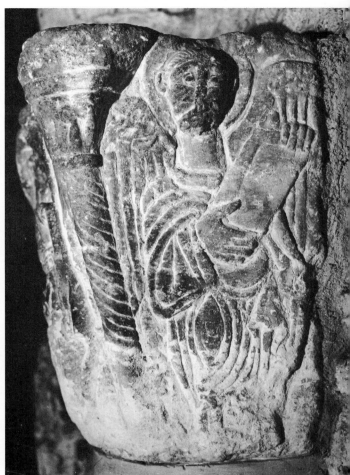

EARLY MIDDLE AGES

CAROLINGIAN AND OTTONIAN ART

18 *Equestrian statuette of Charlemagne c. 870?*
Paris, Louvre

19 *Cover of the Lorsch Gospels c. 81[...]*
Rome, Vatican Museum

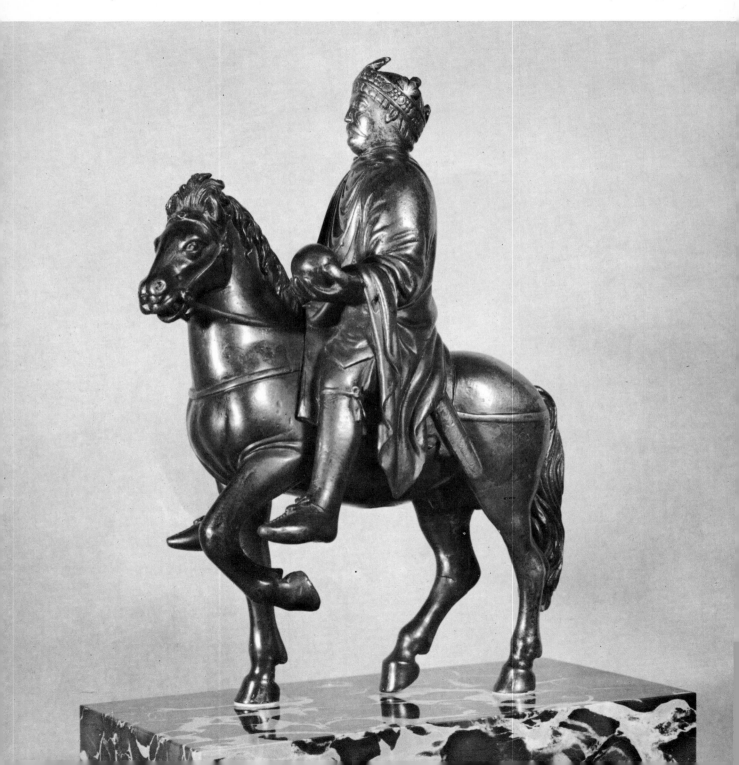

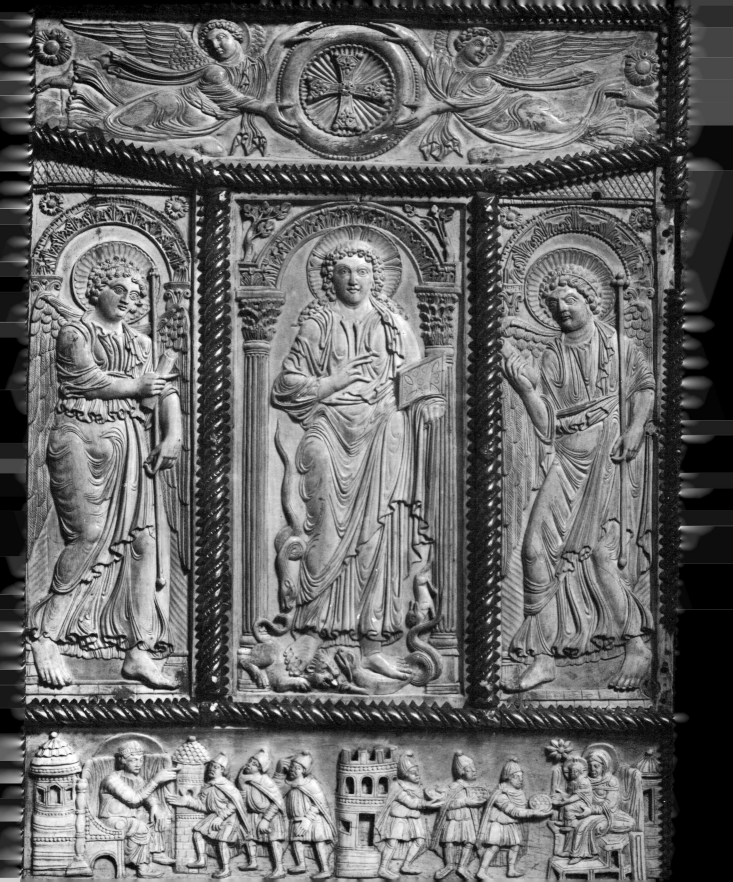

20 *Procession of saints*, detail 9th cent:
Cividale, Chapel of Sta Maria in Valle

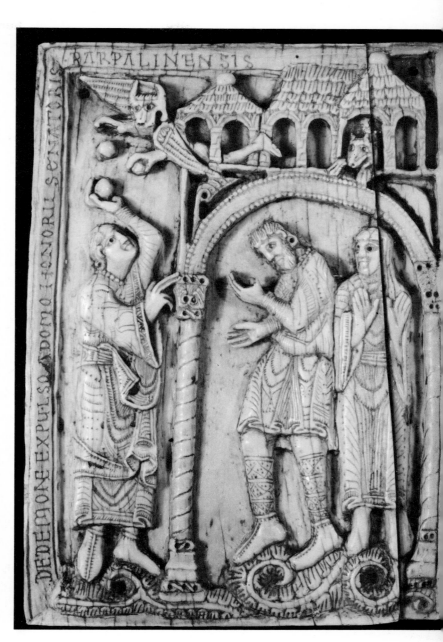

The Master of Echternach
Moses receiving the Tablets of the Law c.990
Berlin, Staatliche Museen

22 *St Emilianus expelling the Devil from the*
house of Senator Honorius 1033?
Madrid, Museo Arqueológico

23 *Symbolic representations and the Creation of
Man and Woman*, detail, early 11th cent.
Augsburg, Cathedral

24 *The Nativity and the Adoration of the Ma*
detail *c.* 1008–15
Hildesheim, Cathedral

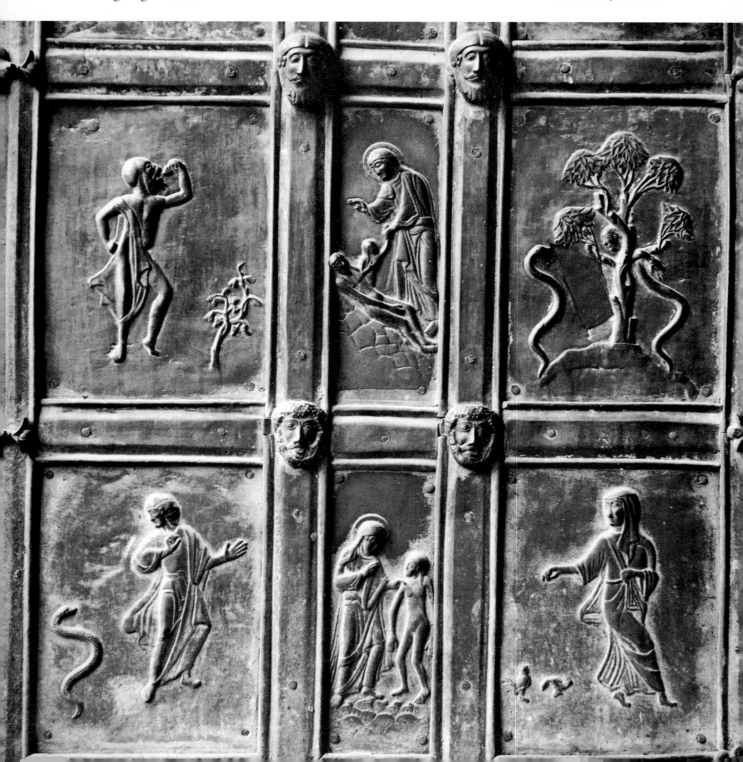

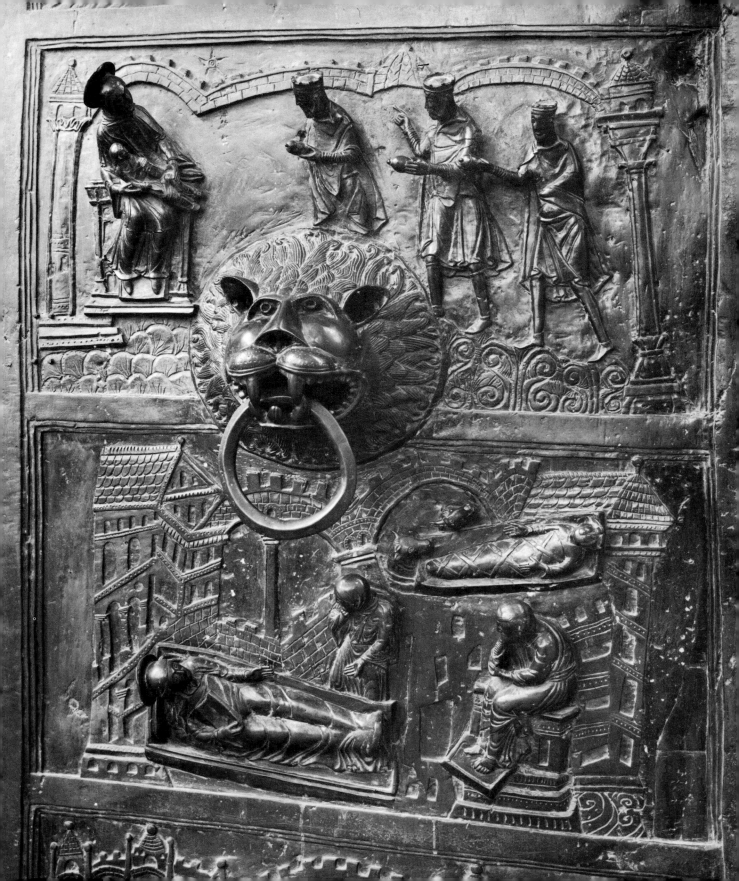

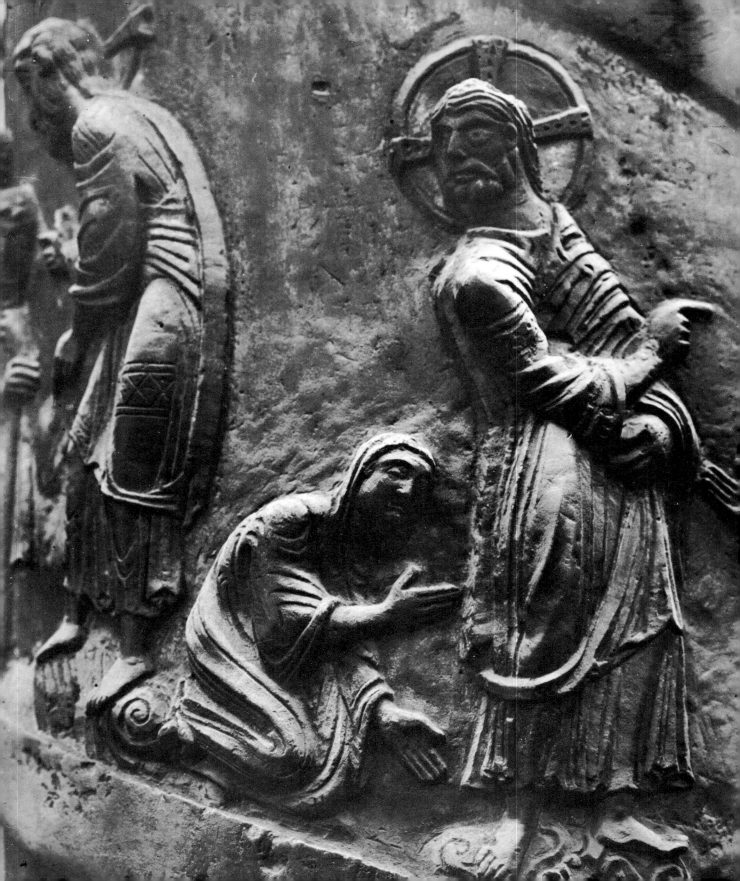

25 *'Noli me tangere'*, detail of column
 c. 1020–30
 Hildesheim, Cathedral

26 *Panels of a wooden door c.* 1065
 Cologne, St Maria im Kapitol

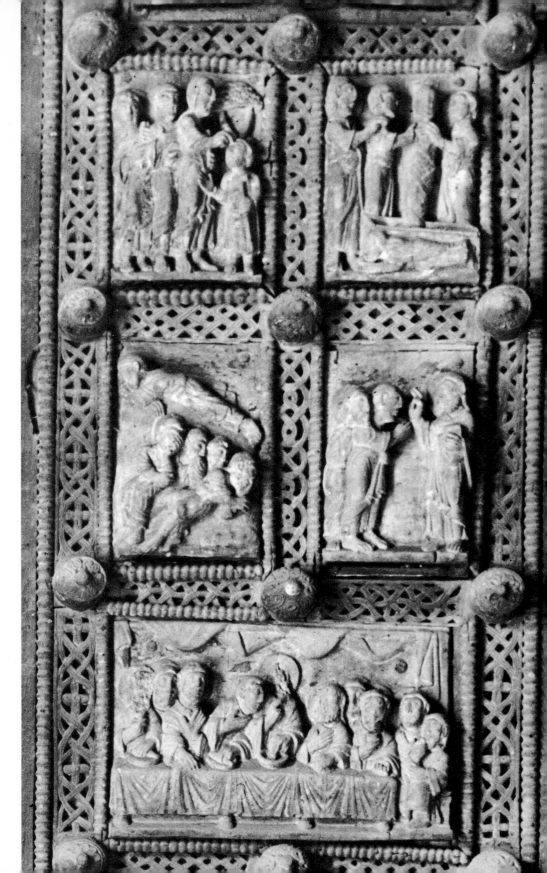

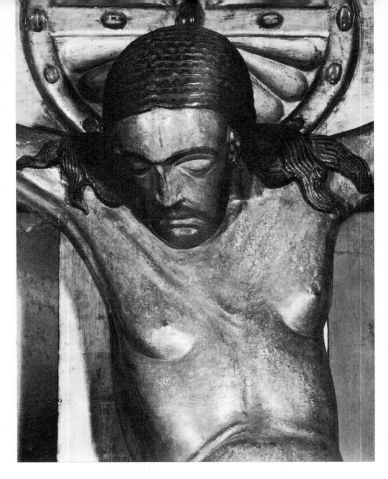

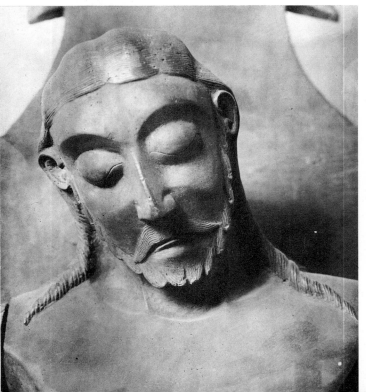

27 *Crucifix*, detail *c.* 970
Cologne, Cathedral

28 *Crucifix*, detail *c.* 1070
Essen–Werden, St Liudger Abbey

29 *Crucifix c.* 1020
Milan, Cathedral

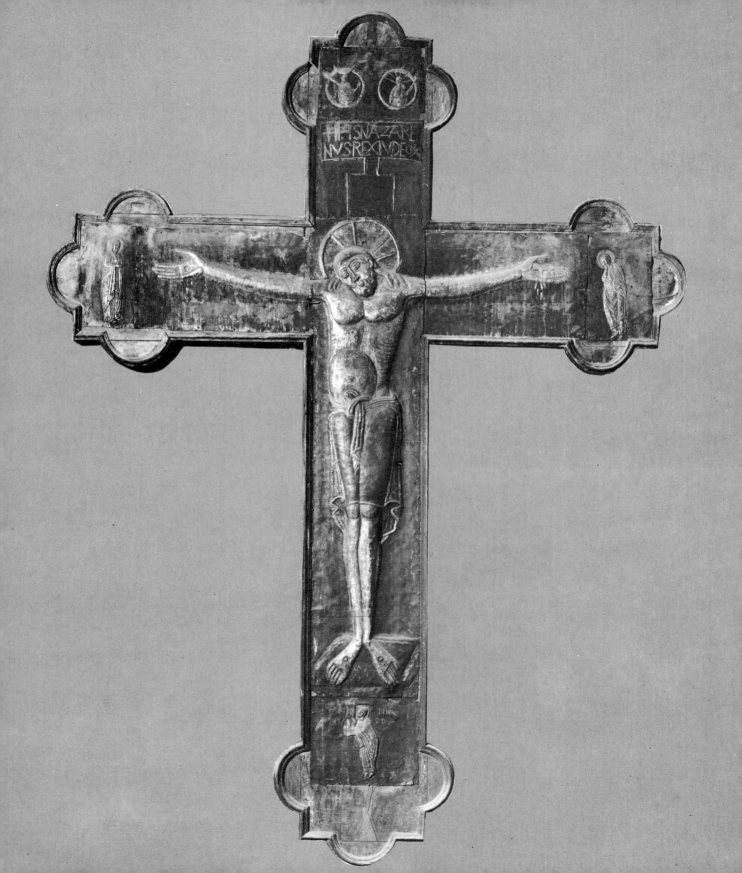

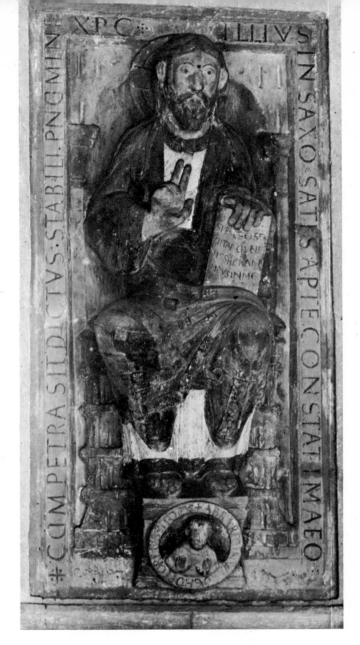

30 *Christ Enthroned c.* 1060
 Regensburg, St Emmeram

31 *Tomb of Abbot Isarn c.* 1050
 Marseilles, Musée Borély

32 *Sign of the Zodiac: Aquarius c.* 1080
 Bonn, Rheinisches Landesmuseum

33 *The Dormition of the Virgin c.* 1093
 Civate, S. Pietro al Monte (crypt)
 (*overleaf*)

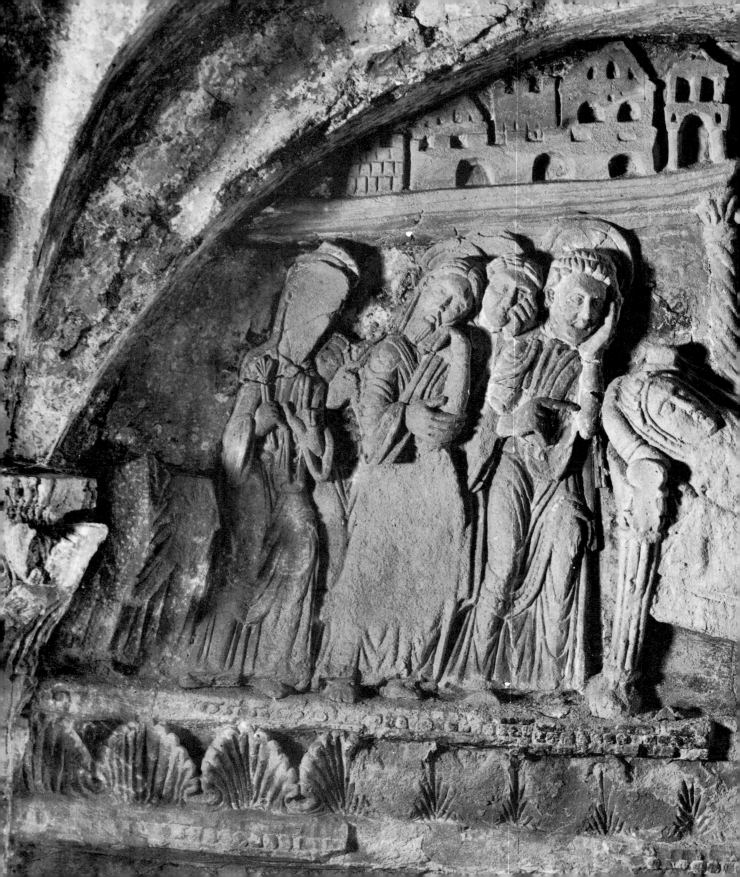

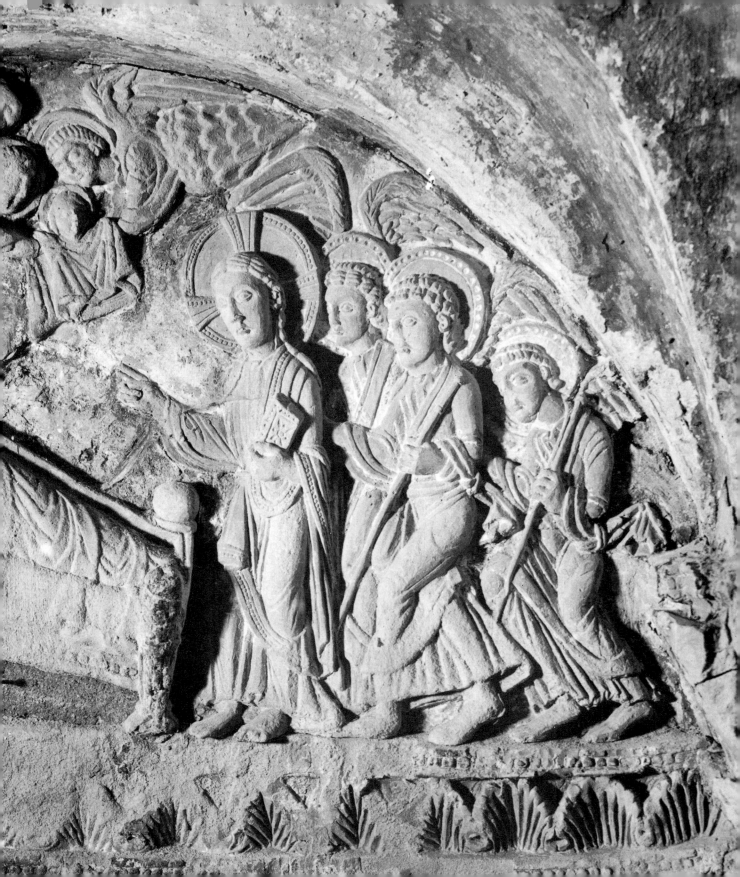

ANGLO-SAXON AND
IRISH ART

34 *Christ Triumphant*, detail of cross
c. 675–85
Ruthwell (Dumfries)

35 *Monumental cross* mid 8th cent.
Kilkieran (Kilkenny, Eire)

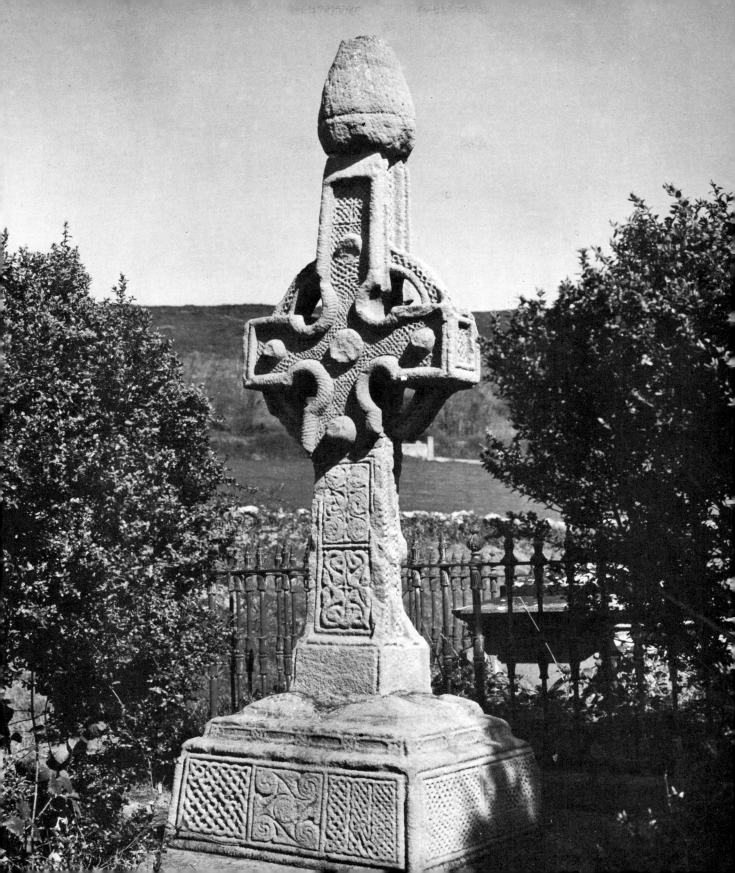

36 *Horseman*, detail of cross end 8th cent. Banagher (Offaly, Eire)

37 *Shaft of monumental cross* beginning 9th cent. London, Victoria and Albert Museum

38 *Crucifix* first half 11th cen Romsey (Hampshire), Abbey

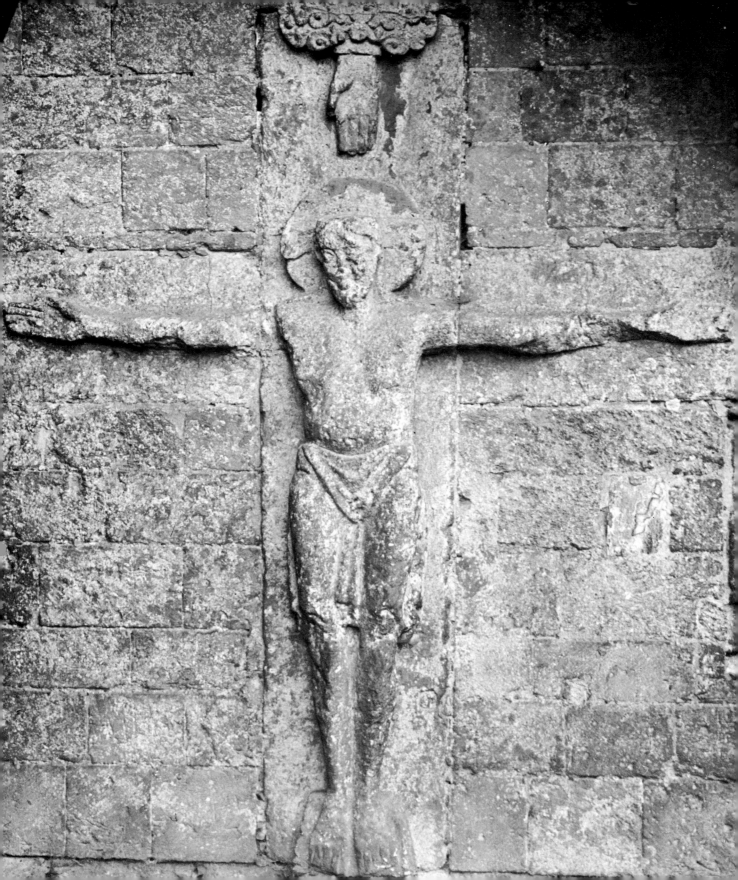

ROMANESQUE SCULPTURE
BURGUNDIAN SCHOOL

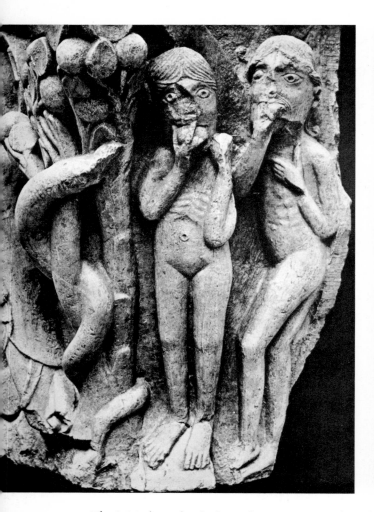

39 *The Original Sin*, detail of capital
c. 1090–5
Cluny, Musée du Farinier

40 *Agriculture*, detail of capital *c.* 1090–5
Cluny, Musée du Farinier

41 *The Third Mode of Music*, detail of capit
c. 1090–5
Cluny, Musée du Farinier

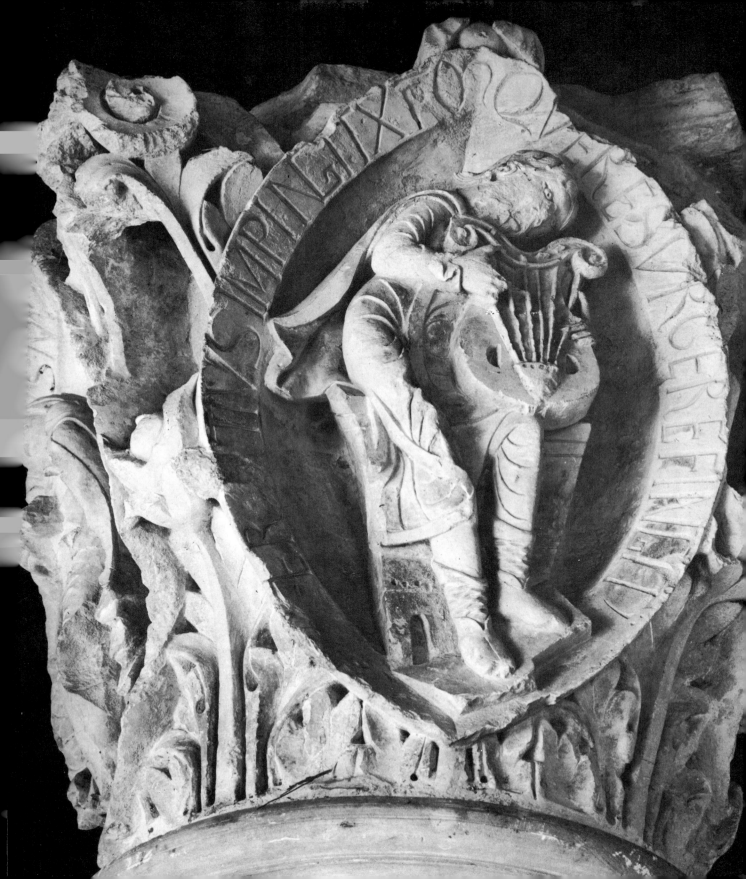

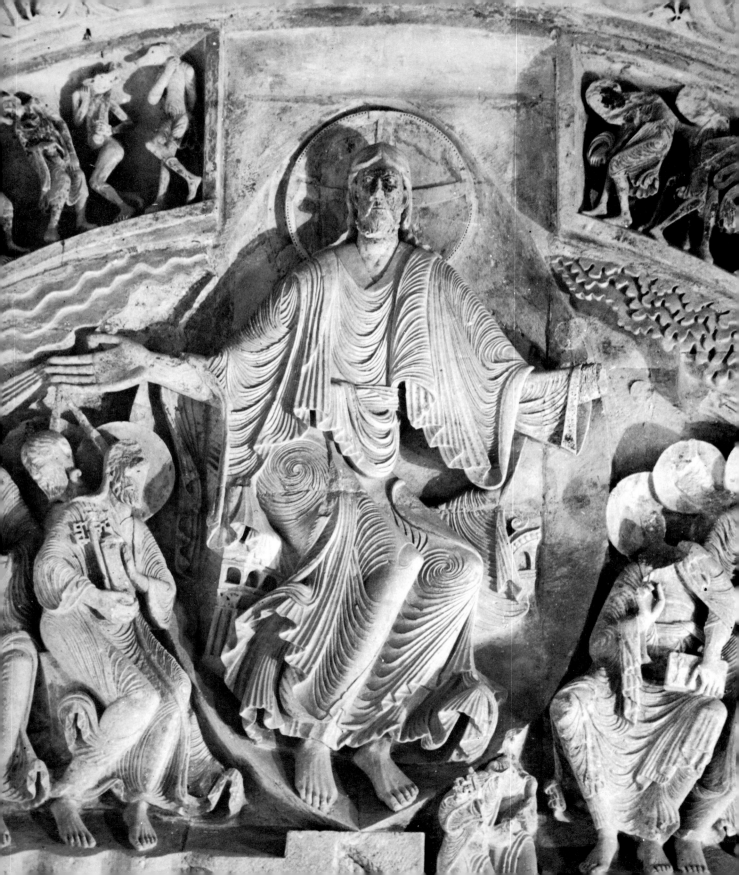

42 *The Mission of the Apostles*, detail of
tympanum *c.* 1130
Vézelay, Abbaye Ste Madeleine

43 *Head of the Virgin c.* 1109–15
Cluny, Musée Ochier

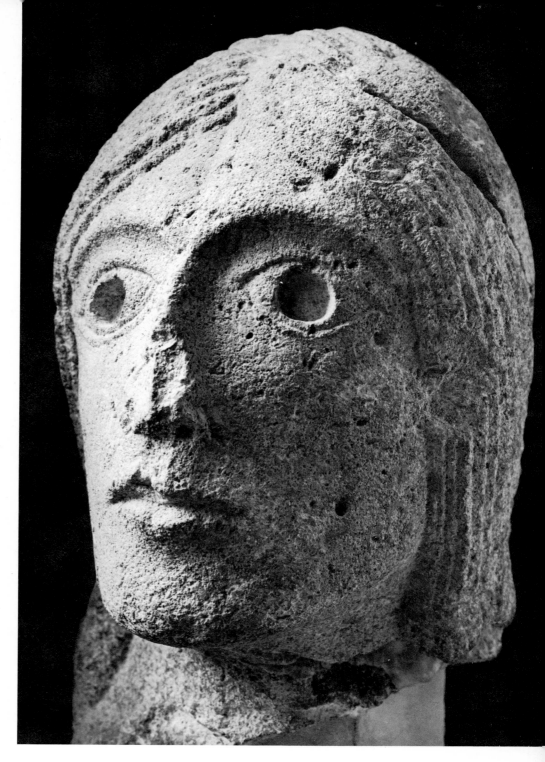

ROMANESQUE SCULPTURE

44 *Signs of the Zodiac and human figures,*
 detail of archivolt *c.* 1130
 Vézelay, Abbaye Ste Madeleine

45 *St Paul's mystical mill,* detail of capital
 c. 1125
 Vézelay, Abbaye Ste Madeleine

46 Gislebertus
 The Last Judgement, portal *c.* 113
 Autun, St Lazare (*opposite, above*

47 Gislebertus
 The Resurrection of the Dead, detail o
 lintel in 46

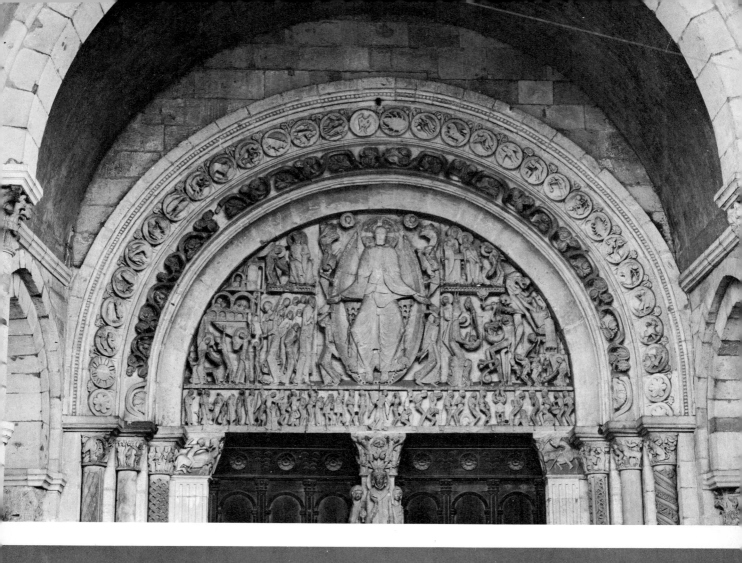

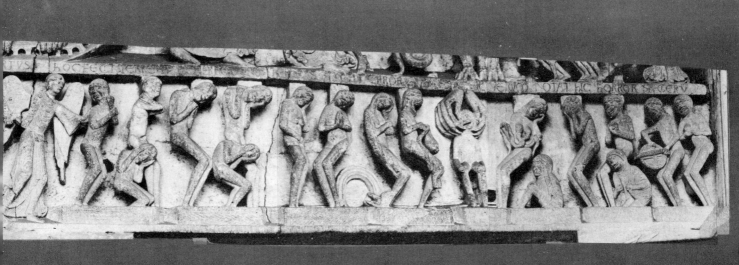

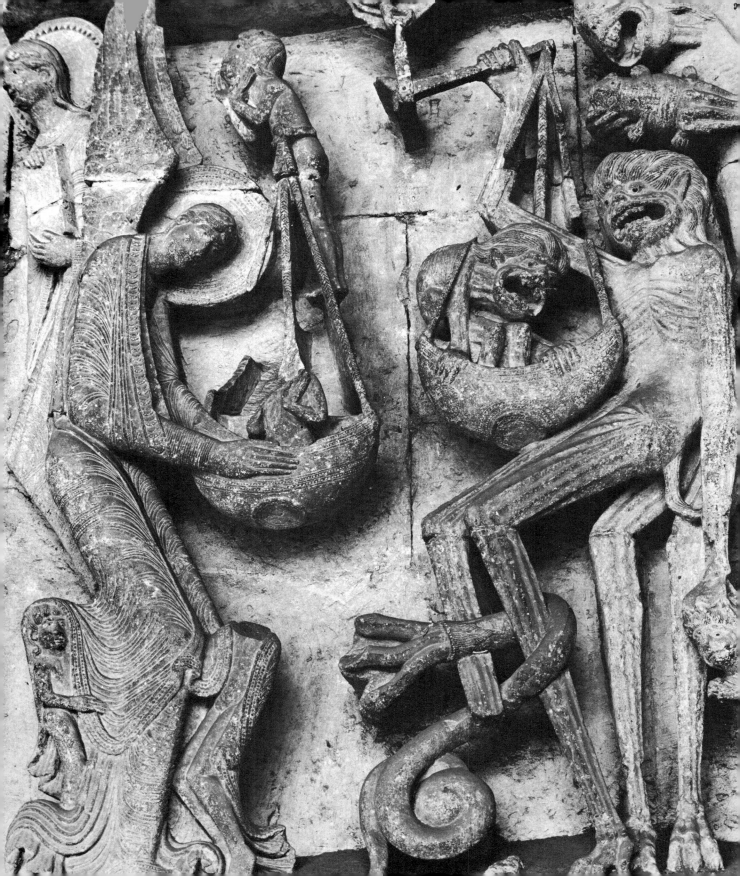

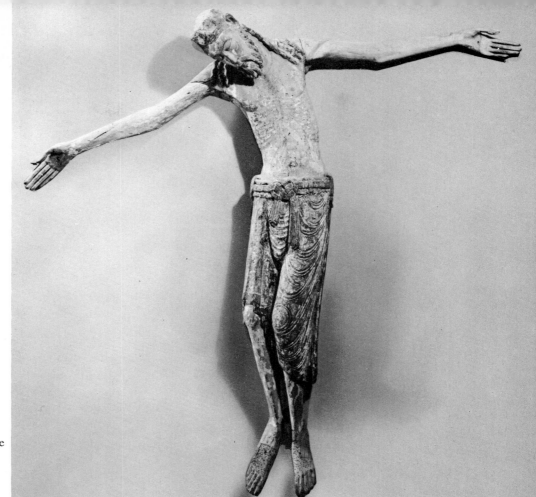

48 Gislebertus
The Weighing of Souls, detail of lunette
in 46

49 *The Deposition c.* 1140
Paris, Louvre, Courajod Donation

50 Gislebertus
The Vision of the Magi, detail of capital
c. 1130
Autun, St Lazare

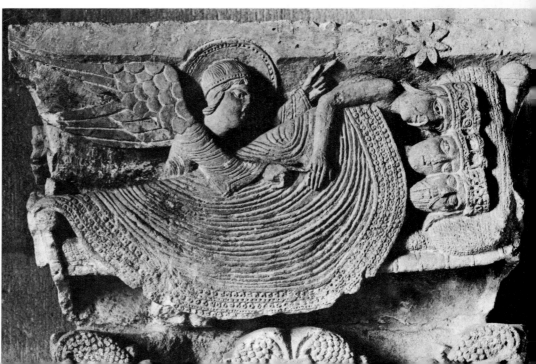

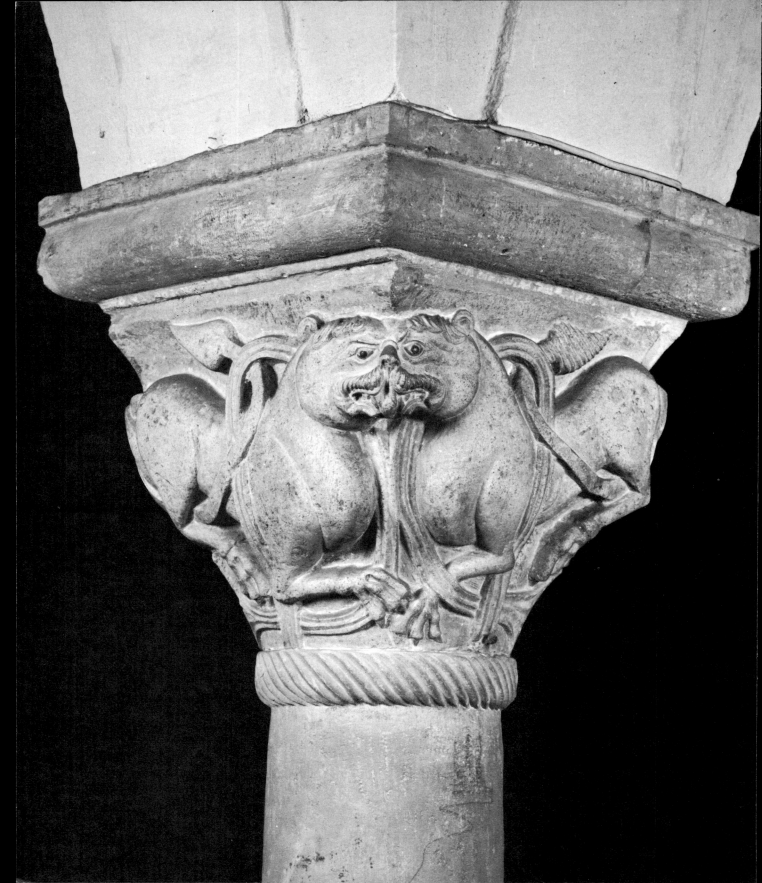

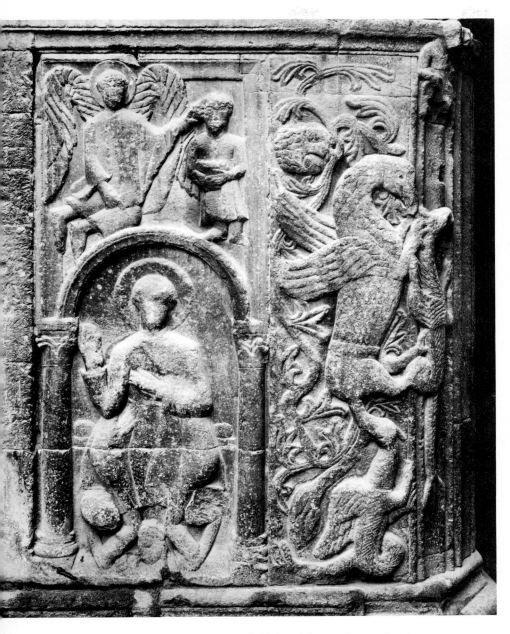

I *Capital with lion c.* 1100
Modena, Cathedral
(Crypt)

52 *Habakkuk and the Angel; Daniel in the lions' den*, reliefs on the portal beginning 12th cent.
Como, S. Fedele

53 *Animals rampant*, detail of main portal *c.* 1090
Milan, S. Ambrogio

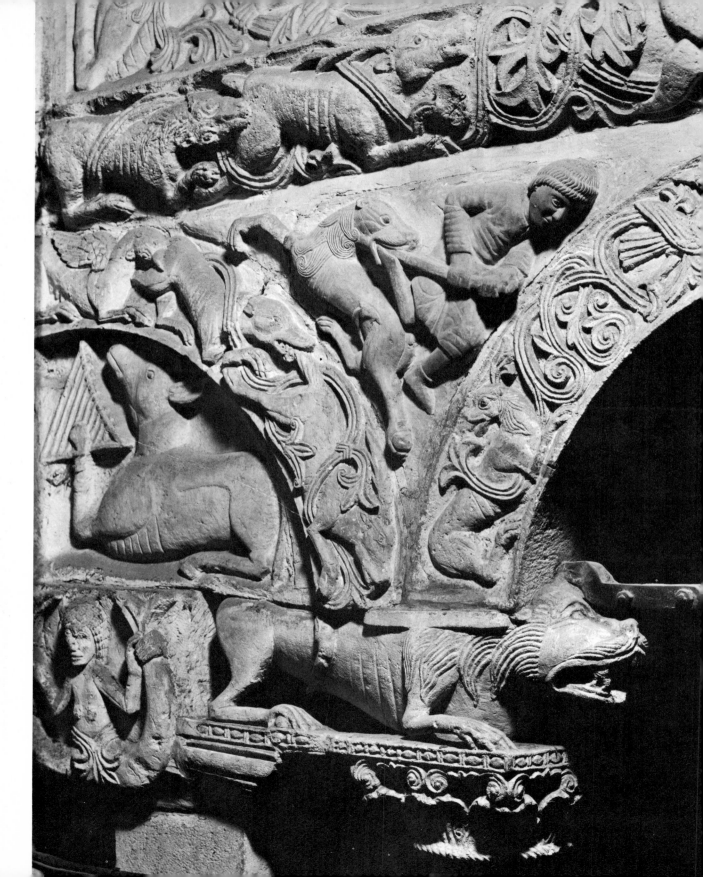

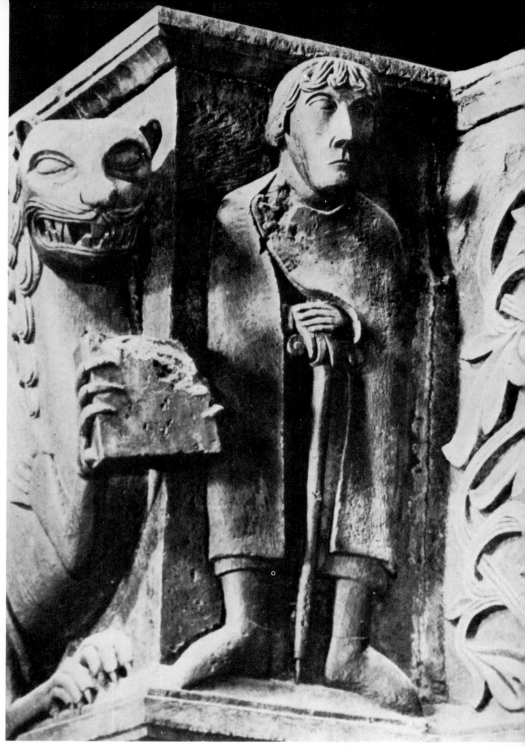

54 *Scene with hunters, animals, and monsters*,
detail of pulpit *c.* 1100–10
Milan, S. Ambrogio

55 *The Lion of St Mark and Abbot William
of Volpiano*, detail of ambo *c.* 1115
S. Giulio d'Orta, S. Giulio

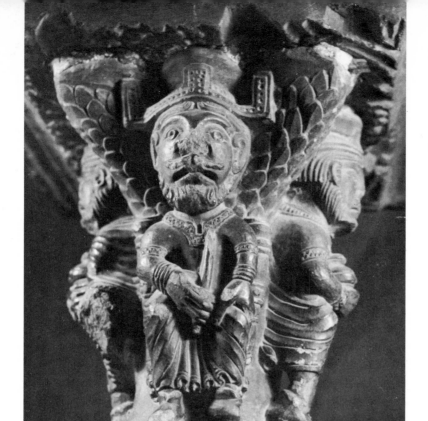

56 *Herod enthroned*, detail of capital o
the Magi *c.* 1130–3
Aosta, S. Orso

57 *The Nativity*, detail of capital
c. 1130–3 Aosta, S. Orso

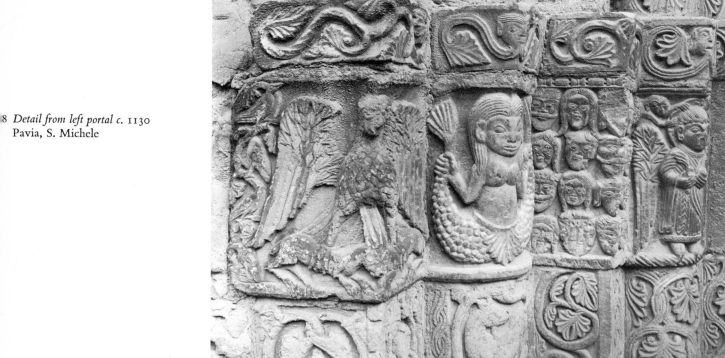

8 *Detail from left portal c.* 1130
Pavia, S. Michele

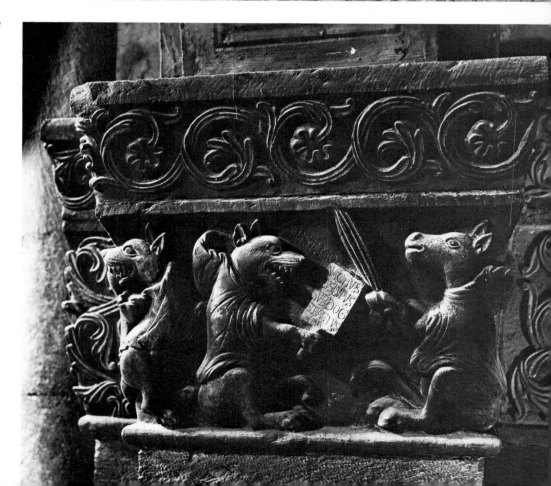

9 *Monk with wolf's head taught by an
ass*, detail of capital *c.* 1130–40
Parma, Cathedral

60 *Samson and the lion*, detail of capital
c. 1160
Mainz, Cathedral (east door)

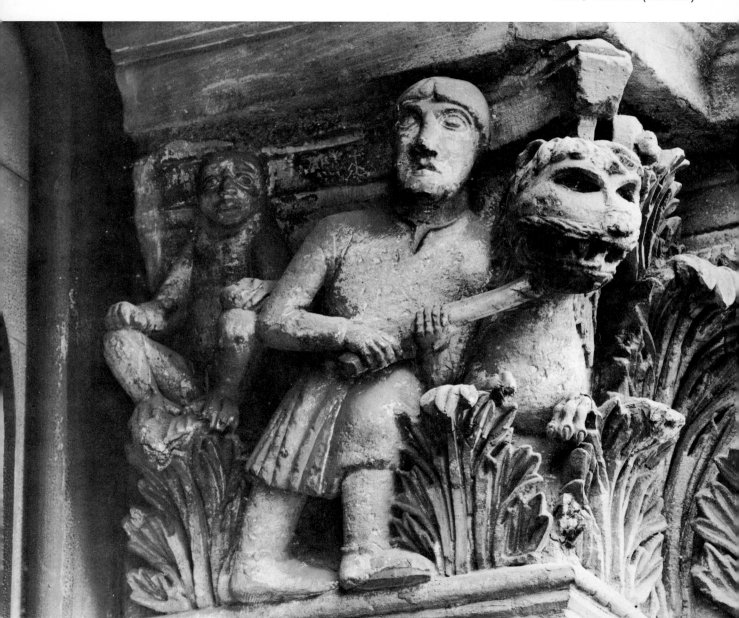

61 *The 'Giant Finn'* c. first half 12th cent.
Lund, Cathedral (crypt)

62 *Virtue conquering Vice*, detail of cloister
door c. 1170–80
Millstatt (Carinthia, Austria)
Benedictine Monastery

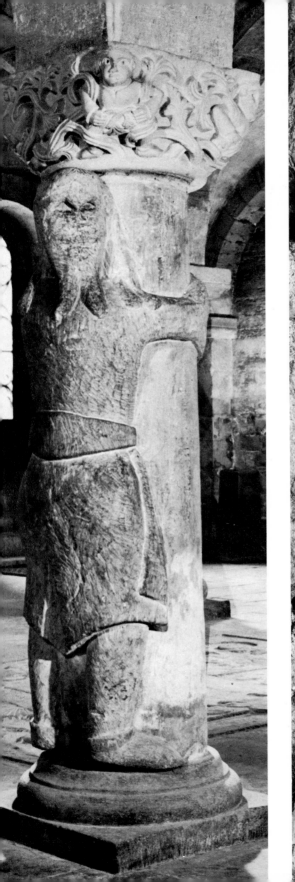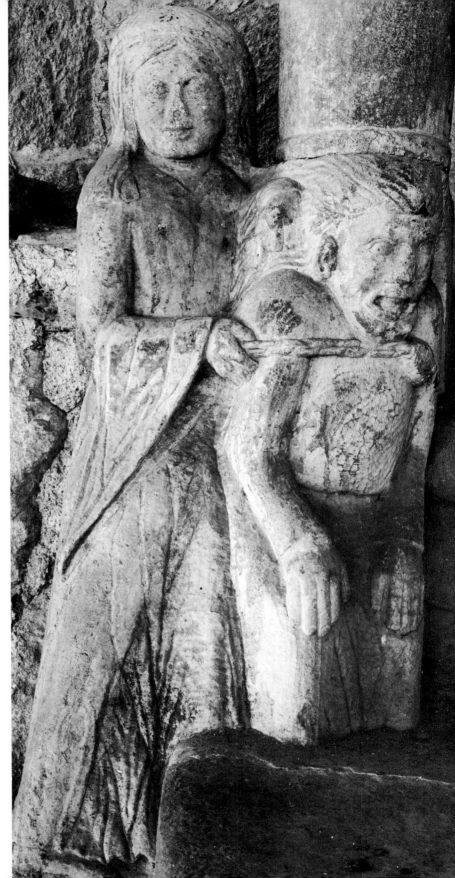

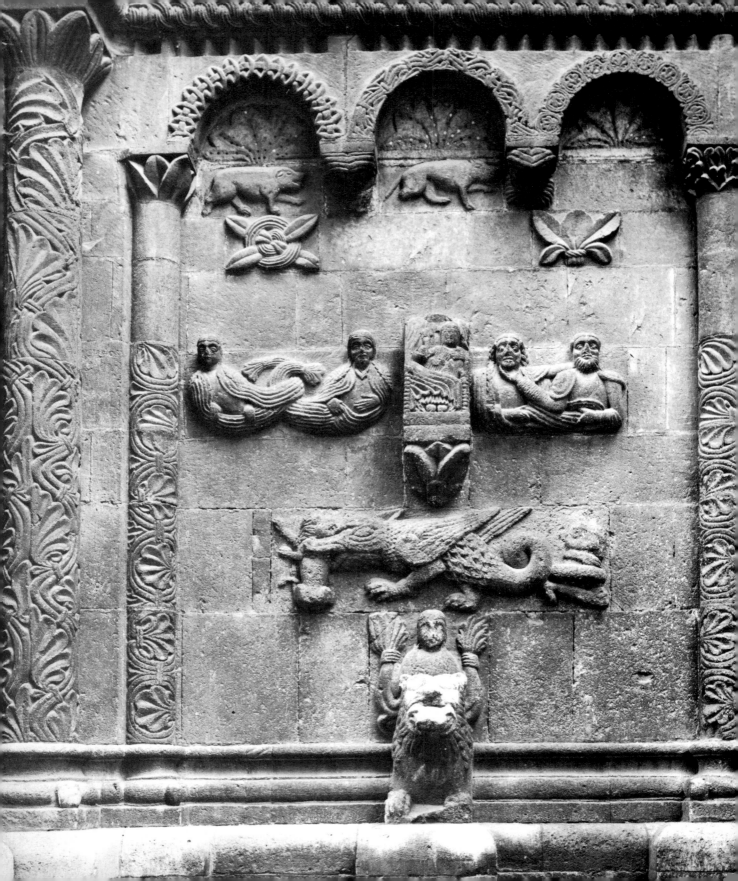

63 *Virgin and Child, dragon and mermaids,*
 detail of north portal *c.* 1160–70
 Regensburg, St Jakobskirche

64 *Hares ensnaring a hunter,* relief on the
 apse *c.* 1150
 Königslutter, SS. Peter and Paul

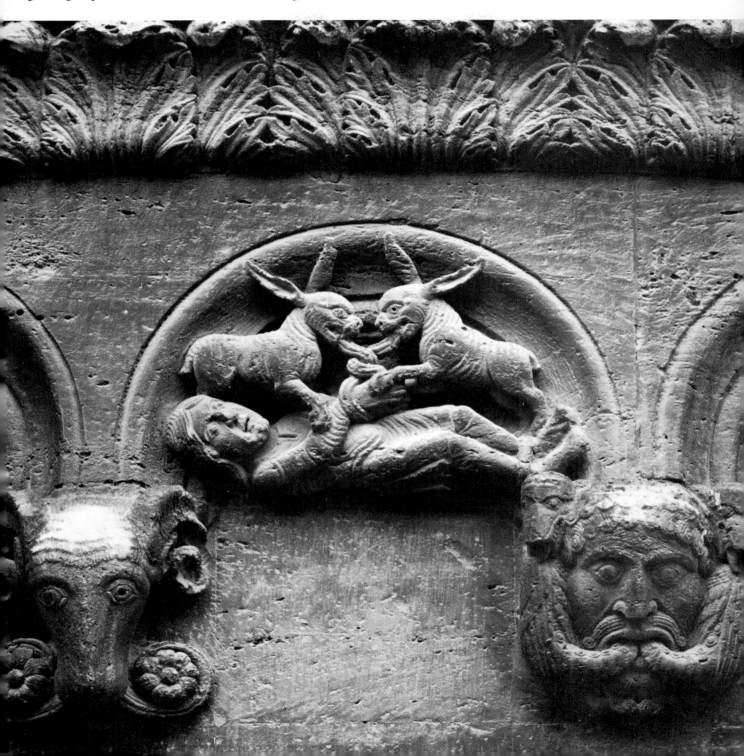

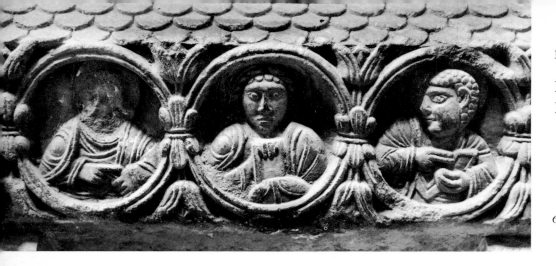

65 Bernard Gilduin
Portraits of three Apostles c. 1096
Toulouse, St Sernin (altar table)

66 *The Allegory of Lust*, detail of
capital *c.* 1100
Toulouse, St Sernin
(Porte des Comtes)

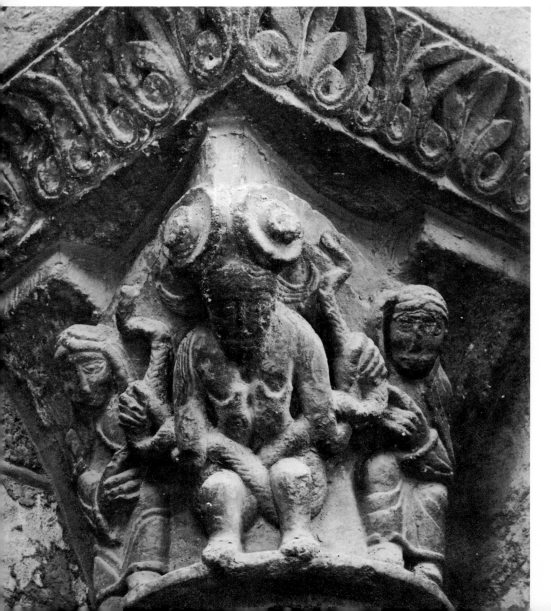

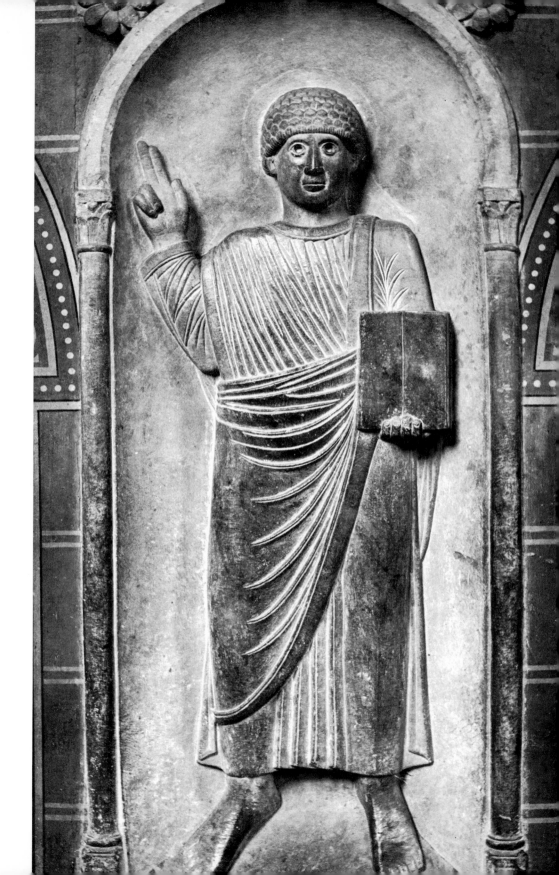

57 Bernard Gilduin
Apostle giving a benediction c. 1096
Toulouse, St Sernin (cloister)

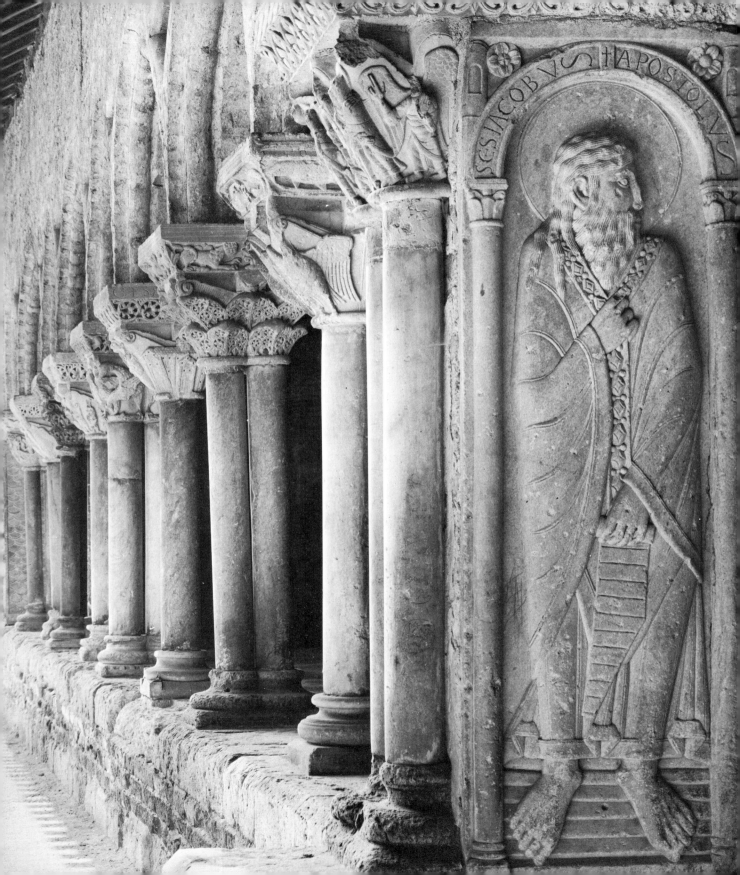

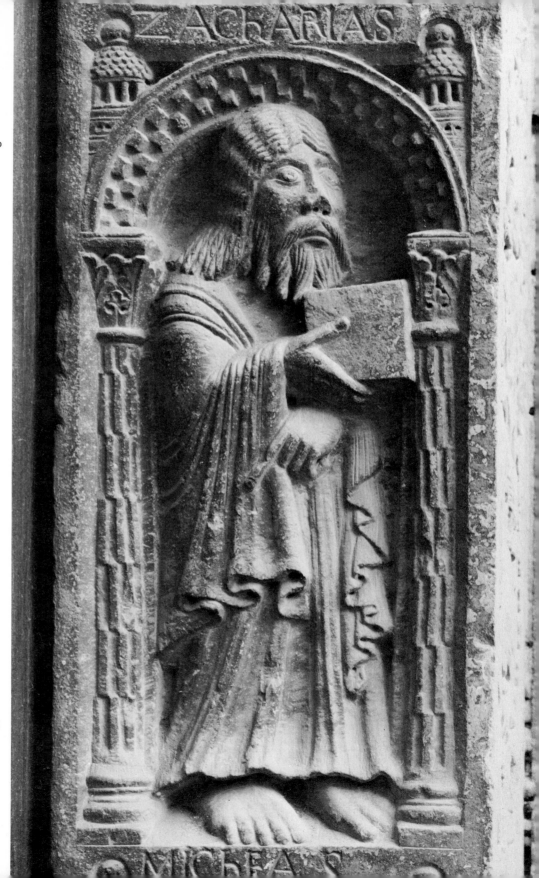

8 *St James on a square pillar* c. 1098–1100
Moissac, Abbaye St Pierre (cloister)

MODENA SCHOOL

9 Wiligelmo
The Prophet Zacharias, detail c. 1100–6
Modena, Cathedral (west portal)

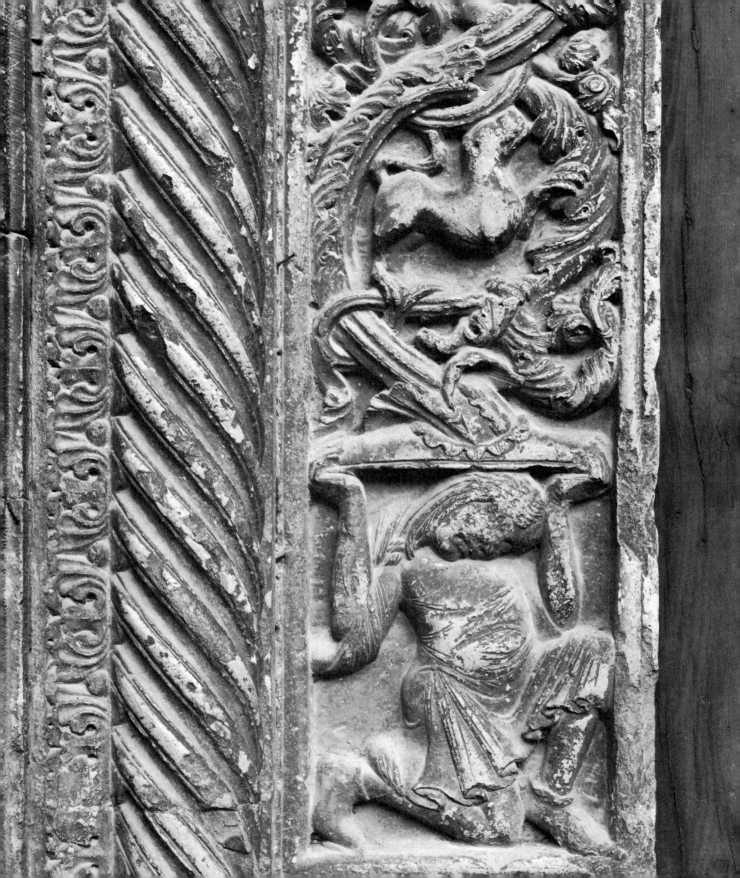

Wiligelmo
Atlas, detail of left jamb *c.* 1100–6
Modena, Cathedral (west portal)

71 Wiligelmo
The Creation of Eve, detail *c.* 1100–6
Modena, Cathedral (façade)

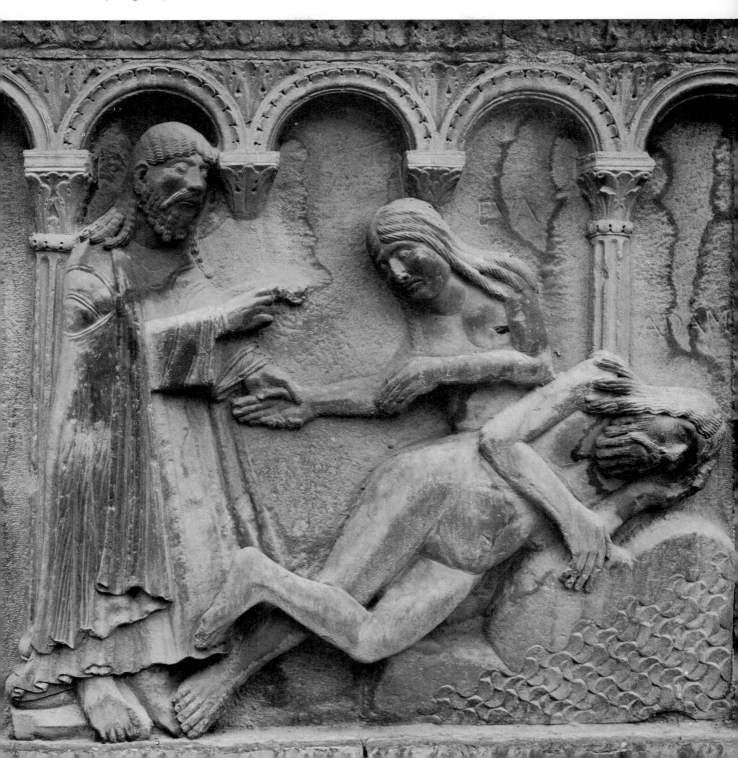

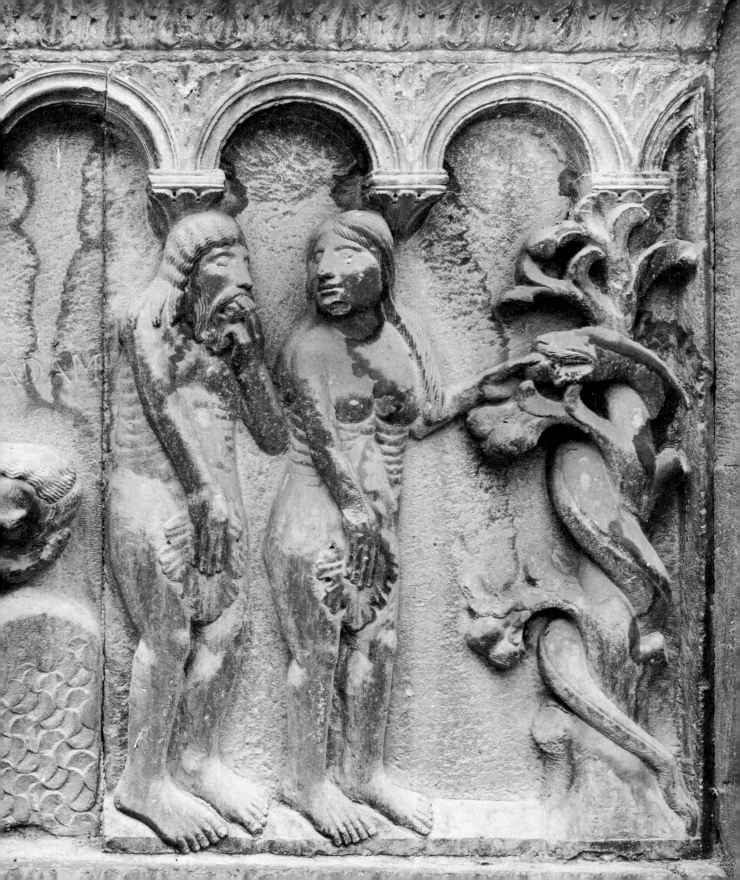

Wiligelmo
The Original Sin, detail c. 1100–6
Modena, Cathedral (façade)

73 *Departure and sea journey of S. Gimignano*,
detail of lintel c. 1105–10
Modena, Cathedral
(Portale dei Principi)

74 Wiligelmo
*Enoch and Elijah holding foundation
inscription*, detail c. 1106
Modena, Cathedral (façade)

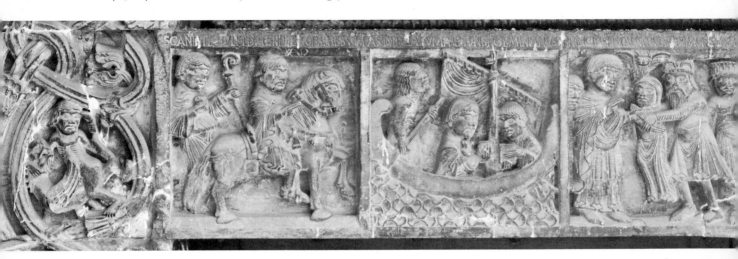

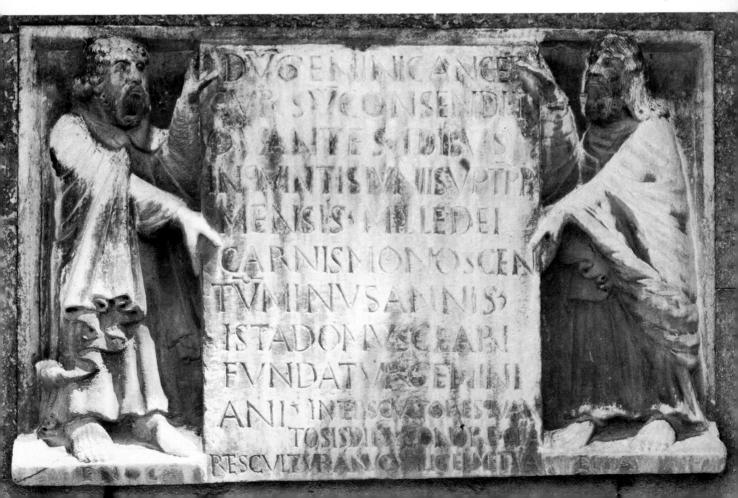

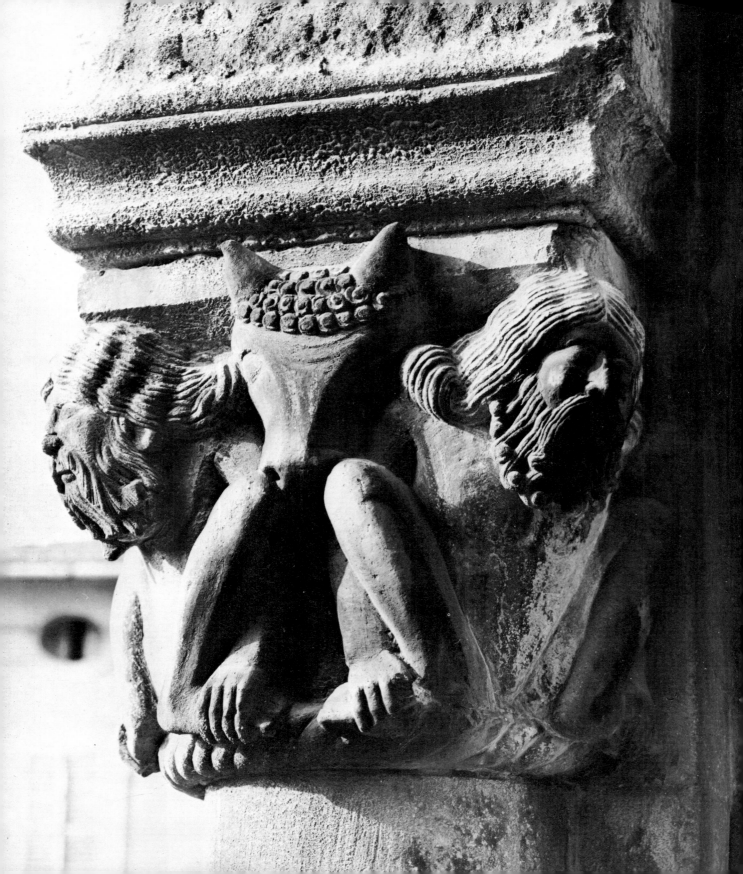

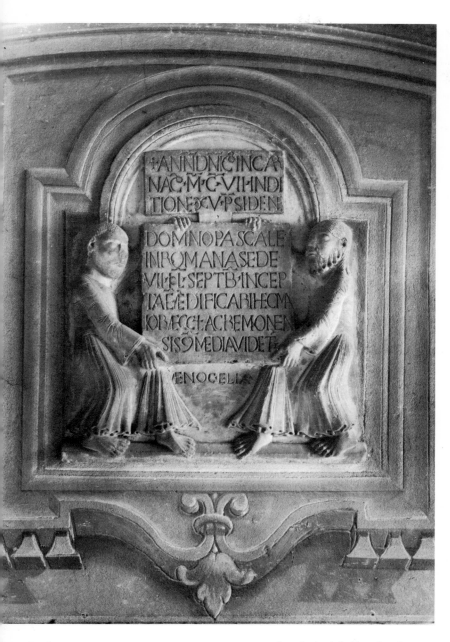

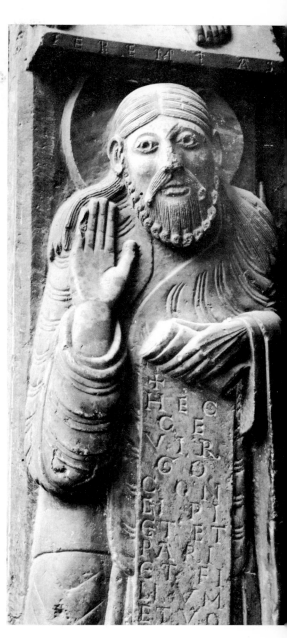

75 Wiligelmo
Old men with ox skull, detail of capital
c. 1106–10
Modena, Cathedral (façade gallery)

76 *Enoch and Elijah holding foundation
inscription c.* 1110
Cremona, Cathedral (sacristy)

77 *Prophet with a scroll c.* 1110
Cremona, Cathedral (main portal)

78 *Atlas-figures supporting bishop's throne*
 c. 1100–5
 Bari, S. Nicola

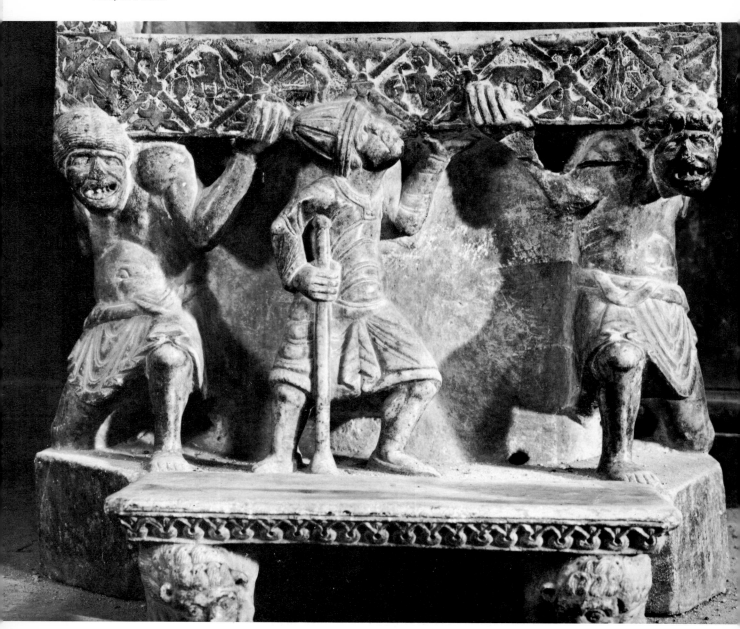

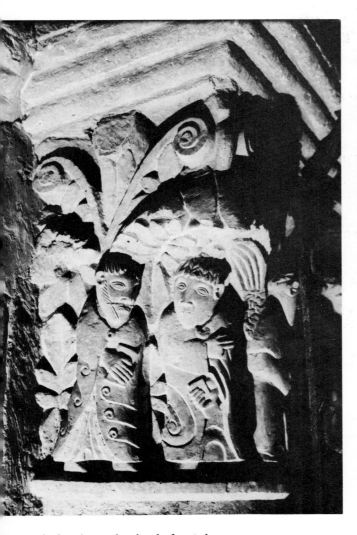

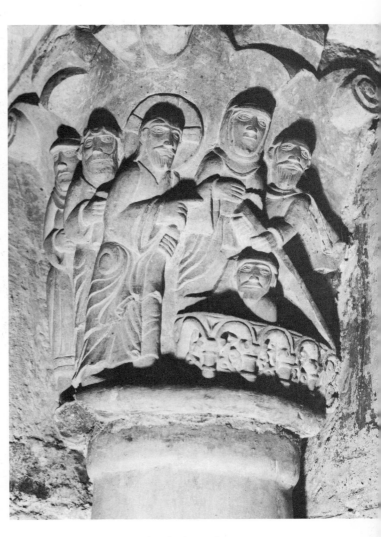

Moses leading the Exodus, detail of capital
c. 1095–1100
León, S. Isidoro (Capilla de los Reyes)

80 *The Raising of Lazarus*, detail of capital
c. 1095–1100
León, S. Isidoro (Capilla de los Reyes)

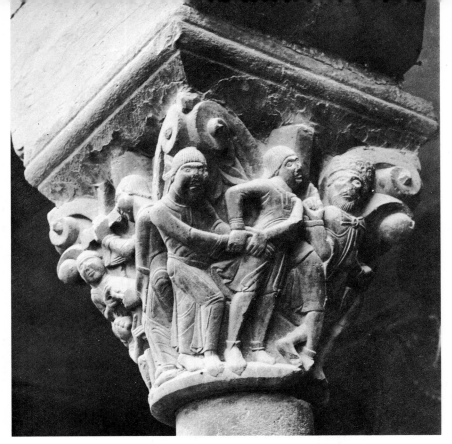

81 *The legend of St Sixtus*, detail of
capital *c.* 1110–15
Jaca, Cathedral (porch)

82 *The Sacrifice of Abraham*, detail of
capital *c.* 1110–15
Jaca, Cathedral (south doorway)

83 *Three Apostles c.* 1110–20
London, Victoria and
Albert Museum

84 *The Soul ascending to Heaven*, detail from
 tomb of Doña Sancha *c.* 1110–20
 Jaca, Monasterio de las Benedictinas

85 *The three Marys at the Holy Sepulchre; t*
 Descent from the Cross; the Ascension,
 lunette of south transept doorway *c.* 11:
 León, S. Isidoro (Puerta del Perdón)

86 *Signs of the Zodiac; King David, etc.,*
 reliefs on south aisle portal *c.* 1120
 León S. Isidoro (Puerta del Cordero)

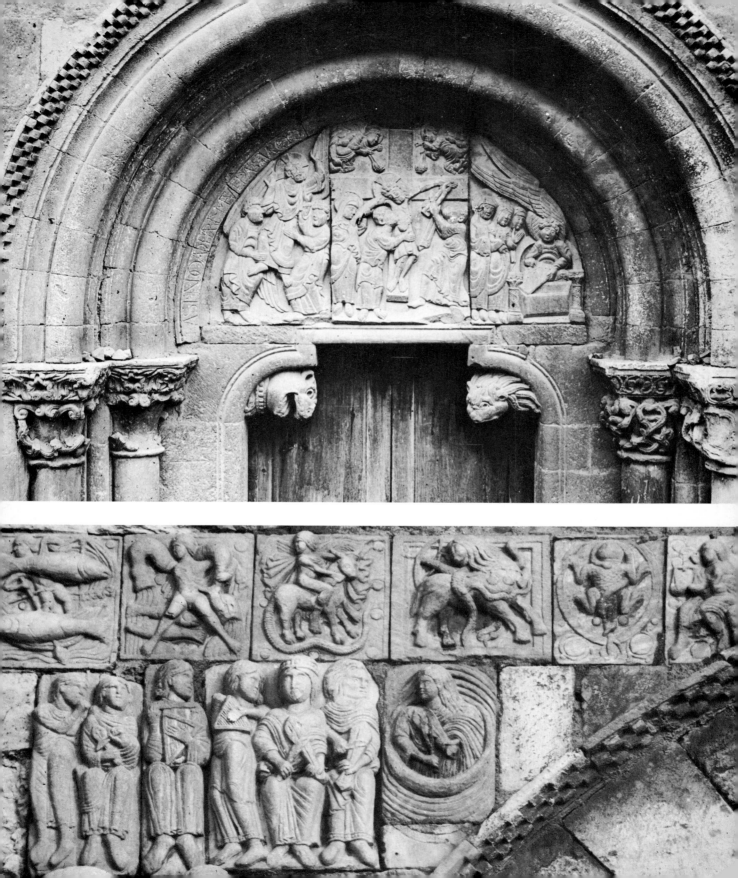

87 *The Sign of Leo*, detail of east door
 jamb *c.* 1115
 Santiago de Compostela
 (Puerta de las Platerías)

88 *The Allegory of Lust*, detail of lunette,
 c. 1115
 Santiago de Compostela
 (Puerta de las Platerías)

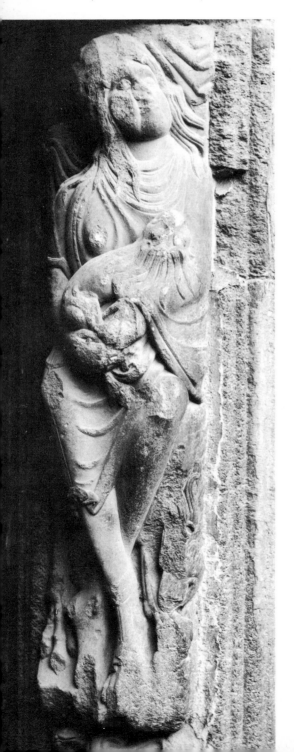

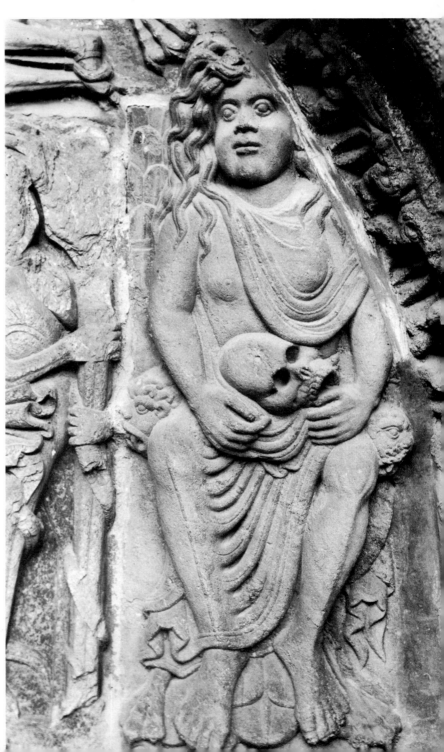

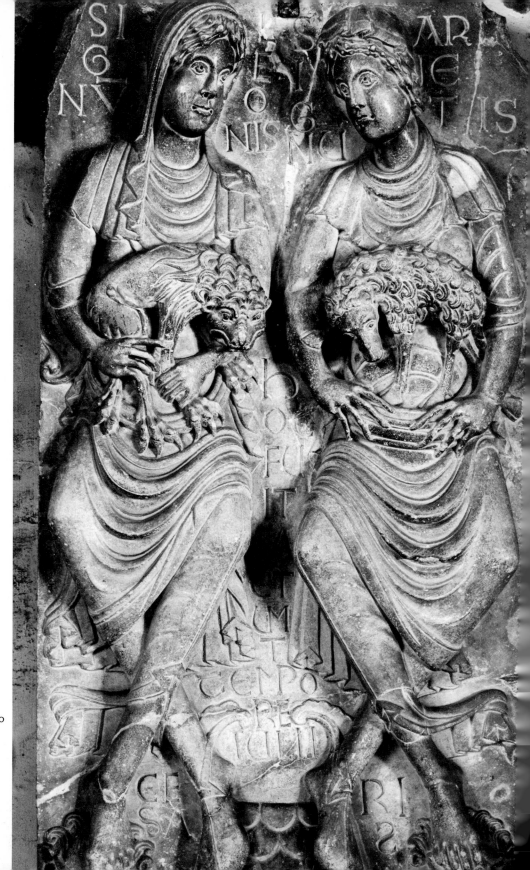

Signs of the Zodiac: Leo and Aries c. 1120
Toulouse, Musée des Augustins

90 *The Assumption and the Apostles*, lunette
 and lintel *c.* 1105–10
 Toulouse, St Sernin (Porte de Miègeville)

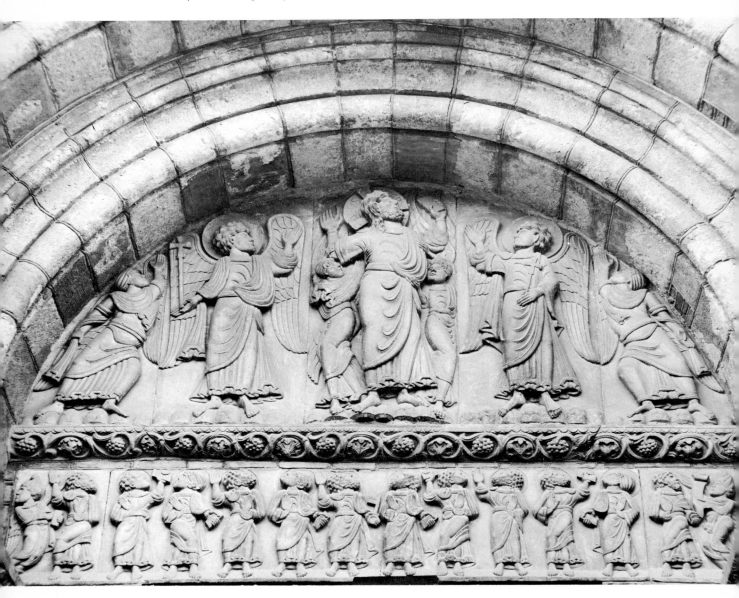

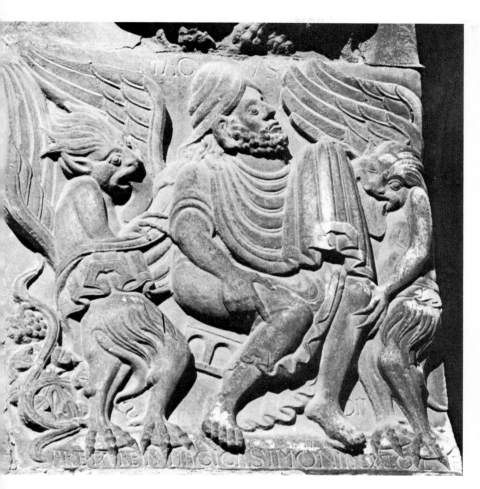

Simon Magus, relief *c.* 1110
Toulouse, St Sernin (Porte de Miègeville)

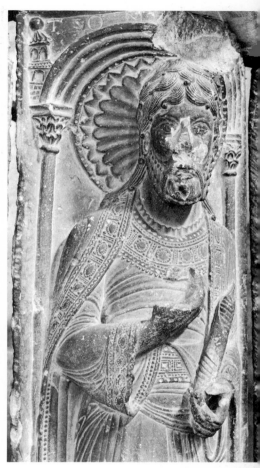

92 Gilabertus
St Thomas the Apostle c. 1120–30
Toulouse, Musée des Augustins

93 Niccolò
Three Prophets 1135
Ferrara, Cathedral (main portal)

94 Niccolò
Signs of the Zodiac, detail of jamb
c. 1120 Val di Susa (Piedmont),
Sagra di S. Michele, Abbey

95 Niccolò
Scenes from Genesis 1138
Verona, S. Zeno (façade)

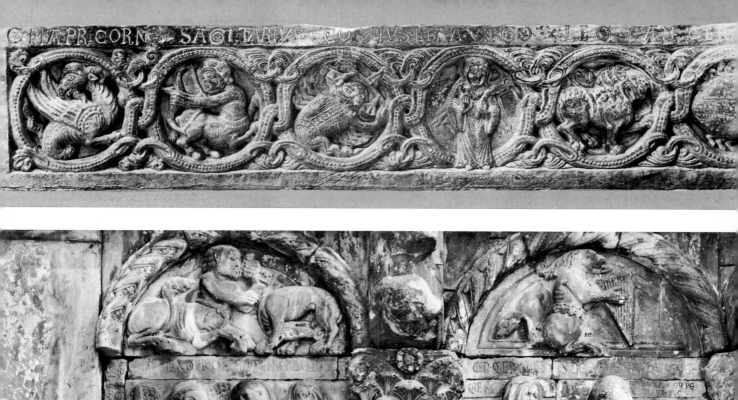

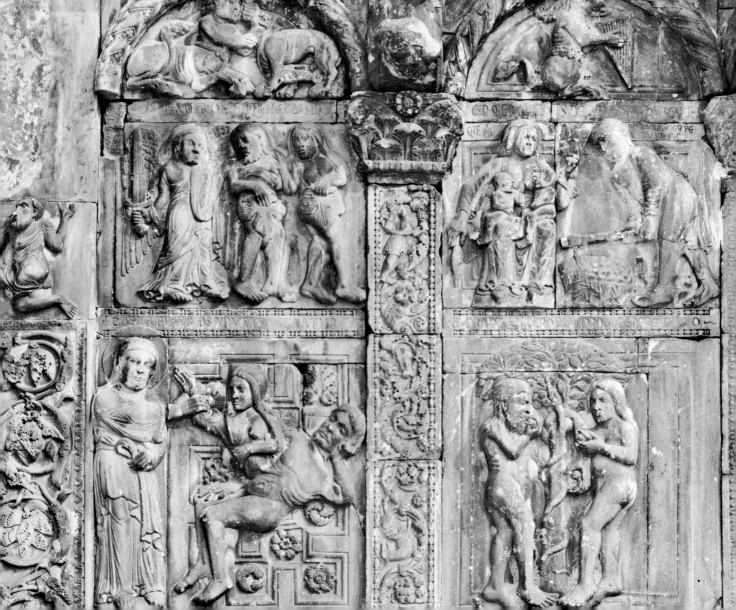

THIRD SCHOOL OF LANGUEDOC

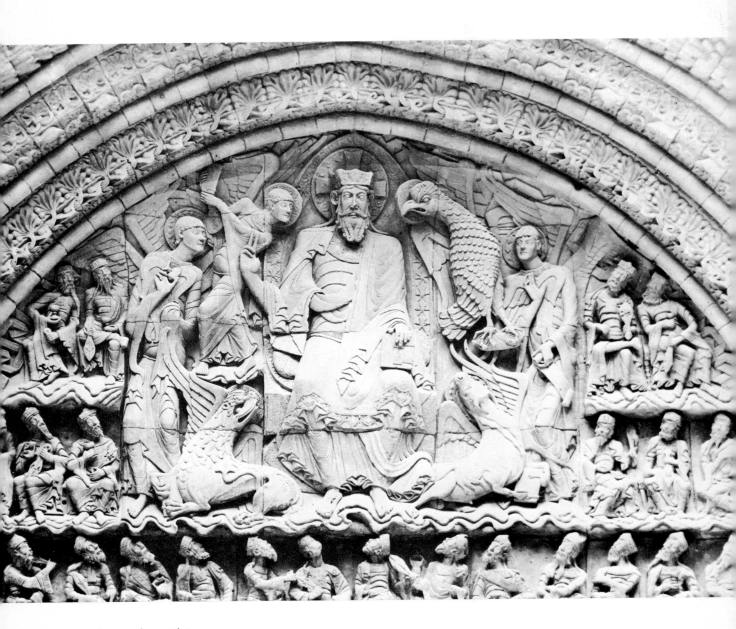

96 *The Apocalyptic Christ c.* 1125–30
Moissac, Abbaye St Pierre (west portal,
tympanum)

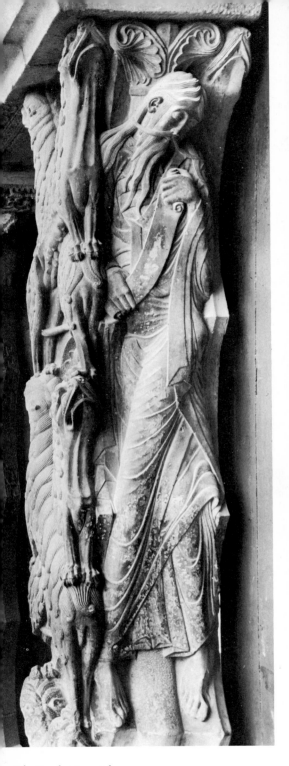

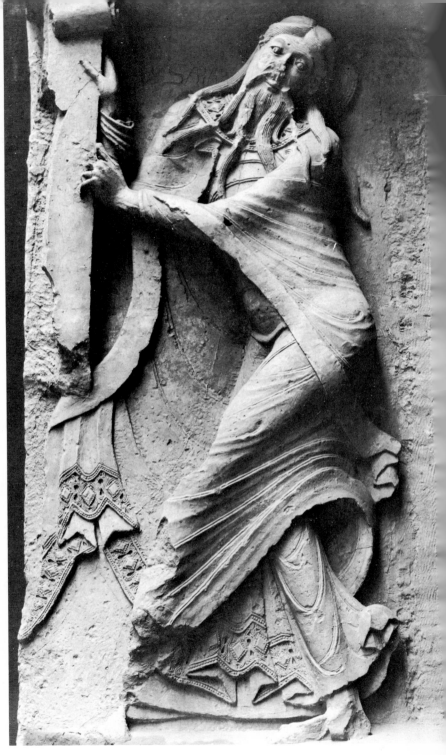

97 *The Prophet Jeremiah c.* 1125–30
Moissac, Abbaye St Pierre (west portal,
trumeau)

98 *The Prophet Isaiah c.* 1135
Souillac, Abbaye Ste Marie
(reconstructed portal, jamb)

99 *The Adoration of the Magi*, detail *c.* 1130
Moissac, Abbaye St Pierre (porch
interior)

100 *Fabulous beasts c.* 1135
Souillac, Abbaye Ste Marie

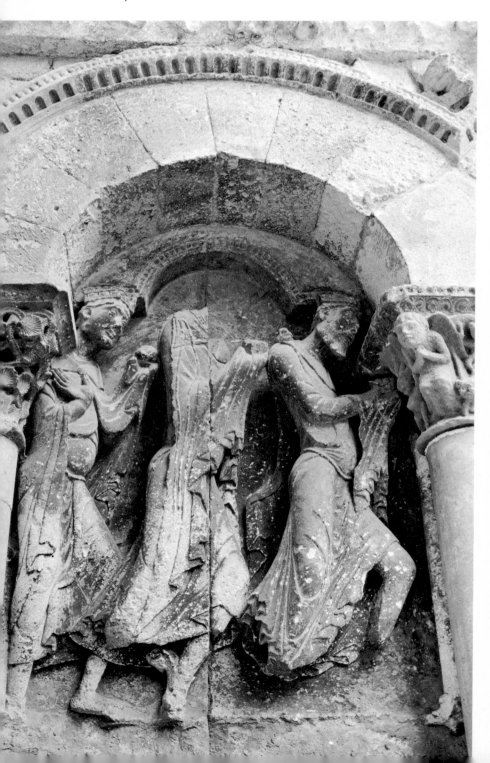

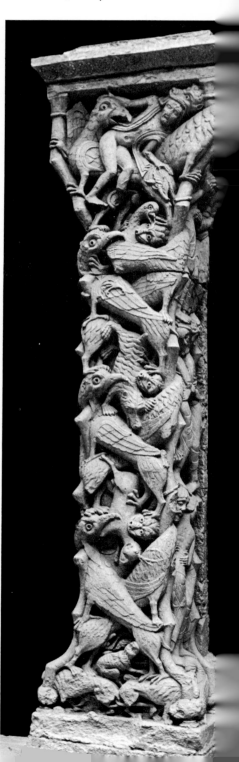

LANGUEDOC AND
BURGUNDIAN
INFLUENCE IN
ITALY

201 *Truth tearing out Falsehood's tongue,*
relief *c.* 1125–30
Modena, Cathedral
(Portale dei Principi)

202 *Girl watching a tumbler c.* 1130–40
Modena, Museo Lapidario
del Duomo

Tale from the Arthurian legends, detail
of archivolt *c.* 1120–30
Modena, Cathedral
(Porta della Pescheria)

104 *Atlas-figure, foliage, and animals*, detail of
right door jamb *c.* 1120–30
Modena, Cathedral
(Porta della Pescheria)

105 *The Month of June*, detail of left door
jamb *c.* 1120–30
Modena, Cathedral
(Porta della Pescheria)

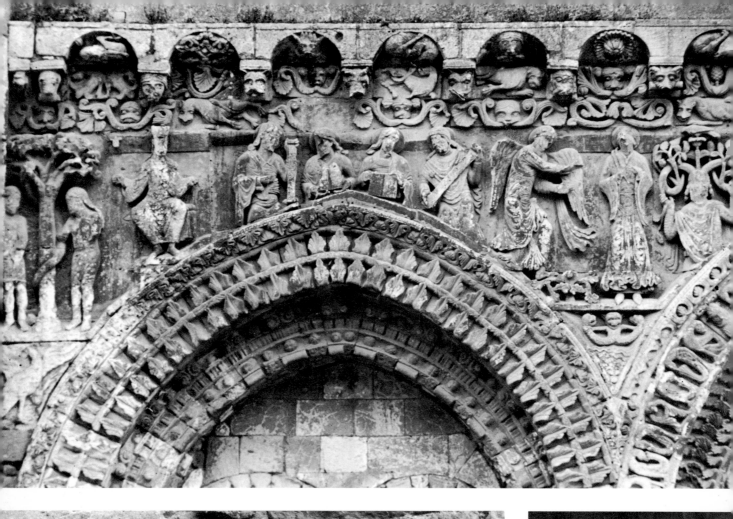

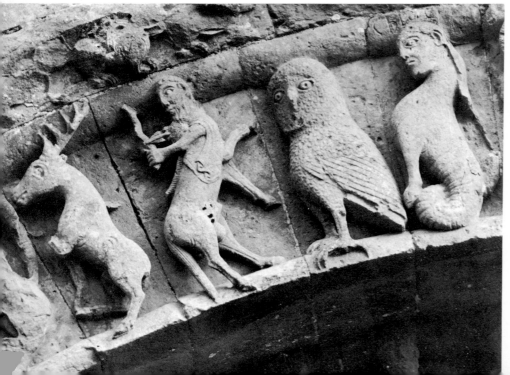

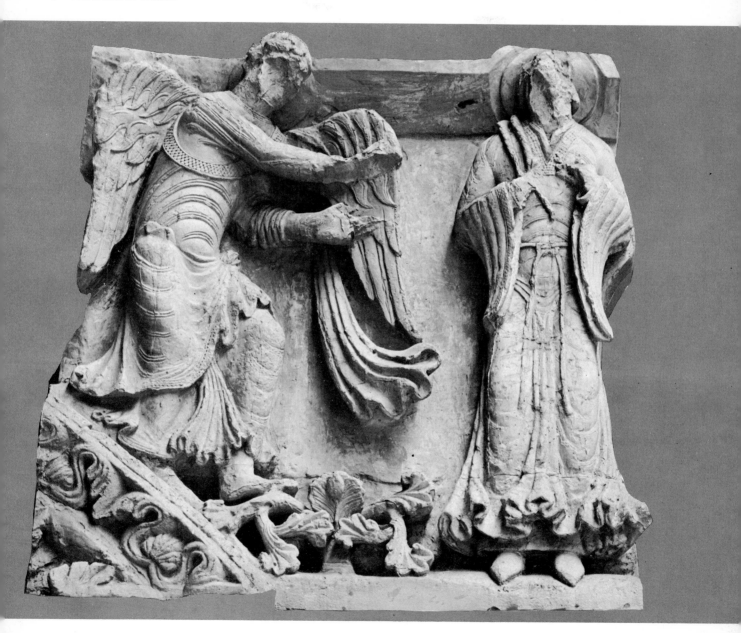

110 *The Sacrifice of Isaac; Jacob wrestling with the Angel; Jacob's dream c.* 1170–80 Trani, Cathedral (left jamb of west portal) (*far left*)

111 *Scenes from the Old Testament c.* 115 Capua, S. Marcello (right door jamb) (*centre left*)

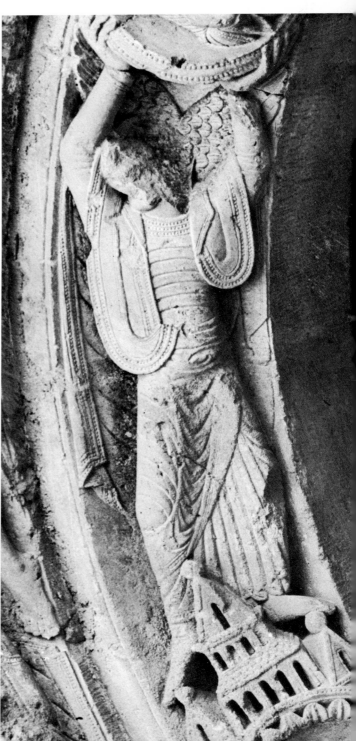

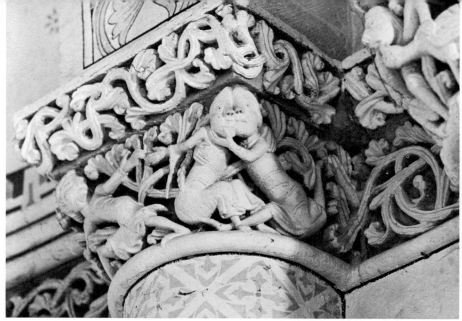

2 *Detail of archivolt c.* 1140
Parthénay-le-Vieux,
Notre-Dame-de-la-Couldre
(main doorway) (*left*)

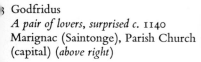

3 Godfridus
A pair of lovers, surprised c. 1140
Marignac (Saintonge), Parish Church
(capital) (*above right*)

4 Godfridus
Fabulous beast devouring a naked man,
detail of capital *c.* 1140–50
Chauvigny, St Pierre (choir)

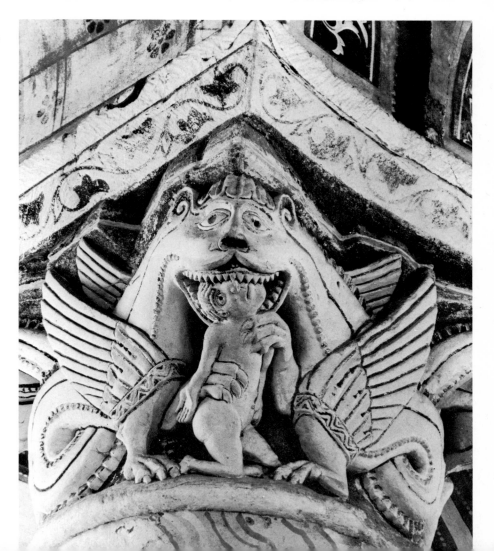

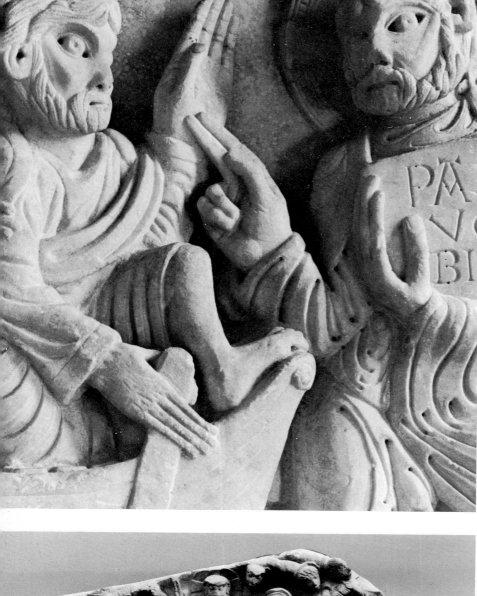

115 The Master of Cabestany
The Summoning of the Disciples c. 1150
Barcelona, Museo Marés

116 The Master of Cabestany
The Dormition and Assumption of the Virgin; St Thomas receiving the Virgin's girdle c. 1150
Cabestany, Parish Church (lunette)

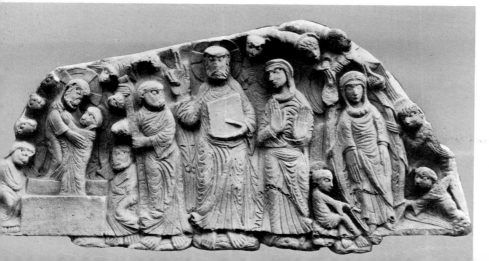

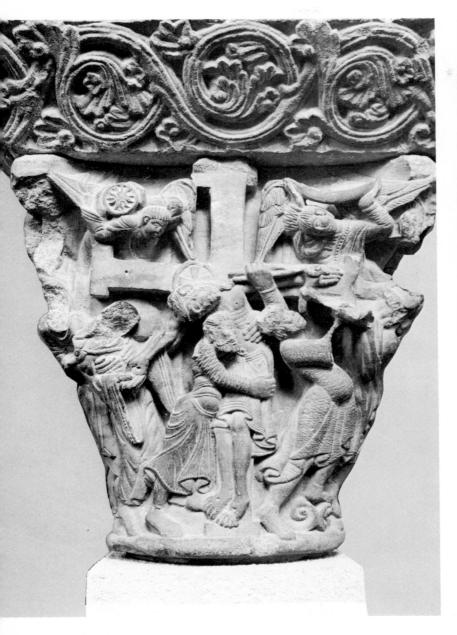

117 *The Descent from the Cross* c. 1140
Pamplona, Museo de Navarra

118 *The Pilgrims of Emmaus*, detail
c. 1135–40
S. Domingo de Silos (cloister)

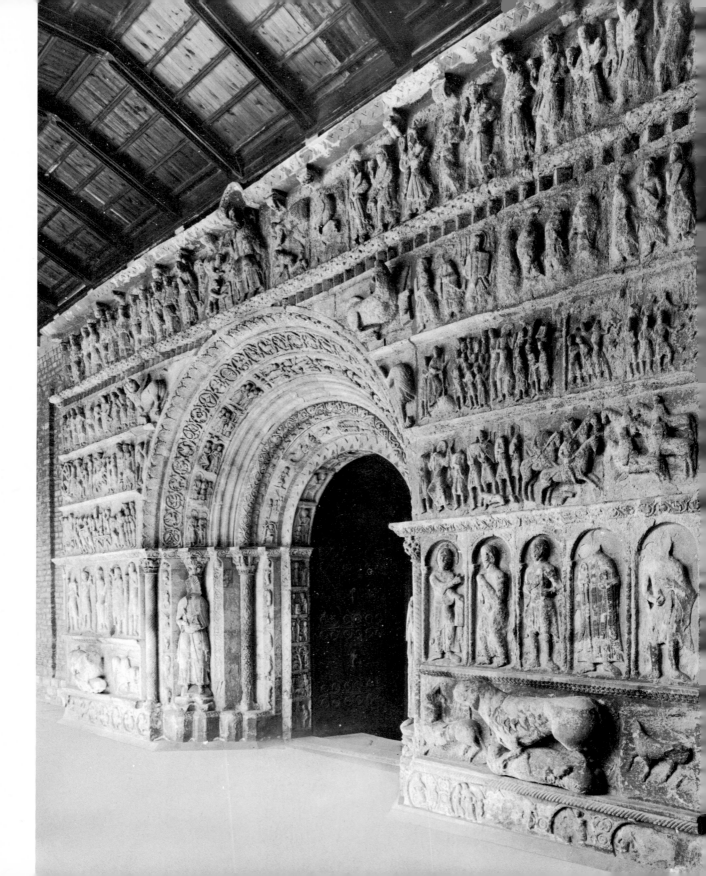

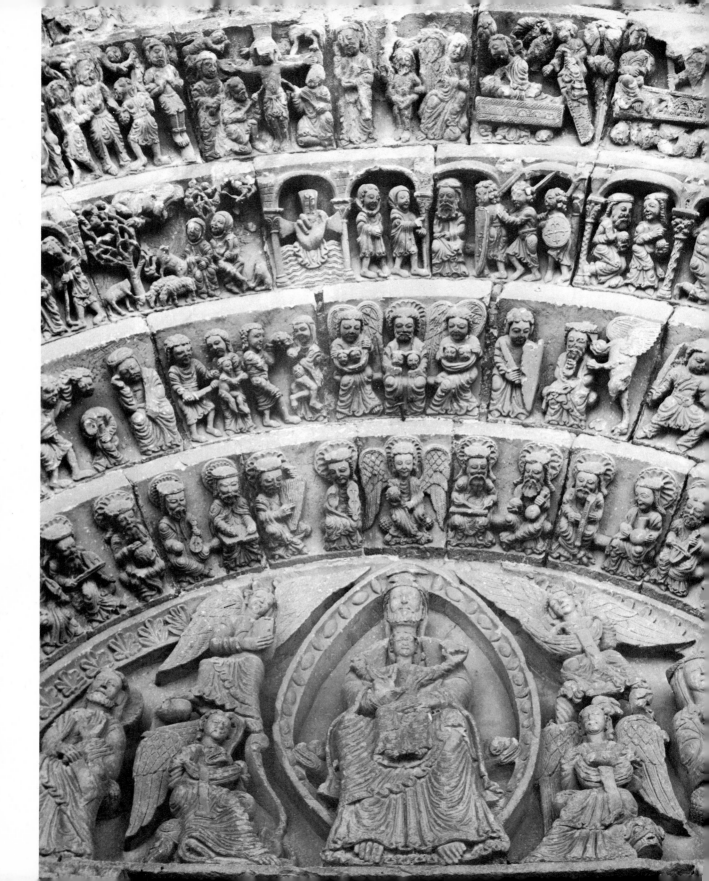

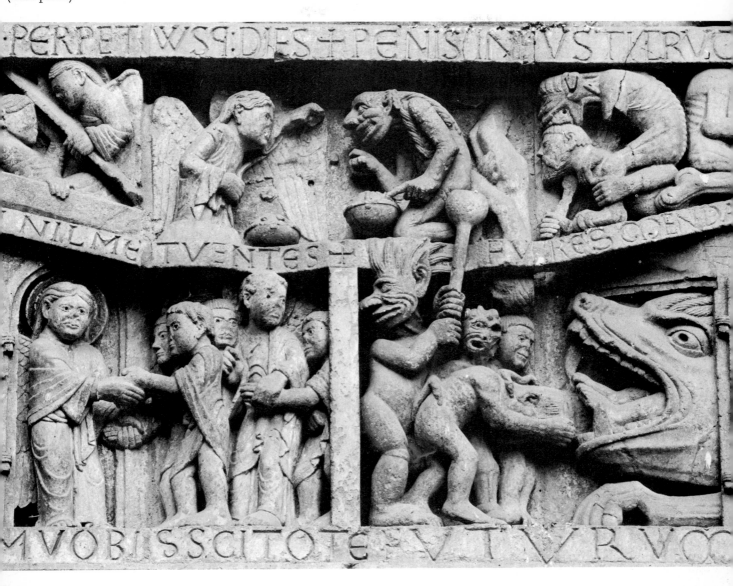

ROMANESQUE SCULPTURE
The Holy Trinity and other subjects,
detail second half 12th cent.
Soria (Castile), S. Domingo
(main portal)

SCHOOL OF THE MASSIF CENTRAL

3 *The Blessed received into Paradise and the
Damned driven down to Hell,* detail of
tympanum *c.* 1110
Conques, Ste Foy (west portal)

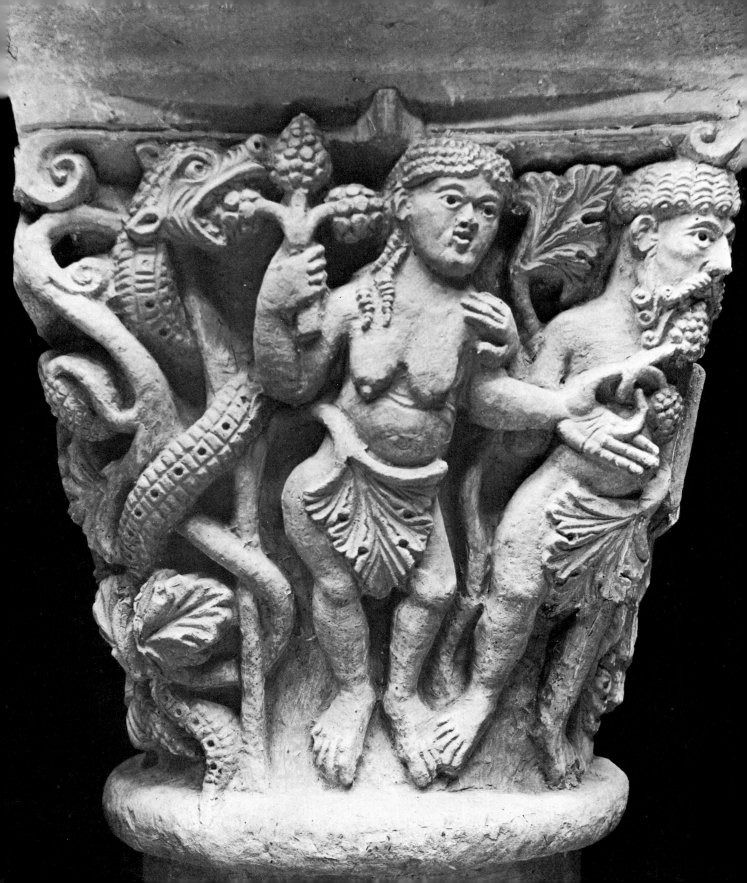

4 Robert
The Original Sin, detail of capital *c.* 1150
Clermont-Ferrand,
Notre-Dame-du-Port (choir)

125 Brunus and another
The Apostles John and Peter, detail of
central portal *c.* 1130
St Gilles, Abbey Church (façade)

126 *The Archangel Michael c.* 1140
St Gilles, Abbey Church (façade)

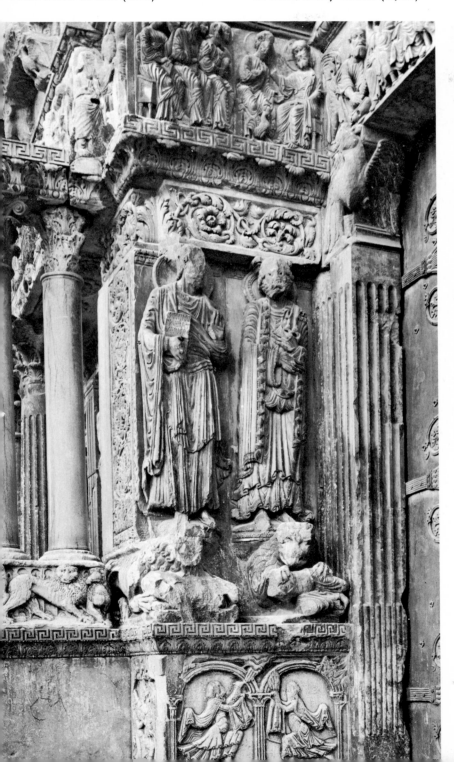

127 *Roman soldiers*, detail of frieze c. 1140 St Gilles, Abbey Church (façade)

128 *Man devoured by a lion*, detail of central portal c. 1130 St Gilles, Abbey Church (façade)

129 *St Peter and St John*, detail of portal c. 1150–8 Arles, St Trophime (façade)

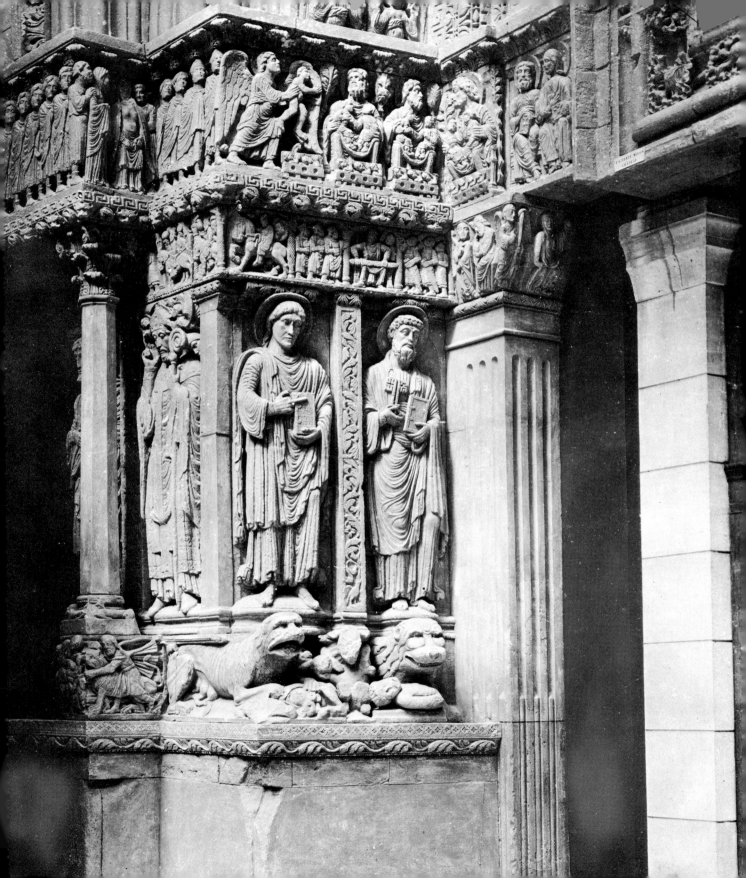

130 *Head of St Trophime*, detail of square
pillar *c.* 1145–50
Arles, St Trophime

131 *Joseph's dream*, detail of capital *c.* 1160–70
Arles, St Trophime (cloister, east side)

132 *The Expulsion from Paradise*, detail of
frieze *c.* 1150
Nîmes, Cathedral (*below*)

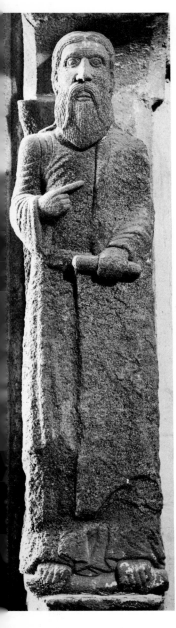

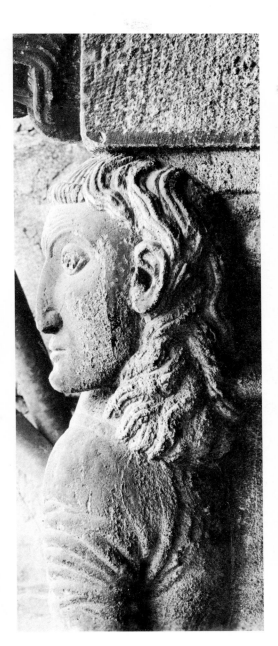

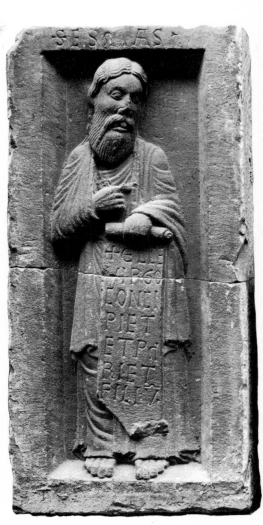

3 *A Prophet*, apse window *c.* 1175
Val di Susa (Piedmont), Sagra di
S. Michele, Abbey

134 *Atlas-figure*, external galley *c.* 1150–60
Piacenza, Cathedral

135 *The Prophet Isaiah c.* 1170
Castellarquato (Piacenza),
Collegiate Church (ambo)

136 *Caryatid*, detail of choir screen *c.* 1178
Chur (Grisons), Cathedral (crypt)

137 *Caryatid*, detail of rood screen *c.* 1170
Modena, Cathedral

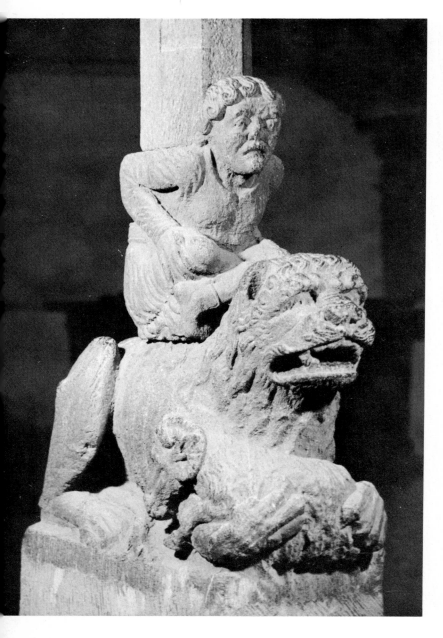

138 Guglielmo
The Annunciation; the Nativity; the th[
Marys at the Holy Sepulchre, detail of
ambo 1159–62
Cagliari, Cathedral

ROMANESQUE SCULPTURE

139 Guglielmo
Lion fighting with a dragon, detail of
ambo *c.* 1159–62
Cagliari, Cathedral

140 Bonanus Pisanus
Adam and Eve after the Expulsion,
detail of door 1185
Monreale (Sicily), Cathedral (west
portal) (*opposite*)

141 Bonanus Pisanus
The Journey of the Magi c. 1190–5
Pisa, Cathedral (Porta di S. Ranier
(*opposite, far right*)

142 Bonanus Pisanus
Three Prophets, detail *c.* 1190–5
Pisa, Cathedral (Porta di S. Ranier

ELA SERUEAADA

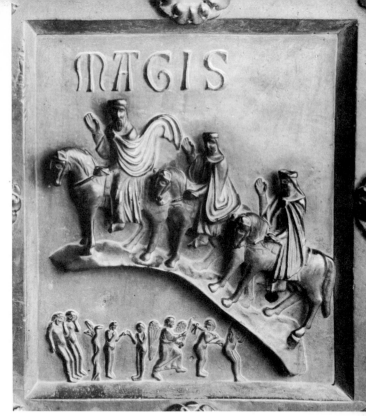

MAGIS

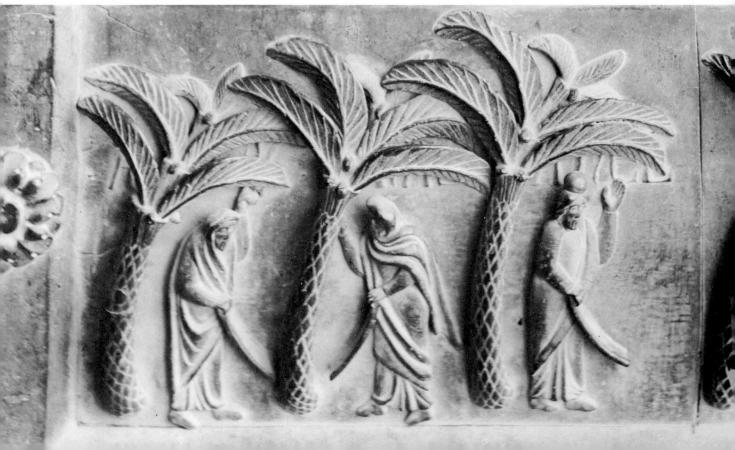

143 *Atlas-figures*, detail of tomb of
Roger II *c.* 1155
Palermo (Sicily), Cathedral

144 *The Presentation in the Temple*,
detail of capital *c.* 1175–89
Monreale (Sicily),
Cathedral (cloister)

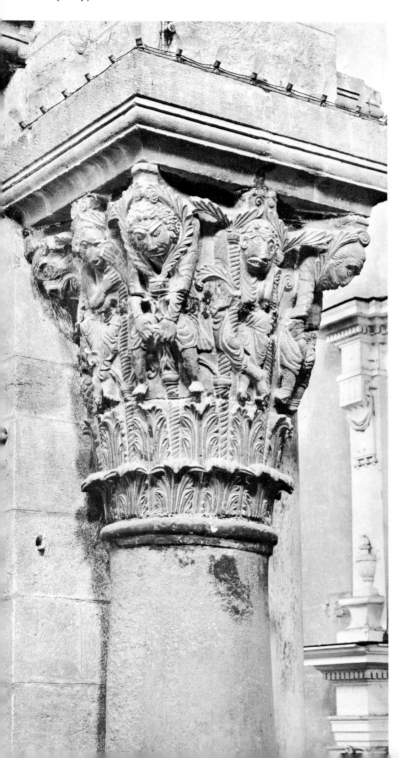

145 *Capital with Atlas-figures c.* 1160
Cefalù (Sicily), Cathedral

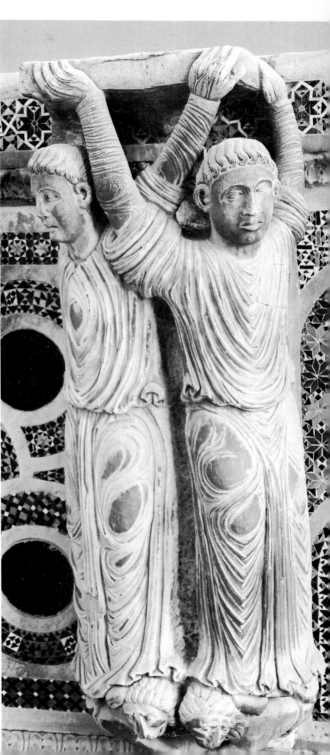

146 *Figures supporting lectern in ambo c.* 1180
Salerno, Cathedral

147 *Scenes from the Life of Christ*, detail of
 door *c.* 1190
 Benevento, Cathedral

152 *The Presentation in the Temple*, detail of
 lunette *c.* 1200–10
 Parma, Baptistry
 (south portal, interior)

153 *March and April c.* 1230
 Ferrara, Museo dell'Opera del Duomo

154 Benedetto Antelami
 King Solomon, detail *c.* 1200
 Parma, Baptistry (exterior)

159 *The Adoration of the Magi c.* 1145
La-Charité-sur-Loire, Ste Croix
(lintel of south portal in north tower)

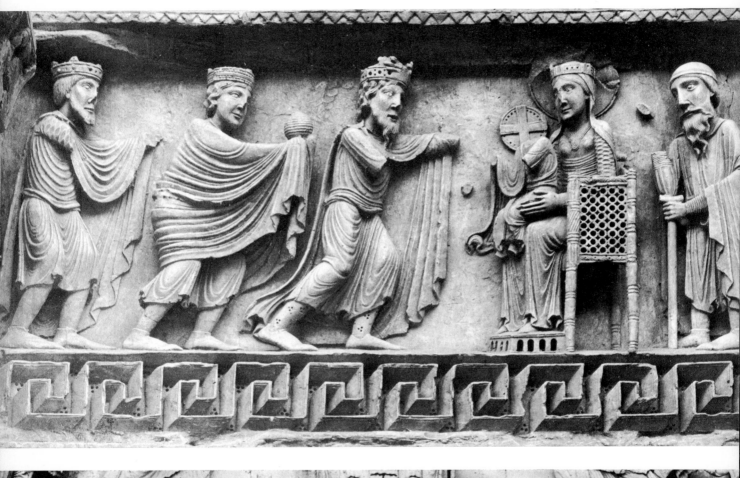

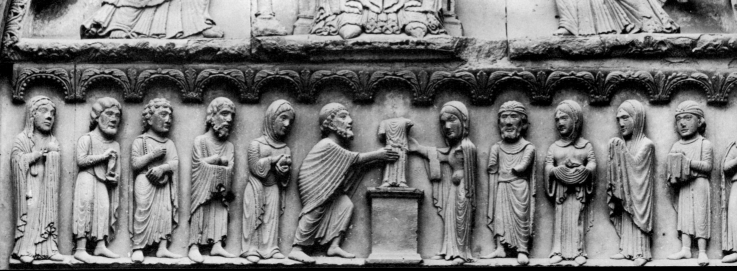

161 *The Annunciation to the Shepherds c.* 1150
Bonn, Rheinisches Landesmuseum
(*above*)

162 *Column statue with crossed legs c.* 1150–5
Chartres, Cathedral (Royal Portal)
(*right*)

160 *The Presentation in the Temple c.* 1145–50
Chartres, Cathedral (*left*)

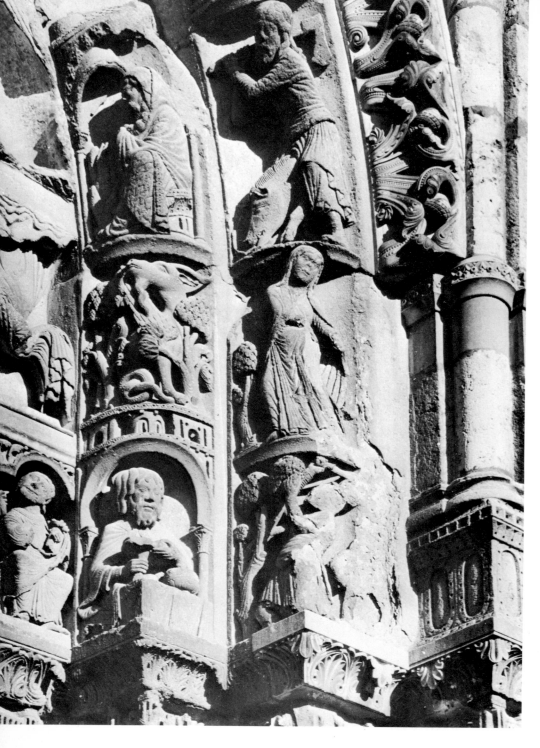

163 *The Months and Signs of the Zodi*
 c. 1150–5
 Chartres, Cathedral (Royal Port

164 *Column statues c.* 1150–5
 Chartres, Cathedral (Royal Port

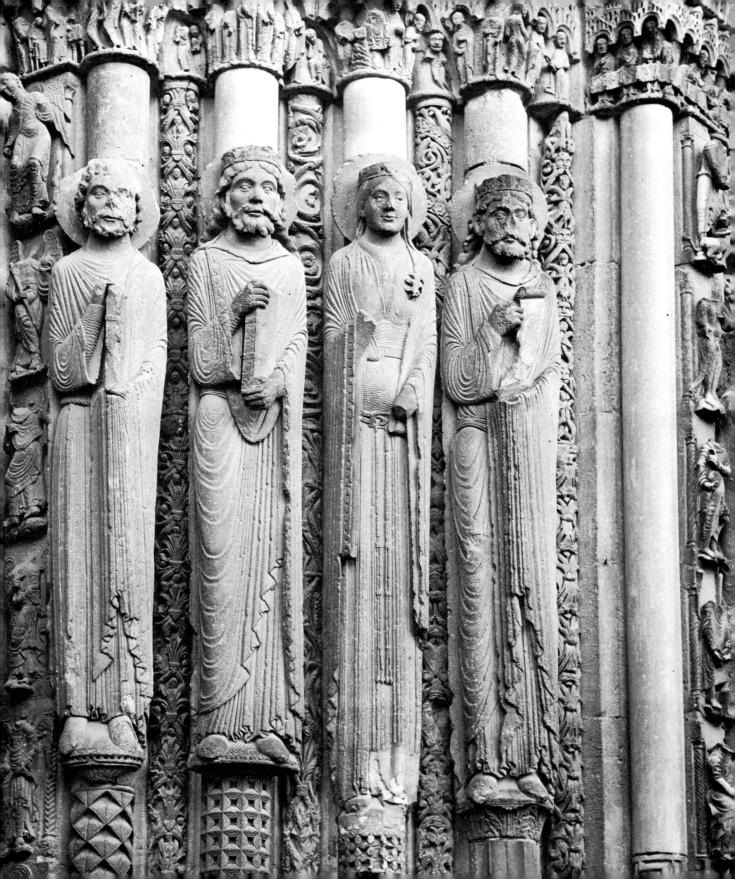

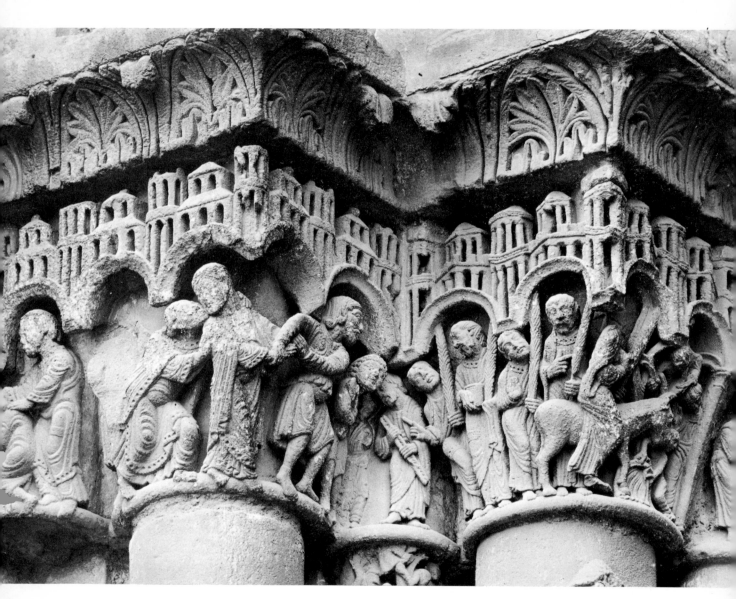

165 *Christ's entry into Jerusalem c.* 1150–5
Chartres Cathedral (Royal Portal)

166 *Fiddle-Player c.* 1210
Cologne, Schnütgen Museum

167 *Trumeau figure c.* 1170–5
St Loup-de-Naud, St Loup
(west portal)

168 *King Solomon c.* 1180–90
Paris, Louvre

169 *Queen of Sheba c.* 1180–90
Paris, Louvre

170 *Mary mourning c.* 1210–20
Halberstadt, Cathedral

171 *The Descent from the Cross c.* 11
Horn, Entrance to sanctuary
(*right*)

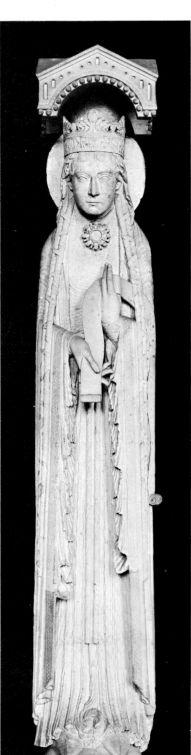

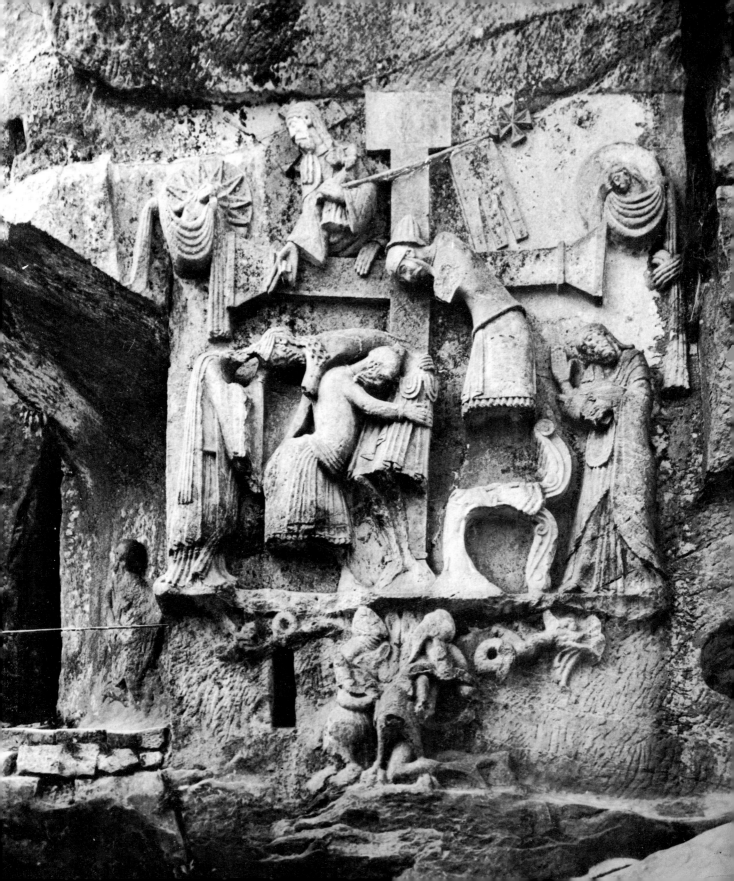

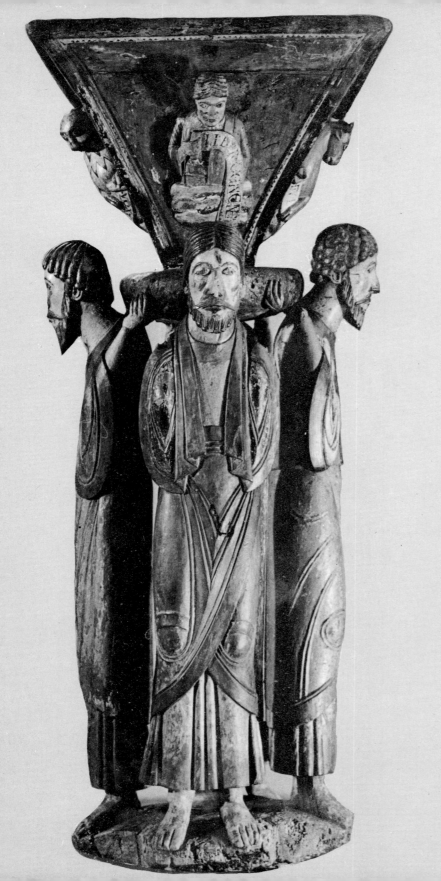

172 *The four Evangelists*, lectern *c.* 11
Freudenstadt (Black Forest),
Parish Church

BRITISH ROMANESQU

173 *The Sisters Lamenting*, detail fron
the Raising of Lazarus *c.* 1150
Chichester, Cathedral

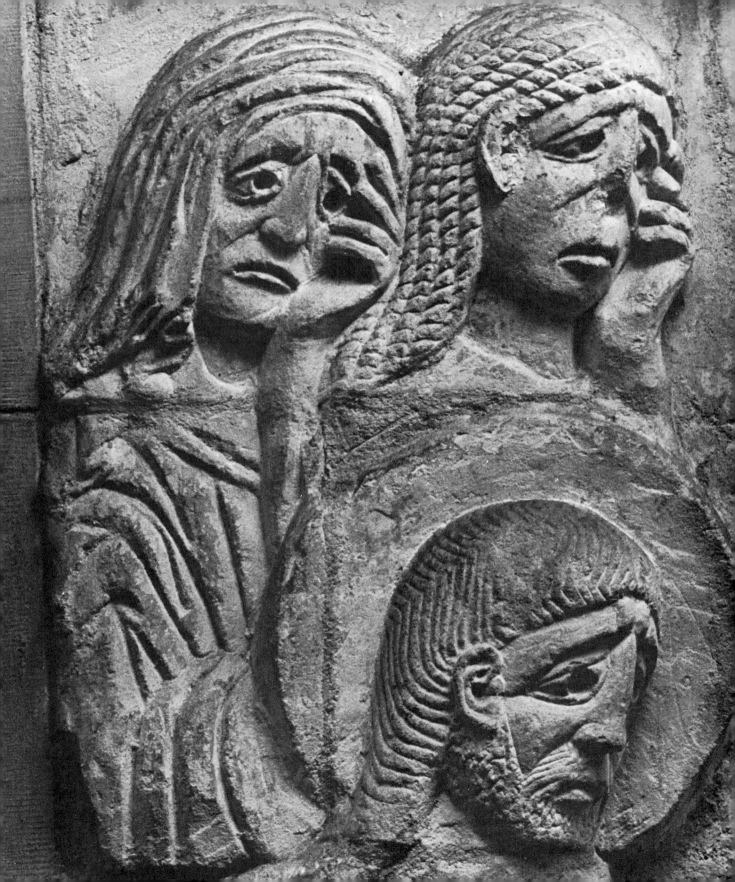

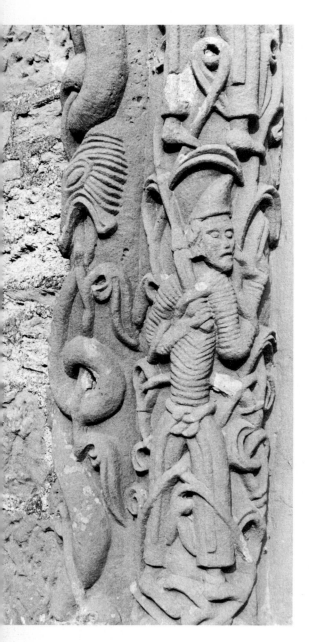

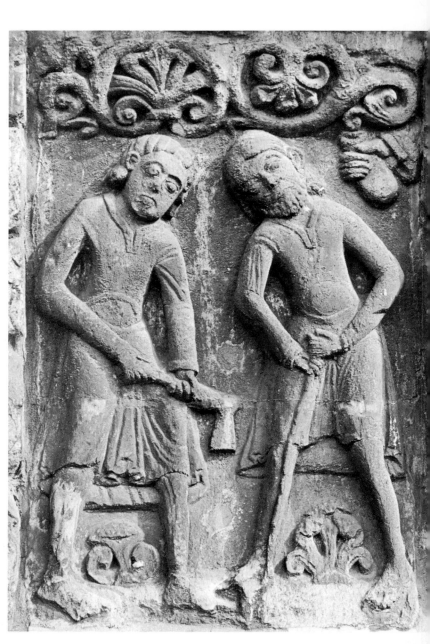

174 *Vine tendrils, snakes, and warriors,*
detail of jamb c. 1150
Kilpeck (Herefordshire), St Mary
and St David (south doorway)

175 *Cain and Abel tilling the fields c. 1145–8*
Lincoln, Cathedral (west front)

176 *Noah building the Ark, deta*
c. 1145–8
Lincoln, Cathedral
(west front)

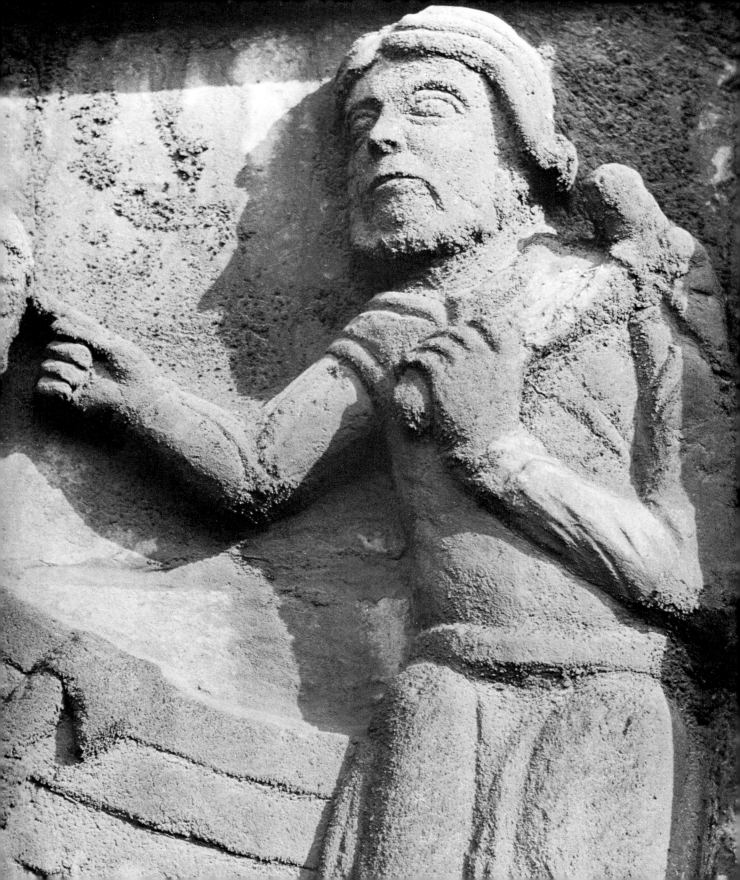

177 *Caryatid*, originally supporting the rib
of a vault *c.* 1140
Durham, Cathedral

178 *An Apostle c.* 1165–75
Malmesbury (Wilts), Abbey Church
(south porch)

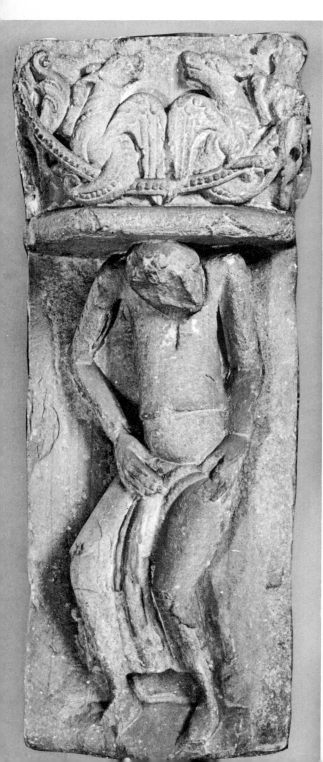

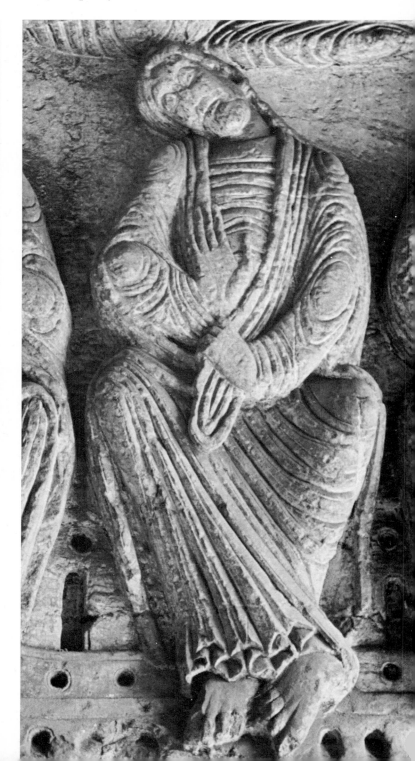

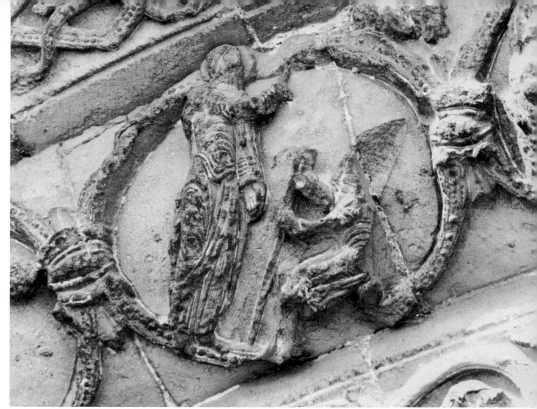

79 *The Sacrifice of Isaac c.* 1165–75
 Malmesbury (Wilts), Abbey Church
 (outer doorway)

80 *The Judgement of Solomon*,
 capital, *c.* 1150
 London, Westminster Abbey

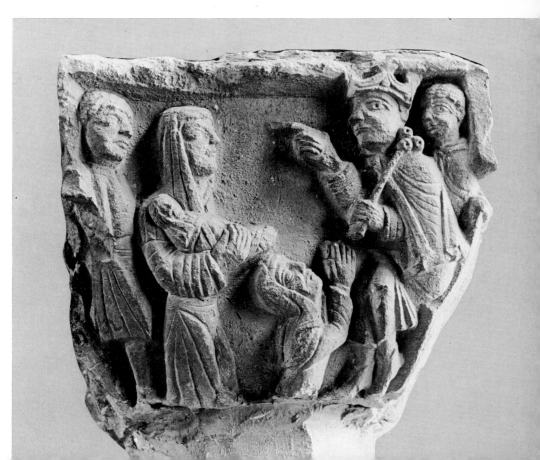

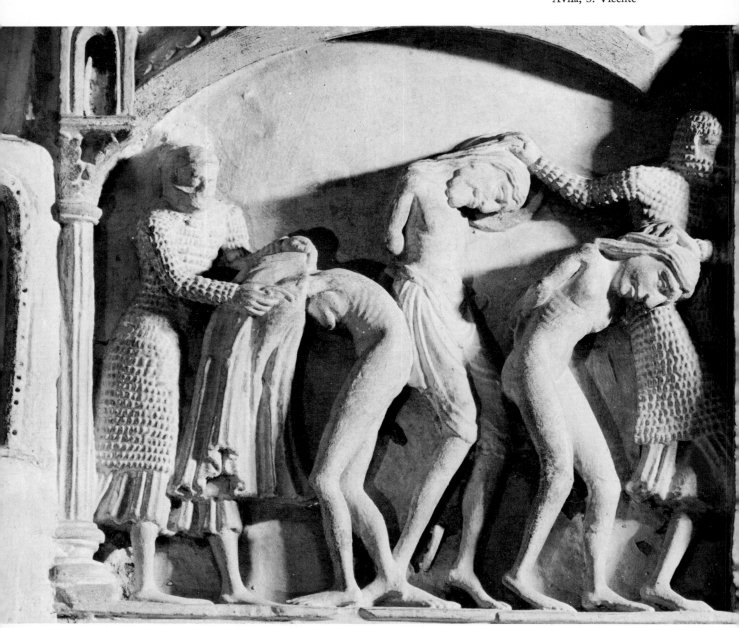

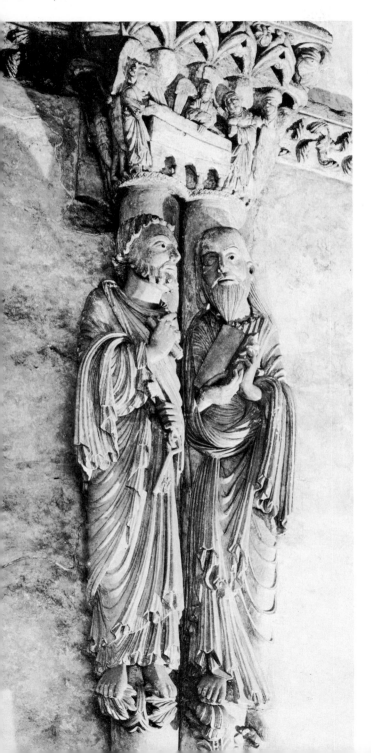

82 *Two Apostles c.* 1180
Oviedo, Cámara Santa

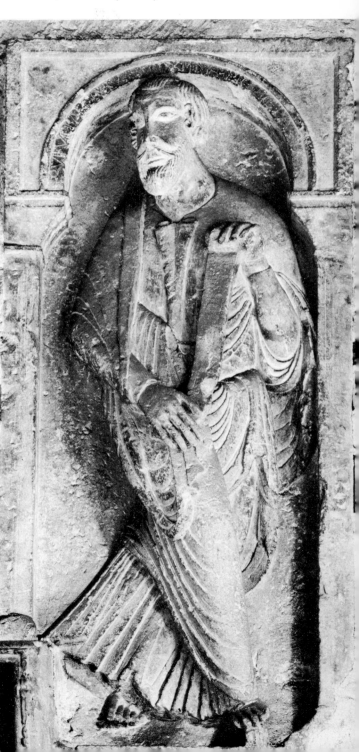

183 *St Paul the Apostle c.* 1140
Oviedo, Cathedral (cloister)

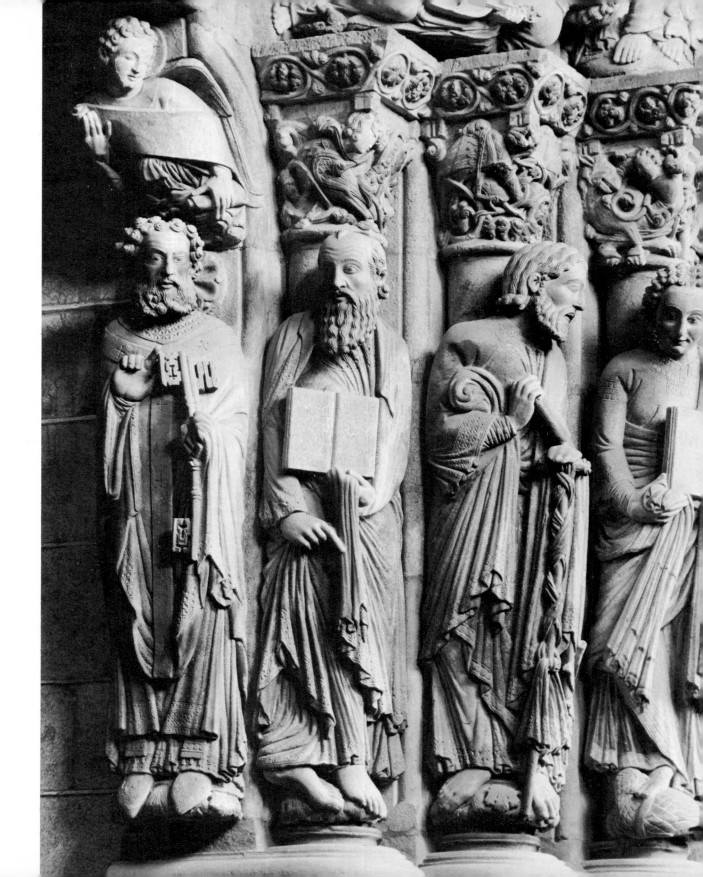

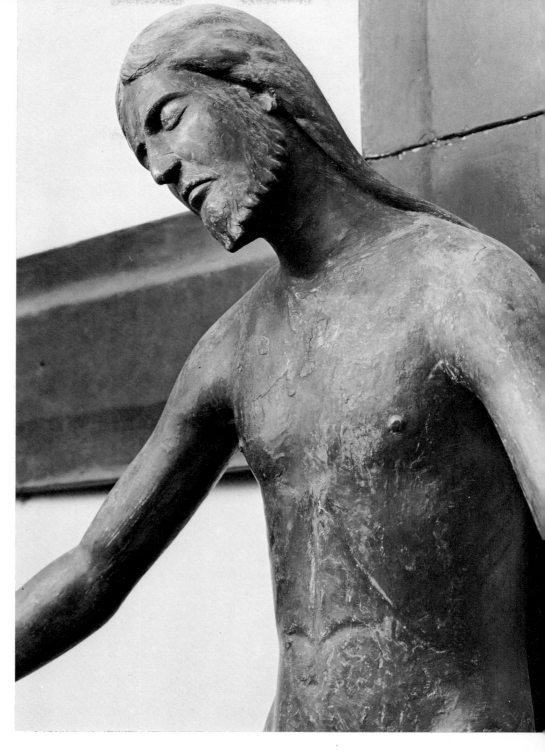

LATE ROMANESQUE SCULPTURES IN WOOD

185 *The Descent from the Cross*, detail
c. 1210–20
Tivoli, Cathedral

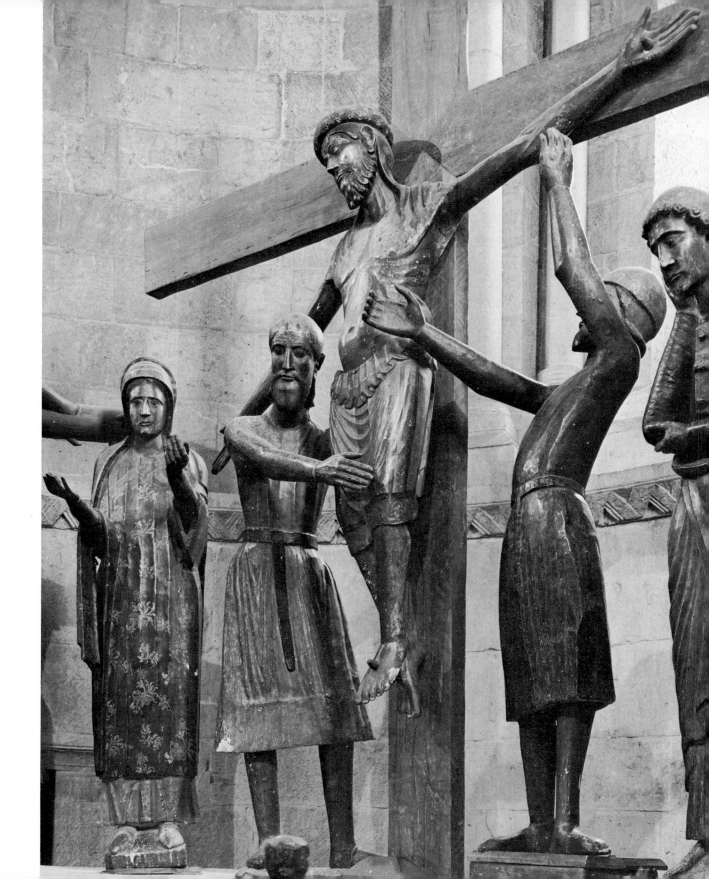

86 *The Descent from the Cross* 1251
S. Juan de las Abadesas, Monastery
(*left*)

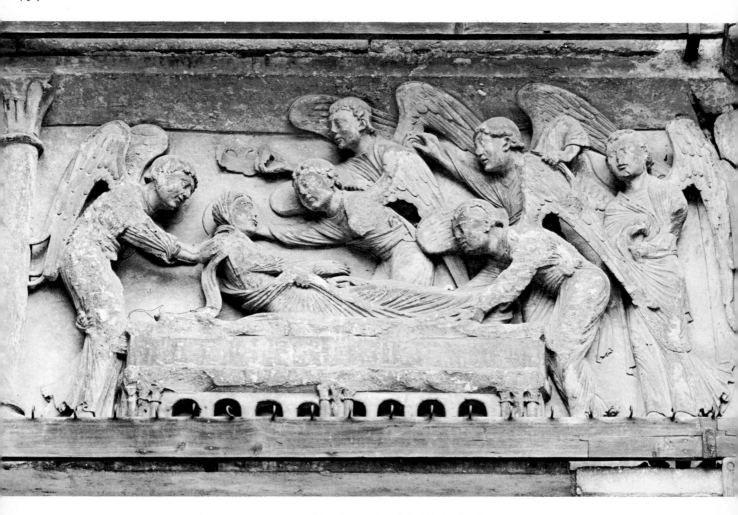

GOTHIC SCULPTURE

FRENCH 13TH CENTURY

187 *The Assumption of the Virgin*, detail
of lintel *c.* 1175
Senlis, Cathedral (west portal)

188 *Allegory*, detail of jamb *c.* 1210
Paris, Notre-Dame (left portal)

189 *The Visitation*, detail of lintel *c.* 1175
Paris, Notre-Dame (right portal)

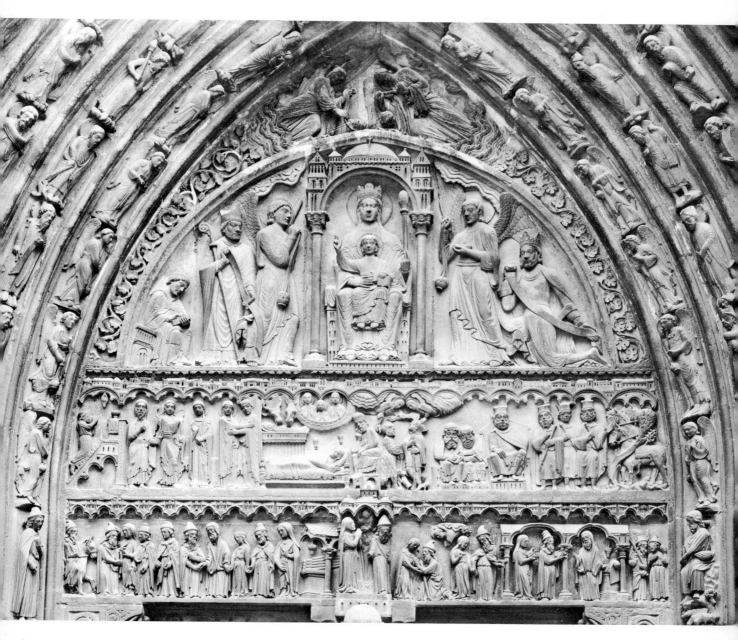

*The Virgin Enthroned; Legends of
St Anne c.* 1175
Paris, Notre-Dame (tympanum)

191 *The Creation of Adam*, detail *c.* 1210–25
 Chartres, Cathedral (north portal)

192 *Ste Modeste*, detail *c.* 1220–5
 Chartres, Cathedral (north portal)

193 *St George*, detail *c.* 1210–15
 Chartres, Cathedral (south port.

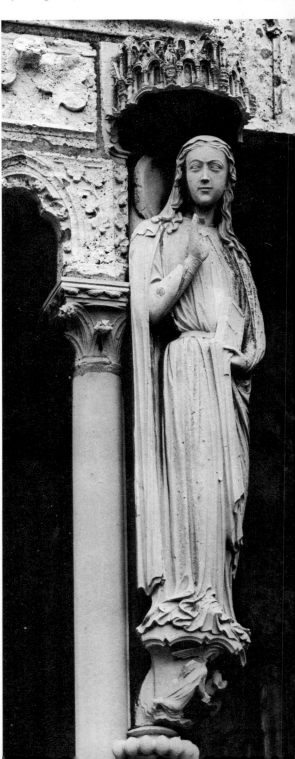

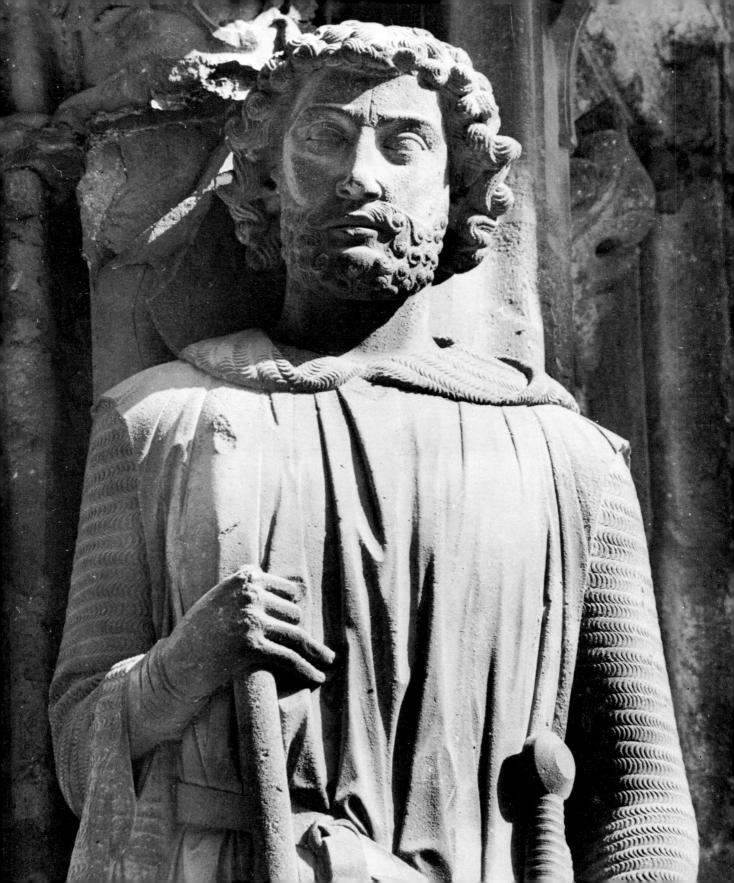

194 *October, November, December*, detail
c. 1225–36
Amiens, Cathedral (west portal,
left door)

195 *Two scenes of student life* (?) c. 1260
Paris, Notre-Dame (portal of
south transept)
(bottom of page)

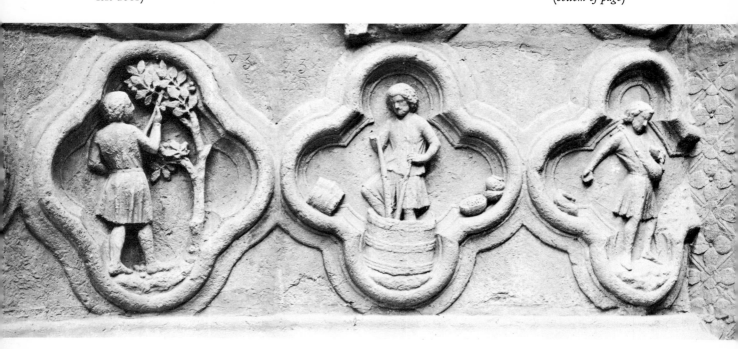

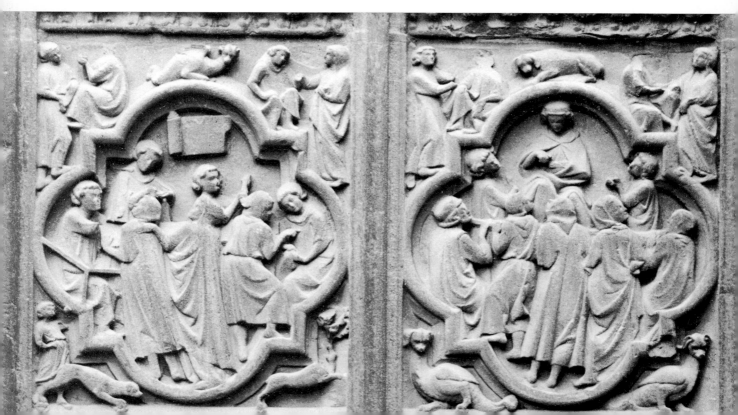

196 *Church and Synagogue c.* 1230
Strasbourg, Cathedral
(portal of south transept)

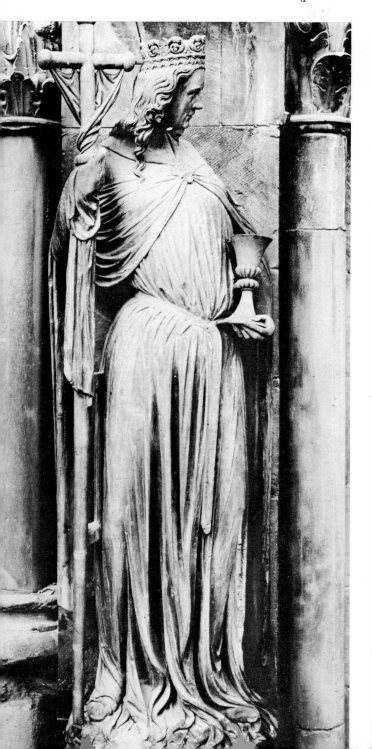
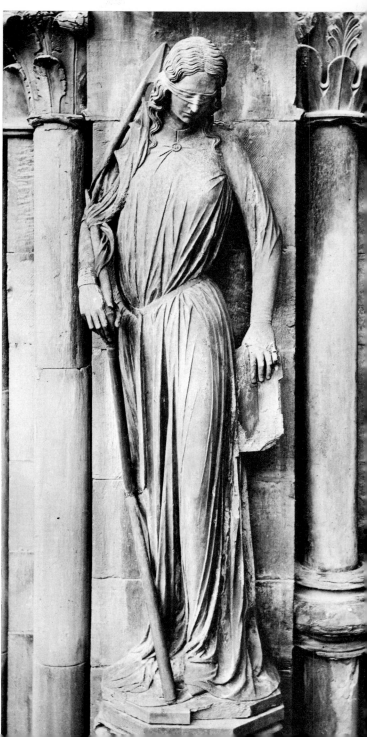

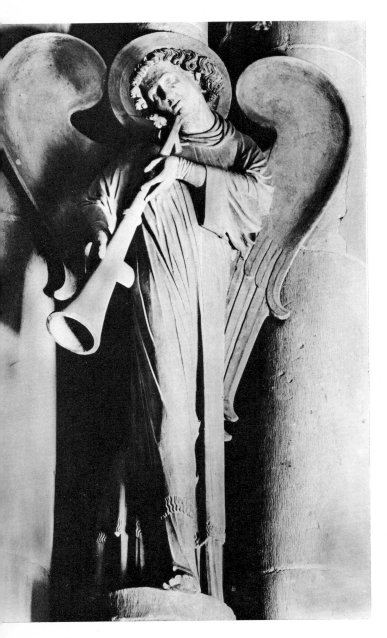

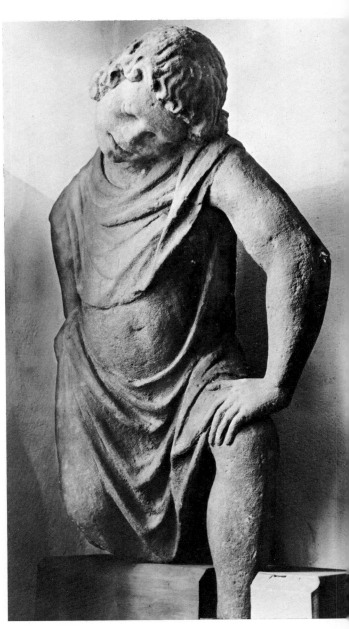

197 *Angel pillar*, detail *c.* 1230–40
Strasbourg, Cathedral
(interior of transept)

198 *Caryatid c.* 1225
Strasbourg, Cathedral Museum

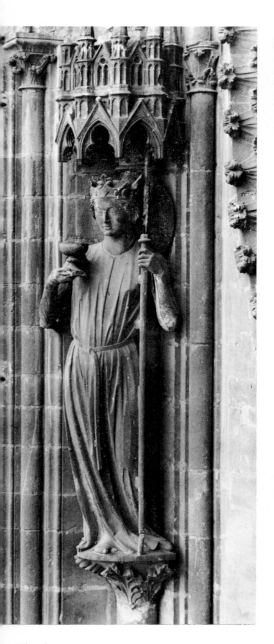

199 *Church c.* 1240
Rheims, Cathedral
(south transept front)

200 *King Philippe Auguste c.* 1235
Rheims, Cathedral
(north transept front)

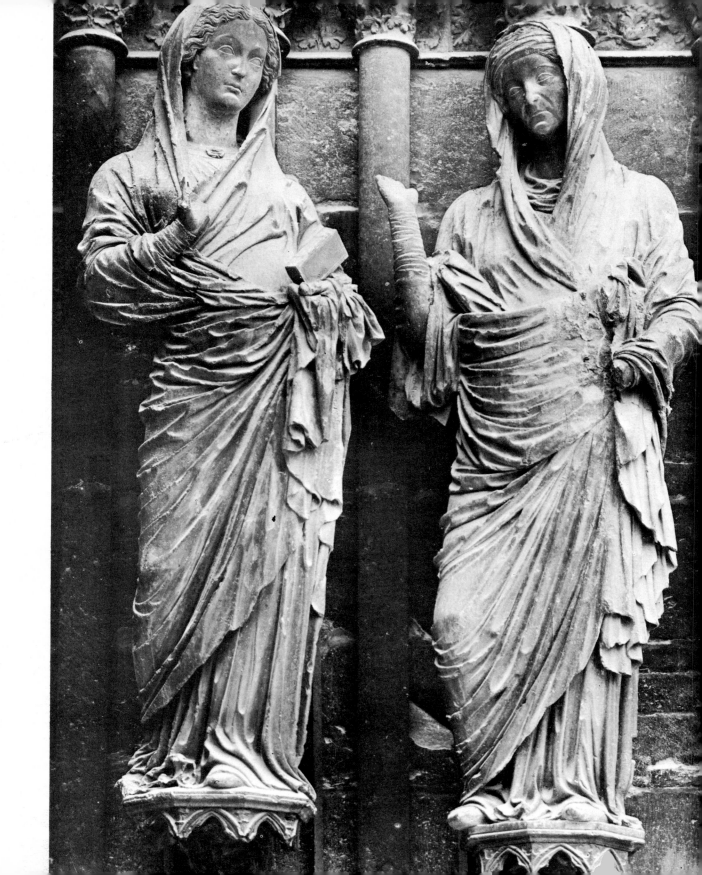

201 *The Visitation c.* 1240
 Rheims, Cathedral
 (central portal of west façade) *(left)*

202 *The Resurrection of the Dead,*
 detail *c.* 1235
 Rheims, Cathedral
 (north transept front)

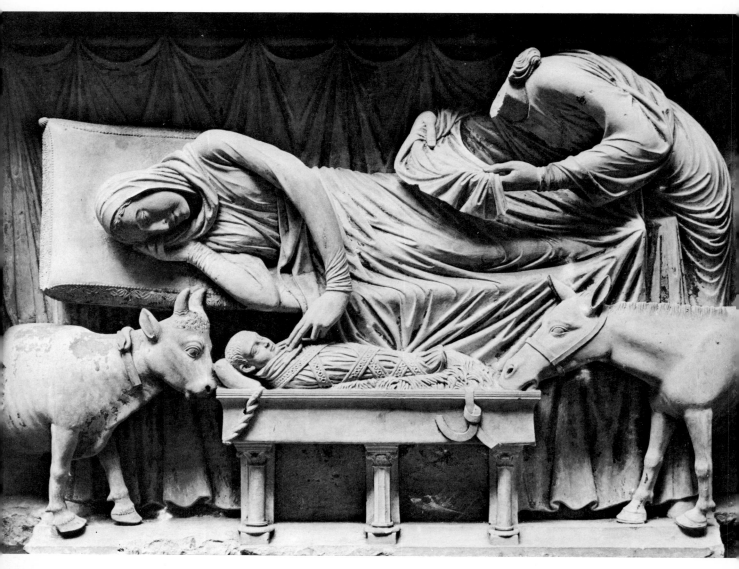

203 *The Nativity*, fragment from
rood-screen *c.* 1230–40
Chartres, Cathedral

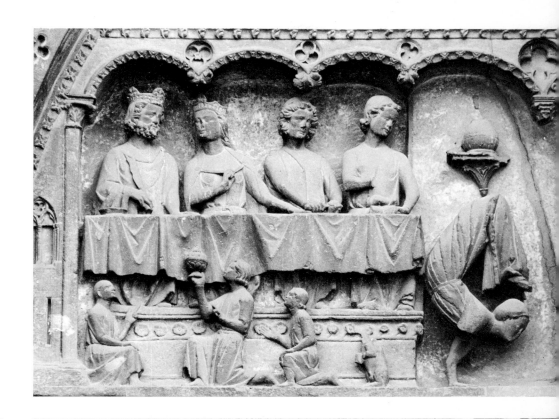

204 *The Dance of Salome*, detail of
tympanum *c.* 1250–60
Rouen, Cathedral
(façade, left doorway)

205 *The Last Judgement*, detail *c.* 1270
Bourges, Cathedral
(central doorway)

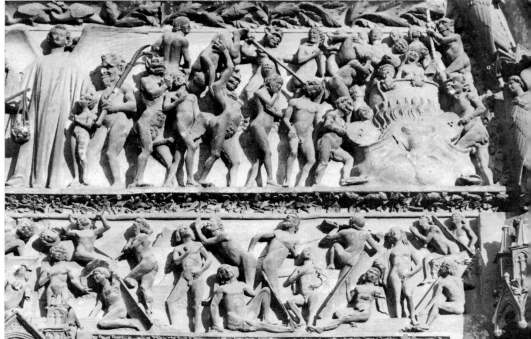

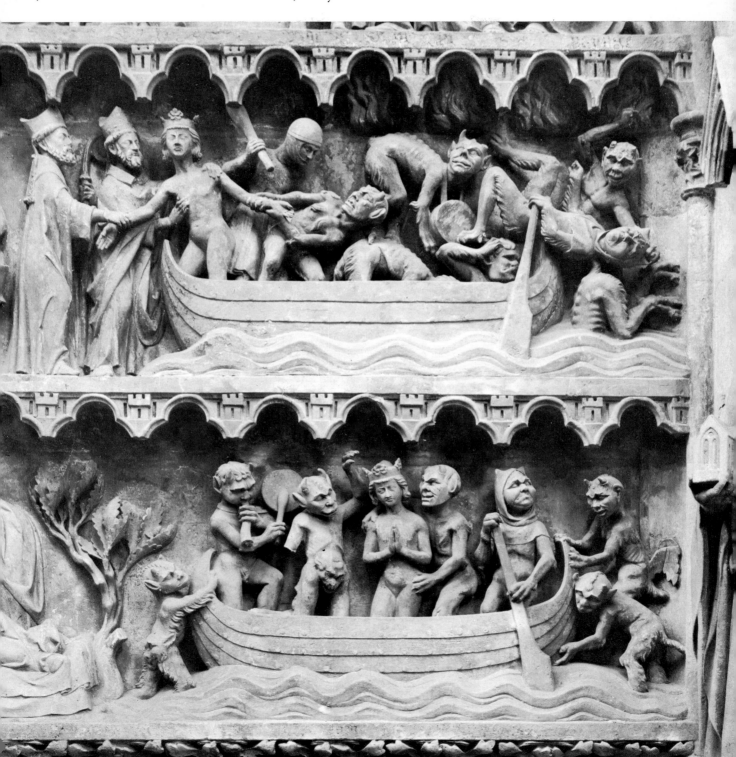

GOTHIC SCULPTURE

6 *The Descent from the Cross* c. 1250
 Paris, Louvre

207 *The Vision of John the Hermit*, detail
 of the tomb of King Dagobert
 c. 1263–4
 St Denis, Abbey Church

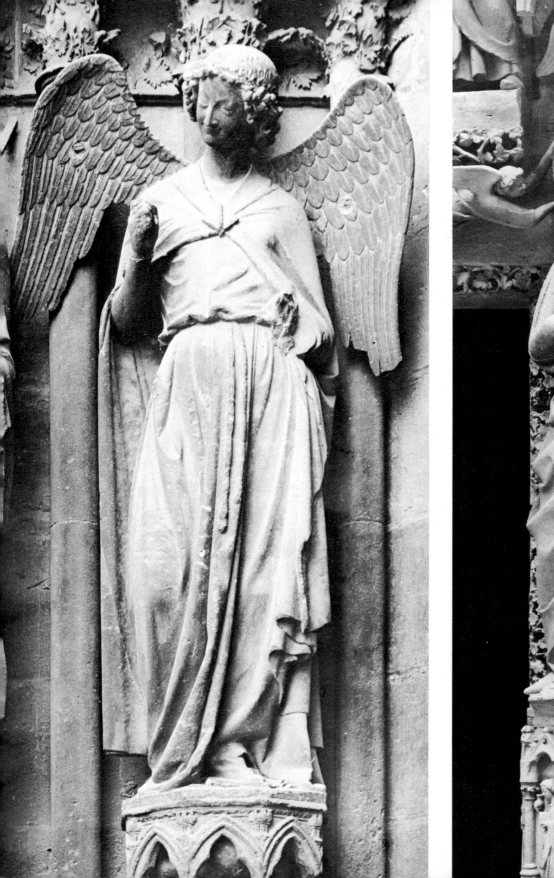
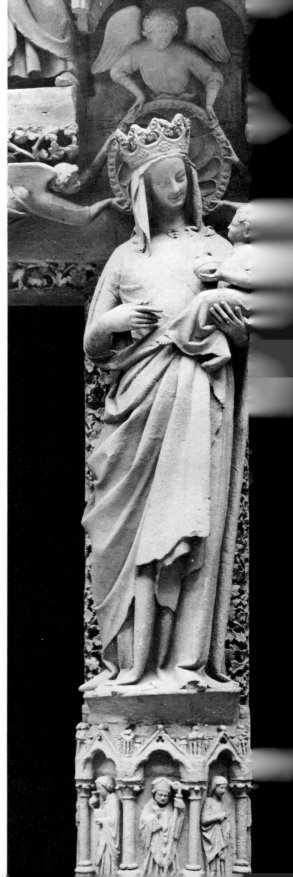

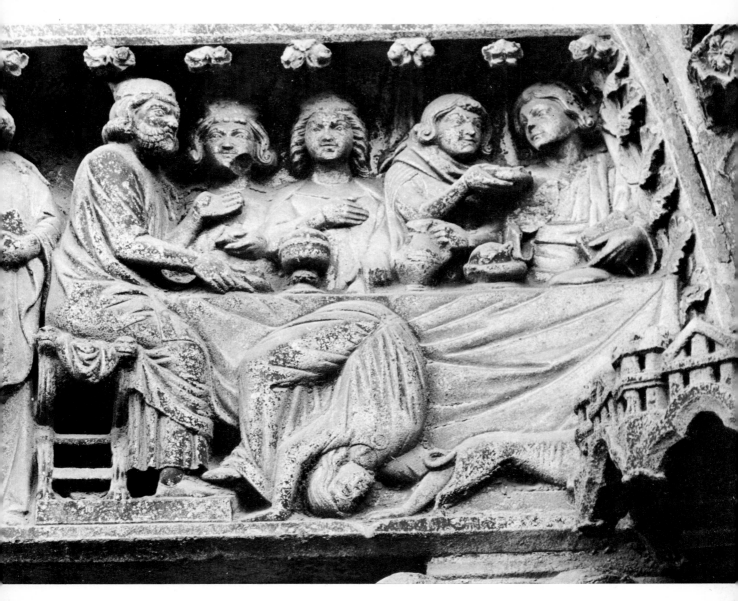

08 *The Smiling Angel c.* 1250
Rheims, Cathedral
(west front, left doorway) (*far left*)

09 *The Golden Virgin c.* 1260
Amiens, Cathedral
(south front, *trumeau* of portal)

210 *St Thomas at an Indian marriage feast,*
detail of tympanum *c.* 1250
Semur-en-Auxois (Côte d'Or),
Collegiate Church (north portal)

211 *Four Prophets c.* 1225
Bamberg, Cathedral
(St George's Choir)

212 *A Prophet*, detail *c.* 1230
Bamberg, Cathedral
(Fürstenportal, left embrasur

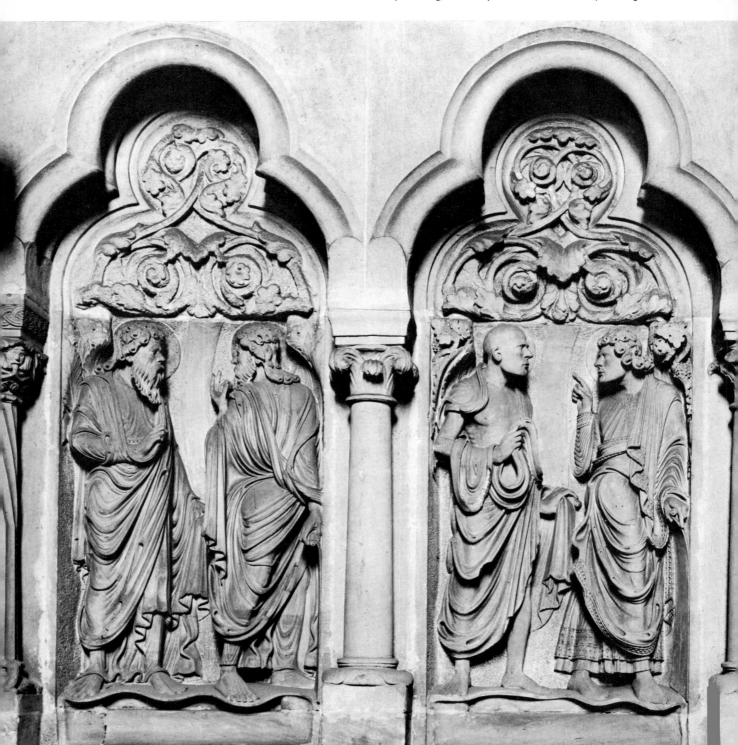

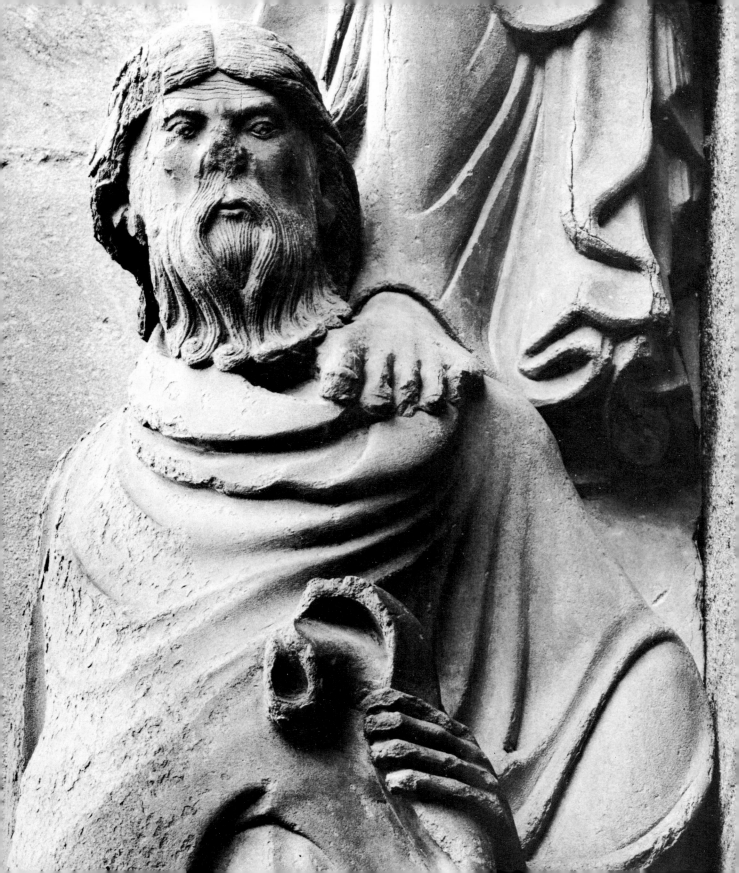

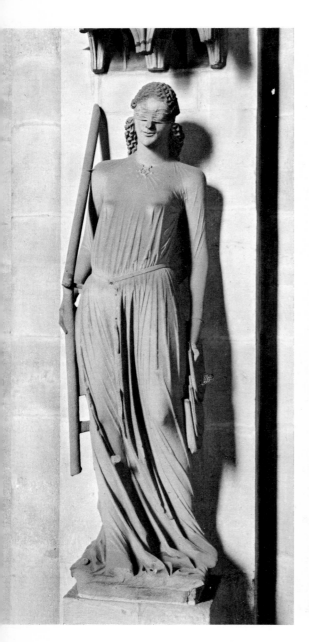

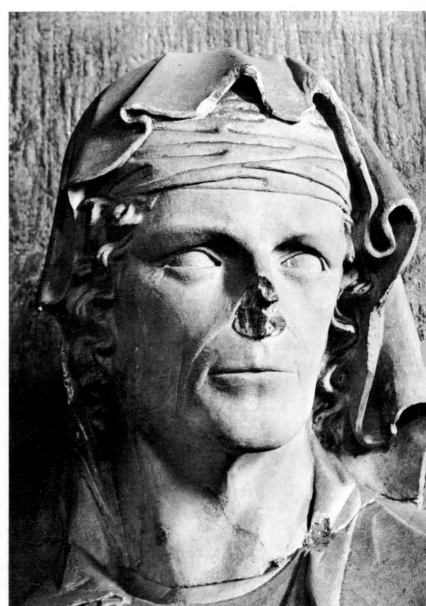

213–14 *The Synagogue* and *St Elizabeth*
c. 1230
Bamberg, Cathedral (interior)

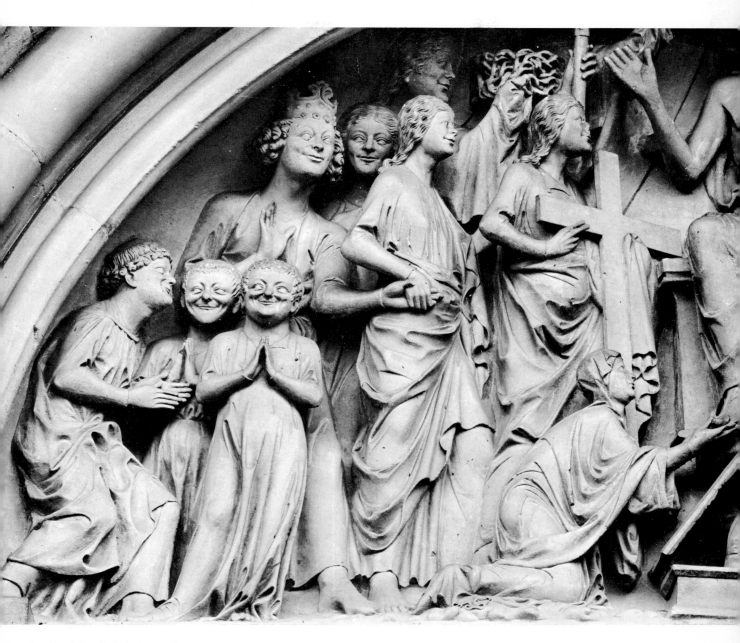

15 *The Blessed*, detail of The Last Judgement
 c. 1235
 Bamberg, Cathedral
 (Fürstenportal, tympanum)

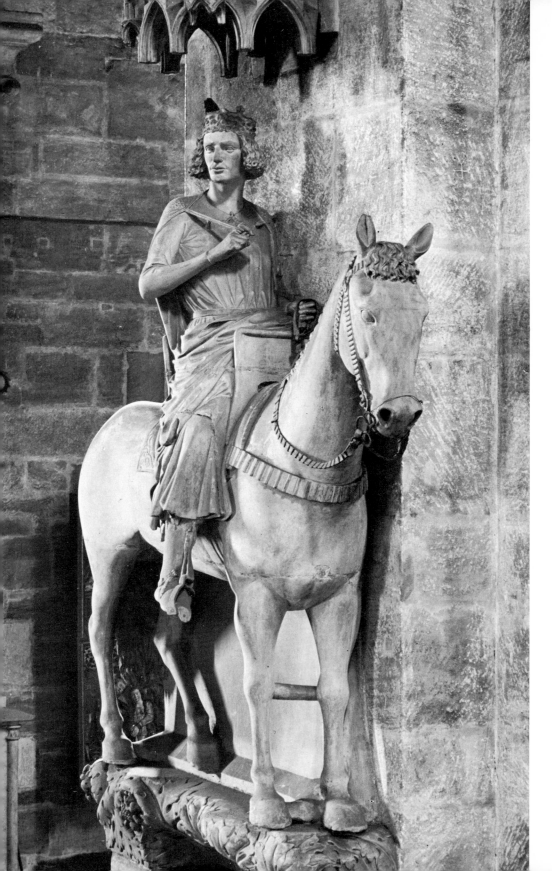

216 *The Rider of Bamberg c.* 1235
Bamberg, Cathedral (interior)

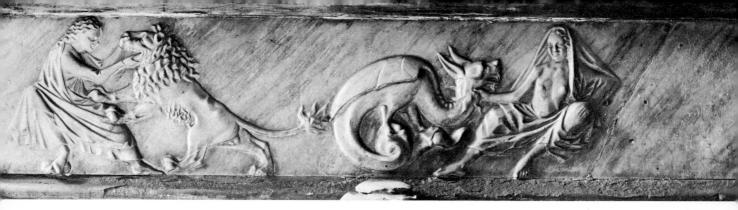

7 *Fortitude and Prudence*, detail of
tomb of Pope Clement II *c.* 1240
Bamberg, Cathedral

8 *St Peter, Adam and Eve c.* 1235–40
Bamberg Cathedral (Adam Portal)

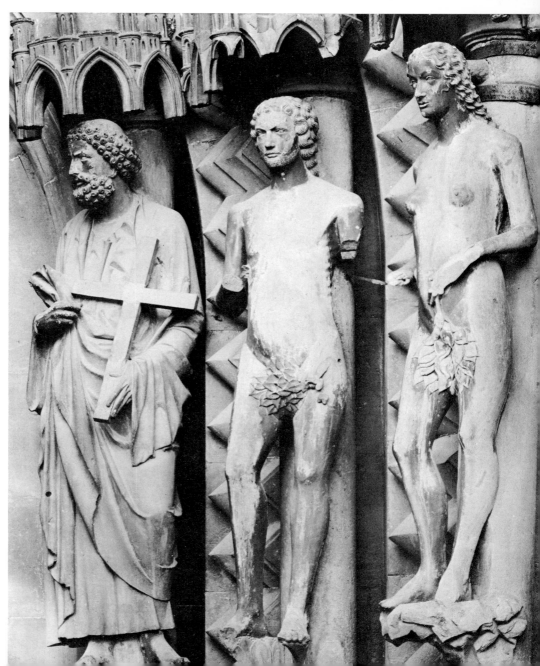

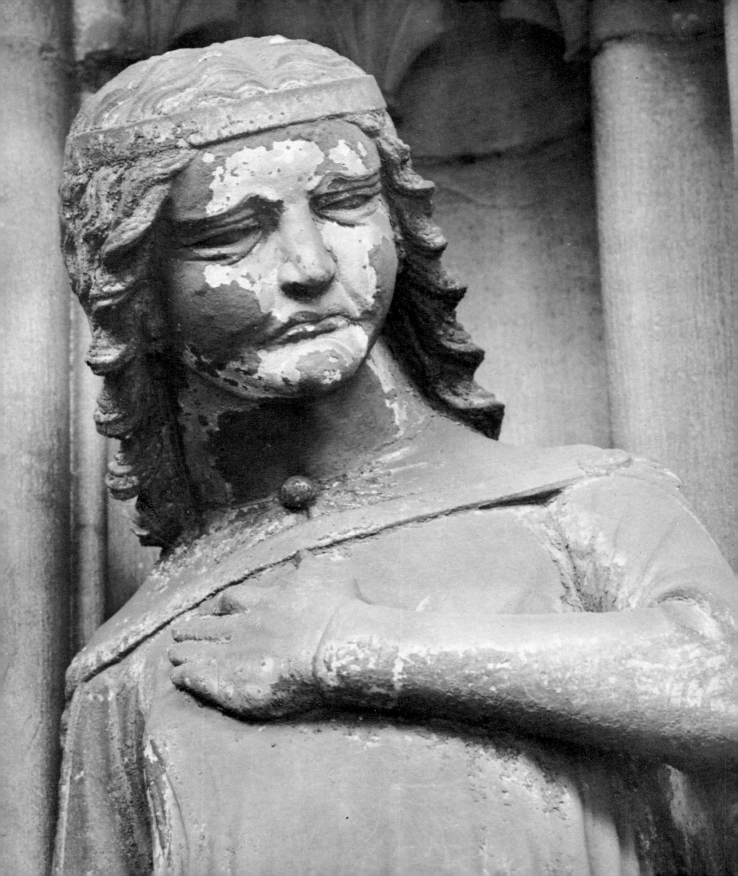

19 *A Foolish Virgin* c. 1240–5
 Magdeburg, Cathedral
 (north transept, doorway)

20–1 *The Last Supper* and *The Arrest of
 Christ* c. 1240–2
 Naumburg, Cathedral (choir screen)

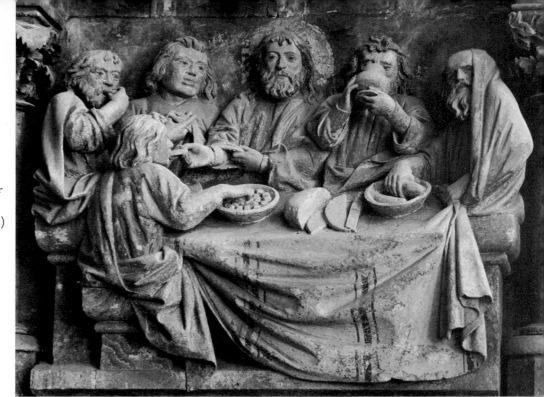

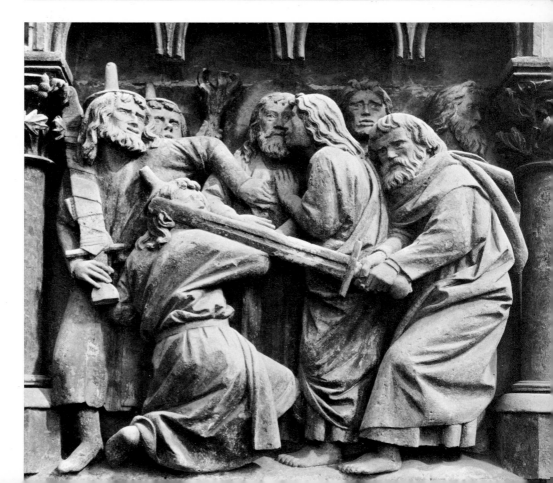

222 *St John the Evangelist c.* 1245–50
Naumburg, Cathedral
(choir screen, doorway)

223–4 *Timo de Kistericz* and *Marchioness*
Uta c. 1248–50
Naumburg, Cathedral (west choir)

225–6 *Moses and St John*, details
c. 1200–10 York,
Museum of Yorkshire

227–8 *Corbel and Capitals* c. 1200–10
Wells, Cathedral
(*far right, top and below*)

GOTHIC SCULPTURE

229–30 *Deacons* and *The Dead rising to Judgement* c. 1230–40
Wells, Cathedral (west front)

31 *Tomb effigy of William Longespée*
c. 1230–5
Salisbury, Cathedral

32 *Corbel figure c.* 1240
Oxford, Christ Church
(Chapter-house)

33 *Fabulous beast*, corbel *c.* 1235–45
Lincoln, Cathedral (west front)

34 *Corbel figure c.* 1255
London, Westminster Abbey
(triforium of choir)

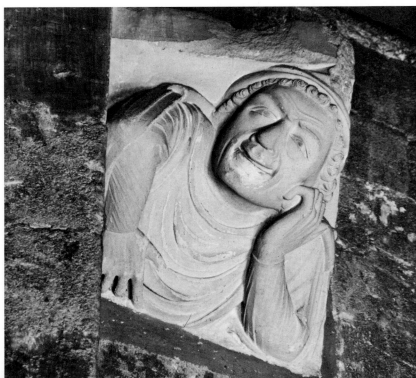

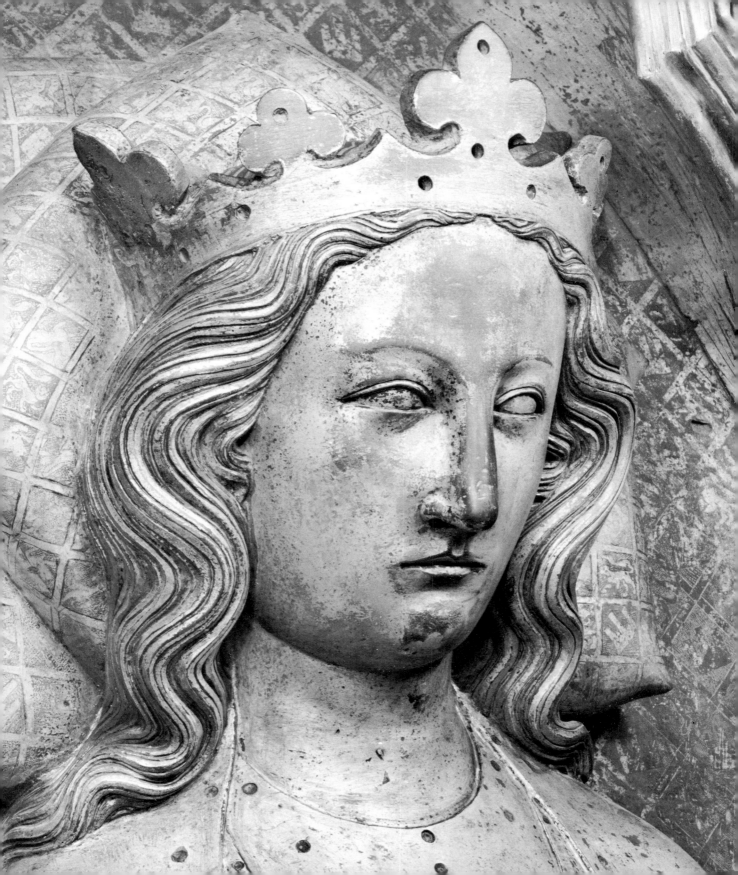

235 William Torel
Tomb effigy of Eleanor of Castile 1291–3
London, Westminster Abbey

236 *Head of a youth c. 1240*
Salisbury, South Wiltshire and
Blackmore Museum

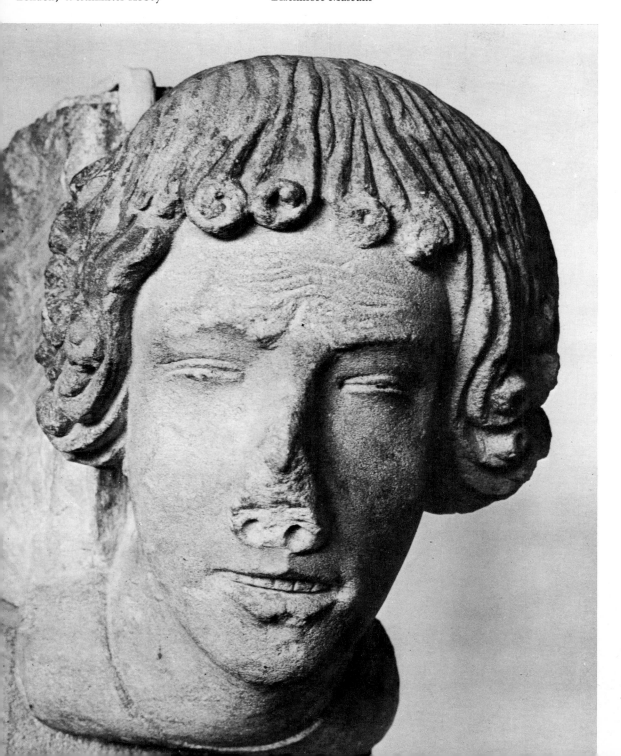

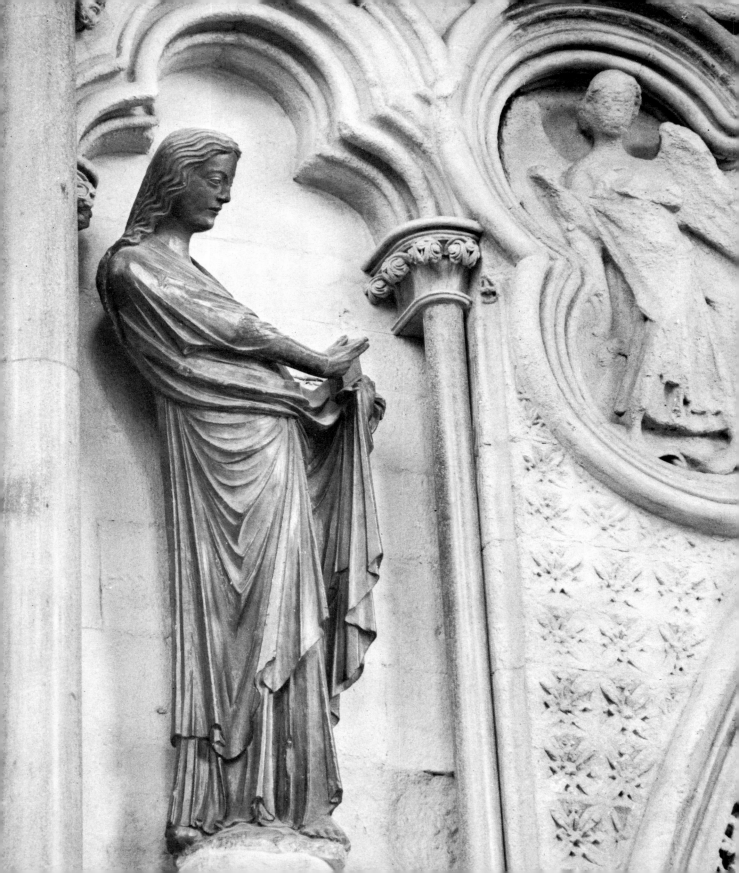

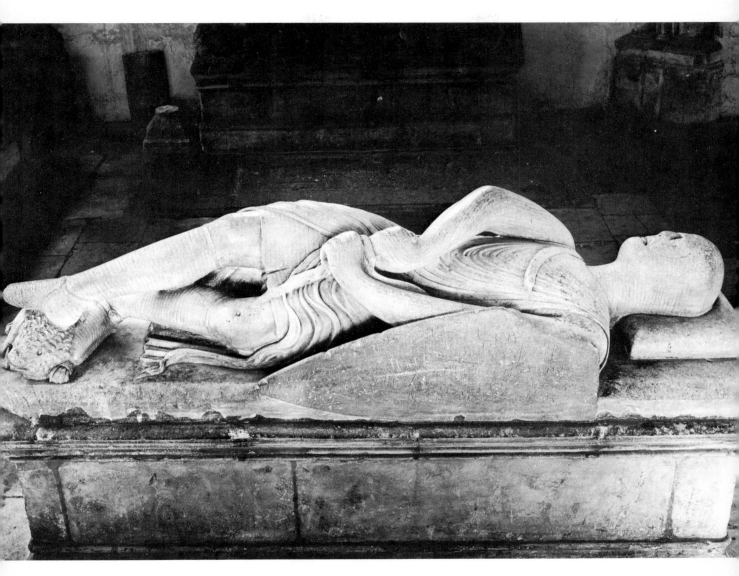

37 William Yxeworth?
Angel of the Annunciation and
Angel with censer 1253
London, Westminster Abbey

238 *Tomb effigy of a knight c.* 1295–1300
Dorchester, Abbey Church

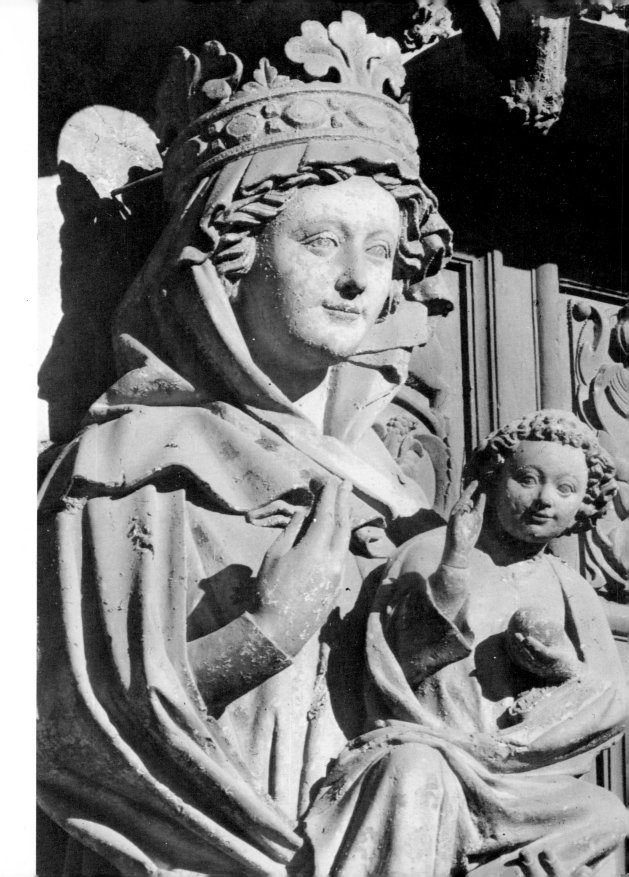

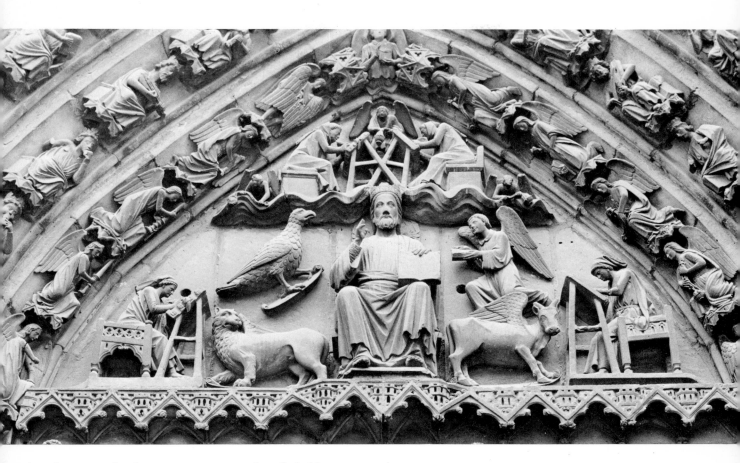

39 *The White Virgin*, detail *c.* 1260
León, Cathedral (west portal)

240 *Christ flanked by two Evangelists writing*
c. 1240
Burgos, Cathedral
(Portada del Sarmental)

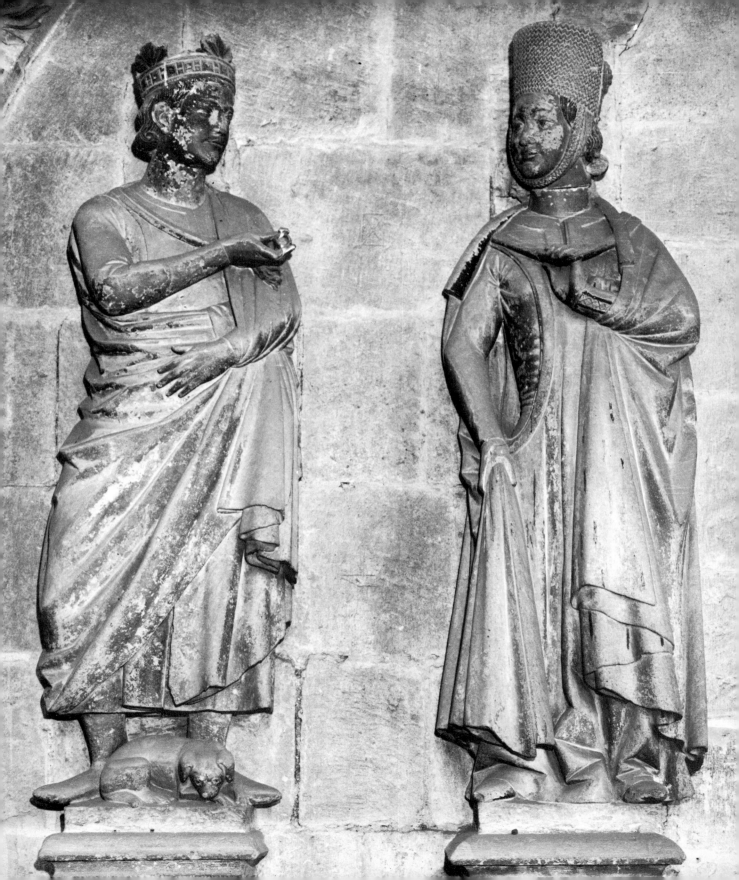

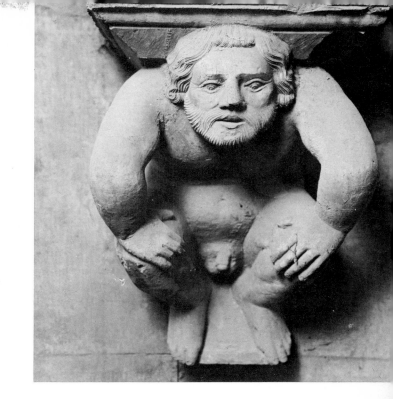

241 *King Alfonso presenting a ring to Queen Violante c.* 1260–70 Burgos, Diocesan Museum (*left*)

ITALIAN 13TH AND 14TH CENTURY

242 *Corbel head c.* 1240–50 Andria, Castel del Monte

243 *Corbel, Atlas-figure c.* 1240–50 Andria, Castel del Monte

244 *Head of a poet or philosopher c.* 1240 Capua, Museo Campano

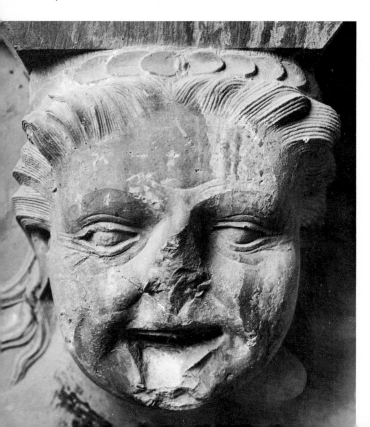

245 Nicola Pisano
 The Adoration of the Magi, detail of
 pulpit 1255–60
 Pisa, Baptistry

246 Nicola Pisano
 The Allegory of Hope, detail of
 pulpit 1255–60
 Pisa, Baptistry

247 Nicola Pisano
The Presentation in the Temple, detail of
pulpit 1255–60
Pisa, Baptistry

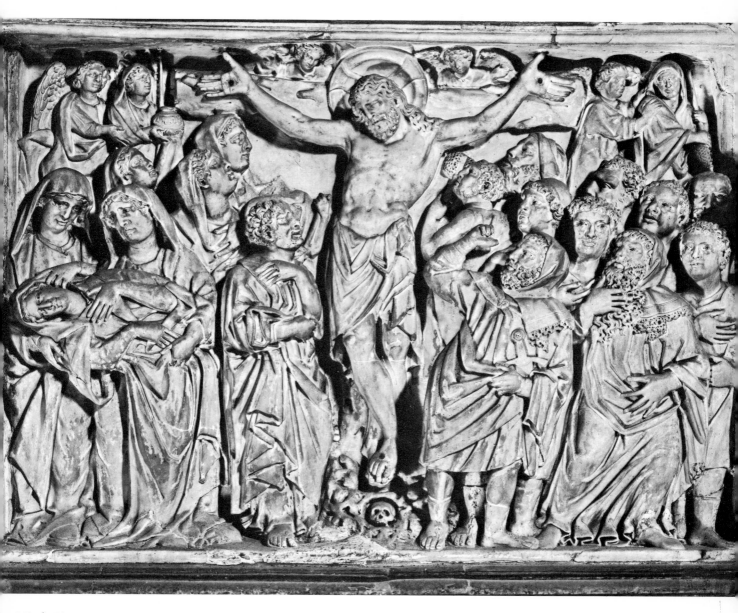

48 Nicola Pisano
The Crucifixion, detail of pulpit
1255–60
Pisa, Baptistry

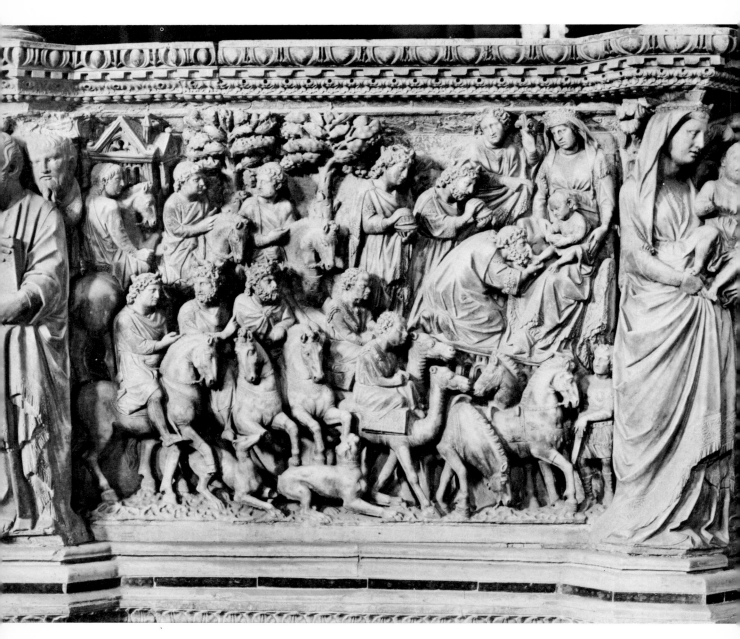

249 Nicola Pisano
*The Adoration of the Magi; Virgin and
Child* 1265–8
Siena, Cathedral

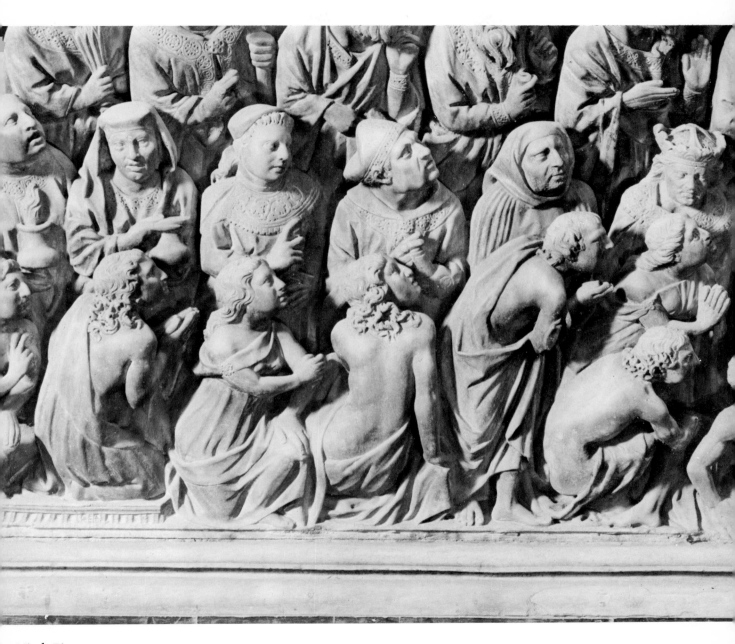

50 Nicola Pisano
The Resurrection of the Dead 1265–8
Siena, Cathedral

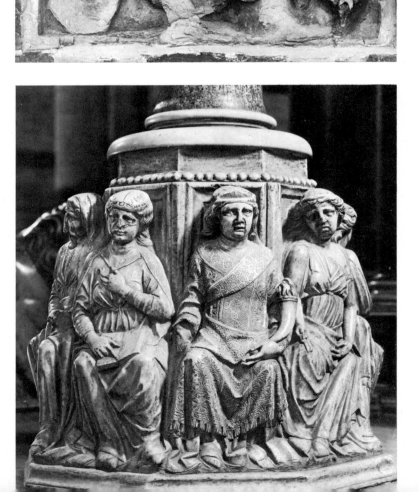

251 Lapo
St George and the Dragon c.
Florence, Palazzo Vecchio

252 Lapo
The Liberal Arts, detail of pu
1265–8 Siena, Cathedral

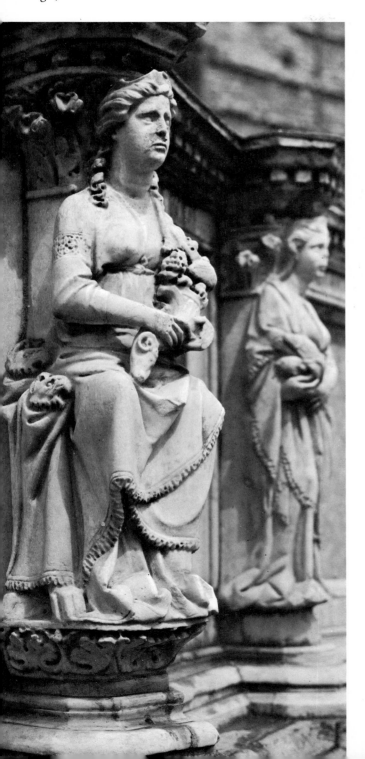

253 Nicola and Giovanni Pisano
Augusta Perusia 1278
Perugia, Piazza fountain

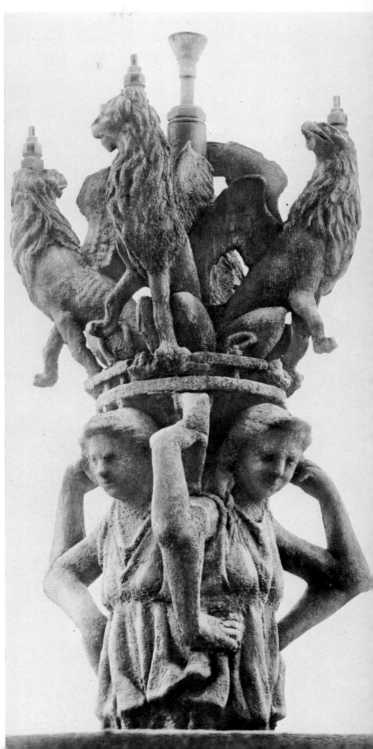

254 Nicola and Giovanni Pisano
Female figures and griffons 1278
Perugia, Piazza fountain

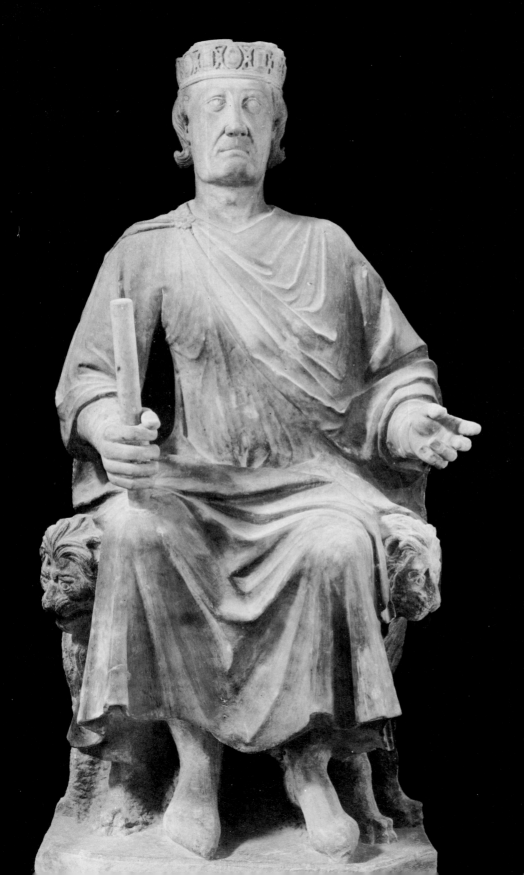

255 Arnolfo
King Charles of Anjou c. 1275–8
Rome, Museo Capitolino

256 Arnolfo
Virgin and Child c. 1282 marble,
detail of the tomb of Cardinal d
Braye, Orvieto, S. Domenico

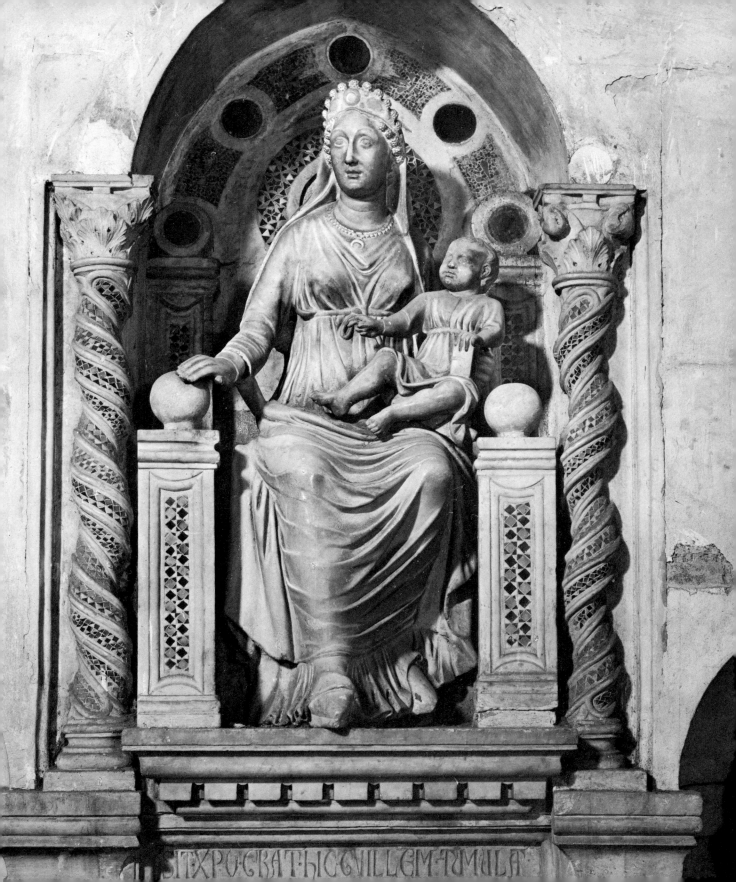

SIXPOCRATICCVILLEMTVMVLA

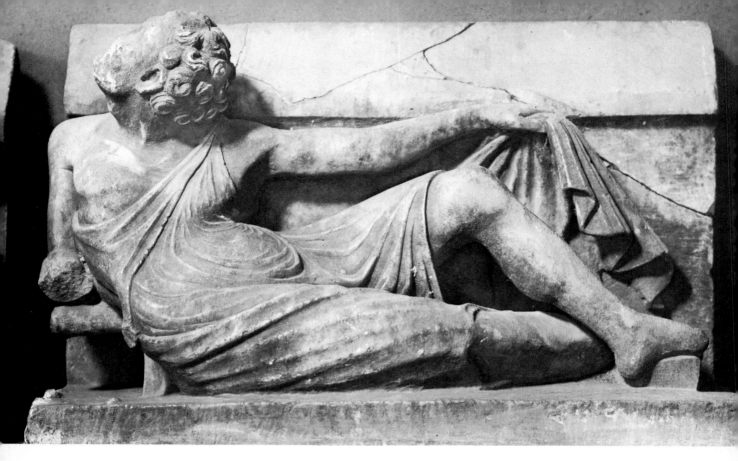

257 Arnolfo
Male figure, fragment of fountain 1277
Perugia, National Gallery of Umbria

258 Arnolfo
The Virgin of the Nativity c. 1296–13
Florence, Museo dell'Opera del Duom

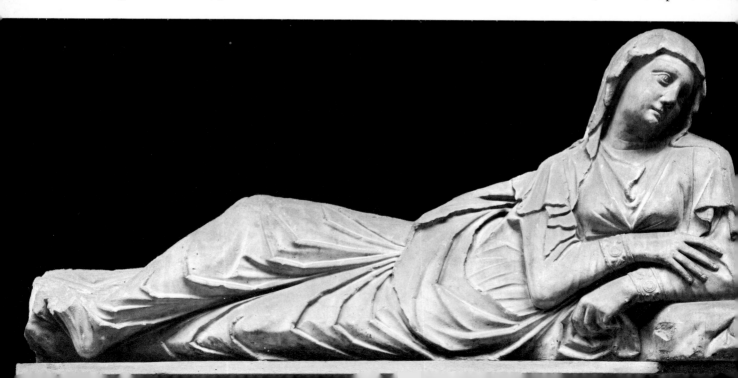

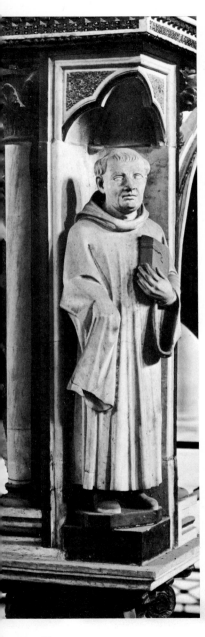

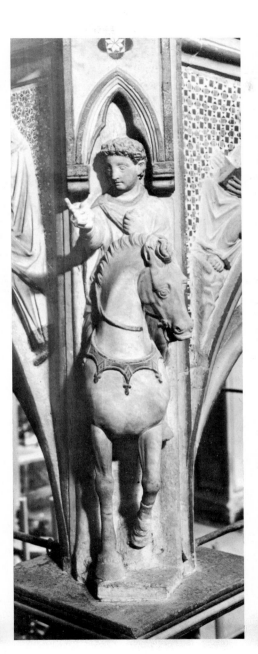

59 Arnolfo
St Benedict 1285
Rome, S. Paolo fuori le Mura
(ciborium)

260 Arnolfo
St Tiburtius 1293
Rome, Sta Cecilia in Trastevere
(ciborium)

261 Arnolfo
Draped figure 1296–1300
Florence, Casa Buonarroti

262 *Virgin and Child c.* 1295–1300
London, Victoria and Albert Museum

263 Giovanni Pisano 1298
Virgin and Child
Pisa, Tesoro del Duomo

264–5 Giovanni Pisano
Maria di Mosè and Habakkuk c. 1284–96
Siena, Museo dell'Opera del Duomo

266 Bartolomé de Gerona
Virgin and Child 1280
Tarragona, Cathedral (main portal)

267 Giovanni Pisano
A Sybil, detail of pulpit 1298–1301
Pistoia, S. Andrea

268 Giovanni Pisano
The Massacre of the Innocents, detail of
pulpit 1298–1301
Pistoia, S. Andrea

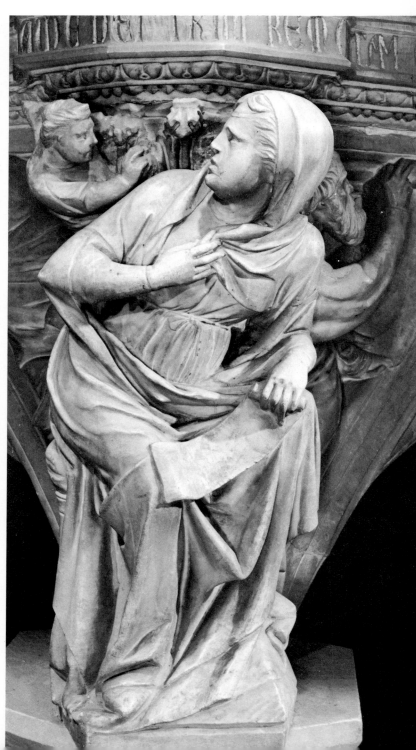

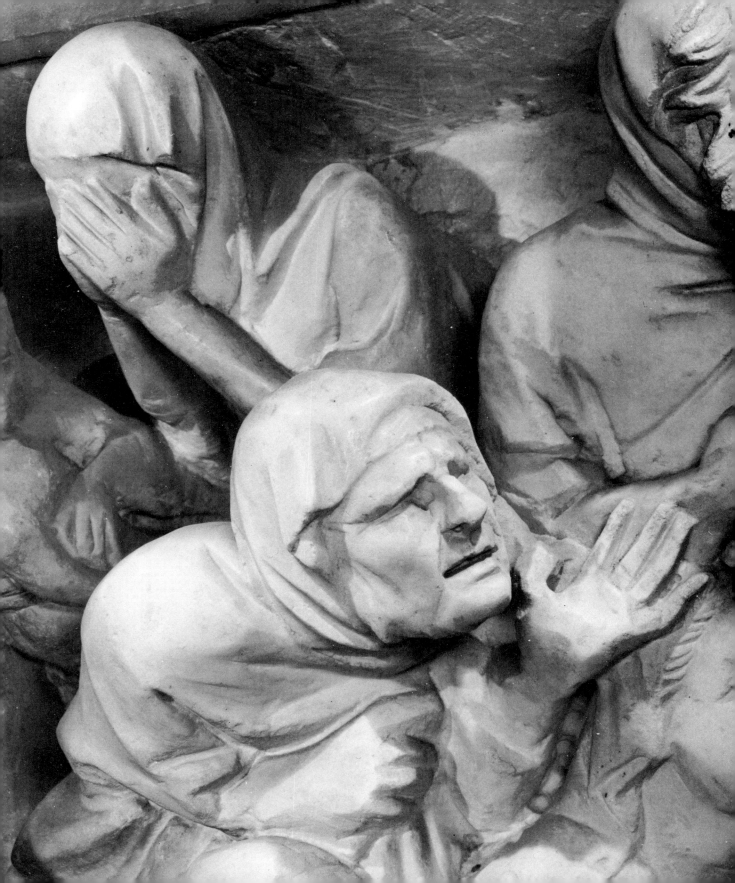

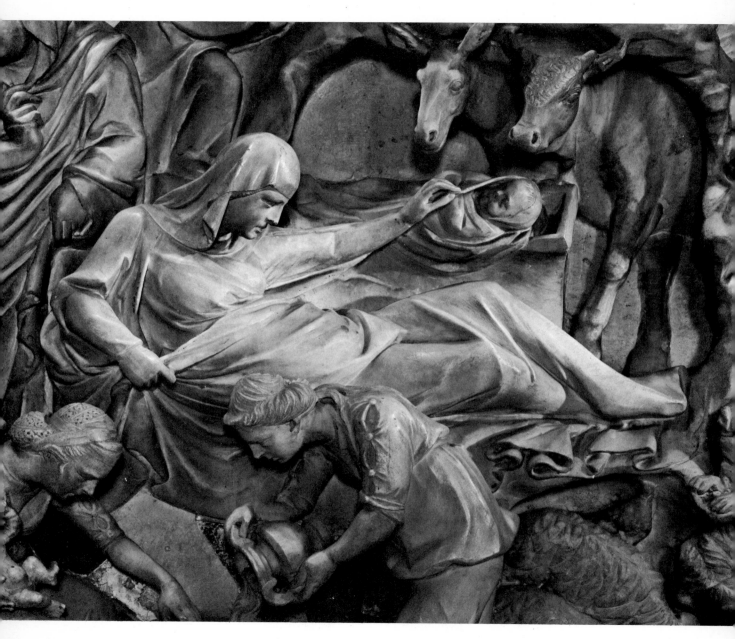

269–70 Giovanni Pisano
The Nativity and the Flight into Egypt,
detail of pulpit 1302–10
Pisa, Cathedral

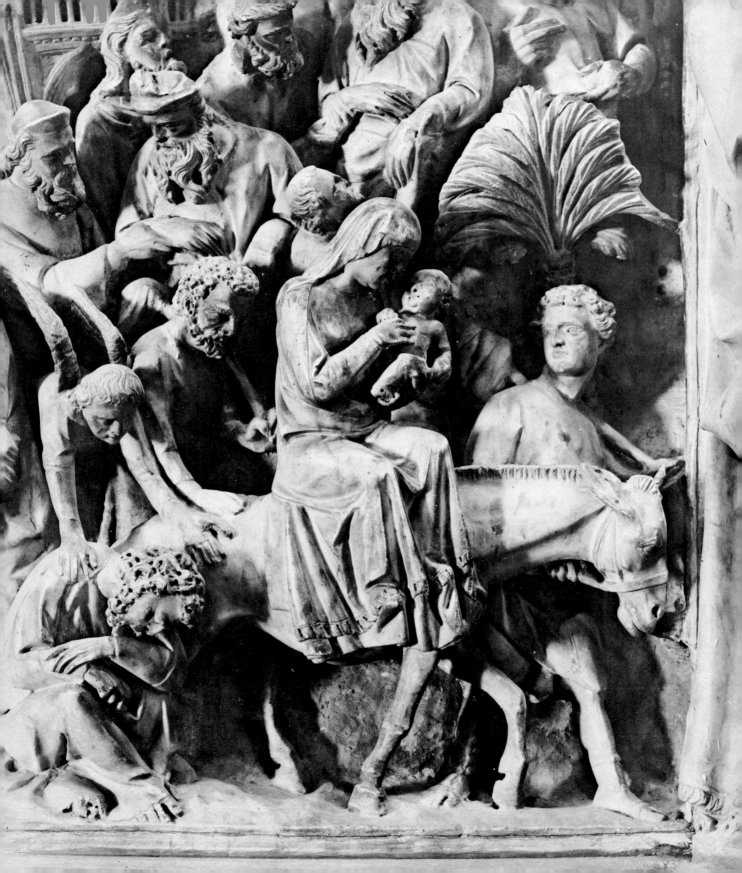

274 *Virgin and Child c.* 1290
Assisi, Tesoro di S. Francesco

275 Andrea Pisano
*The Disciples visiting St John the
Baptist in prison* (detail)
Florence, Baptistry (south door)

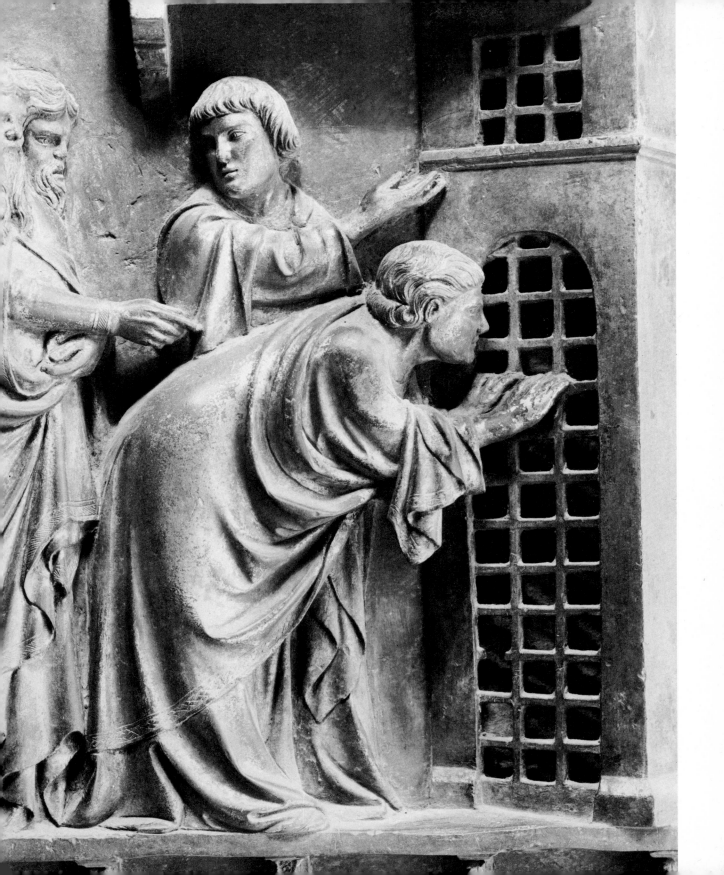

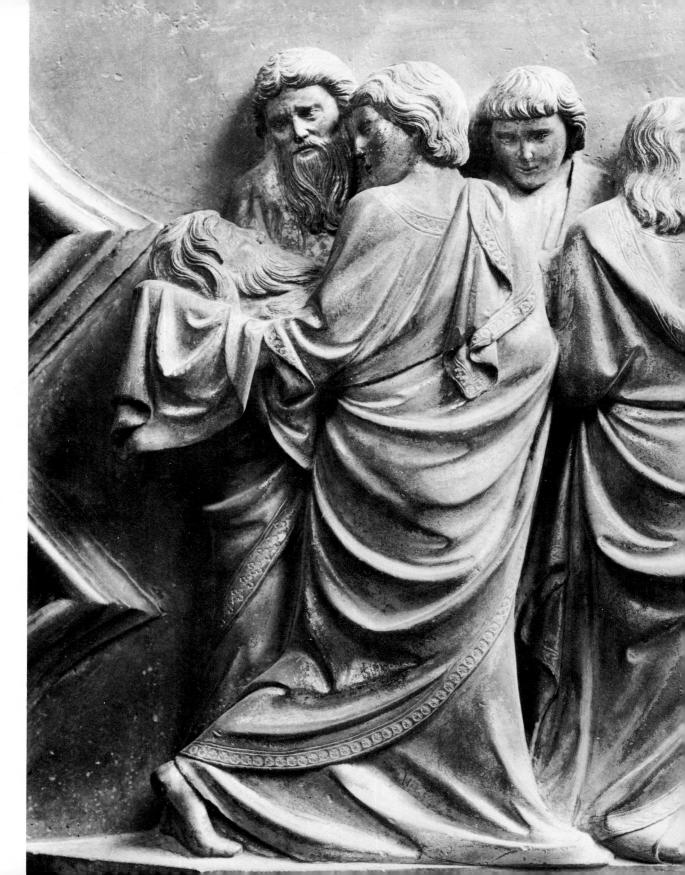

276 Andrea Pisano
 The Burial of St John the Baptist 1330
 Florence, Baptistry (south door)

277–8 Andrea Pisano
 Medicine and *Agriculture* c. 1334–70
 Florence, Cathedral (base of campanile)

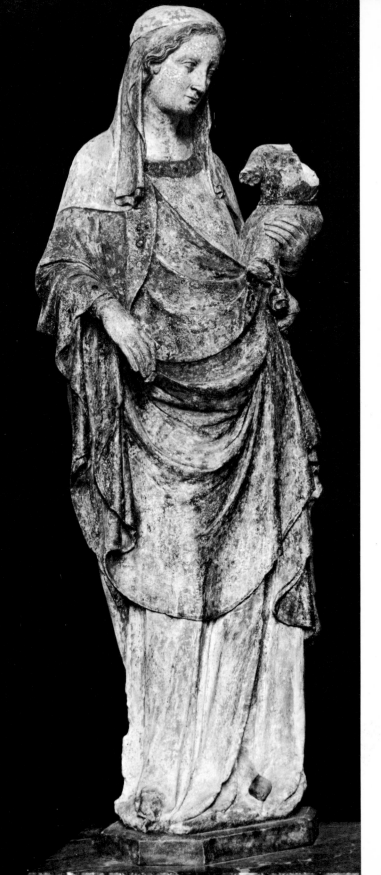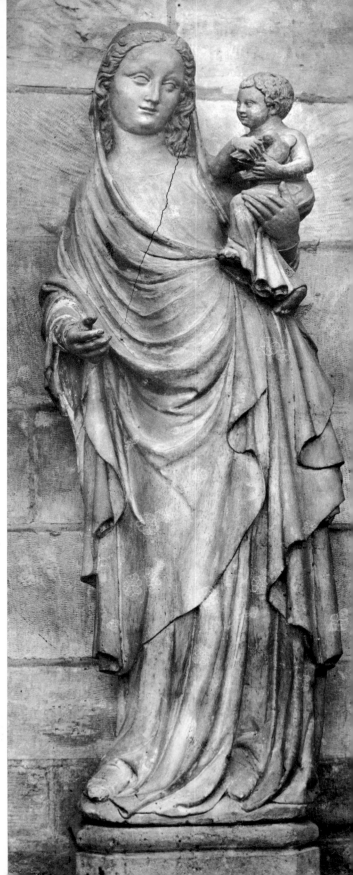

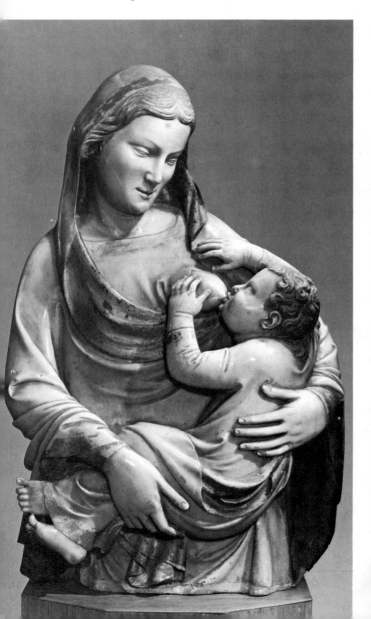

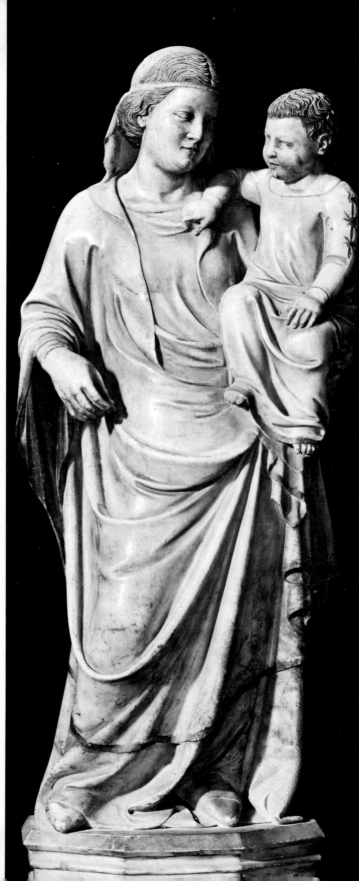

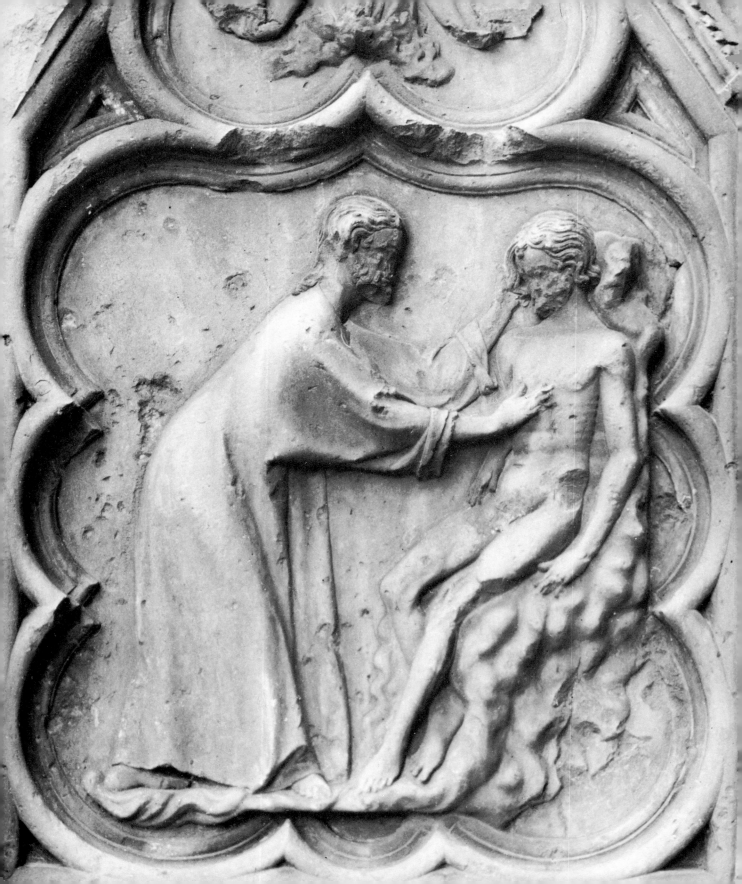

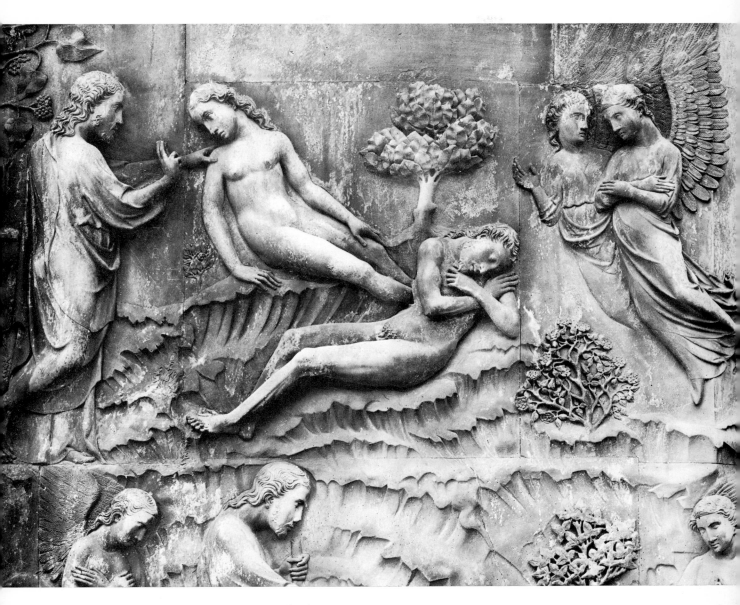

83 *The Creation of Man c.* 1310
Auxerre, Cathedral
(base of left portal in façade)

284 Lorenzo Maitani
The Creation of Woman c. 1320
Orvieto, Cathedral (façade, left portal)

285 Andrea Orcagna
The Annunciation, detail of shrine
c. 1355–9
Florence, Or San Michele

286 Giovanni di Balduccio
Justice and Temperance 1335–49
Milan, S. Eustorgio
(shrine of St Peter Martyr)

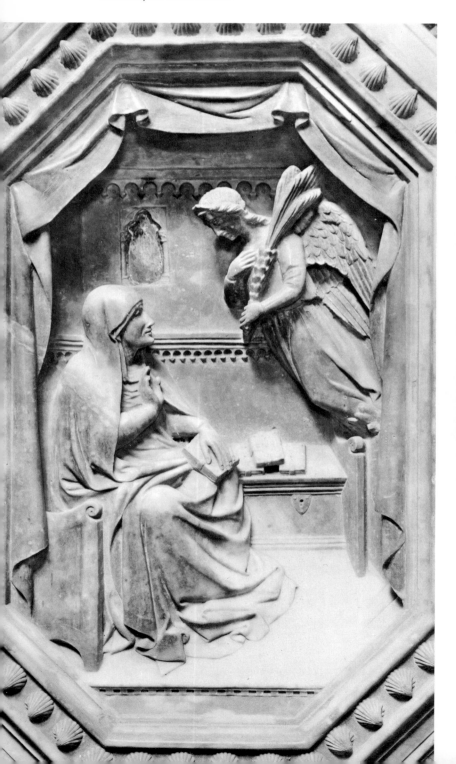

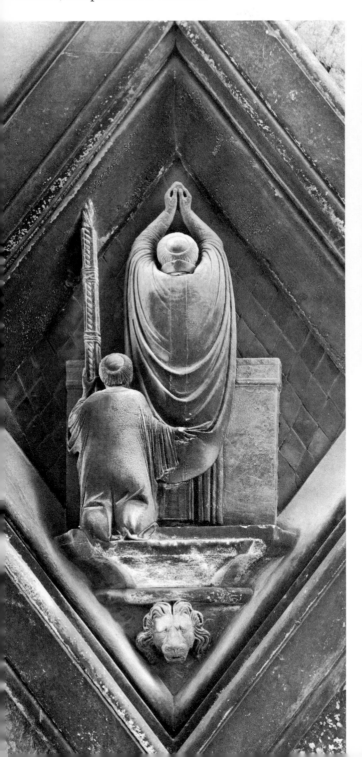

287 Alberto Arnoldi
The Eucharist c. 1351
Florence, Campanile of the Cathedral

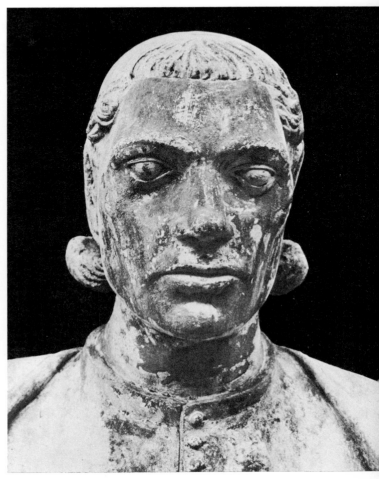

288 Ugo da Campione?
St Stephen, detail
Milan, Loggia degli Osii

289 Bonino da Campione
Votive relief 1360
Cremona, S. Agostino

290 *Ornamental hairpin c.* 1360
Modena, Museo Estense

91 *Equestrian memorial statue of Cangrande della Scala c.* 1330
Verona, Museo di Castelvecchio

GOTHIC SCULPTURE

292 *The Virgin* from an Annunciation
 or a Visitation group *c.* 1300
 Munich, Bayerisches National-
 museum

SPANISH 14TH CENTURY

293 Jaime Cascalls
 Charlemagne c. 1350
 Gerona, Cathedral

GERMAN
14TH CENTURY

294 *Christ and St John c.* 1320
 Berlin, Staatliche Museer

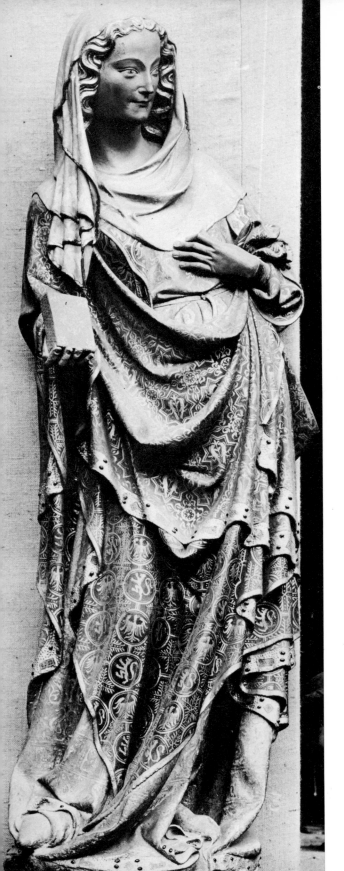

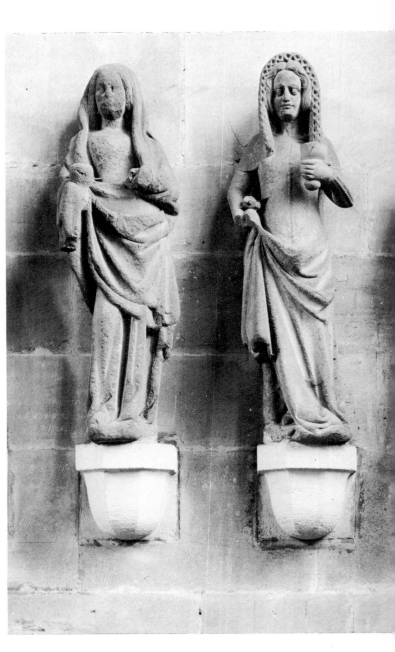

295 *The Virgin Annunciate*
c. 1315–20 Cologne,
Cathedral (choir)

296 *Two Foolish Virgins c. 1350*
Schwäbisch-Gmünd, Kreutzkirch

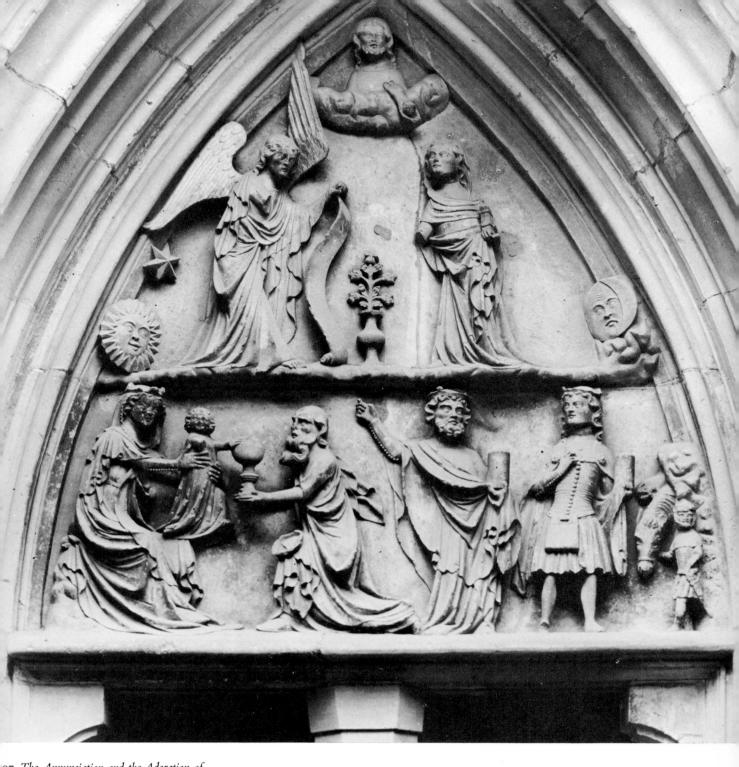

97 *The Annunciation and the Adoration of
the Magi c.* 1340
Rottweil (Swabia), Kappellenturm
(tympanum of north portal)

298 *The sleeping guard*, detail *c.* 1330–40
Freiburg i. B., Münster
(Easter Sepulchre)

299 *A Prophet* detail *c.* 1330
Freiburg i. B., Cathedral Museum

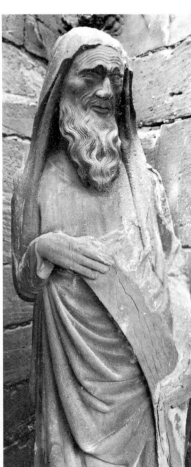

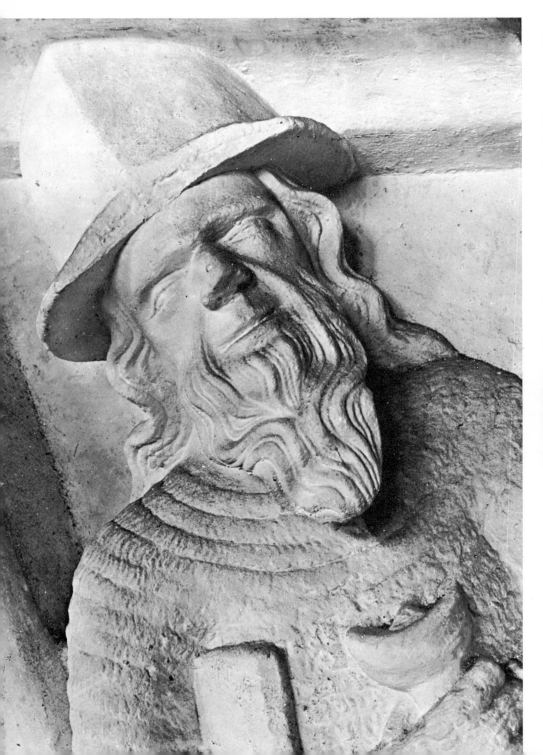

BRITISH
14TH CENTURY

300 *Tomb of Aymer de Valence*, detail of
canopy *c.* 1325
London, Westminster Abbey

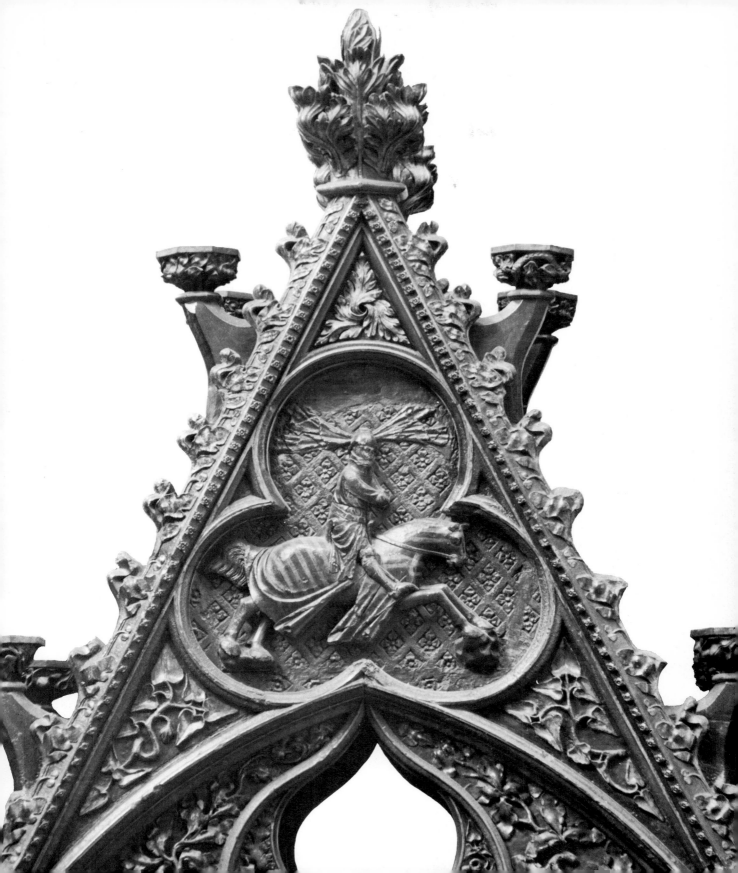

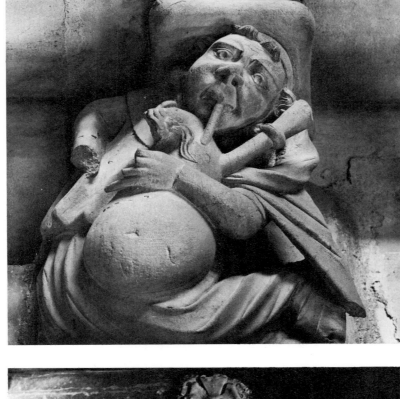

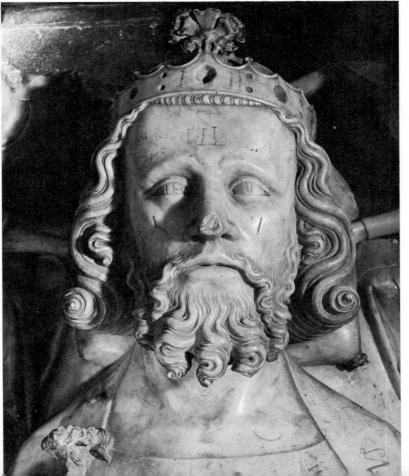

301 *Man playing the bagpipes*, detail of
altar screen *c.* 1335
Beverley (Yorkshire), Minster

302 *Effigy of Edward II*, detail *c.* 1330–
Gloucester, Cathedral

303 *The Descent from the Cross c.* 1380
London, Victoria and
Albert Museum

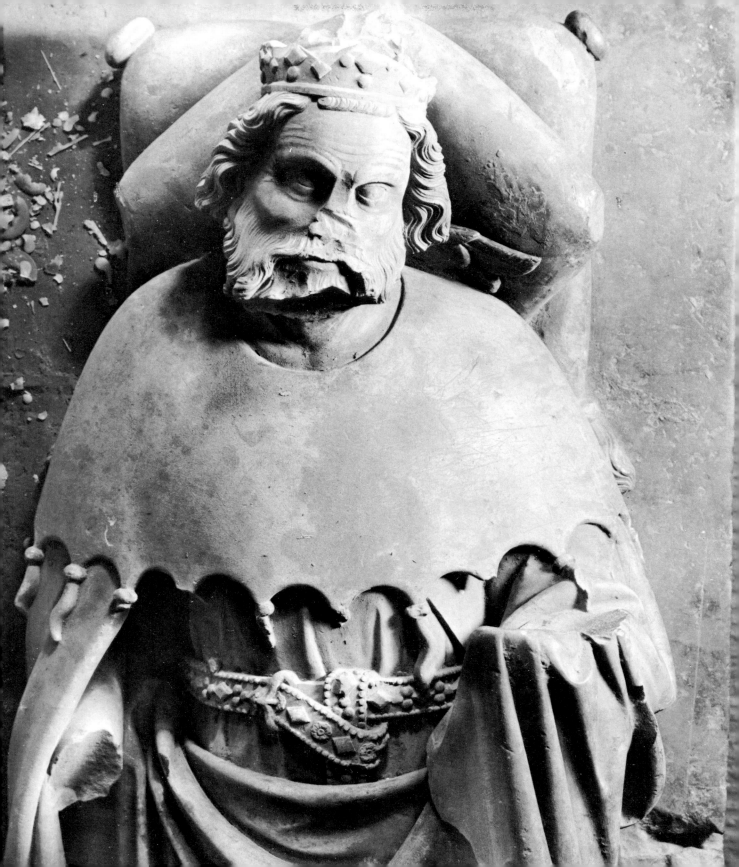

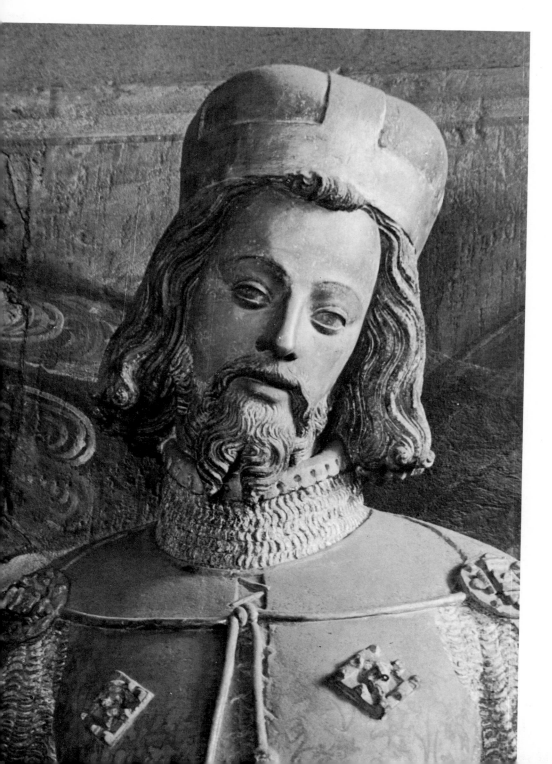

307 Heinrich Parler
Statue of St Wenceslas 1373
Prague, Cathedral of
St Vitus (choir)

308 Peter Parler and assistants
Bust of Anna von Schweidnitz
c. 1379–85 Prague, Cathedral
of St Vitus (choir)

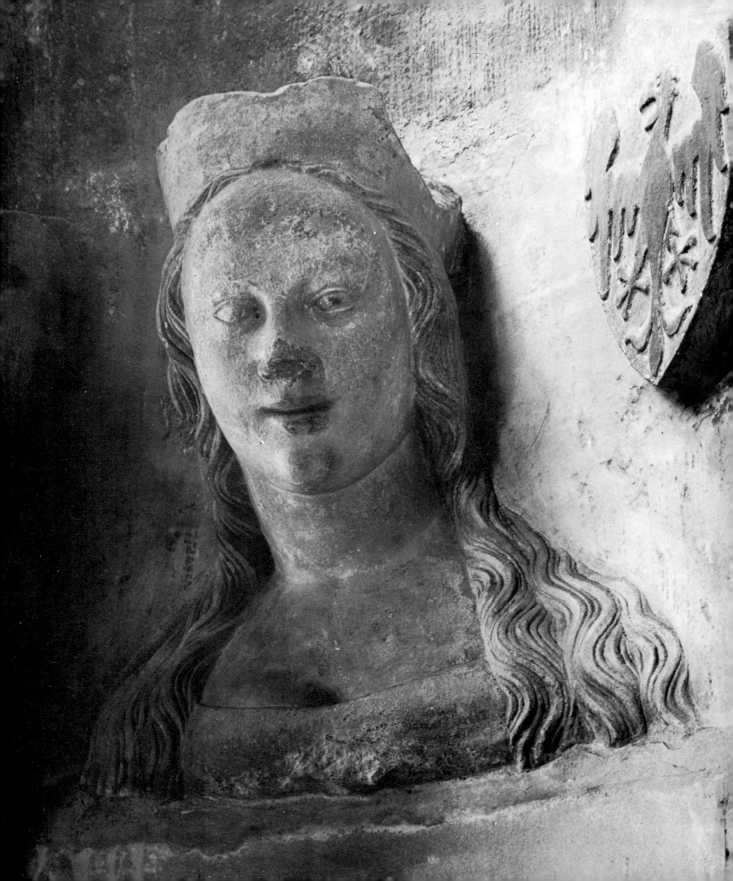

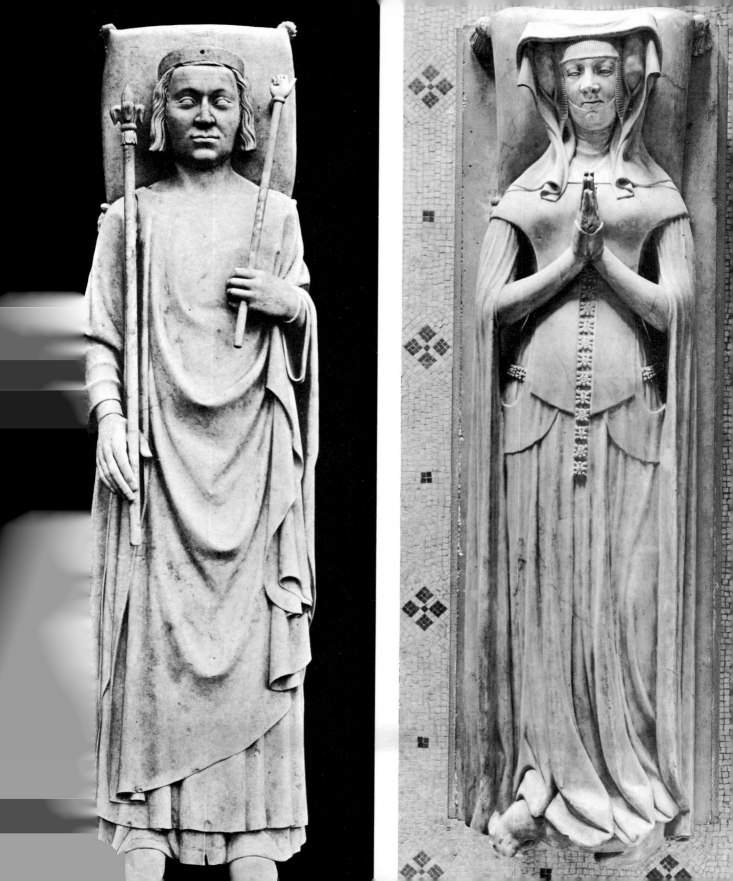

309 André Beauneveu
Recumbent figure of Charles V 1364
St Denis, Abbey Church (*far left*)

310 *Recumbent figure of Catherine d'Alençon*
1412–13
Paris, Louvre

311 *Charles IV leaning over the balcony c.* 1380
Mühlhausen (Thuringia), Marienkirche
(transept doorway)

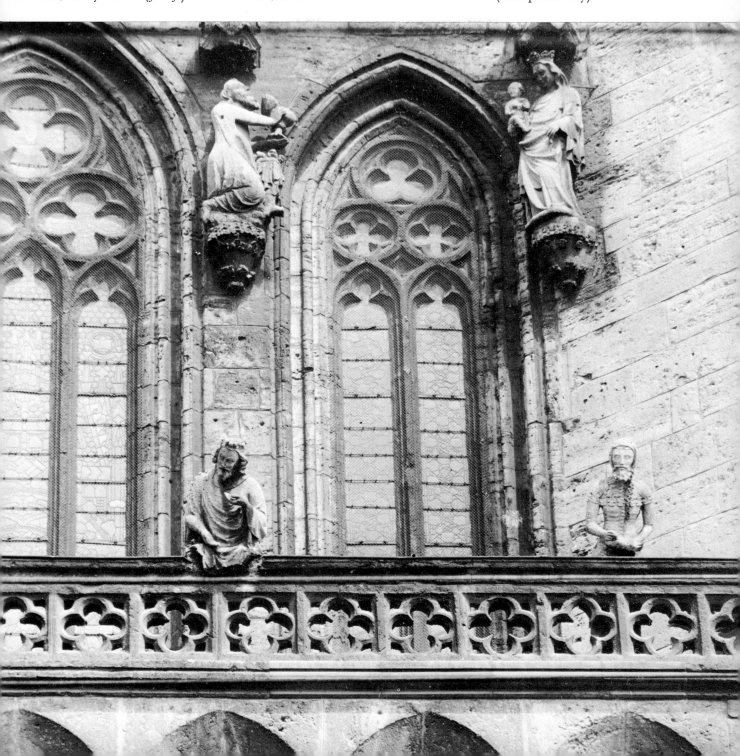

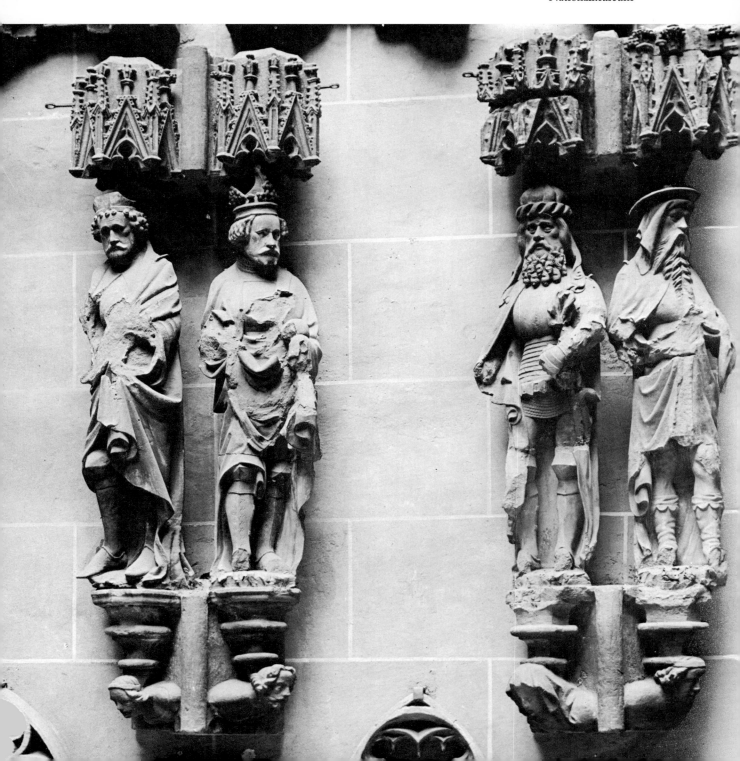

312 Heinrich Beheim and assistants
Three Royal Electors and the hero,
Godefroy de Bouillon 1385–96
Nuremberg, Germanisches
Nationalmuseum

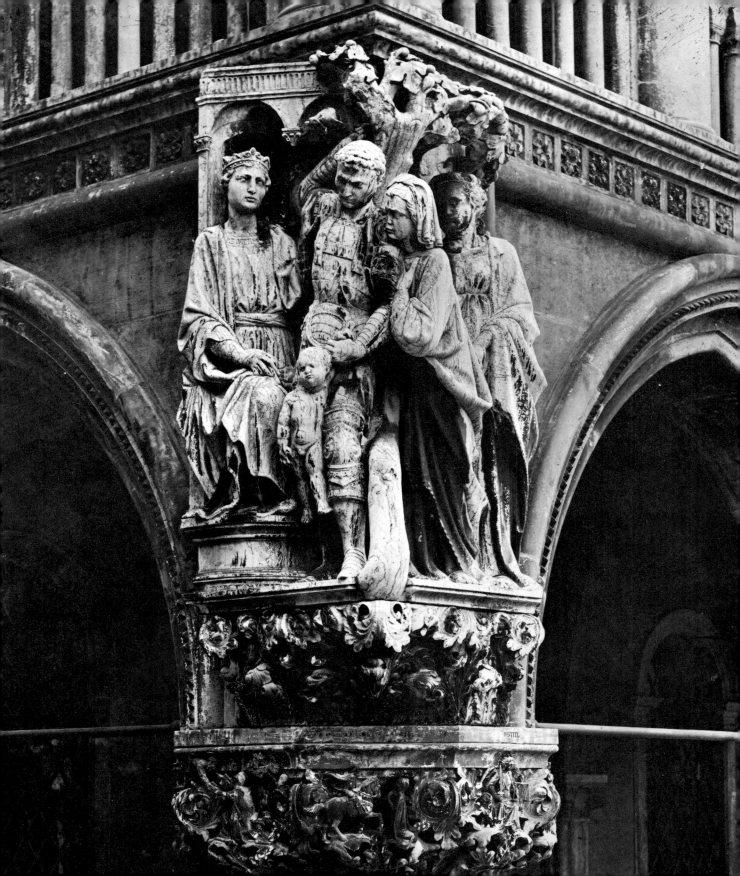

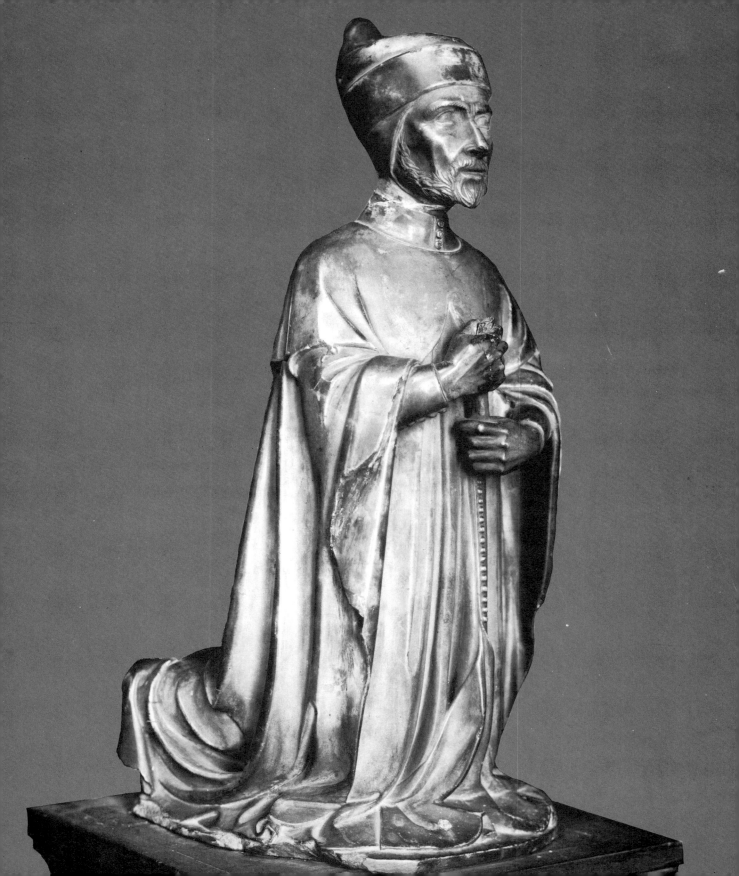

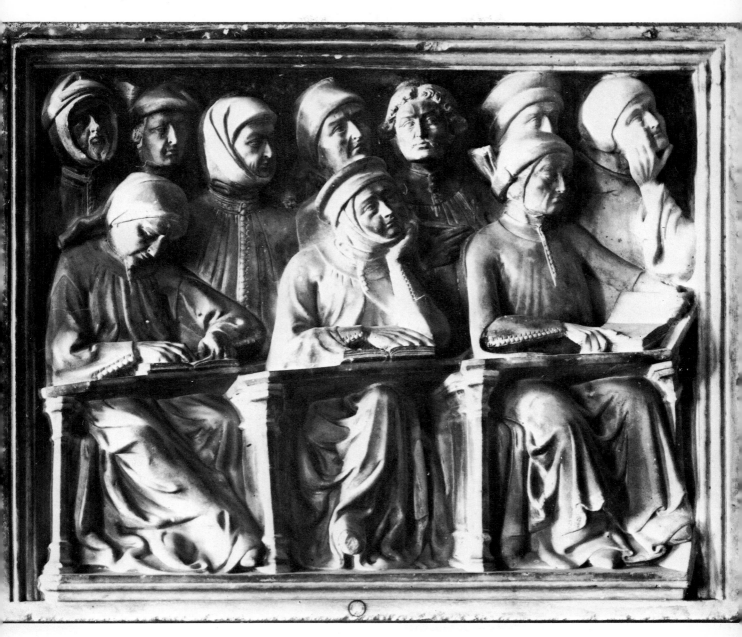

319 Jacobello dalle Masegne
 Statue of Doge Antonio Venier
 c. 1395–1400
 Venice, Museo Correr

320 Pier Paolo dalle Masegne
 A class of university students 1386
 Bologna, Museo Civico

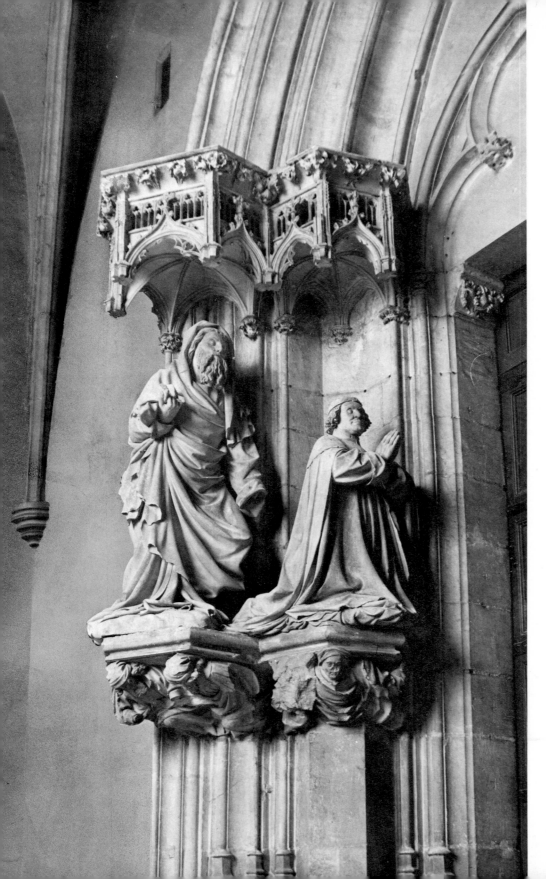

321 Claus Sluter
*St John the Baptist and Philip the
Bold c.* 1391 Dijon, Charter-house
Champmol (Chapel portal)

322 Claus Sluter
The Prophet Jeremiah 1398–1402,
detail of the Puits de Moïse
Dijon, Charter-house of
Champmol

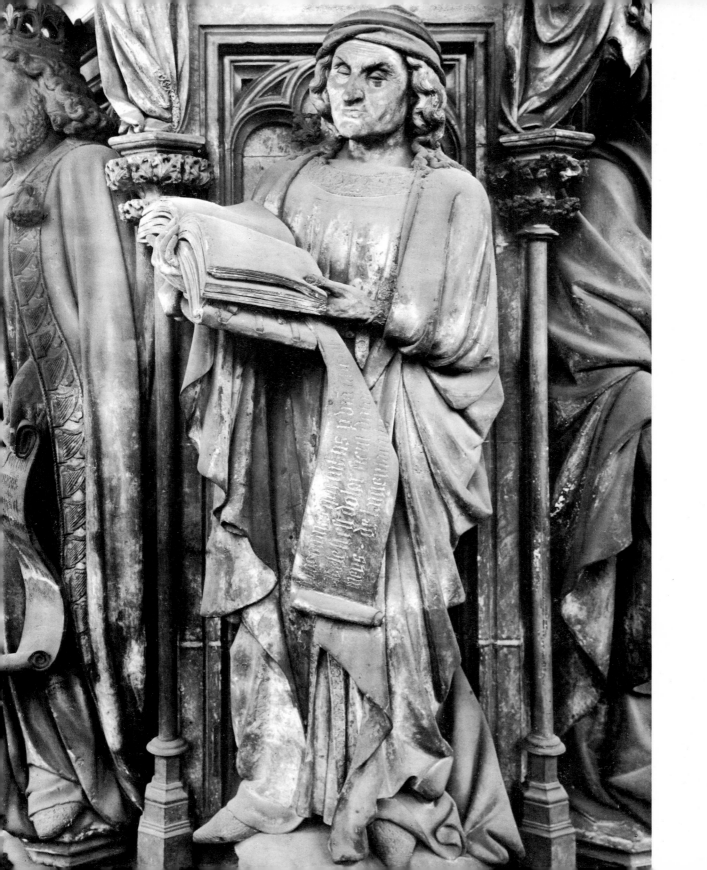

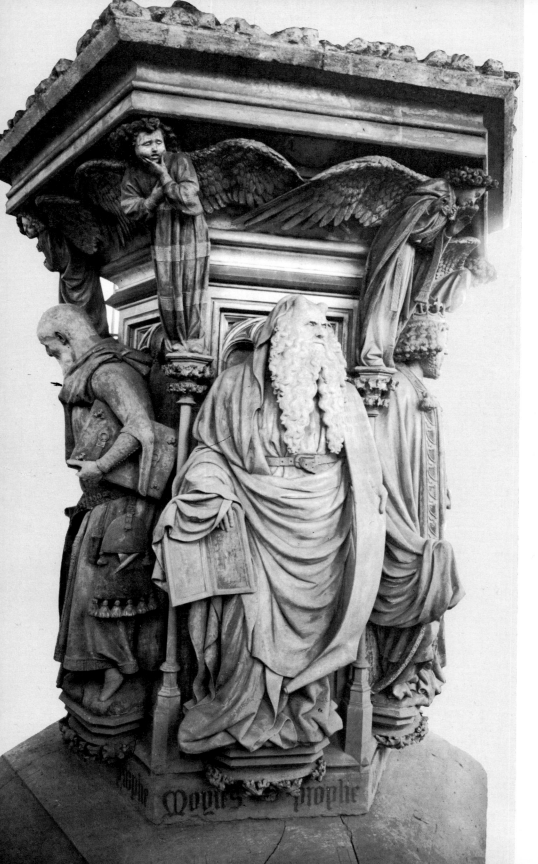

323 Claus Sluter
The Prophet Moses 1398–1402,
detail of the Puits de Moïse
Dijon, Charter-house of
Champmol

324 Claus Sluter
King David, detail of the Puits de
Moïse 1398–1402
Dijon, Charter-house of
Champmol

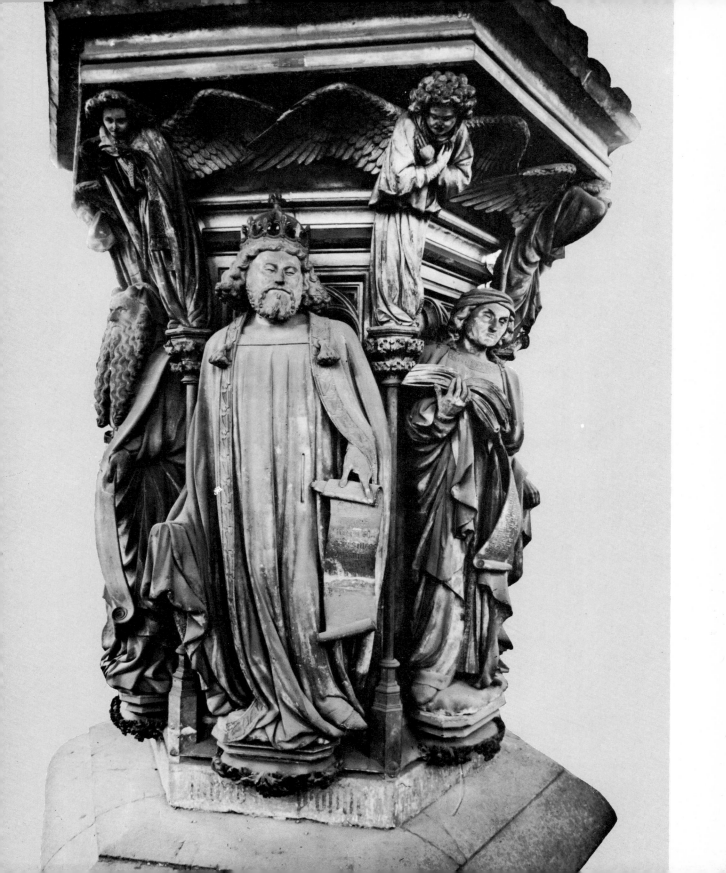

325–6 Claus Sluter
 Two weepers, detail of tomb of Philip
 the Bold 1410
 Dijon, Museum

327 *St Ildefonso receiving the Virgin's mantle*
 detail of tympanum *c.* 1390
 Toledo, Cathedral (Puerta del
 Perdón) *(right)*

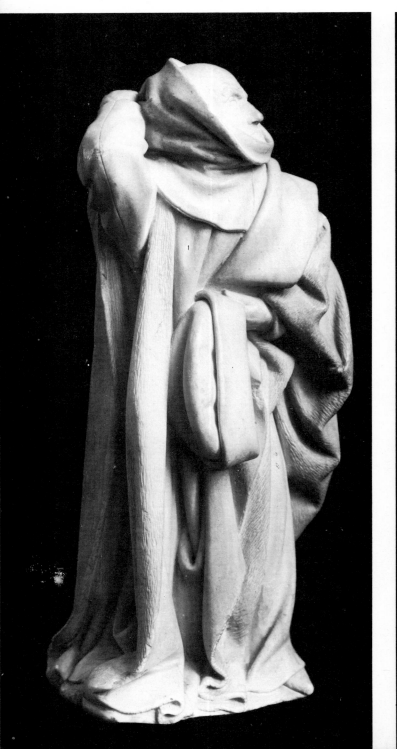

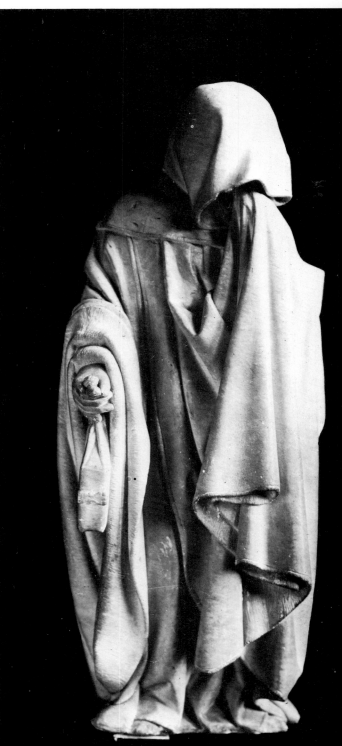

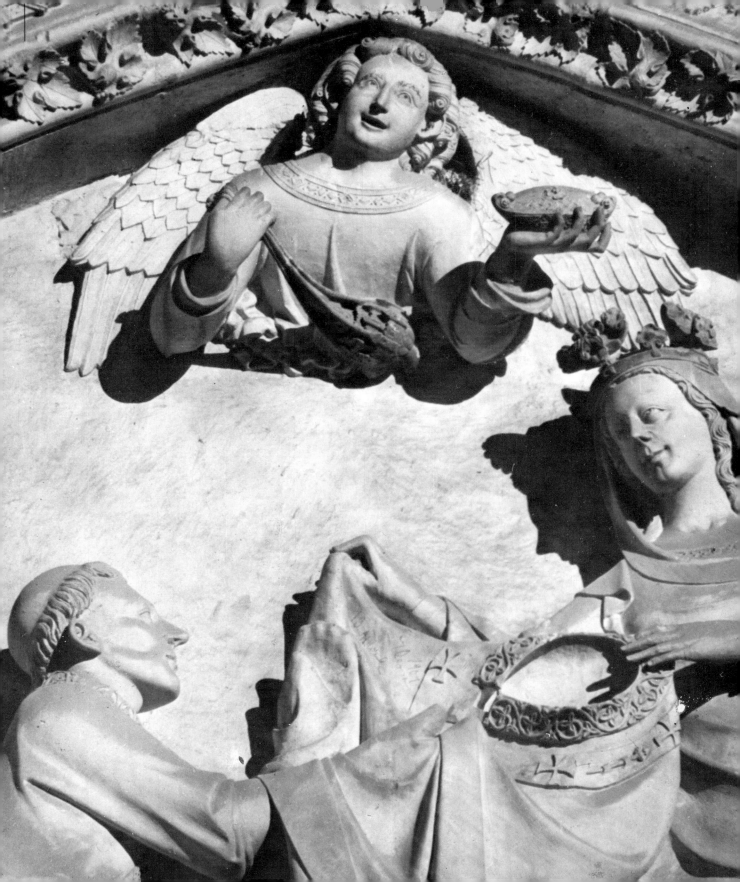

INTERNATIONAL GOTHIC

328 *Three clerics*, detail of the tomb of
William of Wykeham *c. 1400*
Winchester, Cathedral

329 Niccolò dell'Arca
Mary of Cleophas 1485–90,
detail of Descent from the Cross
Bologna, Chiesa della Pietà della Vita

330 Niccolò dell'Arca
St John the Evangelist 1469–73
Shrine of St Dominic
Bologna, S. Domenico

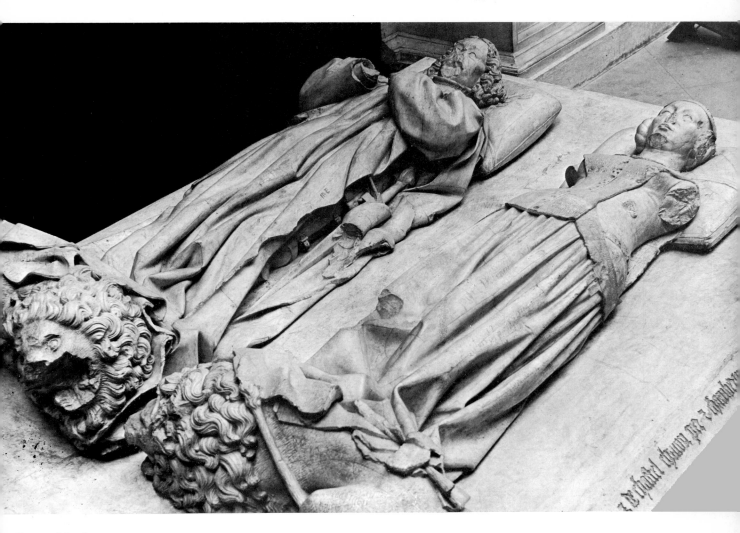

31 Jacques Morel
 Tomb of Agnes of Burgundy and Charles I
 of Bourbon 1453
 Souvigny, Parish Church

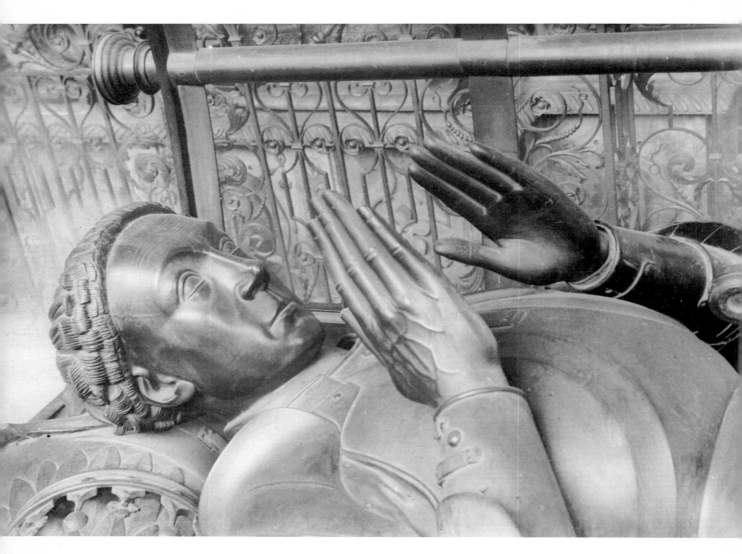

332 John Massingham
 Tomb of Richard, Earl of Warwick 1450
 Warwick, St Mary's

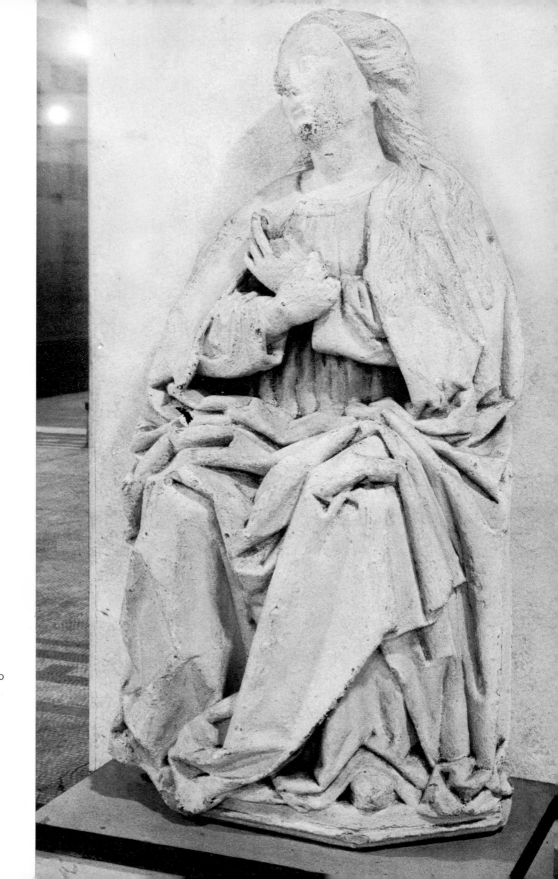

333 *The Virgin Annunciate c.* 1441–50
London, Westminster Abbey

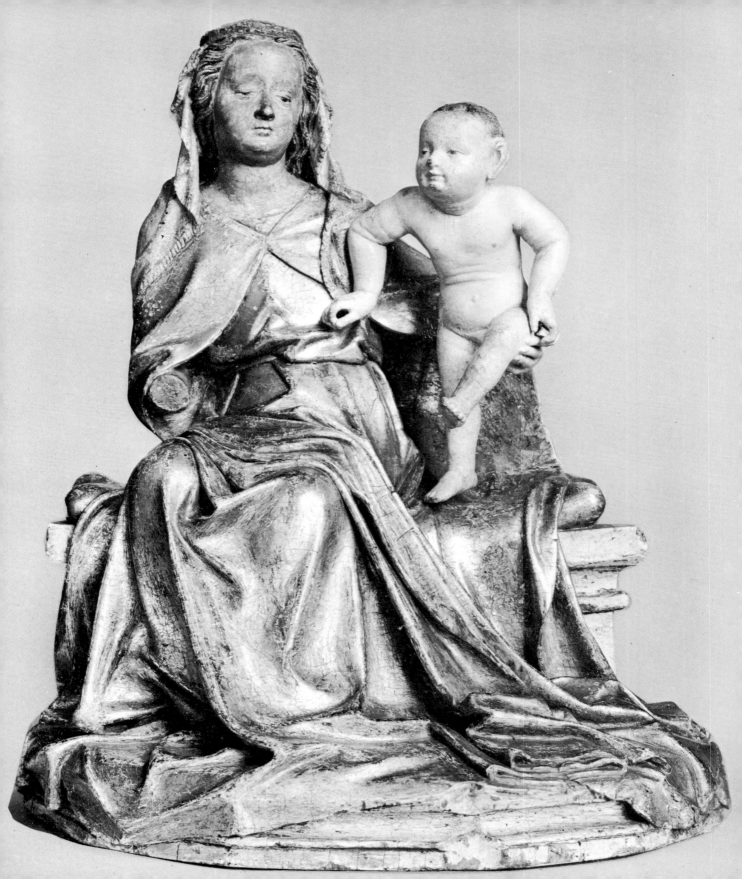

334 Hans Multscher
The Virgin Enthroned c. 1430–5
Munich, Bayerisches Nationalmuseum

335 Hans Multscher
St Florian 1456–8
Vipiteno (Sterzing, South Tyrol)
Civic Museum

336 Hans Multscher
The Man of Sorrows 1429
Ulm, Cathedral

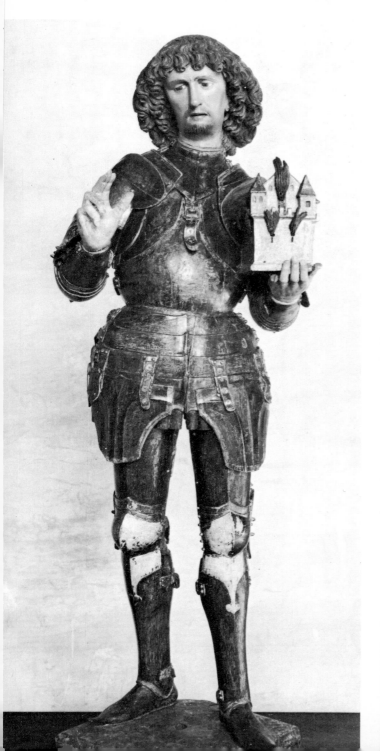

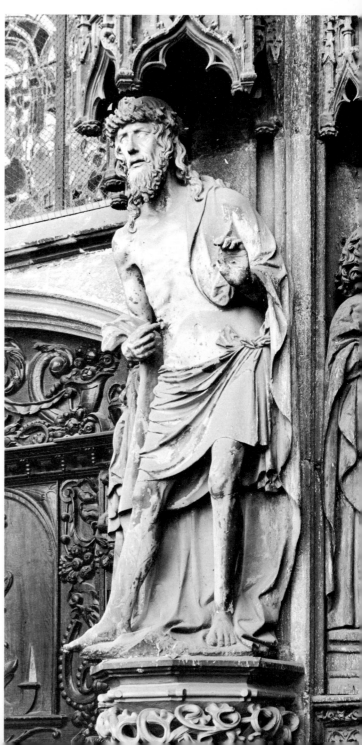

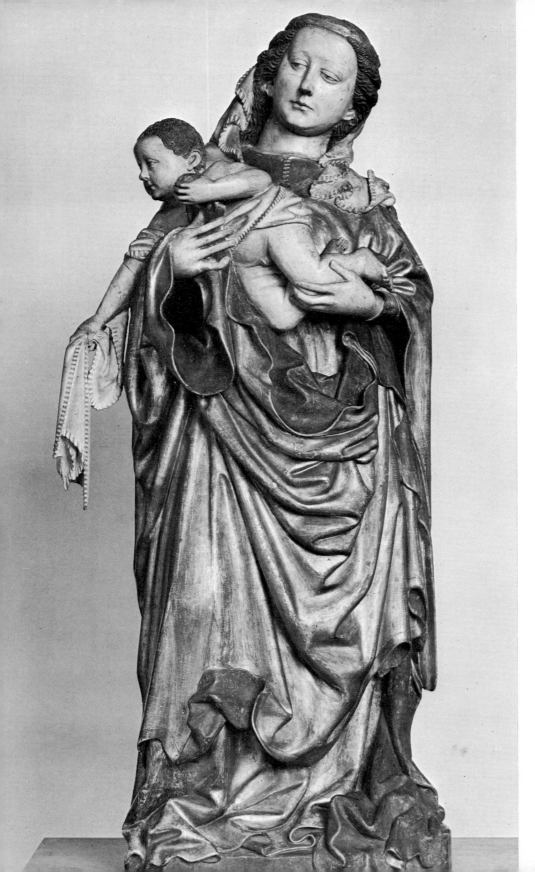

337 Jakob Kaschauer
Virgin and Child 1443
Munich, Bayerisches
Nationalmuseum

338 Nicolaus Gerhaert
Self-portrait? c. 1467
Strasbourg, Musée de l'Œuvre de
Notre-Dame

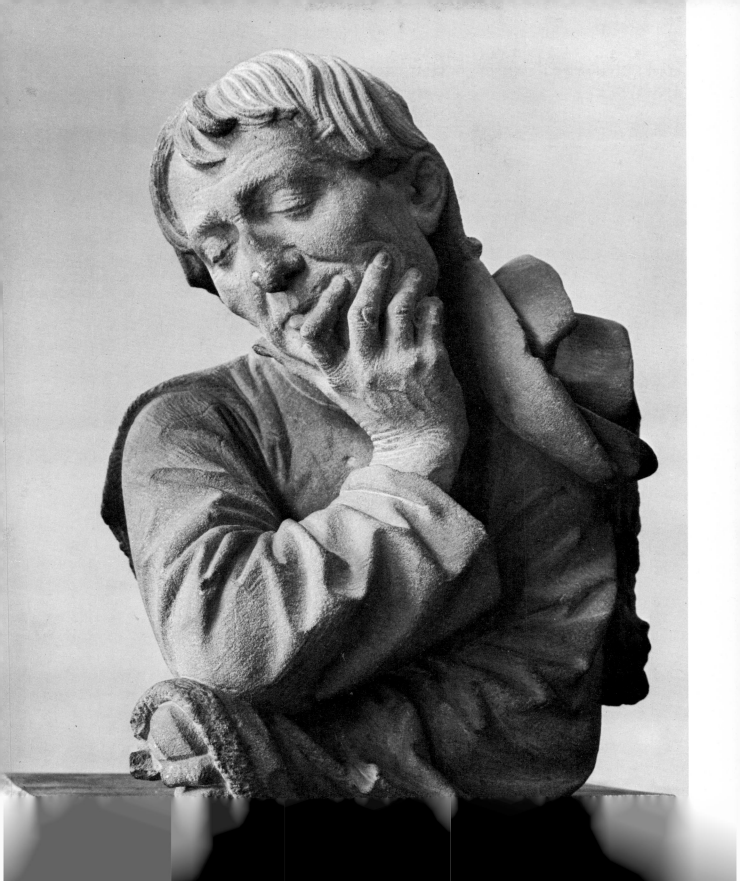

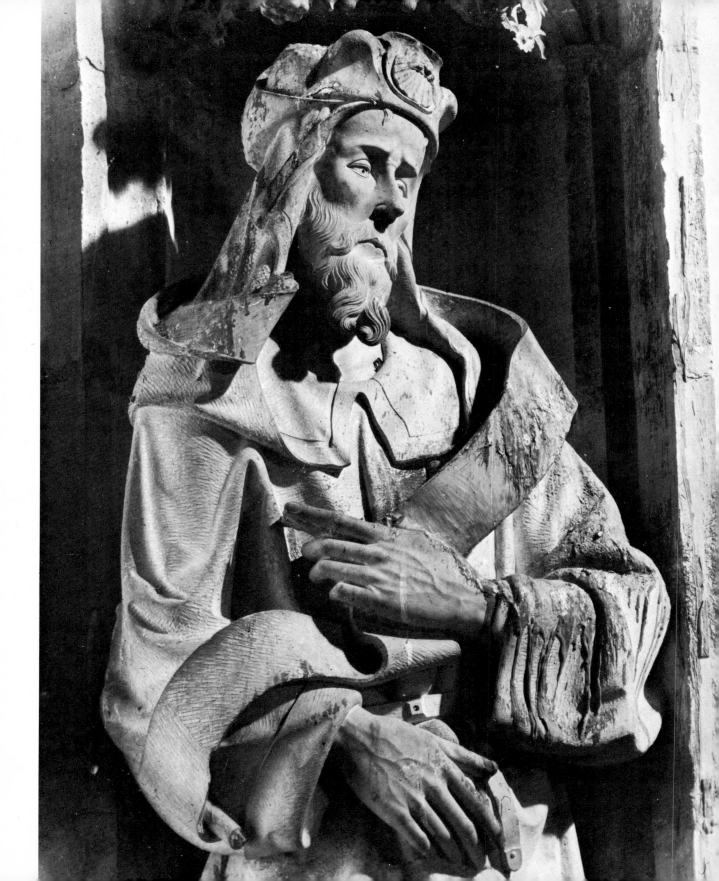

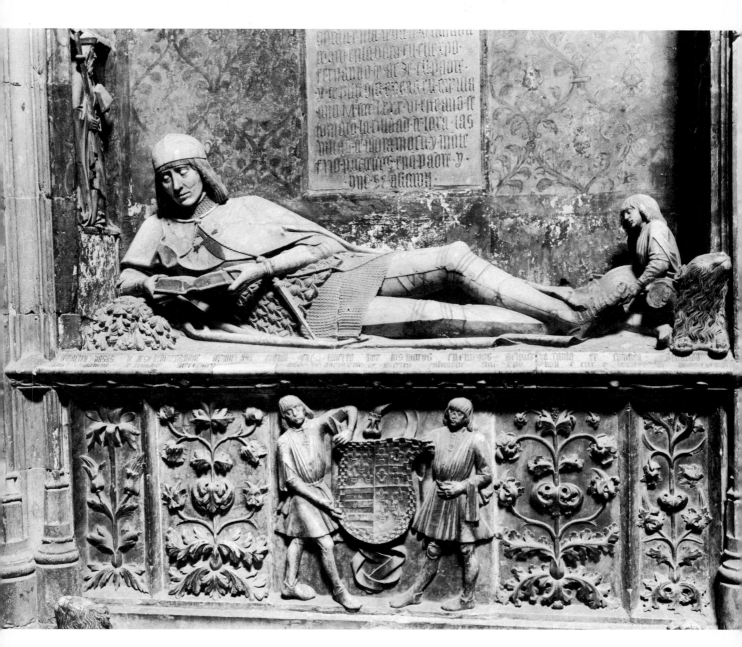

39 School of Juan Guas
St James the Apostle, detail *c.* 1490
Toledo, S. Juan de los Reyes

340 *Tomb of Martin Vazquez de Arce, called*
'*El Doncel*' *c.* 1488
Sigüenza, Cathedral

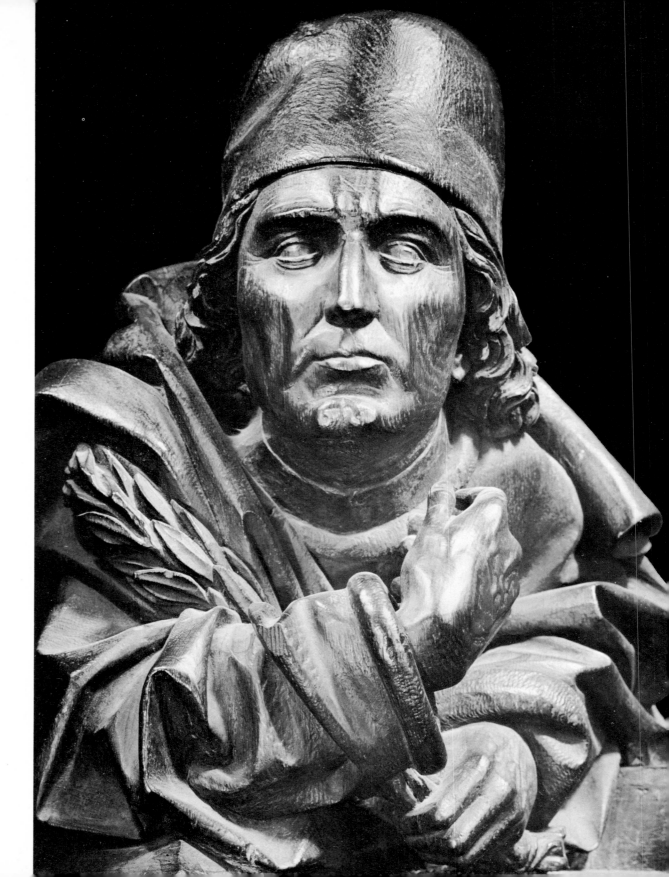

341 Jörg Syrlin
 Virgil 1469–74
 Ulm, Cathedral (choir stall)

342 *The Virgin standing on the sickle moon*
 c. 1475
 Trier, Cathedral (cloister)

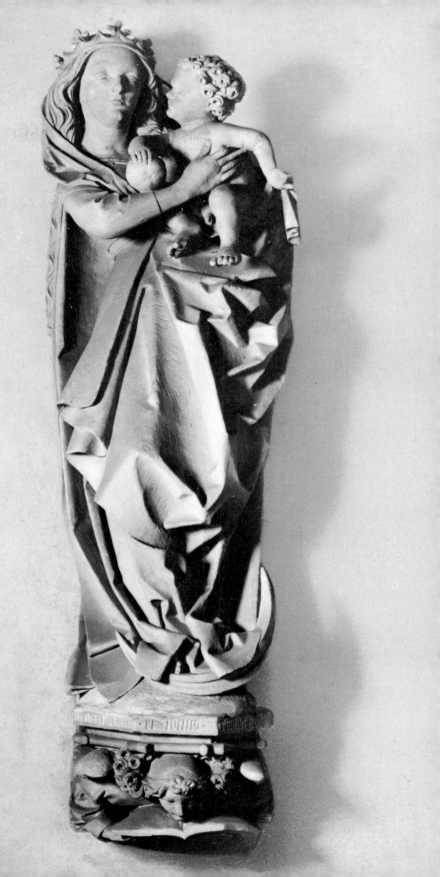

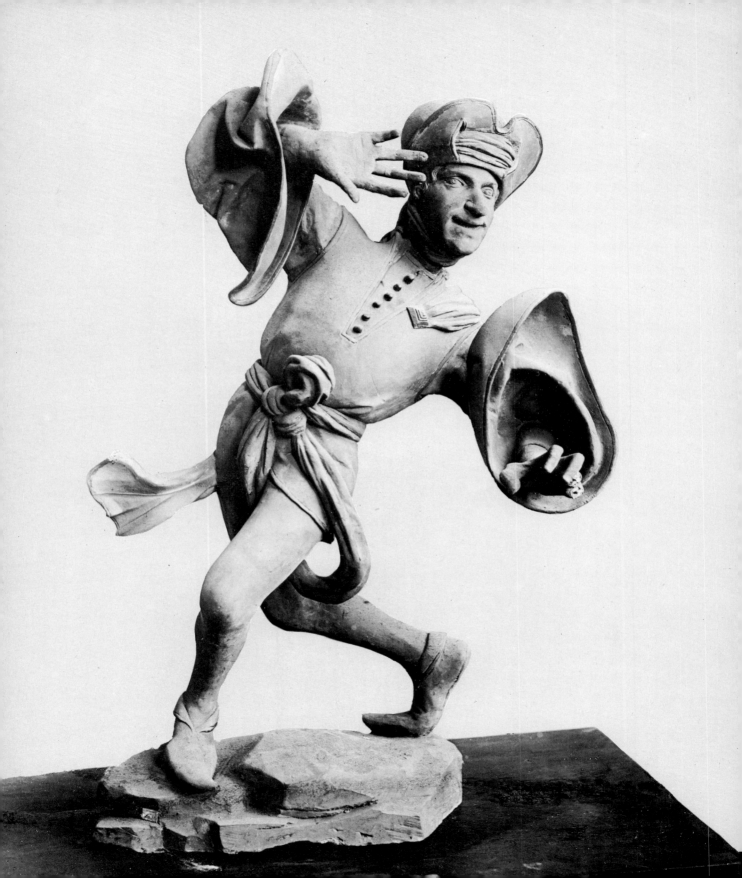

343 Erasmus Grasser
A Morris dancer 1480
Munich, Münchner Stadtmuseum

344 Erasmus Grasser
St John c. 1480
Munich, Bayerisches National-
museum

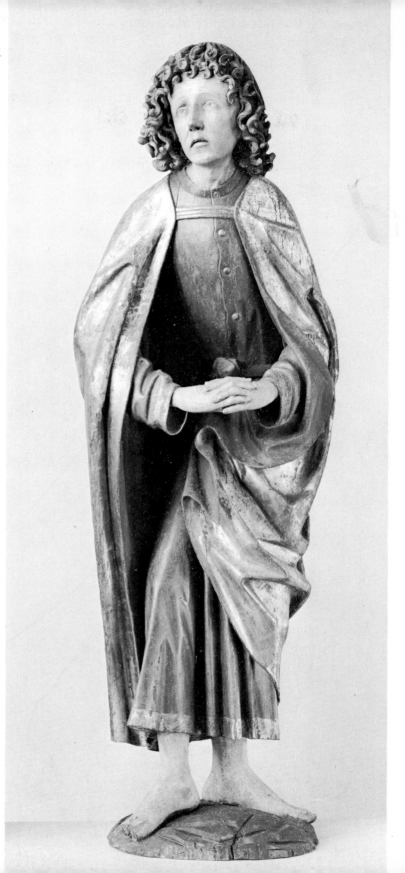

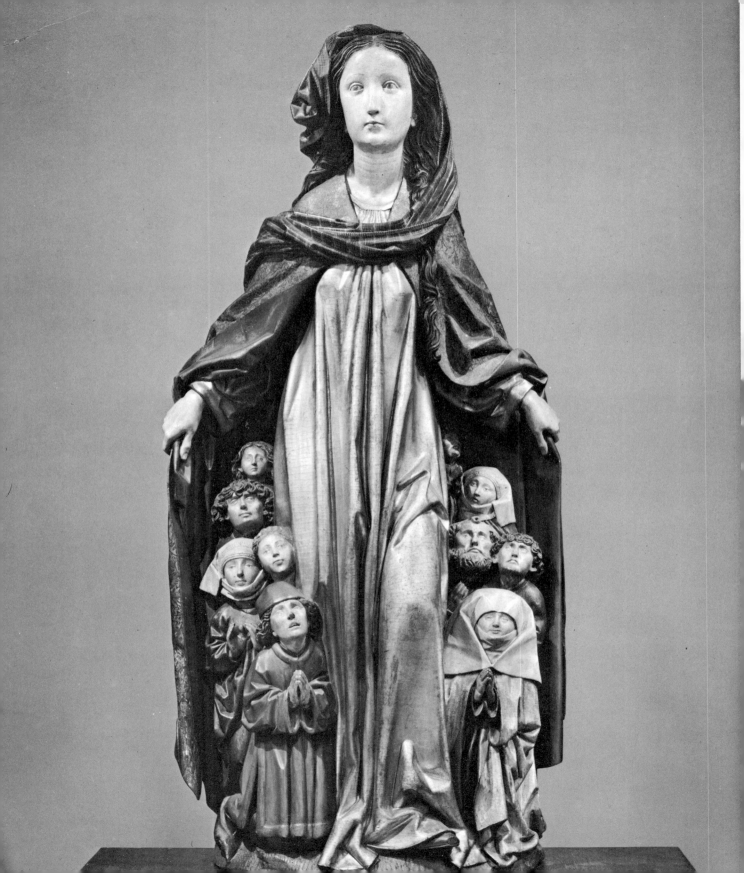

345 Michel Erhart
The Merciful Madonna c. 1480
Berlin, Staatliche Museen

346 Michael Pacher
St Michael slaying the dragon, detail
of altarpiece, 1471–5
Bolzano-Gries, Parish Church

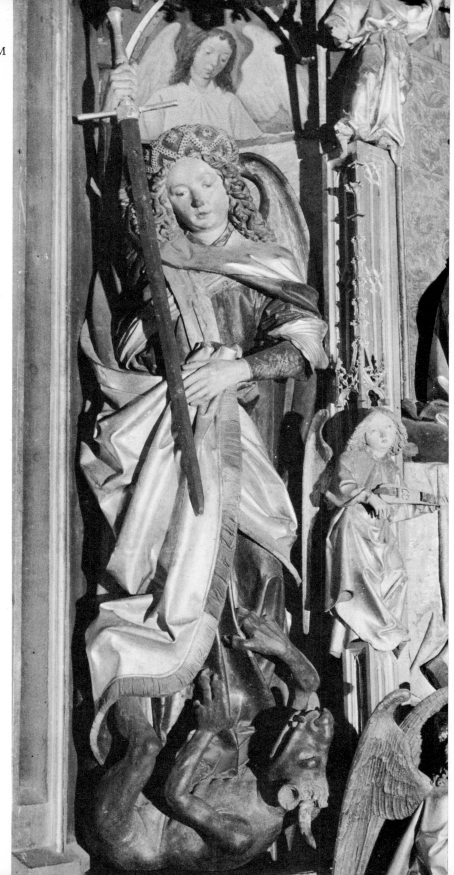

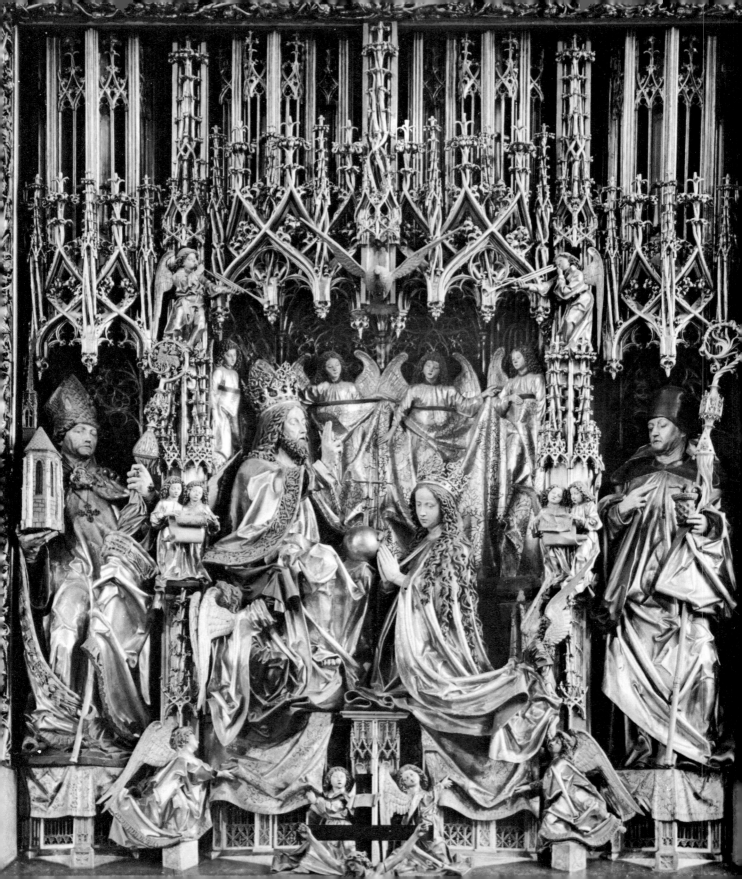

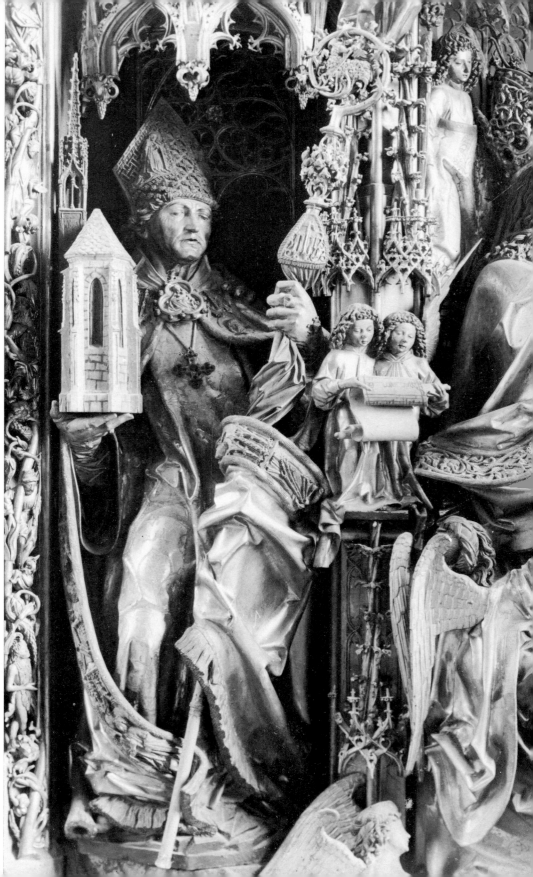

47–8 *Coronation of the Virgin; St Wolfgang*, details of altarpiece
 c. 1481
 St Wolfgang am Abersee, Parish Church

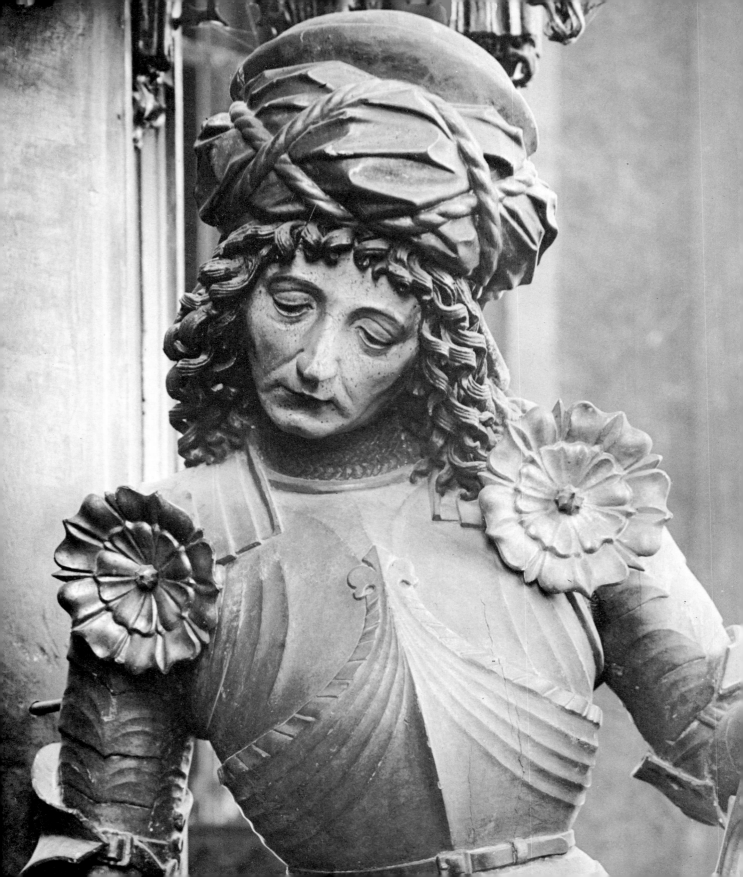

349 *St Florian*, detail of Altarpiece *c.* 1481
St Wolfgang am Abersee,
Parish Church

350–1 Tilman Riemenschneider
Adam and Eve 1491–3
Würzburg, Mainfränkisches Museum

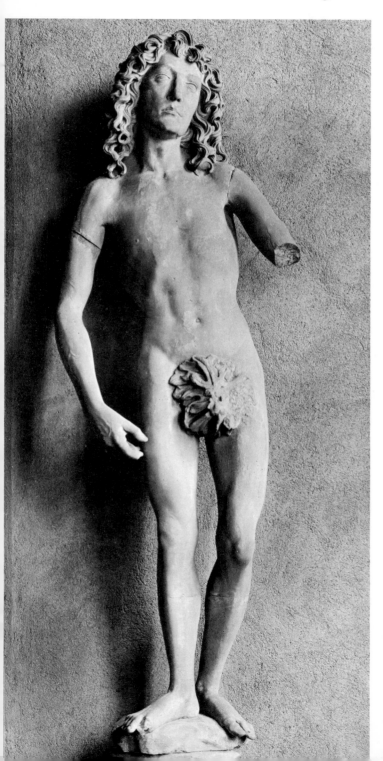

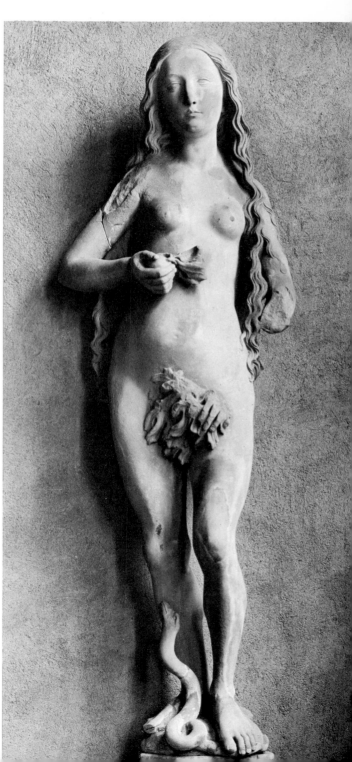

352 Tilman Riemenschneider
The Last Supper, detail 1501–4
Rothenburg, St Jakobskirche
(Altar of the Sacred Blood)

353 Tilman Riemenschneider
The Virgin and Child, detail *c.* 1510
Berlin, ehem. Staatliche Museen

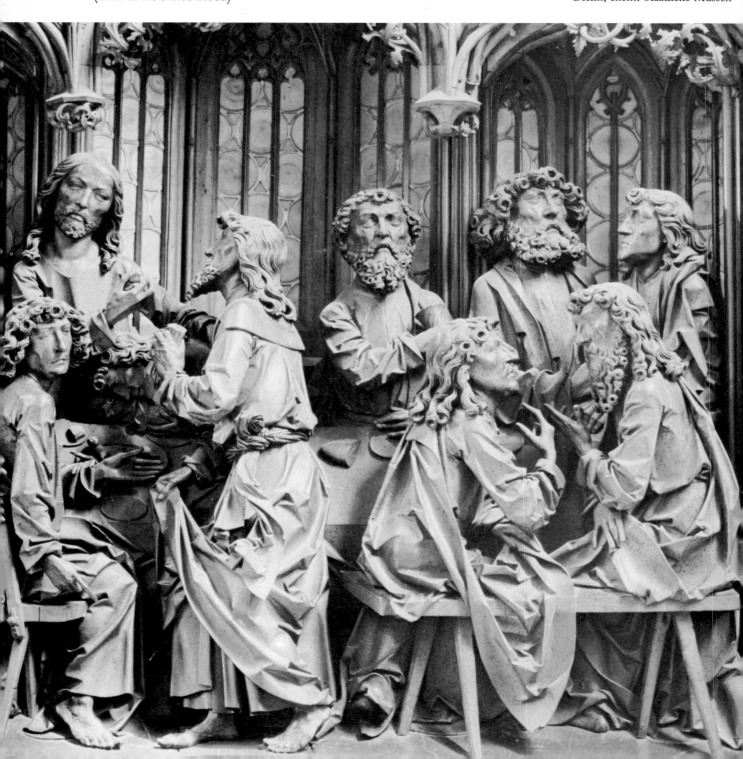

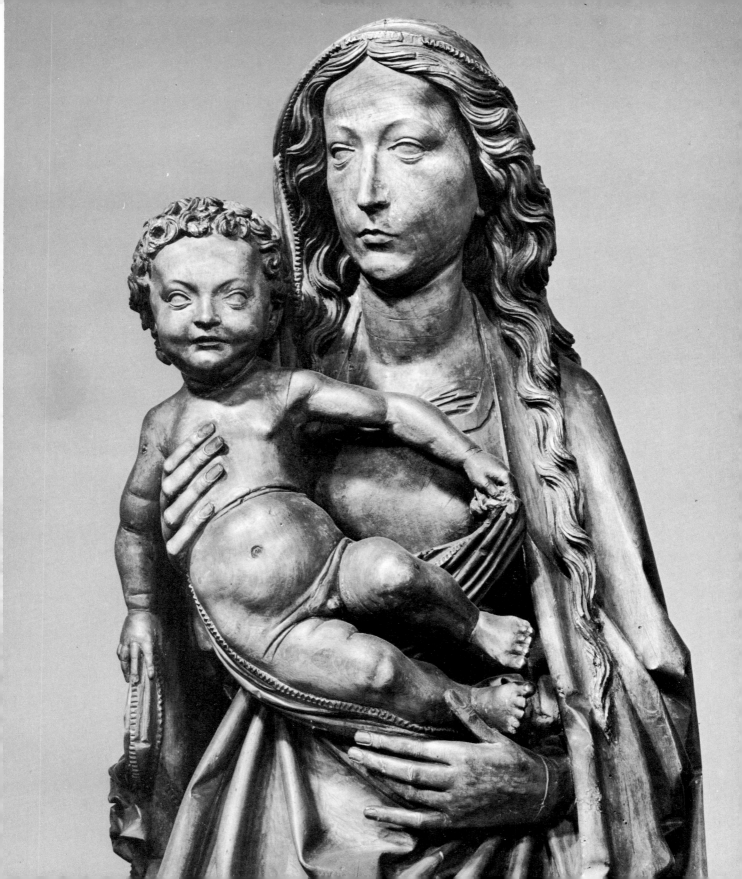

354 Bernt Notke
St George and the dragon 1483–9
Stockholm, Storkyrka

355 Adam Kraft
Self-portrait, detail of Shrine of the
Sacrament 1493–6
Nuremberg, St Lorenzkirche

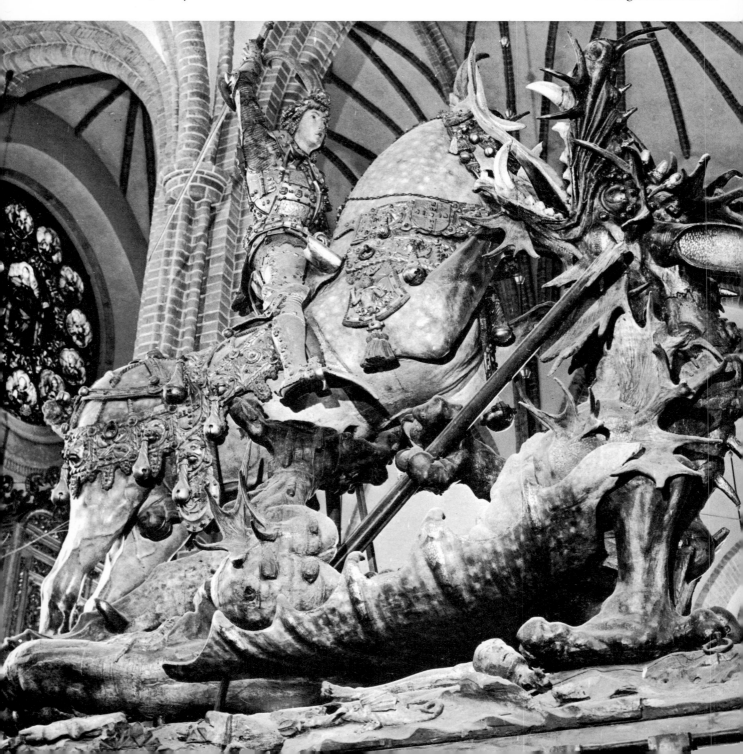

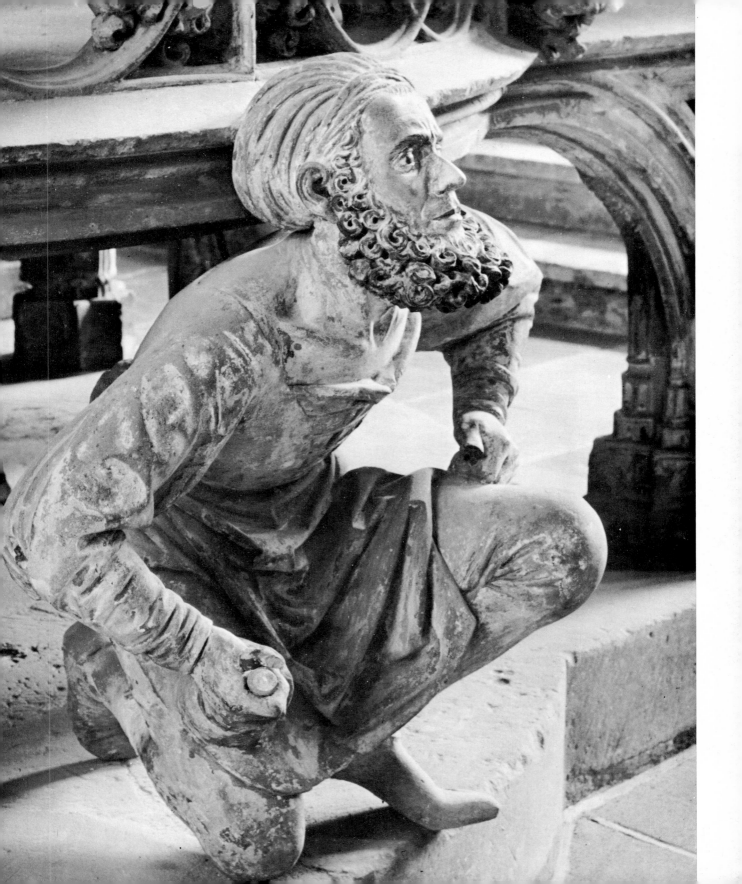

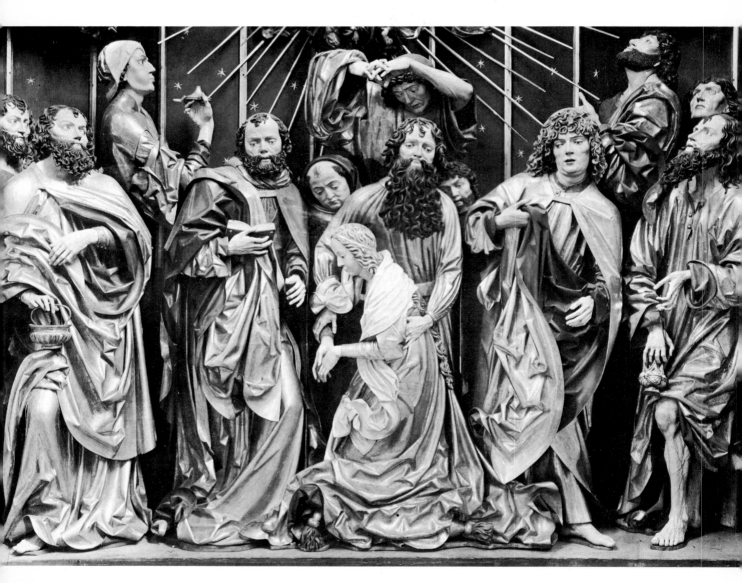

356 Veit Stoss
The Dormition of the Virgin,
detail 1477–89
Cracow, St Mary's

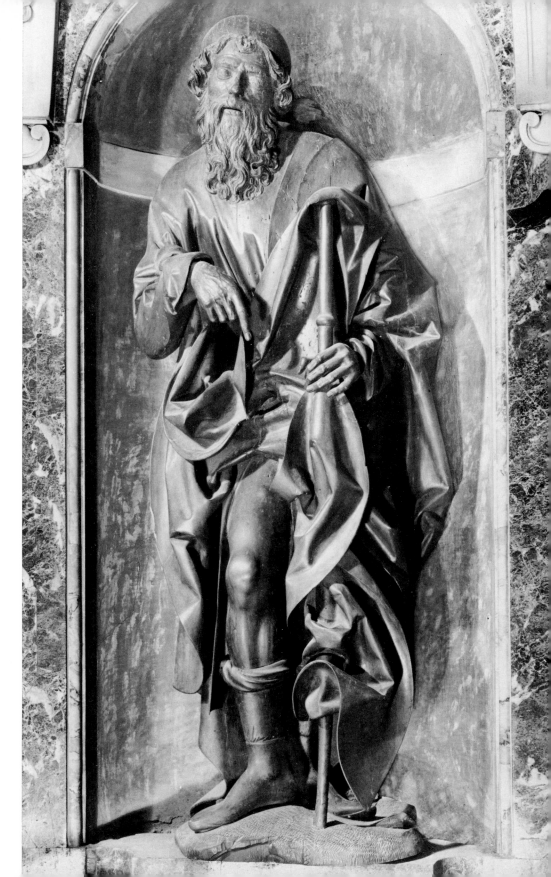

357 Veit Stoss
St Roch c. 1505
Florence, SS. Annunziata

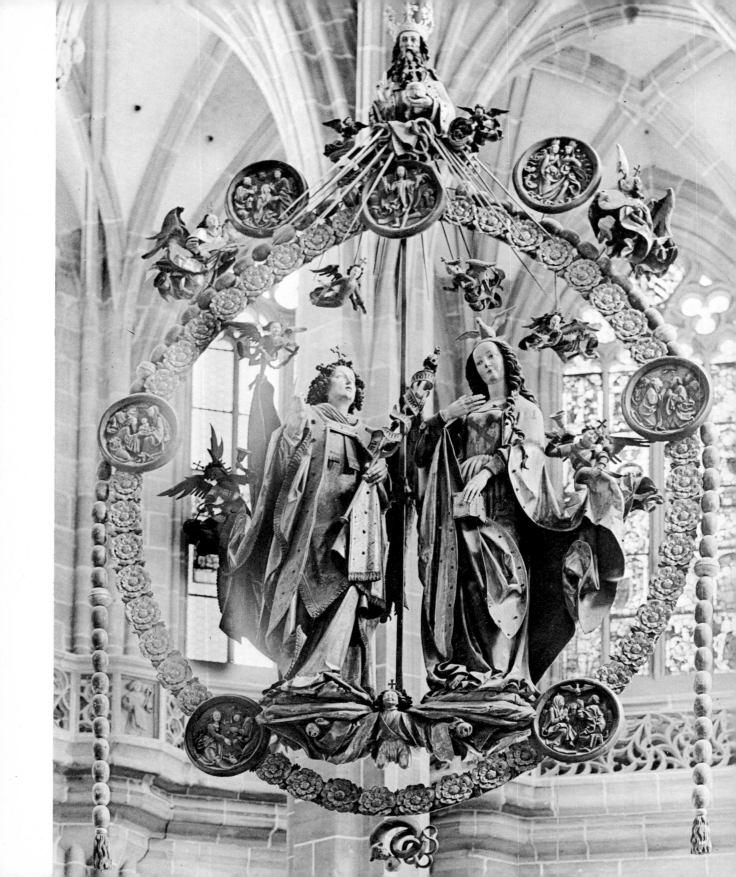

15TH CENTURY NATURALISM
AND LATE GOTHIC

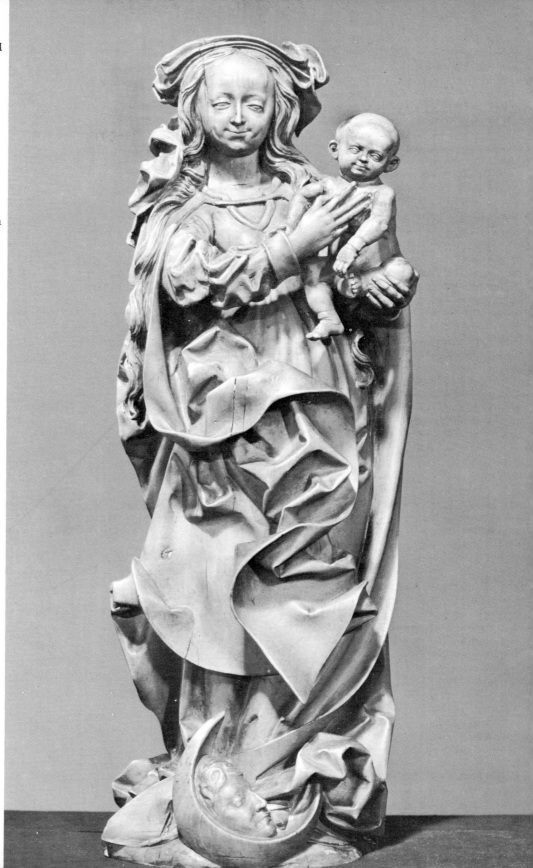

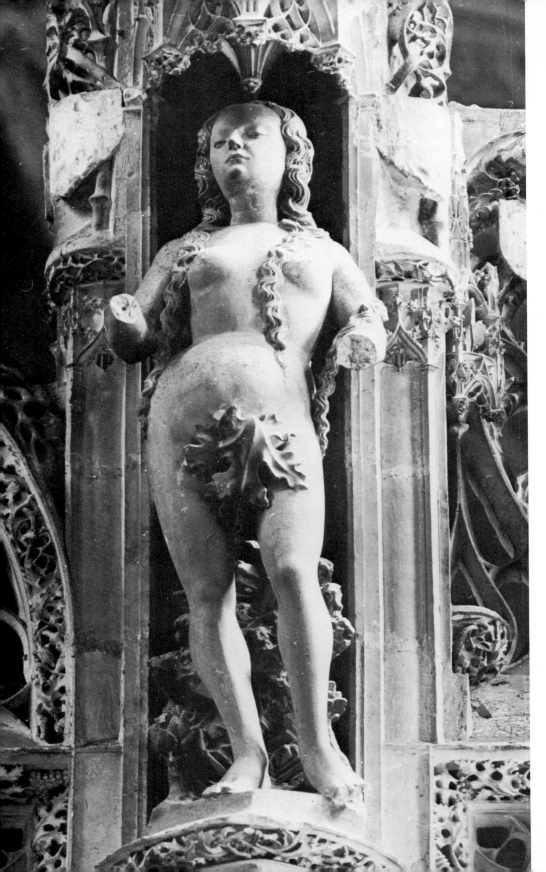

360 *Eve c.* 1500
 Albi, Cathedral (choir screen)

NOTES ON THE COLOUR PLATES

Measurements are given in the order height, width and depth unless otherwise indicated.

 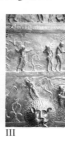 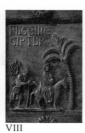

I II III IV V VI VII VIII IX

WOLVINIUS AND ASSISTANT

I *Scenes from the life of Christ*, detail from the Golden Altar *c*. 850 gold 0·85 × 2·20 × 1·22 m. (the whole work)
Milan, S. Ambrogio
The work consists of a golden front portraying Christ enthroned surrounded by the Symbols of the Evangelists and the Apostles in the centre, and twelve stories from the New Testament on the right and left wing; two silver gilt sides, each one bearing a cross and figures of angels and saints, and a silver gilt back with twelve stories from the life of St Ambrosius in the wings and the representation of Bishop Engelbert and the artist Wolvinius, both crowned by St Ambrosius, in the centre panel. The panels are enclosed by precious frames with enamels, filigree, stones, gems, cameos, etc., a splendid decoration of Byzantine origin and classicizing character, diffused all over Carolingian Europe. This plate reproduces three original panels (the Merchants driven out of the Temple, the Healing of the Blind, the Crucifixion) and three late Renaissance panels substituted for the original ones. On the evidence of the dedication inscription on the golden front mentioning Bishop Engelbert, and the presence, on the silver back, of the bishop's portrait beside that of the MAGISTER PHABER Wolvinius, it is incontestable that the altar was erected between 824 and 856. On the other hand, the date 835, frequently quoted, rests on a letter from the bishop, which turned out to be apocryphal, whereas the style seems to be more in keeping with the age of Charles the Bald (i.e. after 843). Every attempt, either to date the entire work in the Romanesque period or to relegate the golden front to the Ottonian period, has proved unsuccessful. Some difference in style between the golden front and the silver sides and back cannot, however, be denied. In the silver panels – certainly Wolvinius' personal work since they include his own portrait – the ample and roundish forms of the figures, inspired to a refined and courtly Classicism, are in harmony with the pictorial quality of the background, whereas landscape is often portrayed in an impressionist manner by means of sparse vegetation and foreshortened objects or buildings. Broadness of space and intense play of light contribute to the creation of an atmosphere of moving solemnity. In the panels of the golden front, another artist, following the master's design, attenuates the formal values of the figures and the spaciousness, and emphasizes the slenderness of the figures and their vivid movement and gestures, thus counterbalancing the undeniable loss of solemnity with original dramatic expressionism.
*Porter 1917, II, 545. Tarchiani, *D*, 1921–22, 14. Deckert, *MJKw*, 1924, 268. Toesca 1927, 425, 454. Francovich, *RJKg*, 1942–4, 113. Tatum, *AB*, 1944, 15. Usener in *Beiträge z. Kunst des mittelalters*, 1950, 104.

Elbern, *Der karol. Goldaltar v. Mailand*, 1952. Rosa in *Storia di Milano* II, 1954, 673. Bascapè, *S. Ambrogio; ragguaglio* etc. 1955, III. Volbach 1968, 239. Ragghianti 1968, 499. Bascapè, *AL*, 1969, 2⁰, 36.

II *Illustration to Psalm 57: Cover of Charles the Bald's Psalter* 860–70 ivory
Paris, Bibliothèque Nationale
This manuscript was transcribed by Luithard (*c*. 842–70), hence the dating. Subjects, iconography and, to some extent, style, owe much to the miniatures in the celebrated Utrecht Psalter. Compared with the calm gravity of the ivories of the Palatine school (19), the style of this work is ebullient. By this time, ivory-carvers had learned to exploit the medium with the utmost skill, and, in this case, the craftsman has achieved a high degree of dramatic eloquence by intersecting his angular composition with fluid diagonal lines.
Goldschmidt 1914. Tselos, *AB*, 1957, 93. Volbach, *CCM*, 1958, 17. Volbach 1968, 247.

III *Adam and Eve after the Fall, the Expulsion and Condemnation to Labour*, detail of door 1015 bronze 4·72 × 1·15 m. (the whole wing)
Hildesheim, Cathedral
The inscription relates that Bishop Bernward had the doors placed '*in faciem angelici templi*' in the year 1015. The chronicler Wolfher writes, in 1035, that Bishop Godehard reconstructed the *Westwerk* of the cathedral '*et valvas . . . ibidem pulcherrime composuit*'. It was formerly believed, therefore, that the door was commissioned by Bernward for the church of St Michael and that it was transferred to the cathedral by Godehard shortly before 1035. It is, however, difficult to see where, in the church of St Michael, the door could have stood, and in no document is St Michael's called '*templum angelicum*'. There is evidence that the *Westwerk* of the cathedral was known as '*chorus angelicus*'. Thus it is now believed that the door has stood in the cathedral from the beginning, and that Wolfher was referring simply to its erection after the reconstruction of the *Westwerk*. This door is the unchallenged masterpiece of Ottonian sculpture. The small figures are lost in the immensity of the surrounding space, in which their contorted bodies, whose frenetic spasms are repeated in the twisted branches of the barren trees, evoke, in an expressionistic manner, the sound of voices crying out at the terrifying immensity of the universe.
Dibelius, *Die Bernwardstür*, 1907. Beenken 1924, 4. Panofsky 1924, 74. Goldschmidt 1926. Von Einem, *JPKslg*, 1938, 3. Jantzen 1947, 125. Fink, *ZKw*, 1948, 1. Beseler-Roggenkamp, *Die Michaeliskirche i. H.*, 1954, 103. Wesenberg 1957. Beckwith 1964, 145. Steingräber 1961, 11.

★ NOTE ON BIBLIOGRAPHICAL REFERENCES Where the author's last name and a date only are given, see *Bibliography* for details. Abbreviations for the names of journals are also explained in the *Bibliography*.

RAINER OF HUY

IV *Two men awaiting baptism*, detail (font). 1107–18 brass 0·60 × 0·80 m.
Liège, St Barthélemy
According to the inscription this font was commissioned by Abbot
Hellinus for the church of Notre-Dame-des-Fonts. The term 'Roman-
esque sculpture' is applied almost exclusively to sculpture in stone.
Thus, although this work belongs to the Romanesque era, strictly
speaking it cannot – in common with almost all contemporary arte-
facts in base or precious metals or enamel of the Mosan region – be
described as Romanesque sculpture. From Roger von Helmarshausen,
through Rainer of Huy, and Godefroid of Claire to Nicholas of Ver-
dun, there evolved an extremely refined Classical art form closely
linked, on the one hand, to the Ottonian courtly tradition (Liège and
the Mosan region were, for political reasons, especially close to the
Empire), and, on the other, to the emergent Gothic movement.
Byzantine restraint combines with Classical balance and naturalism to
create an extraordinarily modern view of the world, to which the
courtly elements of High Medieval art contribute a sense of restrained
energy and aristocratic detachment.
Usener, *MJKw*, 1933, 77. Collin-Gevaert, *Hist. des arts du métal en
Belgique*, 1951, 140. Beckwith 1964, 178, 246. Swarzenski 1967, 31, 58.

NICHOLAS OF VERDUN

V *The Shrine of the Magi*, detail *c.* 1190 silver gilt 1·70 × 2·10 m. (the
entire shrine)
Cologne, Cathedral
It is now universally agreed that this shrine is the work of Nicholas of
Verdun, even though it was, in large part, worked on by other hands
and completed after his death in 1220. This conclusion is based on close
stylistic affinities between this work and the scenes on the enamel altar
front of Klosterneuburg, and the reliquaries of Siegburg and St
Pantaleon in Cologne. Here we find the rugged and fanciful expression-
ism of the Klosterneuburg figures subordinated to Classical discipline,
though the intense dramatic energy is preserved. In terms of artistic
evolution, this work is a forerunner of Gothic art, and in particular the
Classical Gothic of Rheims.
Falke, *ZChrK*, 1905, 161; *Der Dreikönigsschrein des N.v.V.*, 1911.
Weissgerber, *Studien zu N.v.V.*, 1940. Mütherich, *Ornamentik d.
rheinisch. Goldschmiedek.*, 1941. Hoster-Schnitzler, *Der Meister des
Dreikönigschreins*, 1964. Castelnuovo, *N. di V.*, 1966.

VI *Adam and Eve after the fall, the Expulsion, the Labour and the Crime of Cain*,
detail of door *c.* 1100 bronze 0·56 × 0·52 m.
Verona, S. Zeno
The door was enlarged and rearranged at some date around the
the middle of the 12th century, with the addition of a number of new
panels. The two panels here reproduced belong to the earlier, original
series. It has much in common with a small bronze now in the Hirsch
Collection in Frankfurt, signed STEPHANUS LAGER [INUS] which
suggests that it was probably made in a workshop in the valley called
Val Lagarina in the Trentino. The suggestion which has been put
forward that this is a work of the Ottonian school in the style of

Hildesheim, is untenable. It is, on the contrary, a major masterpiece of
Romanesque Lombard sculpture, stylistically naïve, but powerfully
expressive. The movements of the figures are strikingly purposeful,
creating a feeling of indomitable energy and immense determination.
Boeckler, *Die Bronzetür von S.Z.*, 1931. Francovich, *RIASA*, 1936,
Arslan 1943, 71. Jullian 1945. Magagnato, 1962, 12. Salvini 1963, 25.
Ragghianti 1968, 772.

GISLEBERTUS

VII *Eve c.* 1130 stone 0·72 × 1·32 m.
Autun, Musée de la Cathédrale
This is the only surviving figure from the original lintel of the rebuilt
north portal: it was accompanied by the lost figures of Adam and of
the Serpent, thus representing the Original Sin, while the lost original
lunette was carved with scenes from the story of Lazarus. It is an
exceptional masterpiece and perhaps the most fascinating figure in the
whole of Romanesque sculpture. The pictorial delicacy of the model-
ling and the rhythmical subtlety in the prolonged sinuous curves of the
contours strike a note of alluring femininity, immediately redeemed
by a clear spiritual overtone. It seems probable that Gislebertus was
inspired by some earlier Classical work in the style of the *Reclining
Woman* in the Museum at Beaune.
See 46. Jalabert, *GBA*, 1949, 247.

BONANUS PISANUS

VIII *The Flight into Egypt*, detail of door, *c.* 1190–95 bronze *c.* 0·60 × 0·50 m.
Pisa, Cathedral (Porta di S. Ranieri)
The composition, dominated by the upright figure of the Virgin, is
gracefully enclosed within the palm tree and the bent figure of Joseph,
both curving inwards, but the difference in height between the tree and
the man introduces a touch of spontaneity into what might otherwise
have seemed a too rigidly symmetrical scheme. Light pours down
upon the delicately modelled figures while, in contrast, the bundle
swaying on the end of Joseph's pole, and the bending branches of the
palm tree suggest the refreshing breezes and cooling shade of an oasis
after the long journey through the desert.
See 142.

IX *The Coronation of the Virgin, the Crucifixion, the Saints Peter, Paul,
Stephen and a Saint Bishop c.* 1340 ivory. 0·32 × 0·20 m.
London, British Museum
This triptych belongs to a group of ivories bearing the arms of Bishop
John de Grandisson of Exeter and it can be dated by reference to
sculptures in Exeter Cathedral and the Collegiate Church of Ottery St
Mary, both commissioned by Grandisson. It is a typical example of
XIVth century western English ivory carving which owes much not
only to French but also to Italian art (Sienese School: Tino di Camaino,
Goro di Gregorio, Giovanni d'Agostino), as can also be seen in the
diptych panel with the Annunciation and St John the Baptist (British
Museum) and in another similar triptych, where the Virgin and Child
are almost the copy of a Sienese painting.
Stone 1955, 173.

NOTES ON THE MONOCHROME ILLUSTRATIONS

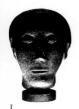

1

2

3

4

5

6

EARLY MIDDLE AGES

PRE-ROMANESQUE SCULPTURE

1 *Head, believed to be of Theodolinda* 7th cent? stone 0·17 × 0·13 m.
Origin unknown
Milan, Museo del Castello Sforzesco
Expert opinion is divided as to date. Vigezzi places it in the 8th–9th
century, while Gray, believing it to be the work of a minor Palatine
craftsman in Monza, favours the end of the 8th century or the beginning
of the 9th. Arslan, on the other hand, noting its similarity to the figures
on the capitals of Sta Maria del Popolo in Pavia (14), places it at the
beginning of the 10th century. The style, however, points to an earlier
date, probably late 6th or early 7th century, for, whereas there is no
known Early Medieval sculpture in the round, such works were by no
means uncommon in Late Classical times. The piece can be regarded
as the plebeian counterpart of the patrician Byzantine head, exemplified
by the Theodora (ii) in the same museum. The clarity and sharp
definition which characterize the latter here give place to rough
surfaces and blurred outlines, and, in contrast to the air of overweening
pride so striking in the Theodora, the features appear more relaxed,
softened as they are by a very human expression of patient resignation.
Vigezzi, *La Scultura in Milano*, 1934, nº 142. Gray, *BM*, 1935, 191.
Salvini 1952, 210. Arslan 1954, 529. Salvini 1956, 20. Felletti Maj
Comm, 1963, 89. Romanini, *Atti 4º Congr. Alto medioevo*, Spoleto 1968.

2 *Statuette of a saint* 7th cent. marble 0·14 m. (the face)
Ravenna, Museo Nazionale
A marble fragment used as masonry in the Campanile of S. Apollinare
Nuovo. Galassi places this piece together with a companion piece, in
the 8th century. It differs from other works definitely attributed to this
period in so far as it preserves rather more of the Antique organic and
plastic conception of form. The type derives from an Early Christian
sarcophagus but the style, on the other hand, is descended from Roman
provincial reliefs like the Florentine pillar (i). All the indications, there-
fore, are that it dates from the 7th century.
Galassi, *L'Architettura Protoromanica nell'Esarcato*, Ravenna, 1928, 105.
Salvini 1952, 210.

3 *St Peter and St Paul* 7th–8th cent. stone slab 0·99 × 0·57 m.
From the Église des Pélérins
Narbonne, Musée Lapidaire
The stylistic affinities of this piece both with Spanish Visigothic

sculpture (4, 5) and with Italian Lombard sculpture (8, 9) show the
unity of stylistic development prevailing in stone and marble sculpture
in Western Europe and the common source in Roman provincial
sculpture.
Santier-Hubert, *Les Origines de l'Art Français*, Paris 1947, 122.
Durliat, *Études mérovingiennes, Actes des Journées de Poitiers*, Paris 1953,
93.

4 *Daniel in the lions' den*, detail of capital, end of 7th cent. stone
S. Pedro de la Nave (Zamora), Parish Church
Although subject and treatment have much in common with Frankish
fibulas, the style clearly derives from the finest examples of Roman
provincial art.
Haupt, *ZGA*, 1910–11, 230. Camps Cazorla, *Historia de España*
(Menendez-Pidal) III, Madrid 1940, 456. Schlunk, *AEA*, 1945, 242.
Palol de Salellas in *I Goti in Occidente*, Spoleto 1956, 65. Francovich
1961, 194. Palol-Hirmer 1965, 16, 155.

5 *Christ between two angels*, detail of capital, 7th–8th cent. stone 0·44 ×
0·93 m.
Quintanilla de las Viñas (Burgos), Parish Church
The remarkable stylistic affinity between this piece and the Ratchis
Altar (9) illustrates once again the derivation of all such works from
Roman provincial art.
Lozoya, *Historia del arte hispanico*, I, Barcelona 1931, 191. Cecchelli
1943, 5. Lambert, *CRAIBL*, 1955, 483. Francovich 1961, 189. Palol-
Hirmer 1965, 16, 155.

6 *Sarcophagus of Theodota c.* 735 marble slab 0·66 × 1·76 m.
From the Abbey of Sta Maria della Pusterla
Pavia, Museo Civico Malaspina
This panel, like the famous one with peacocks and another bearing an
epigraph, originally formed part of the sarcophagus of the Lombard
princess, Theodota (d. 720), who became Abbess. (Whether the other
panels depicting the Agnus Dei and related fragments also formed part
of the same tomb is more doubtful.) The Theodota panel, according
to the somewhat obscurely worded epigraph, was executed in the year
735, or later. Though often described as a masterpiece of Lombard art,
it is one of a number of 8th-century reliefs in the pre-Romanesque
style, much influenced by the refinement of Byzantine art, and also, to
some extent, by the designs of Eastern silks.
Venturi II, 139. Rivoira 1908, 119. Toesca 1927, 277. Haseloff 1930, 54.
Gray, *BM*, 1935, 191. Kautzsch, *RJKg*, 1941, 4. Panazza in *Arte del
Primo Millennio*, 1950, 214, 256. Ragghianti 1968, 358.

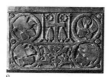

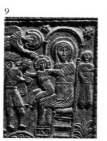

9

10

7

8

11

7 *Cross, flanked by peacocks, stags, and lions c.* 750 marble slab 0·85 × 2·00 m.
From one of the earlier cathedrals on the site of the present one
Modena, Museo Lapidario del Duomo

Removed *c.* 1913 from the south wall of the Romanesque cathedral, where it had been used merely as building material. Another marble fragment, similarly ornamented, though perhaps superior in the harmony of its composition, is inscribed with the name of Bishop Lopicenus, a name also recorded in a document known to date from between 749 and 756. This slab, along with a number of other pieces of carved stone in the same museum, must, therefore, have been part of an enclosure built about the year 750. It has stylistic affinities with the Theodota slab and, like it, shows a strong Byzantine influence, though it is livelier, more powerful and compact.

Bertoni 1921, X. Toesca 1927, 278. Gray, *BM*, 1935, 191. Borghi, *AMDSPM*, 1943. Cecchi, *Atti 4º Congr. Alto medioevo*, Pavia 1967, Spoleto 1969, 353.

8 *Patriarch Sigvald's slab c.* 737 marble 0·77 × 1·26 m.
Cividale, Museo Cristiano

This slab was built into the baptismal font at an undetermined date, but probably during the 8th century. The font was more than once transferred and rebuilt, and is now surmounted by the *tegurium* of the Patriarch Callixtus (since when is not known). The inscription on the median horizontal lintel, HOC TIBI RESTITUIT SIGVALD BAPTISTA JOHANNES, indicates a date in the second half of the 8th century, during the tenure of the Patriarch Sigvald, but the word *restituit* suggests that the slab, or perhaps the whole ensemble to which the slab belonged (an altar or a pulpit?) was restored. Furthermore, the script, in palaeographic terms (*see* Mor), seems to be later than that of the scrolls of the four Evangelists with their verses from the Carmen Paschale, by Caelius Sedulius, 5th century. It seems, therefore, although the opposite view has been widely canvassed, that the piece – like the reliefs of the *tegurium* with which it has features in common – dates from the time of Callixtus. Its stylistic affinity with 6, 7, 9, and other reliefs of the period, confirms that the panel dates from the first half of the 8th century. In spite of a superficial roughness, this piece is remarkably powerful and expressive, through the firmness and tautness of its line in both the surround and the interior design.

Rivoira 1908, 119. Toesca 1927, 277. Santangelo 1936, 15. Cecchelli, 1943, 35. Mor, *MSFg*, 1954–5, 169. Marioni-Mutinelli 1958, 154, 347.

9 *The Adoration of the Magi c.* 740 limestone 0·90 × 0·80 m. (whole slab)
From the Altar of Duke Ratchis, Baptistry of S. Giovanni
Cividale, Museo Cristiano

One of the three reliefs on the altar, dedicated – according to the epigraph – by Ratchis, Lombard Duke of Friuli, 737–44. A remarkably expressive work, in which Naturalism, and even a tendency towards expressionism, are kept in check by a strict formalism, combined with an abstract element deriving from Eastern art.

Toesca 1927, 279. Santangelo 1936, 85. Cecchelli 1943, 1. Marioni-Mutinelli 1958, 353. Fillitz, *JKslgW*, 1958, 39. Brozzi-Tagliaferri, *Arte Longobarda*, 1, Cividale 1961, 27. Francovich 1961, 173.

10 *Horseman slaying a dragon* 9th cent? marble slab 1·68 × 0·55 m.
Aversa, Cathedral

An enigmatic work, in terms of iconography, since it cannot be supposed, at this early date, to represent St George and the Dragon. The style also poses a problem. Critics are uncertain as to whether it has an Eastern origin, which is suggested by the zoomorphic and decorative motifs of its companion slab, or whether it derives from the barbaric sculpture of the North, which is more difficult to substantiate. Undeniable, however, is the considerable artistic merit of the piece, in which a prophetic vision is expressed with quite remarkable power and freedom of line.

Volbach, *AB*, 1942, 172. Ortolani, *BA*, 1948, 296. Bologna-Causa, *Sculture lignee della Campania*, Naples 1950, 24, 31. Valentiner, *AQ*, 1953, 189. Grelle, *Napoli Nobiliss*, 1965, 157. Rotili in *Storia di Napoli*, 1968, 921.

11 *The Massacre of the Innocents and the Flight into Egypt*
First half of 11th cent. marble screen
From the Church of Sta Dominica (Nediljica)
Zara, Museo Medioevale di S. Donà

This piece has been variously ascribed to dates as far apart as the 9th and 12th centuries. Its close affinity with the canopy above the tomb of the Proconsul Gregory (1030–36) indicates a date somewhere in the first half of the 11th century. The composition of 'figures under arches' derives from a well-known group of Early Christian tombs, whereas the 'tubular' style of the panels is related to the Late Roman sculpture of the Balkan-Danube province. Although the carving is in low relief, the figures stand out sharply from the background. The composition, in which the figures are extended here and there to break the stiff continuity of the arches, is felicitous and adds freshness to the folk narrative, while retaining, in both the centre panel and the frieze, some of the elegance of the Byzantine tradition.

Gabelentz, *Mittelalterliche Plastik in Venedig*, Leipzig 1903, 106. Porter 1923, 18. Toesca 1927, 433. Karaman, *Iz kolijevke hrvatske proslosti*, Zagreb 1930, 113. Cecchelli 1932, 187. Jullian 1945, 17. Karaman, *BIz-LUJA*, 1957, 197. Petricioli, *Stucchi 8º Congr. Alto Medioevo*, 1962, 360.

12 *Christ in Majesty*, detail of architrave above portal *c.* 1020 marble
St Genis-des-Fontaines (Eastern Pyrenees), Church of St Genis
This piece, along with the architrave of St André-de-Sorrède and the tympanum in the church of Ste Marie at Arles-sur-Tech (1046), is one of the most important examples of the work of the Pyrenean school. The epigraph indicates a date between 1019 and 1021. The highly decorative, somewhat precious style of the draperies shows the influence of minor crafts in the Carolingian-Ottonian tradition, and the relationship existing between the sculpture and architecture already foreshadows Romanesque art. The work, however, is in the popular tradition of the Early Middle Ages, and is a logical development of the style of which 4, 8, 9 and 11 are typical examples.
Porter 1923, 18. Focillon 1931, 72. Gudiol Ricart-Gaya Nuño 1948, 20. Salvini 1956, 34. Durliat 1958, 76. Gudiol, *20th Intern. Congr.* 1963, 76.

13 *Capital with four Atlas-figures c.* 903–12 stone 0·30 m. (the figures)
Piacenza, S. Savino (crypt)
Some of the capitals in the crypt are very different from those of the church itself, and more archaic in style. The consecration was documented in 1107. It is, therefore, probable that they originally belonged to one of the earlier churches which stood on the site of the existing Romanesque building – and more precisely to the church which we know was built between 903 and 912. If this is so, this capital and some others in the crypt are notable and precocious examples of transitional stone-carving·between the pre-Romanesque and Romanesque eras, in which the organic relationship of sculpture and architecture is already highly developed.
Porter 1917, III, 266, 271, 277. Arslan 1954, 528.

14 *Capital with portrait busts c.* 912–24? stone 0·46 × 0·50 m.
From Sta Maria del Popolo
Pavia, Museo Civico Malaspina
This piece, almost certainly, was originally part of the church rebuilt by Bishop John III between the years 912 and 924. In terms of the relationship between sculpture and architectural structure, it is more primitive than the capitals in the crypt of S. Savino at Piacenza, but it is noteworthy as an example of the steady progress towards plasticity of form.
Porter 1917, III, 189. Arslan 1954, 529. Romanini, *Atti IV Congr. Alto Medioevo*, Spoleto 1968.

15 *Kneeling abbot c.* 1030–40 stone 0·33 m. (the bust)
Tournus, St Philibert
Representing the ABATE·ISTO quoted together with the name of the architect Gerlannus in the epigraph inscribed on the right side of the archway: probably the Abbot Ardain (*c.* 1028–56). This archway originally connected the upper storey of the inner narthex with the central nave. These, at least, are the conclusions to be drawn from recent studies of Vallery-Radot and Lesueur, indicating a date in the 11th century (1028–56) rather than the earlier one previously favoured by scholars. Stylistically, this piece closely resembles the relief portrait of a stonemason in the museum at Poitiers.
Viery, *Saint-Philibert de Tournus*, Paris 1932, 45. Vallery-Radot and Lassalle, *Saint-Philibert de Tournus*, Paris 1955, 15, 208. Lesueur, *Mélanges Crozet*, I, Poitiers 1966, 215.

16 *The Flight into Egypt c.* 1080? stone 0·85 × 1·00 m.
From capital in Gauzlin's tower
St Benoît-sur-Loire, Abbey Church
Date in dispute. Some maintain that not only were the foundations of the tower laid, but the building was largely completed, between the years 1020 and 1030, by Abbot Gauzlin. Others, maintaining that the tower was still unfinished on the death of Gauzlin in 1030 (as stated in the *Vita Gauzlini*), think that the tower was largely built by Abbot Guillaume, who is known to have built the crypt and the choir between 1067 and 1108: therefore, for the tower and its capitals a date around 1075–90 is favoured. The same dating is supported by other scholars, who identify Gauzlin's tower with a fortress tower demolished in 1683 rather than with the present one. The remarkable strength and firmness of the form, and the organic relation between the figures and the structure of the capital are not paralleled in the first half of the 11th century and are more easily explained if the later dating is accepted. This, and the other capitals of the series – from different artists (one of them signed UNBERTUS) – would, in this case, mark the transition between the still uncertain and tentative pre-Romanesque language and the new firmness of Romanesque sculpture.
Focillon 1931, 151. Aubert 1946, 93. *Val de Loire Roman*, Zodiaque 1956, 90. Messerer 1964, 133.

17 *Capital with angel holding a book* mid 11th cent. stone
From the nave of St Germain-des-Prés, Paris
Paris, Musée de Cluny
One of a series of twelve large capitals removed from the site, during restoration work in the last century. Scholars are undecided about the date, placing it somewhere between the first decade and the middle of the 11th century. The integration of the figure with the overall design is striking.
Lefèvre-Pontalis, *Congrès archéol. de France*, 1919, Paris 1920, 301. Messerer 1964, 133.

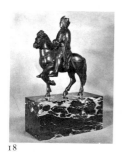

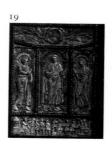

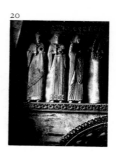

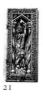

CAROLINGIAN AND OTTONIAN ART

18 *Equestrian statuette of Charlemagne c.* 870? bronze 0·24 m.
From the Metz Cathedral Treasure
Paris, Louvre
Generally believed to be a portrait of Charlemagne, this piece, on the basis of recent studies of the Metz ivories, is considered the most disciplined work of the age of Charles the Bald. It has recently been suggested that it was inspired by the original equestrian statue, *c.* 810, cast in the workshops of Aachen. Whatever the piece may owe to the Roman equestrian monument, it is certainly original in that it succeeds in unifying the two polarized forces of Classic art: naturalism and stylization.
Schramm, *Die zeitgenössischen Bildnisse Karls des Grossen*, Leipzig 1928. Koehler, *Deutsche Literaturztg.*, 1930, 939. Hubert, *L'Art préroman*, Paris 1938, 138. Deer, *Wandlungen christl. Kunst in M.A. Doppelbildnis K. cl. Gr.*, 1953, 139. Schramm-Mütherich, *Denkmale der deutschen Könige und Kaiser*, Munich 1962, Nr. 58. Mütherich, *Festschrift Müller* Munich 1965, 9.

19 *Cover of the Lorsch Gospels c.* 810 ivory 0·38 × 0·27 m.
From the Abbey of Lorsch (Rhineland)
Rome, Vatican Museum
Masterpiece of the Palatine school of Aachen, the work of three craftsmen: (*a*) the two angels holding monogram (*above*); (*b*) Christ and one angel (*on the left*); (*c*) the other angel (*on the right*) and the Adoration of the Magi (*below*). In comparison with the almost academic Classicism of (*a*) (Morey, re-use of ivory carving of the 5th century; cf. Schnitzler for the contrary view), and the strongly Byzantine style of (*c*), the originality of (*b*) appears all the more striking, deriving as it does from the fluidity, fantasy, and irregular linear composition of Late Classical models, while at the same time achieving a style of its own, which is warm and charged with feeling.
Goldschmidt, *JPKslg*, 1905, 59, 64. Morey, *Gli oggetti di avorio e di osso del Museo Sacro Vaticano*, Città del Vaticano 1936. Schnitzler, *MJBK*, 1950, 26. Beckwith 1964, 34. Braunfels 1965, 254. Volbach 1968, 232.

20 *Procession of saints*, detail 9th cent? stucco each fig. *c.* 1·86 × 0·45 m.
Cividale, Chapel of Sta Maria in Valle
Variously ascribed by scholars to the 8th, 9th, 10th, and 11th centuries. They undoubtedly resemble the recently discovered stuccoes of S. Salvatore in Brescia, whose date is also uncertain. In some respects, they are similar to the stuccoes in Germigny-des-Prés, which suggests a date in the 9th century. The Sassanid influence apparent at Germigny is paralleled by the Palmyran and Iranian influences in the Cividale figures. There is, however, a tension and degree of abstraction, which accounts for the view that they are Ottonian in style. They are, in any case, splendid examples of the intensely refined courtly art of the Early Middle Ages.
Toesca 1927, 791. Santangelo 1936, 69. Cecchelli 1943, 93. Francovich, *RJKg*, 1942–44. Coletti, *Il tempietto di Cividale*, Rome 1952. L'Orange, *Atti 2º Congr. Spoleto*, 1953, 95. Cecchelli, *Settimane Spoleto*, 1954, 204. Francovich, *Settimane Spoleto*, 1955, 370. Panazza, *AL*, 1960, 161. Peroni, *AL*, 1960, 187. Torp, *Atti 8º Congr. Spoleto*, 1962, 61. Francovich, *Atti 8º Congr. Alto Medioevo*, Milan 1962, 65. Ragghianti 1968, 377.

THE MASTER OF ECHTERNACH

21 *Moses receiving the Tablets of the Law c.* 990 ivory 0·24 × 0·10 m.
From the Figdor Collection
Berlin, Staatliche Museen
The work of a highly original craftsman of the Echternach-Trier region, who also carved the cover of the Gospels, formerly in the Library at Gotha, now in the Germanisches Nationalmuseum at Nuremberg, which was commissioned by the Empress Theophanu (985–91). There are very few other known examples of his work. Emotional exaltation and spiritual vision are perfectly fused both in the tense lines of the border and in the figure itself, which is conceived in a highly pictorial style, without detriment to the plastic requirements of the medium. This is a work of great stylistic refinement, robust and yet, at the same time, aristocratic and not, as is often suggested, plebeian in character.
Vöge, *JPKSlg*, 1899, 119. Goldschmidt, *Elfenbeinskulpturen* II, 1918, 23, Nordenfalk, *ZKG*, 1932, 153. Jantzen 1947, 141. Oettinger, *JBM*, 1960, 39. Swarzenski 1967, 40.

22 *St Emilianus expelling the Devil from the house of Senator Honorius* 1033? ivory 0·17 × 0·12 m.
From S. Millàn de la Cogolla
Madrid, Museo Arqueológico
These ivories, some still *in situ* (one is in Florence), are often described as examples of Early Romanesque sculpture; in fact they hark back, in sustained elevation of style, to Ottonian art, as can be seen from their affinity with the work of the Master of Echternach, in spite of some slackening of linear tension. For this reason, of all the dates mentioned in reports of the transfer of the Blessed Relics from one place to another (1033, 1053, *c.* 1067–70, *c.* 1073), the earliest is the most likely.
Debenga, *AE*, 1916, 243, 296, 328. Porter 1923, 37. *Ars Hisp.* VI, 1950, 292.

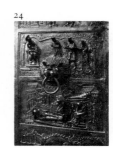

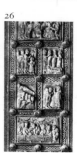

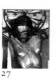

23 *Symbolic representations and the Creation of Man and Woman*, detail from the bronze doors, left wing lower zones early 11th cent. 4·00 × 1·29 m. (the entire wing)
Augsburg, Cathedral
Opinion is divided as to date, some placing it as early as the beginning of the 11th century, others as late as 1060–5. The earlier date seems the more probable, since it must be as old as the cathedral itself, which was built in the early part of the century. The lively, prancing figures in the centre of the panels, surrounded by ample space, evoke a sense of limitless distances. This spatial illusion, typical of Late Antique art, is combined with an intensely pictorial relationship between figures and background, owing much to Carolingian and Byzantine influences.
Beenken 1924, 14. Panofsky 1924. Goldschmidt 1926. Jantzen 1947, 129. Feulner-Müller 1953, 29. Leisinger 1956, pls. 36–57. Steingräber 1961, 11.

24 *The Nativity and the Adoration of the Magi*, detail of bronze doors, right wing, *c.* 1008–15, 4·72 × 1·15 m. (the entire wing)
Hildesheim, Cathedral
See note on III. It should be noted that the right side of the door is the work of a minor artist who, though maintaining a high level of craftsmanship, tends to blow up the figures out of all proportion to the background, thereby undermining the harmonious relationship between modelling and surrounding space, so evident in the work of the principal artist.

25 'Noli me tangere', detail of column *c.* 1020–30 bronze 0·45 m. (detail) 3·79 × 0·58 m. (column)
Hildesheim, Cathedral
Work commissioned by Bishop Godehard, and executed by the workshop of the great master who created the bronze doors. The composition was inspired by Roman triumphal columns and it is a splendid example of the spirit of the Late Antique reborn in Ottonian art. The Christian miracles are presented as the deeds of a warrior. In contrast to the relief on the door, the narrative unfolds at a more tranquil and leisurely pace, in which figures and frame form a remarkably harmonious entity.
Zeller 1907. Haftmann, *ZKG*, 1939, 151. Jantzen 1947, 128. Fink, *ZKW*, 1948, 1. Tschan 1951, 271, 336. Wesenberg 1957. Oakeshott 1959, 68. Beckwith 1964, 146.

26 *Panels of a wooden door c.* 1065 walnut in an oak frame with traces of polychrome 4·85 × 1·12 m. (each wing)
From portal of north transept

Cologne, St Maria im Kapitol
The original setting suggests that it was completed in 1065, at the same time as the choir, rather than in 1049, when the nave was built, or at an earlier date. The style of this piece has often been described as Middle High German and even Low German, implying that it falls into the category of popular Romanesque art. In fact, the style is elevated, in the Medieval Latin tradition. The choice of materials and layout owes much to Early Christian models (Sta Sabina in Rome, S. Ambrogio in Milan), which are also recalled in the Classic proportions and sophisticated harmonies of the piece. These, while not detracting from the vivacity of the narrative, strike the dominant stylistic note. The workmanship also shows affinities with typically post-Ottonian ivory-carvings, in particular the small London plaque illustrated in Swarzenski 1967, 38–9, the cover of the Gospel Book of the Abbess Theophanu in Essen, another carving by the same artist in the Schnütgen Museum (catalogue 1964, no. 3b), and a fragment of carved bone (*ibid.*, no. 11).
Panofsky 1924, 77. Hamann, *Die Holztür der Pfarrkirche zu St. Maria im Kapitol*, Marburg 1926. Jantzen 1947, 130. Feulner-Müller 1953, 40.

27 *Crucifix*, detail *c.* 970 oak, originally polychrome 1·87 m.
Cologne, Cathedral
Gift of Archbishop Gero (*d.* 976), recorded in Thietmar's Hagiography. The spacious and harmonious composition, Classical in conception, nevertheless has strong elements of expressionist realism; in this, it is one of the masterpieces of aristocratic Ottonian art.
Beenken 1924, 214. Hamann, *MJKw*, 1924; *StJ*, 1930. Blankenburg, *JPKSlg*, 1943, 139. Jantzen 1947, 132. Keller, *Festschrift Jantzen*, Munich 1951. Feulner-Müller 1953, 31. Haedeke, *KDb*, 1958, 42. Steingräber 1961, 10, 12. Beckwith 1964, 150.

28 *Crucifix*, detail *c.* 1070 bronze 1·00 m.
From Helmstedt
Essen-Werden, St Liudger Abbey
This piece is profoundly different in style from Gero's Crucifix, which antedates it by a hundred years. In place of the acute tension and overpowering realism of the Cologne Crucifix, we find a new abstract quality and a cumulative sense of sorrowful resignation. The former can also be seen in the hitherto unfamiliar geometric abstraction of the face, in which subtle touches of lightness and discreet asymmetry here and there, in breach of any tradition of rhythmic inertia, underline the intensely poetic quality of the work.
Rademacher, *ZDVKw*, 1941, 141. Jantzen 1947, 133. Steingräber 1961, 12. Beckwith 1964, 174. Swarzenski 1967, figs. 218–20.

29

30

31

32

33

34

29 *Crucifix c.* 1020 beaten copper, Gothic mounting 0·26 × 0·19 m.
From S. Dionigi
Milan, Cathedral
At the foot of the Crucifix is a figurine of Archbishop Ariberto (1018–45), offering a model of the church of S. Dionigi. This piece, though it has not had the recognition it deserves, is a notable example of Ottonian art in Lombardy. Taking into account its stylistic affinities with the apse frescoes of S. Vincenzo at Galliano (1007), and its iconographic as well as stylistic relations with miniatures (Sacramentary of Lorsch, Chantilly) and niellos (Mainz, Cathedral, cover of MS. no 1) of the end of the 10th century and the beginning of the 11th, the most probable date is soon after the elevation of Ariberto to the archbishopric.
Salmi, *D*, 1921–2, 762. Toesca 1927, 754. Francovich, *RA*, 1935, 1; *RJKg*, 1942–4, 223. Hackenbroch. *Ital. Email des frühen Mittelalters*, Basle-Leipzig 1938, 32. Arslan 1954, 530.

30 *Christ Enthroned c.* 1060 polychrome stone 1·25 m.
Regensburg, St Emmeram
The medallion portrait of Abbot Reginwart (1049–69) establishes the date of this work, which has often erroneously been regarded as an early example of Romanesque sculpture. The fact is that although this and its companion figures have been erected round one of the doors, they bear no relationship to the architecture, and each stands in isolation, solid and self-contained.
Porter 1923, 33. Jantzen 1947, 149. Feulner-Müller 1953, 49. Salvini 1956, 33.

31 *Tomb of Abbot Isarn c.* 1050 marble 2·87 × 0·59 m.
From St Victor
Marseilles, Musée Borély.
Hitherto considered an early example of Romanesque sculpture, this work is in fact courtly in character, and is in the tradition of Ottonian art. The perfect frontal view, and the sharply defined powerful contours obliterate the sense of space and relationship of the figure with its background, creating an impression of both abstraction and volume, reinforced by the brilliantly conceived geometrical framework of the slab, which in turn is accentuated by the extremely elegant capital lettering.
Porter 1923, 32. Salvini 1956, 33, 49. *Art Roman*, 1961, 402.

32 *Sign of the Zodiac: Aquarius c.* 1080 stone 0·62 × 0·42 m.
From the tower of Brauweiler Abbey
Bonn, Rheinisches Landesmuseum

This work, along with the rest of the series, is a masterpiece of great pictorial delicacy and rhythm. The series is a rare example – another is the Astrolabe in the Regensburg Museum – of what might be called the 'decorative' phase in Ottonian art.
Francovich, *RIASA*,1940, 266. Salvini 1956, 47. Steingräber 1961 13.

33 *The Dormition of the Virgin c.* 1093 stucco 1·13 × 1·90 m.
Civate, S. Pietro al Monte (crypt)
Although reliable scholars have ascribed the piece to the 12th century or later, seeing in it traces of the influence of Niccolò or Antelami, there is, nevertheless, indisputable internal evidence that these stuccoes, as well as those in the church itself, and the adjoining frescoes, are distinguished examples of the final phase of Ottonian art. There are, moreover, a number of historical references which clearly indicate 1093 as the approximate date. The subtle rhythmic quality and great delicacy of the modelling are in accordance with the characteristic style of the medium, so that the ritual solemnity of the scene is softened by a prevailing mood of muted grief.
Feigel, *MhKw*, 1909, 206. Toesca 1912–1966, 62; 1927, 768. Ladner, *JKSlgW*, 1931, 154. Toesca, *Monumenta Artis photographice edita: Abbazia di SP. alM a C.*, Florence *s.a.* Francovich, *RJKg*, 1942–4, 139. Arslan 1954, 583. Salvini 1954, 626; *AL*, 1964, 61.

ANGLO-SAXON AND IRISH ART

34 *Christ Triumphant*, detail of Cross *c.* 675–85 red sandstone 4·57 m. (cross)
Ruthwell (Dumfries)
A very fine work, showing Byzantine and Italian Early Christian influences, as well as a clear inspiration from provincial Roman art in Britain. These elements are fused in a style which has patrician overtones. It is certainly later than the victory achieved by the Roman mission over the Celtic Church at the Synod of Whitby, 663, and subsequent to the import of Eastern objects by Benedict Biscop, 674, but – since the inscription on the Cross is in the Northumbrian dialect of Old English – earlier than 685, when the Northumbrians were driven out of the area.
Brown 1921, *V*, cap. 7. Saxl, *JWCI*, 1943. Shapiro, *AB*, 1944. Stone 1955, 10.

35 *Monumental Cross* mid 8th cent. stone
Kilkieran (Kilkenny, Eire)

35

36

37

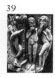

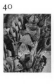
38

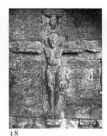

39

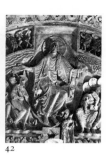
40

41

42

Irish art, abstract but not geometrical, full of vitality, yet without a trace of naturalism, finds its highest expression in illumination and metalwork. Irish sculpture is mainly to be found in the form of monumental crosses similar – though differing somewhat in form – to those found in England, Scotland, and Wales. The decoration, though abstract, is extremely vigorous, and carried out with dynamic freedom; it is often further enlivened by animal motifs of astonishing intricacy, all of which recall the ancient Celtic art from which it sprang. The dating of this work rests on its close affinities with metal objects of the period.
Henry, *La sculpture irlandaise*, Paris 1952, 164. Roe, *The High Crosses of Western Ossory*, Kilkenny 1958. Henry 1965, 139.

36 *Horseman*, detail of Cross end of 8th cent. sandstone 0·34 × 0·38 m.
Banagher (Offaly, Eire)
Part of a hunting scene. The stylized figures are placed one above the other as in Eastern art, whose influence is detectable in Celtic art from the very beginning. In composition and other stylistic features, this work closely resembles crosses to be found in Scotland. It also has affinities with the miniatures in the Book of Kells.
Henry 1965, 144.

37 *Shaft of monumental Cross* beginning 9th cent. sandstone 0·64 × 0·44 m.
From Easby (Yorkshire)
London, Victoria and Albert Museum
The figures (Christ in Majesty and the Apostles), as well as the decorative panels, Classical in style and carved with exceptional delicacy, demonstrate that English sculpture had fully assimilated the civilizing influence of Carolingian art.
Longhurst, *Arch*, 1931. Kitzinger, *Ant*, 1936, pl. VI. Stone 1955, 20.

38 *Crucifix* first half 11th cent. stone 1·80 m.
Romsey (Hampshire), Abbey
That this superb piece of sculpture belongs to Ottonian culture can be demonstrated by its affinities – often noted by scholars – with a number of German ivories, and above all by the remoteness and solemnity of the figure which, though substantial, retains something of the disembodied quality of an apparition.
Clapham 1930, 138. Kendrick 1949, II, pl. 21. Talbot Rice 1952, 98. Stone 1955, 40.

ROMANESQUE SCULPTURE
BURGUNDIAN SCHOOL

39 *The Original Sin*, detail of capital *c.* 1090–5, stone *c.* 0·79 × 0·45 m.

40 *Agriculture*, detail of capital *c.* 1090–5 stone *c.* 0·80 m.

41 *The Third Mode of Music*, detail of capital *c.* 1090–5 stone *c.* 0·85 × 0·70 m.
From the choir of the Abbey Church
Cluny, Musée du Farinier
Nos 1, 4, and 8 of the capitals from the ambulatory, destroyed in 1823. Although many scholars have dated this famous series to 1115–20, 1150, or even later, their elevated style and great beauty point to an earlier period. Indeed, it can be said with certainty that they were completed before 1095, the date of the consecration of the choir, since it was common practice at that time to complete the carving prior to installation. Collectively, they create – through a fresh pictorial quality in the modelling and a rhythmic elegance in the design – an impression of relaxed intimacy, in which musical overtones, lively and elegiac at one and the same time, can be distinguished.
Terret, *Cluny*, Cluny 1914. Porter, *GBA*, 1920, 73. Porter 1923, 77. Focillon 1931, 155. Francovich, *RIASA*, 1940, 266. Deschamps 1947, 57. Conant, *Spec.*, 1954. Salvini 1963, 41.

42 *The Mission of the Apostles*, detail of tympanum *c.* 1130 stone
Vézelay, Abbaye Ste Madeleine (portal)
Probably completed before its consecration by Pope Innocent II in 1132. The subject relates to the vision of Honorius the Hermit, and the inspiration of the iconography is a miniature in the Cluny Lectionary (*c.* 1100). The style, however, is entirely original, notably in the broad sweep of the composition, which gives to the figures a swirling movement, echoed in the thin folds of the drapery which spiral outwards from a whorl. As a result, the figures, detached from their surroundings, are living presences, to which the flowing, linear movement of the whole imparts a mystic solemnity.
Porée, *L'Abbaye de Vézelay*, Paris s.a. (*c.* 1910). Porter 1923, 109. Oursel 1928. Katzenellenbogen, *AB*, 1944, 41. Salet, *La Madeleine de V.*, Melun 1948. Deschamps, *BMon*, 1948, 229. Salvini 1963, 47. Messerer 1964, 69. Kerber 1966, 20

43 *Head of the Virgin*, fragment from architrave of main portal *c.* 1109–15 stone 0·16 × 0·12 m.

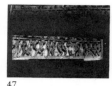
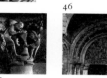

Cluny, Musée Ochier

Apparently by the same hand as the capital in the choir (39), and the last of the series, representing the Sacrifice of Isaac. This does not conflict with the dating of the capitals (*c*. 1090–5), since, in this work, a more rigorous control of proportion is combined with greater complexity and a larger degree of plastic freedom, which already foreshadows the style of Vézelay and, even more strikingly, of Autun.

44 *Signs of the Zodiac and human figures*, detail of archivolt *c*. 1130 stone 10·60 × 9·40 m. (the whole) 0·45 wide (each sign)
Vézelay, Abbaye Ste Madeleine

The archivolt is decorated with scenes of the nations of the earth and fabulous peoples, such as the shaggy-haired Cappadocians, described by Isidore of Seville and others, awaiting conversion to Christianity by the teaching of the Apostles. On the outer cornice are to be seen the Months and the Signs of the Zodiac. These groups, designed to fit the curve of the stone, create – through the skill of the craftsman in making the reliefs and the stonemasonry seem part of a single entity – an effect of pictorial delicacy, enlivened by subtle touches of sensuality. This is in complete contrast to the centre panel of the tympanum, where the stone seems almost dissolved, or at least made ethereal, by the intensity of the spiritual experience portrayed.

45 *St Paul's mystical mill*, detail of capital *c*. 1125 stone 0·66 × 0·66 m.
Vézelay, Abbaye Ste Madeleine (nave)

The date of consecration, 1104, refers to the choir, later replaced by a new Gothic one. The nave and aisles must have been built after the destruction of the old Carolingian nave in the fire of 27 June 1120. The capital portrays Moses tipping grain into a mill, which pours out as flour into the hands of St Paul, thus symbolizing the Old and New Testaments as a continuous revelation. The pictorial delicacy of the work and harmonious line express the inward joy of supreme piety.

GISLEBERTUS

46 *The Last Judgement*, portal *c*. 1135 stone 3·85 × 6·40 m. (tympanum and architrave)
Autun, St Lazare

The extreme elongation of the figures, invariably regarded as a sign of immaturity by archaeological scholars in former times, represents the progressively spiritual stylization inherent in all Burgundian Romanesque art. Beneath the feet of Christ is the legend: GISLEBERTUS HOC FECIT. Compared with the Vézelay relief, this work is less earthbound,

the mystic exaltation being expressed with even greater subtlety and intensity. The style suggests a date later than the Vézelay relief. Furthermore, a document of 1132, which refers only to the door of the north side, indicates a date some time after this.

Porter 1923, 1. Terret, *Autun*, Autun 1925. Focillon 1931. Aubert 1946, 100. Deschamps 1947, 61. Grivot-Zarnecki, *Gislebertus*, Paris 1960. Salvini 1963, 47. Sauerländer, *Festschrift Müller*, Munich 1965, 17. Kerber 1966, 22.

GISLEBERTUS

47 *The Resurrection of the Dead*, detail of lintel (46) 1·55 × 1·68 m.

The intense visionary quality of the work does not preclude a fresh and lively appreciation of nature and the flesh, although this is transfigured by an immediate transcription into an arabesque, the wonderfully pure lines of which transform these little people, as they rise, naked and trembling, from the grave.

GISLEBERTUS

48 *The Weighing of Souls*, detail of lunette (46) 1·77 m. (feet to wing tip)

49 *The Deposition c.* 1140 polychrome and gilded wood 1·55 × 1·68 m.
Paris, Louvre, Courajod Donation.

Originally belonging to a group of wood figures depicting the Descent from the Cross, this work is a masterpiece of the highest quality, very close in style to the carving of Gislebertus at Autun.

Courajod, *GA*, 1884, 91, 129. Porter 1923. Francovich, *Boll. Stor. Lucchese*, 1936; *KJBH*, 1938, 167.

GISLEBERTUS

50 *The Vision of the Magi*, detail of capital in nave *c*. 1130 stone 0·46 × 0·42 m.
Autun, St Lazare

An intensely lyrical work, owing to the pictorial delicacy of the modelling and the rhythmic lines of the composition. In the words of Zarnecki, 'the concentric curves of the cover spread outwards, like ripples on water stirred by the rhythmic breathing of the sleepers'.

Grivot-Zarnecki, *Gislebertus*, Paris 1960, 61. Sauerländer, *Festschrift Müller*, Munich 1965, 17.

LOMBARD SCHOOL AND RADIATIONS

51 *Capital with lion c.* 1100 stone 0·41 m.
Modena, Cathedral (crypt)

A pair of lions, one on each face of the capital, joined at the muzzle on

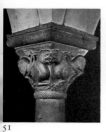
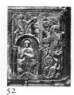

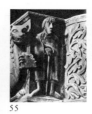
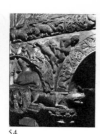

51 52 53 54 55 56 57 58 59

the corner. This technique of joining the two beasts at the head suggests that the sculptor used it as a convenient method of portraying the two profiles of a single lion. The foundations of the cathedral were laid in 1099. The crypt was the work of a Lombard master-mason, as can clearly be seen if this sculpture is compared with those on the capitals of S. Pietro in Cieldoro, and other churches in Pavia.
Bertoni 1921, XX. Salvini 1966, 126.

52 *Habakkuk and the Angel; Daniel in the lions' den*, reliefs on the portal beginning of 12th cent. stone 2·25 × 1·50 m.
Como, S. Fedele
Of all the schools of Romanesque sculpture, none adheres more strictly or wholeheartedly, in terms of bas-relief, to the pre-Romanesque popular conventions, while at the same time deploying much imaginative fantasy and a lively sense of the monstrous and grotesque.
Francovich, *RIASA*, 1935–6. Salvini 1963, 20.

53 *Animals rampant*, detail of main portal *c.* 1090 stone
Milan, S. Ambrogio
The main portal is a composite structure, made up partly from material despoiled from other churches, and partly from sculptures and slabs especially commissioned in the last decade of the 11th century. The detail reproduced here represents the birth of figurative sculpture, strictly circumscribed by the form of the building and designed to enliven the architectural features.
Arslan 1954, 538. Salvini 1963, 17.

54 *Scene with hunters, animals, and monsters*, detail of pulpit, *c.* 1100–10
Milan, S. Ambrogio
Damaged in 1196 when part of the roof fell in, the pulpit, incorporating the original sculptures, was restored in the first ten years of the following century. This masterpiece of Lombard sculpture expresses great tension, while at the same time always subordinating the figurative elements to the demands of the architecture. As a result, the bold naturalism of the carving endows the pulpit itself with an indomitable, if mysterious, vitality.
Porter 1917, 570, 573, 593. Conway, *BM*, 1919, 175. Gall, *MhKw*, 1921, 5. Porter 1923, 67. Toesca 1927, 755, 884. Francovich, *RIASA*, 1935–6, 294. Jullian 1945, 22. Arslan 1954, 557. Salvini 1963, 19.

55 *The Lion of St Mark and Abbot William of Volpiano*, detail of ambo *c.* 1115 serpentine, 1·03 m. (detail); 3·50 m. (ambo)
S. Giulio d'Orta, S. Giulio

Here the plebeian accents characteristic of Lombard Romanesque sculpture are infused with a new spirit of solemn exaltation which owes its being to the dominant influence of Ottonian art. But in the intimate *rapport* between architectural structure and decoration – expressed in terms of a close dialectical bond, where figures and stone are one and yet not one – the pulpit, while retaining its integrity as a superb abstract composition, pulsates with a secret life of its own, which is the very essence of Romanesque art.
Porter 1917, 470. Francovich, *RIASA*, 1937, 47. Canestro Chiovenda 1955. Salvini 1963, 20.

56 *Herod enthroned*, detail of capital of the Magi *c.* 1130–3 streaky marble 0·30 m.
Aosta, S. Orso (cloister)

57 *The Nativity*, detail of capital *c.* 1130–3 streaky marble 0·26 m.
Aosta, S. Orso (cloister)
An inscription dates the opening of the monastery in 1133, from which it may be deduced that the cloister was completed shortly before. An outstandingly lively work by a Lombard sculptor, having close affinities with the portals of S. Michele of Pavia. The hard, almost geometric simplicity of line endows the figures in these capitals with a severe and primitive humanity. The sober, yet imaginative vision of the artist evokes, with marvellous skill, the rustic intimacy of primitive Christianity.
Toesca, *Aosta*, Rome 1911, 116. Porter 1917, 66. Francovich, *RIASA*, 1936, 281. Jullian 1945, 138. Breton, *I capitelli del chiostro di Sant'Orso*, Nova 1956. Salvini 1963, 24.

58 *Detail from left portal c.* 1130 stone
Pavia, S. Michele
A typically Lombard sculpture, where the shallow cutting of the relief does not in the least detract from the vitality and fantasy of the work. The dating rests upon the close affinities between this piece and the capitals in the cloister of S. Orso in Aosta, known to have been completed shortly before 1133.
Francovich, *RIASA*, 1936. Jullian 1945. Peroni, *S. Michele di Pavia*, 1968.

59 *Monk with wolf's head taught by an ass*, detail of capital *c.* 1130–40 marble 0·26 × 0·30 m.
Parma, Cathedral
A satirical subject, probably referring to the rivalry between monks and clergy, as suggested by the words of the book held up by the

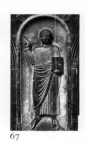

60 61 62 63 64 65 66 67

wolf-headed monk: EST MONACHUS FACTUS LUPUS AB ASINO SUB DOGMATE TRACTUS. The style is Lombard rather than Emilian, but powerfully influenced by the Burgundian School. The date can be deduced from the history of the church, which was destroyed in the earthquake of 1117, and rebuilt some years later. The satire is accentuated and underlined by the gentle curves of the relief, and the easy freedom of the linear composition.
Porter 1917. Toesca 1927, 764. Francovich, *RIASA*, 1936. Jullian 1945. Salvini 1963, 23.

60 *Samson and the lion*, detail of capital, east door, *c.* 1160 stone 0·58 m.
Mainz, Cathedral
In Germany, the facile Lombard style was widely disseminated by itinerant craftsmen, and is especially common in the Rhineland.
Kautzsch, *RAC*, 1914; *Der Mainzer Dom*, Frankfurt a. M. 1925. Hege, *Die Kaiserdome am Mittelrhein*, Berlin 1933. Francovich, *RIASA*, 1937. Lehmann, *ZKw*, 1951.

61 *The 'Giant Finn'* *c.* first half of 12th cent. stone 1·72 m.
Lund, Cathedral (crypt)
The work of an itinerant Lombard craftsman. This piece, as can clearly be seen, has close affinities with the animal reliefs of the portal of S. Ambrogio, Milan (53).
Wrangel, *Atti X Congr. Intern. di St. dell'Arte*, Rome 1922, 131. Anderson, *ASt*, 1928, 53. Francovich, *RIASA*, 1937, 48. Rydbeck, *Lunds Domkyrka*, Lund 1951. Canestro Chiovenda, 1955, 143.

62 *Virtue conquering Vice*, detail of cloister door *c.* 1170–80 stone 0·96 m., Millstatt (Carinthia, Austria), Benedictine Monastery
Here again, the shallow cutting of the relief is in the manner of the Lombard school. The date can be inferred from the building records of the monastery.
Hamann, 1922, I, 127. Novotny, *Romanische Bauplastik in Oesterreich*, Vienna 1930, 61, 77. Francovich, *RIASA*, 1937. Baldass-Buchowiecki-Mrazek, *Romanische Kunst in Oesterreich*, Vienna 1962, 75.

63 *Virgin and Child, dragon and mermaids*, detail of north portal *c.* 1160–70 stone
Regensburg, St Jakobskirche
The layout of the sculptures and ornamental figures, as well as the style of carving, sharp and uncompromising yet expressive, recall the work of Pavian sculptors. The church was rebuilt by Abbot Gregory in the second half of the 12th century.
Francovich, *RIASA*, 1937. Feulner-Müller 1953, 46. Salvini 1963, 84.

64 *Hares ensnaring a hunter*, relief on the apse *c.* 1150 stone 0·70 × 0·35 m.
Königslutter, SS. Peter and Paul
Here, as in Regensburg, the influence of Pavia is apparent, but in this instance a touch of wit is added through the liveliness of the modelling.
Beenken 1924, 112. Panofsky 1924, 101. Bernheimer, *Romanische Tierplastik*, Munich 1931. Kluckhohn, *MJKw*, 1939, 527.

FIRST SCHOOL OF LANGUEDOC

BERNARD GILDUIN

65 *Portraits of three Apostles*, altar table *c.* 1096 marble 0·17 m.
Toulouse, St Sernin
This altar table, signed BERNARDUS GILDUINUS, is undoubtedly the one consecrated by Pope Urban II on 22 May 1096. The archaic rigidity of carving and the strong lines of the portraiture, accentuated by the deep folds of the draperies, single out these powerful reliefs as the common ancestors of all the Romanesque sculptures.
Deschamps, *Bull. Arch.*, 1923. Focillon 1931. Rey 1936. Gerke, *Mainzer Akad.*, 1958, 451. Scott, *AB*, 1964, 271.

66 *The Allegory of Lust*, detail of capital *c.* 1100 stone 0·38 × 0·38 m.
Toulouse, St Sernin (Porte des Comtes)
This probably represents the punishment of the wealthy libertine, whose story is narrated in the other capitals. Resembling in some ways the capitals in the cloister of Moissac, the carving here is softer and more sumptuous, and there is livelier interplay of light and shade, creating the impression of a powerful force emanating from a central nucleus.
Rey 1936. Sheppard Jr., *Spec.* 1960, 584. Scott, *AB*, 1964, 271.

BERNARD GILDUIN

67 *Apostle giving a benediction c.* 1096 marble 1·70 × 0·60 m.
Toulouse, St Sernin (Cloister)
One of a series of reliefs attributed to the sculptor of the altar table (66) or one of his most gifted pupils. It is not known where they came from originally. Although there are resemblances to Ottonian ivory-carving, the sharp definition and lively execution of this piece, with its remarkable, yet controlled use of light and shade, is typically Romanesque. The way in which the figure stands out from its concave niche, alone, as it were, in a luminous, silent cell, re-echoes the mood of Late Roman sculpture.
Focillon 1931. Rey 1936. Gaillard, *RAs*, 1951, 77. Salvini 1963, 28.

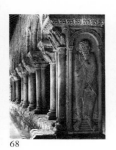
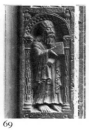
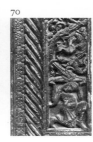
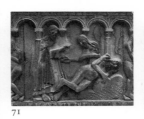
70

72

73

71

68 *St James on a square pillar c.* 1098–1100 marble 1·10 m.
Moissac, Abbaye St Pierre (cloister)
It is known from an inscription that the cloister with its figures of the
Apostles was completed in 1100, in the time of the Abbot Ansquetil.
These figures represent a decline in the stylistic influence of Bernard
Gilduin in favour of that of another great sculptor, whose name is
unknown. In spite of decorative motifs, inspired by Spanish Ottonian
ivories, the figures themselves are rounded and correctly proportioned.
Their faces, expressive of devotion, accentuate their humanity. The
face of St James is that of a visionary, like so many of the faces in the
later work of the sculptors of Moissac.
Focillon 1931. Rey 1936. Gaillard, *RAs*, 1951, 80.
Salvini 1963, 22.

MODENA SCHOOL

WILIGELMO
69 *The Prophet Isaiah*, detail of west portal *c.* 1100–6 stone *c.* 0·38 m.
Modena, Cathedral
The date can be deduced from the records of the building of the
church, the foundations of which were laid in 1099. In the same year
work on the façade of the building and the apse was begun. This figure,
although it owes something in style to the Apostles in the cloister of
Moissac, has nothing of their visionary quality. The Prophet is por-
trayed very much as a man of flesh and blood, with an expression of
intense moral fervour, which symbolizes the sustained determination
of primitive man to free his spirit from the density of matter.
Jullian 1945, 42.
Salvini 1956, 63; 1966, 115.

WILIGELMO
70 *Atlas*, detail of left jamb *c.* 1100–6 stone *c.* 0·30 m.
Modena, Cathedral (west portal)
A feeling of substance and physical strength is expressed in the rounded
curves of the figure, which are repeated in the surround. At the same
time, the huge figure is cramped and constrained, suggesting the
repressed and rebellious anguish of the slave, crushed beneath the
burden of his cruel fate. Atlas and the companion figure on the other
door jamb are probably the oldest Atlas-figures employed in the com-
position of a portal, though later ones, many executed in the round,
are to be found in Romanesque buildings all over Italy.
Salvini 1956, 75; 1966, 118.

WILIGELMO
71 *The Creation of Eve*, detail of façade *c.* 1100–6 stone 2·80 m. (whole
relief)
Modena, Cathedral
One of a series of four reliefs, illustrating stories from Genesis, from the
Creation to the Flood. They are set in the wall alongside the main
portal, though the two outer ones were raised to a higher level in about
1200, when the side doors were built. There is no foundation for the
suggestion recently made (Quintavalle), that the reliefs originally
formed the balustrade of a rood-screen inside the cathedral. Indeed, it
is clear – for one thing because the idea was so quickly taken up else-
where, notably in Lincoln Cathedral (175–6) – that the panels are an
integral part of the original design of the façade. The strictly geometric
composition of the group, the intense sculptural power of the figures,
and the contrast between the emerging forms and their link with the
background plane, give an impression of figures overcoming the
inertness of matter with great effort.
Toesca 1927, 758. Salvini 1956, 81; 1966, 72, 121. Quintavalle 1964–65,
189.

WILIGELMO
72 *The Original Sin*, detail of façade *c.* 1100–6 stone *c.* 2·80 m. (whole relief)
Modena, Cathedral
This representation of the Original Sin is, without doubt, the most
intensely spiritual in the whole history of art. The First Man and
Woman are portrayed as primitive, almost animal creatures. The theme
is underlined by the bowed and weary stance of the protagonists,
against the background. Substantial though the figures are, it is
impossible to forget that they represent humanity in the raw, taking its
first, feeble, hesitant steps into life, and, in all innocence, stumbling
into committing a sin of indescribable enormity, and finding itself
inexorably trapped by the mysterious forces of destiny.
Salvini 1956, 81; 1966, 121.

SCHOOL OF WILIGELMO
73 *Departure and sea journey of S. Gimignano*, detail of lintel *c.* 1105–10 stone
Modena, Cathedral (Portale dei Principi)
The work of a pupil of Wiligelmo, who echoes the intensely dramatic
style of the master in tones at once livelier and more relaxed. The
saint is on his way to the court of the Emperor Jovianus, to exorcize
the demon by which his daughter is possessed.
Francovich, *RIASA*, 1940, 226. Jullian 1945, 156. Salvini 1956, 117;
1966, 131.

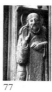

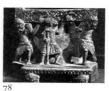

74

75

76

77

78

79

80

74 *Enoch and Elijah holding foundation inscription,* detail of façade *c.* 1106
stone
Modena, Cathedral
The epigraph records the date of laying of the cathedral foundations
(6 July 1099), and pays tribute to the fame of the sculptor, Wiligelmo·
The figures of the two Prophets can therefore be regarded as signed
pieces, and no other work can be attributed to the master without
reference to them. The bolder modelling of these figures, combined
with a more dramatic use of light and shade, suggests that they are later
in date than the Genesis panels, having probably been commissioned
for the solemn celebrations attending the consecration of the crypt in
October 1106. The recent suggestion (Quintavalle) that this panel
originally formed part of the high altar cannot be entertained.
Toesca 1927, 756. Salvini 1956, 90; 1966, 78, 125. Quintavalle 1964–5,
57, 186.

WILIGELMO
75 *Old men with ox skull,* detail of capital *c.* 1106–10 stone
Modena, Cathedral (façade gallery)
Many of the capitals of the façade gallery are attributable to Wiligelmo
himself, and are among the most original of Romanesque capitals. The
structural features, being wholly sculptural in character, illustrate the
complete fusion of sculpture with architecture. Comparison with the
capital in 51 reveals the profound difference between the work of
Wiligelmo and that of craftsmen of the Lombard school.
Krautheimer-Hess, *MJKw,* 1928, 239. Salvini 1956, 92.

76 *Enoch and Elijah holding the foundation inscription c.* 1110 stone
Cremona, Cathedral (sacristy)
The inscription records the foundation of Cremona Cathedral in 1107,
and was rescued from the façade, destroyed in the earthquake of 1117.
A recent suggestion (Quintavalle), that the relief once formed part
of the high altar, is untenable. The relief – although attributed to
Wiligelmo by Porter, and dated some time later than 1130 by Kraut-
heimer-Hess – is, nevertheless, clearly the work of an unknown pupil
of Wiligelmo, who translated the elevated work of the master into
popular narrative terms.
Porter 1917, I, 270; 1923, I, 73, 218, 325, 327. Krautheimer-Hess,
MJKw, 1928, 245. Salvini, *Comm.,* 1951, 153; 1956, 127. Quintavalle
1964–5, 187. Salvini 1966, 79.

77 *Prophet with a scroll c.* 1110 stone lifesize
Cremona, Cathedral (main portal)
One of a group of four Prophets, later placed on either side of the
portal. Variously attributed to Wiligelmo (Porter), one of his pupils
(Toesca), the unknown sculptor of the carving in 76 (Jullian), or
even the 'school of Piacenza', after 1170 (Krautheimer-Hess), these
sculptures are without doubt earlier than 1117, the year of the earth-
quake (witness the fact that they have been moved from their original
position), and are the work of a major artist, trained in the school of
Languedoc, and influenced by Wiligelmo. This sculptor, familiar with
the pulsating vitality of Wiligelmo's figures, nevertheless scrupulously
contains his own lifelike figures within the rigorous formal limits laid
down by the founders of the school of Languedoc.
Porter 1917, I, 270; 1923, I, 73, 218, 325, 327. Toesca 1927, 761.
Krautheimer-Hess, *MJKw,* 1928, 295. Jullian 1945, 38. Salvini, *Comm.,*
1951, 157. Salvini 1956, 130.

78 *Atlas-figures supporting bishop's throne c.* 1100–5 marble *c.* 0·40 m.
Bari, S. Nicola
This piece was formerly ascribed, erroneously, to the year 1098,
because it was thought to be part of a throne built in honour of the
visit of Pope Urban II, which took place in that year. It was, in fact,
completed in about 1105, the year of the death of Bishop Elia, who is
named as the donor in the inscription. Indeed, the close stylistic
affinities between this work and some of the sculptures in the Collegiate
Church of Monopoli, dated 1107, rule out any much earlier date. The
Apulian craftsman is much influenced not only by the school of
Languedoc, but also by Wiligelmo, and manages to express, through
the use of striking sculptural tension and contrast, a sense of un-
restrained, almost savage drama.
Porter 1923. Francovich, *RIASA,* 1940, 252. Salvini 1963, 38.

EARLY ROMANESQUE SCULPTURE IN SPAIN

79 *Moses leading the Exodus,* detail of capital *c.* 1095–1100 stone 0·63 m.

80 *The Raising of Lazarus,* detail of capital *c.* 1095–1100 stone 0·44 m.
Leon, S. Isidoro (Capilla de los Reyes)
Owing to a misinterpretation of the relevant documents, this piece
has generally been supposed to date from the year 1067. It can be seen,
however, that the sculptor owes much to the carvings on the great
tower of St Benoît (16) and to some unknown probable early work of
Wiligelmo, antedating the masterpieces of Modena. Thus, it seems

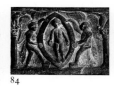

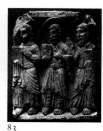

81 82 84 85 86 87

83

unlikely that these capitals were carved much before 1100, and, like the chapel, must be included in the building plans for the final years of Queen Urraca's reign (1101). Thus Spain, along with France and Italy, produced in the very early years of Romanesque art works of great, almost elemental power, charged with dramatic tension.

Porter 1928. Gómez Moreno 1934, 48. Gaillard 1938, 1. Gudiol Ricart-Gaya Nuño 1948. Durliat 1962, 17. Salvini 1963, 67. Palol-Hirmer 1965, 69.

81 *The legend of St Sixtus*, detail of capital in porch *c*. 1110–15 stone

82 *The Sacrifice of Abraham*, detail of capital *c*. 1110–15 stone
Jaca, Cathedral (south doorway)
References to the original church in two documents dated 1063 have led Spanish scholars and others to ascribe a date *c*. 1070 to the interior of the cathedral, including the above capitals and the many others on the portico and south portal. The building of the present cathedral, however, was not begun until after Doña Sancha's endowment of 1094. Although 81, in crispness of narrative vigour and some formal aspects, resembles the sculptures on the Portale dei Principi at Modena (*c*. 1105–10, cf. 74), the other capitals of the portico are closer in style to the Porte de Miègeville at St Sernin in Toulouse (*c*. 1110, cf. 91). As to 82, this is the work of a different and greater craftsman, creator of many groups of capitals, including others in the cathedral itself. This artist's work is deeply imbued with Classical influences – attributable to the wealth of Roman sculpture to be found in this region – vigorous, yet rich in pathos, as can be seen in the naked figure of Isaac and the agonized, contorted face and body of Abraham.

Porter 1928. Gómez Moreno 1934, 122. Gaillard 1938, 87. Francovich, *RIASA*, 1940, 3. Gudiol Ricart-Gaya Nuño 1948, 122. Durliat 1962, 19, 64. Salvini 1963, 72. Palol-Hirmer 1965, 72.

83 *Three Apostles c*. 1110–20 limestone 0·82 × 0·64 m.
From Vich (Catalonia)
London, Victoria and Albert Museum
In this piece, the influences of Languedoc and Modena (Wiligelmo and the sculptor of the Portale dei Principi) exert equal force. The profound and dramatic anguish of Wiligelmo is transformed, in these tense and angular figures, into an eager and masterful dynamism. Other reliefs in the series are to be found in the Museo Lapidario of Vich, the Lyons Museum and the Nelson Gallery in Kansas City.

Porter 1928. Gómez Moreno 1934. Gaillard 1938. Francovich, *RIASA*, 1940. Gudiol Ricart-Gaya Nuño 1948. Salvini 1963, 76.

84 *The Soul ascending to Heaven*, Doña Sancha's tomb (detail) *c*. 1110–20.

Jaca, Monasterio de las Benedictinas
Doña Sancha, daughter of Ramiro I, King of Aragon, and widow of the Comte de Provence, died not later than 1097 in the Convent of Santa Cruz de la Serós. She left a substantial endowment to the Benedictine community of Jaca, for the provision of a chapel. On the assumption that the tomb (later moved to Jaca) was carved immediately after her death, Porter and Beenken maintain that Aragonese sculpture antedated that of Languedoc and Modena, and exerted a formative influence on these schools. Gaillard and Francovich, on the other hand, hold that the Jaca tomb is influenced, not only by the work of Wiligelmo, but also by that of his earliest pupils at Modena (73) and Cremona (76). It therefore follows that the sarcophagus must have been completed some twenty years after the death of Doña Sancha, when the building of the chapel in the cloister of Santa Cruz was sufficiently advanced to accommodate it. The carving is lively though somewhat stiff, but the sculptor adds touches of decorative relief to the powerful physical presence of the figures, derived from Wiligelmo. This piece, though by a different artist, has close affinities with 81.

Porter 1923, 248; *BM*, 1924, 16. Beenken, *Belv*, 1925, 108. Gaillard 1938. Francovich, *RIASA*, 1940, 226. Durliat 1962, 65. Salvini 1963, 71. Palol-Hirmer 1965, 73.

85 *The three Marys at the Holy Sepulchre; the Descent from the Cross; the Ascension*, lunette of south transept doorway *c*. 1120 stone 1·10 × 1·90 m.
León, S. Isidoro (Puerta del Perdón)

86 *Signs of the Zodiac; King David, etc.*, reliefs on south aisle portal *c*. 1120 stone 0·80 m. width of the two reliefs
León, S. Isidoro (Puerta del Cordero)
Though both the above groups have touches of originality, they clearly derive from the second phase of Languedoc sculpture, of which the Porte de Miègeville and other sculptures in the region of Toulouse are examples. Having regard to these influences and to the date of the consecration of the church (1149), which is known to have taken many decades to build, it seems probable that these sculptures were completed in about 1120. In the tympanum relief of the Puerta del Perdón the three Biblical stories are united by a common idiom, intimate, human, warm, and sad. The reliefs surrounding the Puerta del Cordero, remarkable for their intensely pictorial style, were probably moved to their present position at some later date.

Porter 1928. Gómez Moreno 1934. Gaillard 1938. Gudiol Ricart-Gaya Nuño 1948. Durliat 1962, 80. Palol-Hirmer 1965, 71.

87 *The Sign of Leo*, detail of east door jamb *c*. 1115 grey marble 1·00 m.

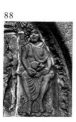
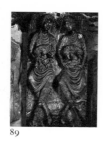
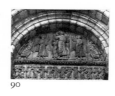

88

89

90

91

92

88 *The Allegory of Lust*, detail of lunette *c.* 1115 granite 1·00 m.

Santiago de Compostela (Puerta de las Platerías, façade, south transept)
The incongruous diversity of subject-matter and the many different
styles of sculpture to be seen on this façade may be due to the incor-
poration of reliefs from the west portal (demolished by Master
Matthew in 1180) and the north portal (demolished in the 18th
century). But, since some of these incongruities were already apparent
in 1139 to the author of the Pilgrim's Guide, it must be supposed that
the sculptures were hastily re-erected and restored after the fire in the
riots of 1117. Lust (according to the Guide, it represents an adulteress,
compelled by her husband to embrace the skull of her lover twice a
day), which completes the tympanum relating the Temptation of
Christ, is a fragment, apparently cut on the right. It certainly dates,
therefore, from before 1117. *The Sign of Leo* closely resembles it in
style. Both sculptures are executed in a fantastical, even grotesque vein,
and though imbued with carnal voluptuousness, they are tinged with
pathos, all of which is reminiscent of the late sculptures of the Porte de
Miègeville at Toulouse.

Porter 1928, 30. Gómez Moreno 1934. 14. Gaillard 1938. Gudiol
Ricart-Gaya Nuño 1948. Durliat 1962, 15, 84. Salvini 1963, 77. Palol-
Hirmer 1965, 82, 114.

SECOND SCHOOL OF LANGUEDOC

89 *Signs of the Zodiac: Leo and Aries c.* 1120 marble 1·35 × 0.68 m.

From the Porte des Comtes, St Sernin
Toulouse, Musée des Augustins
The inscriptions SIGNUM LEONIS and SIGNUM ARIETIS suggest that
this piece is a portrayal of these two signs of the Zodiac. The third
inscription, however, which reads HOC FUIT FACTUM TEMPORE
JULII CAESARIS, lends colour to the interpretation of the historian
Bernard of Toulouse (1515), who claims that they refer to a miracle
mentioned by St Jerome as having occurred at Toulouse in the time of
Julius Caesar. Two virgins gave birth, one to a lion, the other to a
lamb, signifying Christ in two of His aspects: the judge of sinners,
terrible as a lion, and the lover of innocents, meek as a lamb. Scholars
disagree as to the date of this relief, ascribing it to various dates between
1110 and 1150. The style of the Porte de Miègeville undergoes here an
obvious alteration towards greater refinement and subtlety – perhaps
under the impact of Burgundian sculpture. The relief has much in
common, stylistically, with the Roi Antoine relief in the Musée des
Augustins (from the west portal of St Sernin) convincingly dated by
Scott to about 1115–18.

Porter, 1923, 215. Gaillard 1938, 204, 230. Mesplé 1961, nᵒ 206. Scott,
AB, 1964, 271.

90 *The Assumption and the Apostles*, lunette and lintel *c.* 1105–10 marble
3·00 m. wide
Toulouse, St Sernin (Porte de Miègeville)
The strong influence of Bernard Gilduin (66–7) is apparent in the
Apostles on the architrave, although for all their archaic stiffness and
angular contours, they are portrayed in motion. In the figures of the
tympanum, probably slightly later in date, there are signs of a tentative
experiment in pictorial fluidity, though this is not yet by any means
the dominant note.

Gaillard, *GBA*, 1929, 325. Rey 1936, 53. Aubert 1946, 53. Deschamps
1947, 22. Salvini 1963, 50. Scott, *AB*, 1964, 274.

91 *Simon Magus*, relief *c.* 1110 marble 0·60 m.

Toulouse, St Sernin (Porte de Miègeville)
This relief, below the one of St Peter, portrays Simon Magus flying
with the help of two evil spirits. The style is similar to that of the
tympanum, and the pictorial fluidity, possibly Burgundian in origin,
is harmoniously integrated with the powerful sculptural curves,
probably deriving from the school of Wiligelmo. It is in this phase of
Toulouse sculpture that the origins of the Compostela sculptures
(87–8) are to be found.

Gaillard, *GBA*, 1929, 325. Rey 1936, 53. Aubert 1946, 53. Deschamps
1947, 22. Salvini 1963, 50. Scott, *AB*, 1964, 274.

GILABERTUS

92 *St Thomas the Apostle c.* 1120–30 stone 1·15 m.

From the ruins of the Chapter-house of St Étienne at Toulouse
Toulouse, Musée des Augustins
One of a series of portraits of the twelve Apostles which, according to
ancient sources, were grouped in the cloisters round the door leading
to the great hall of the chapter-house. This figure and that of St
Andrew bore the signature (mentioned in a catalogue of 1864, but now
obliterated) of Master Gilabertus, whose hand can also be detected in
four of the other Apostles in the series, though the remainder appear
to be the work of an apprentice. Here, in contrast to the reliefs of the
Porte de Miègeville, there is a return to sharpness of outline and a
feeling for monumental sculpture which were to influence Master
Niccolò in Italy, the masters of St Gilles in Provence, and possibly
even the great craftsmen of the Royal Portal at Chartres.

Vöge 1894, 71. Grautoff, *RKw*, 1915, 80. Porter 1923, 150. Rachou
1934, 37. Rey 1936, 194. Lafargue 1940, 85. Mesplé 1961, nᵒ 5.

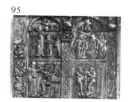

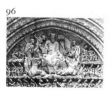

SECOND SCHOOL OF LANGUEDOC – INFLUENCE IN NORTHERN ITALY

NICCOLÒ

93 *Three Prophets* 1135 limestone 0·90 m. (each figure)
Ferrara, Cathedral (main portal)
This work is signed (on archivolt) and dated (on Lombard porch). A variety of influences can be detected, namely, Wiligelmo's substantial sculptural form, Gilabertus's statuary conception, and the mannered refinement of other works of the second school of Toulouse (capitals of La Daurade). In contrast to the dramatic intensity of the Prophets of Modena (69), the style of these figures is ornate, expressed in colloquial terms, and yet imbued with gravity.
Porter 1917; 1923, 241. Toesca 1927, 761, 886. Krautheimer-Hess, *MJKw*, 1928, 257. Robb, *AB*, 1930, 374. Arslan 1943, 95. Jullian 1945. Salvini 1963, 56; *EUA* ix, 1963, 929.

NICCOLÒ

94 *Signs of the Zodiac*, detail of jamb *c.* 1120 marble 2·37 m. (the whole jamb)
Val di Susa (Piedmont), Sagra di S. Michele, Abbey
The Porta dello Zodiaco, which cannot be dated with certainty, has been constructed from architectural and sculptural pieces removed from the cloister, and with pieces of another dismembered portal by Niccolò. It is carved on one jamb with signs of the Zodiac, and on the other with the constellations following Aratus. These jambs, as well as two capitals and two carvings of lions, of considerable promise, appear to be early works of Niccolò, contemporary with and much influenced by the first school of Toulouse (65, 67), and revealing an intimate knowledge of the art of Wiligelmo (70). Since these sculptures appear to be earlier than those of the south portal of Piacenza Cathedral, begun in 1123, a date around 1120 seems indicated.
As 93. Add: Gaddo, *La Sacra di S. Michele*, Domodossola 1935 and 1958. Bernardi 1962, tav. IV. Verzár 1968, 37.

NICCOLÒ

95 *Scenes from Genesis* 1138 stone
Verona, S. Zeno (façade)
An inscription on the south wall of the church, dated 1178, indicates that the building was reconstructed forty years earlier. These carvings, therefore, must date from about 1138, and were probably part of an earlier façade, moved to their present position towards the end of the 12th century. They are the mature work of the sculptor Niccolò, and

in them the dramatic intensity of Wiligelmo (71–2) is translated into more relaxed narrative terms, conveying the gusto of the story-teller as well as a sense of affectionate intimacy with the characters.
As 93. Add: Magagnato 1962, 8.

THIRD SCHOOL OF LANGUEDOC

96 *The Apocalyptic Christ*, tympanum *c.* 1125–30 stone 4·42 × 6·55 m.
Moissac, Abbaye St Pierre (west portal, tympanum)
According to the Chronicles of Abbot Aymery de Peyrac (1377–1406), the portal was carved and erected during the tenure of the Abbot Ansquetil (1085–1115). A date somewhere between 1110 and 1115 has, therefore, been generally accepted. The source, however, is a late one, and the chronicler may have been mistaken in associating the name of Ansquetil – on record as the architect of the cloisters, completed in 1100 (68) – with other, later parts of the building. On the front of the vestibule adjacent to the portal is a portrait bust of Abbot Roger, styled *beatus*, thus indicating that it was completed after his death in 1131. Stylistically, the portal appears to date from roughly the same period as the vestibule, and is certainly not more than a few years earlier. French scholars have noted resemblances between this work and miniatures of an earlier date, but this view does not take into account the elevated emotional and visionary spirit which pervades the work, and recalls rather the carvings at Cluny and other Burgundian sculpture of the same period.
Porter 1923, 132. Lefrançois-Pillon 1931, 107. Focillon 1931 (1964), 183, 193. Meyer Schapiro, *AB*, 1931, 249, 464. Francovich, *RIASA*, 1940, 202. Aubert 1946, 63. Deschamps 1947, 29. Salvini 1963, 51. Messerer 1964, 76.

97 *The Prophet Jeremiah c.* 1125–30 stone 1·50 m.
Moissac, Abbaye St Pierre (west portal, *trumeau*)
It was formerly thought that the *trumeau* was added to the portal a few years later, an unfounded supposition. The imaginative energy of these carvings is truly remarkable. Hard in outline though the figures are, they seem to bend and sway in the joyous spiritual ecstasy of a sacred dance.
As 96.

98 *The Prophet Isaiah c.* 1135 stone 1·76 m.
Souillac, Abbaye Ste Marie (reconstructed portal, jamb)
After it was damaged in the Calvinist riots of 1562, the portal, a

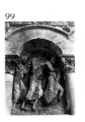

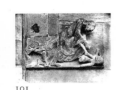

magnificent example of its kind, was rebuilt inside the church. It dates from about 1135, being very close in style to the door jambs and *trumeau* of Moissac, and possibly, indeed, the work of the same sculptor. Here, too, the prophetic vision is portrayed in terms of the refined and subtle rhythms of a sacred ritual dance.

As 96. Add: Messerer 1964, 22. *Quercy Roman* 1959, 252.

99 *The Adoration of the Magi*, detail *c.* 1130 stone *c.* 0·70 m.
Moissac, Abbaye St Pierre (porch interior)
Here too the influence of Burgundian sculpture, especially of Vézelay, foreshadowing that of Souillac, is clearly to be seen, as evidenced by the combination of joy and ritual solemnity expressed in the dance of the three Magi.

As 96.

100 *Fabulous beasts c.* 1135 stone 3·56 m.
Souillac, Abbaye Ste Marie (*trumeau* of reconstructed portal)
See 98. This intricately carved composition of fabulous beasts, drawn from Bestiaries and other sources, is a symbolic representation of human sins and frailties. To the older tradition of Languedoc is added all the fantasy, picturesqueness, and delicacy of modelling associated with the Burgundian School.

As 96.

LANGUEDOC AND BURGUNDIAN INFLUENCE IN ITALY

101 *Truth tearing out Falsehood's tongue*, relief *c.* 1125–30 stone
Modena, Cathedral (south side, near Portale dei Principi)
A pre-war photograph, the relief having been damaged by bombs in 1944. The present site is not the original one; this was probably where the Porta Regia, opened in about 1200, now stands. Formerly attributed by Porter to Wiligelmo, it has recently been acknowledged to be a work strongly influenced by the school of Languedoc (Moissac). Jacob's struggle with the Angel and the conflict between Truth and Falsehood are given substance by a vision at once apocalyptic in its Biblical power and informed by a delicately inspired and prophetic imagination.

Porter 1917, I, 394; III, 43; 1923, 332. Toesca 1927, 759. Francovich, *RIASA*, 1940, 274. Jullian 1945, 47. Salvini 1956, 163; 1963, 53; 1966, 135. Quintavalle 1964–5, 214.

102 *Girl watching a tumbler c.* 1130–40 marble *c.* 0·58 × 0·75 m.
Modena, Museo Lapidario del Duomo
Originally one of a series of eight reliefs which, up to 1950, formed *antefixae* or metopes on the tops of the pilasters on both outer walls of the central nave. This work by a pupil of Wiligelmo strongly influenced by the sculpture of Burgundy and Languedoc (Souillac), is notable for an impeccable balance of mass and an almost Ionic elegance of line. The modelling is subtly pictorial, and radiates a noble sense of quiet contemplation.

Venturi 1903, III, 147. Beenken, *Belv.*, 1925, 113. Toesca 1927, 772. Frankl, *JKw*, 1927, 145. Krautheimer-Hess, *MJKw*, 1928, 252. Francovich, *RIASA*, 1940, 275. Jullian 1945, 157. Salvini 1956, 191; 1963, 55; 1966, 146.

103 *Tale from the Arthurian legends*, detail of archivolt *c.* 1120–30 marble

104 *Atlas-figure, foliage, and animals*, detail of right door jamb *c.* 1120–30 marble 0·73 × 0·24 m.

105 *The Month of June*, detail of left door jamb *c.* 1120–30 marble 0·40 × 0·23 m.
Modena, Cathedral (Porta della Pescheria)
The following subjects are illustrated on the portal on the north side (Pescheria): the rescue of Guinevere (here called Winlogee) from the Arthurian legends (archivolt); animal fables (lintel and external faces of jambs); the Months (internal faces of jambs). Many scholars, believing that the legends of King Arthur did not reach Italy until twenty or thirty years after the publication, in 1135–40, of Geoffrey of Monmouth's *Historia Regum Britanniae*, have placed these portal sculptures in the second half of the 12th century. But the spelling of names suggests a source earlier than Geoffrey, and palaeographic evidence, pointing to a date in the first half of the century, is in perfect accord with the style, which resembles that of other Modenese sculptures influenced by the Burgundian School, of about 1120–30. Furthermore, in a document of 1125 there appears, among a list of benefactors of the cathedral, the name of one Artusius. The whole door is the work of a single master-craftsman, who narrates the Arthurian story with a melodious clarity worthy of a Court minstrel, and portrays with idyllic tenderness the cycle of the seasons and man's labour in relation to the natural rhythms of the year.

Förster, *Zeitschr. f. rom. Phil.*, 1898, 243, 526. Colfi, *AMDSPM*, 1899, 133. Venturi 1904, III, 160. Porter 1917, I, 280, 436; III, 44. Mâle 1922, 268. Porter 1923, 4, 183. Loomis, *Romanic Review*, 1924, 266.

Deschamps, *Mon. Piot*, 1925–6, 69. Loomis, *Medieval Studies in Memory of G. Schoepperle*, 1928, 209. Porter-Loomis, *GBA*, 1928, 109. Toesca 1927, 761. Gerould, *Spec.*, 1935, 355. Olschki, *Arch. Rom.*, 1935, 145. Loomis, *Arthurian Legends*, 1938, 32. Francovich, *RIASA*, 1940, 273. Jullian 1945, 150. Salvini 1956, 171; 1963, 54. Stiennon-Lejeune, *CCM*, 1963, 281. Salvini 1966, 137.

WESTERN FRENCH SCHOOL AND ITS DISSEMINATION IN SOUTHERN ITALY

106 *Frieze on the façade*, detail *c.* 1140–50 stone length of this part *c.* 4·00 m.
Poitiers, Notre-Dame-la-Grande
In the absence of documentary evidence, the date is uncertain. These reliefs, animated by a lively sense of the picturesque rather than any deep feeling of pathos, belong to the sphere of influence of the Third School of Languedoc, and thus probably date from about the middle of the century. For the question of their relations to Armenia and Pavia, *see* INTRODUCTION, p. 28.
Porter 1923, 320. Aubert 1946, 133. Crozet 1948, 182. Salvini 1963, 62. *Poitou Roman* 1957, 64.

107 *Fabulous monsters*, detail of archivolt *c.* 1170 stone *c.* 0·71 × 0·95 m.
Aulnay, St Pierre (south transept portal)
Here again the date is uncertain, though the style suggests the second half of the century. The amazingly luminous quality of the carving recalls Burgundian sculpture, but a new dimension of imaginative freedom has been added, in which, with marvellous inventiveness, soft, pictorial curves and sharp outlines are interwoven.
Lefèvre-Pontalis, *Congrès archèol. d'Angoulême*, 1912. Chagnolleau, *Aulnay-de-Saintonge*, 1938. Crozet 1948, 182. *Poitou Roman* 1957, 208. Debidour 1961, 200. Salvini 1963, 62.

108 *A Prophet*, detail of portal *c.* 1190 marble 0·75 × 0·31 m.
From Sta Maria Alemanna
Messina, Museo Nazionale
This figure clearly owes much to the sculpture of western France, as can be seen by comparing it with the reliefs of Notre-Dame-la-Grande (106, 109). Furthermore, the portal, or rather such fragments as remain, is similar in general structure to the west door at Aulnay and other portals in western France. The church was probably built at the same time as the associated hospital of the Teutonic Order, traditionally believed to have been built in 1190, at the time of the Third Crusade. Gazzola, *Pall.*, 1941, 207. Bottari, *Monumenti Svevi di Sicilia*, 1950, 10. Salvini, *Festschrift Müller*, 1965, 47.

109 *The Annunciation*, detail of 106 stone *c.* 1·00 × 1·00 m.
Poitiers, Notre-Dame-la-Grande

110 *The Sacrifice of Isaac: Jacob wrestling with the Angel: Jacob's dream c.* 1170–80 marble
Trani, Cathedral (left jamb of west portal)
This portal, without a doubt, was built earlier than the bronze door of Barisano, which dates from about 1185. The sophisticated elegance of the contorted figures clearly derives from the sculpture of western France, in particular that of Parthénay-le-Vieux (112).
Bertaux 1904, 472. Wackernagel 1912. Toesca 1927, 834. Francovich, *RIASA*, 1936. Petrucci, *Cattedrali di Puglia*, 1960, 89. Salvini 1963, 65.

111 *Scenes from the Old Testament c.* 1150 stone
Capua, S. Marcello (right door jamb)
The strong influence of western French sculpture suggests that this is the work of an Apulian craftsman.
Toesca 1927, 849. Bottari, *Comm.*, 1955, 235.

112 *Detail of archivolt c.* 1140 stone 0·80 cm.
Parthénay-le-Vieux, Notre-Dame-de-la-Couldre (main doorway)
The influence of the third school of Languedoc is clearly to be seen in this sculpture of the Poitiers region, but the intense pathos which was the keynote of such works is here subordinated to purely decorative considerations.
Michel, *Mon. Piot*, 1918, 179. Crozet 1948, 243. *Poitou Roman* 1957, 39. Salvini 1963, 63.

GODFRIDUS
113 *A pair of lovers, surprised c.* 1140 stone 0·35 m. (the figures)
Marignac (Saintonge), Parish Church (capital)
This sculpture is here attributed for the first time to Godfridus, on the basis of its close resemblance to the capitals of Chauvigny (114).
Art Roman, 1961, 177.

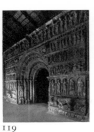

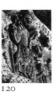

114 115 116 117 118 119 120 121

GODFRIDUS

114 *Fabulous beast devouring a naked man*, detail of capital *c.* 1140–50 coloured stone

Chauvigny, St Pierre (choir)

The words GODFRIDUS ME FECIT appear on the capital of the Adoration of the Magi, which is clearly by the same hand as this and other capitals in the church. An extremely lively work in the popular taste. The soft and smooth plastic masses, on which the light plays almost voluptuously, are enriched by vivid polychrome tints (restored in the original colours), chiefly blood-red and yellow-ochre. In scenes of infernal torment, such as this, the awesome and grotesque monsters of Oriental mythology are treated with whimsical freedom, so that they appear more grotesque and less terrifying. The monster here portrayed is seen with the two profiles of its body stretched out on either side of its head, a Romanesque perspective device wholly appropriate to the shape of the capital.

Lefèvre-Pontalis, *BMon.*, 1911, 423. Crozet 1948, *passim. Poitou Roman* 1957, 96. *Art Roman* 1961, 158. Debidour 1961, 151. Salvini 1963, 63.

WESTERN FRENCH SCHOOL AND ITS DISSEMINATION IN SPAIN

THE MASTER OF CABESTANY

115 *The Summoning of the Disciples c.* 1150 marble 0·82 × 0·61 m. (slab)

From the Portal of S. Pedro de Roda

Barcelona, Museo Marés

One of the finest works of a famous itinerant master-craftsman, whose precise dates are unknown, but who, some time in the middle of the 12th century, completed sculptures in S. Antimo in Tuscany, in Toulouse, Roussillon, Catalonia, and in Navarre. Although this sculptor, probably of Catalan origin, has affinities with the school of Languedoc, his style is individual, his modelling intensely pictorial, and his powerful linear strokes imbued with pathos and simple feeling.

Subías Galter, *El Monestir de Sant Père de Roda*, 1948, 95. Durliat 1954, IV, 16. *Puig i Cadafalch* I, 1957, 179. Ainaud, *Rev. de Gerona*, 1959, 33. Junyent, *Actes 86º Congres Nat. Sociétés savantes*, Montepellier 1961, 169. Durliat 1962, 24.

THE MASTER OF CABESTANY

116 *The Dormition and Assumption of the Virgin; St Thomas receiving the Virgin's girdle c.* 1150 marble 1·70 m. wide

Cabestany, Parish Church (lunette)

In this work, through the composition and the curves of the draperies, the affinities with the sculptures of Languedoc and those of western France are apparent.

As 115.

117 *The Descent from the Cross c.* 1140 marble 0·30 m.

From the cloister of the Cathedral

Pamplona, Museo de Navarra

This magnificent work, showing some traces of the influence of Toulouse, develops the premisses established, under Wiligelmo's impact, by the Romanesque sculptures of Aragon. The curves of the draperies, contrasted with the angularity of the Cross and the figures, together are expressive of sharp, dramatic anguish.

Gómez Moreno 1934. Gaillard 1938, 222. Gudiol Ricart-Gaya Nuño 1948, 166. Durliat 1962, 27, 67. Palol-Hirmer 1965, 115.

118 *The Pilgrims of Emmaus*, detail *c.* 1135–40 marble 1·80 × 1·08 m.

S. Domingo de Silos (cloister)

One of a set of reliefs carved on the four corner pilasters. Though the style here is somewhat more archaic, the debt to the Moissac sculptures is very marked. The gentle grace of the figures and the coherent purity of the overall design convey a mood of serene gravity.

Porter 1923, 44. Whitehill, *AB*, 1932, 316. Gaillard, *BMon.*, 1932, 39. Gómez Moreno 1934, 97. Gudiol Ricart-Gaya Nuño 1948, 236. Durliat 1962, 30, 72. Salvini 1963, 78. Palol-Hirmer 1965, 113.

119 *Monumental west portal c.* 1150 stone 7·65 × 11·60 m.

Ripoll, Sta Maria

This richly decorative work is part of a complete iconographic scheme culminating in the Apocalyptic Christ, and also portrays scenes from the Old Testament, for the most part referring to episodes from the liberation and victory of the people of Israel. For this reason, it is believed that the portal, reminiscent, in composition, of a triumphal arch, was commissioned by Count Ramón Berenguer IV, to celebrate the liberation of Lérida and Tortosa in 1149. This is a notable work, creating an overall impression of pictorial liveliness although the separate figures are austere, even solemn. The exuberant vegetation recalls the work of Lombard sculptors (Pavia), and of those of western France, but there are also echoes of the highly ornate miniatures of the Ripoll Bible (Vatican Library).

Puig i Cadafalch, *BMon.*, 1925, 303. Gudiol Ricart-Gaya Nuño 1948, 64. Junyent, *Catalogne Romane* I, 1960, 192. Durliat 1962, 22, 58. Salvini 1963, 78. Palol-Hirmer 1965, 105.

123

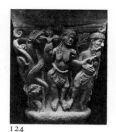

125

126

127

128

122

124

20 *The Apocalyptic Christ*, detail of 119

21 *The Original Sin c.* 1145–50 stone 0·30 × 0·42 m.
Gerona, Cathedral (cloister)
Above the corner pillars and the intermediate ones of the cloister runs a carved frieze illustrating scenes from Genesis. It is generally believed that this cloister was inspired by that of S. Père de Galligans, also in Gerona, which, according to a tomb inscription, was built before 1154. In spite of their mood of quiet gravity, the scenes, especially the early ones, are conceived in popular terms, and are in the Wiligelmo-Niccolò tradition, possibly transmitted by way of Toulouse.
Gómez Moreno 1934. Gudiol Ricart-Gaya Nuño 1948, 81. Casanovas, *El Claustro de la Catedral de G.*, 1955. Junyent, *Catalogne Romane*, II, 1961, 90. Durliat 1962, 24, 57. Palol-Hirmer 1965, 16.

22 *The Holy Trinity and other subjects*, detail second half 12th cent. 8·20 × 6·00 m. (whole portal)
Soria (Castile), S. Domingo (main portal)
The portal, with its multiple-tiered arches, is modelled on those of Poitou and Saintonge, with the tympanum as an additional feature. The style of the sculptures is also directly traceable to the same source.
Gudiol Ricart-Gaya Nuño 1948, 312. Durliat 1962, 29, 77. Palol-Hirmer 1965, 105.

SCHOOL OF THE MASSIF CENTRAL

23 *The Blessed received into Paradise and the Damned driven down to Hell*, detail of tympanum *c.* 1110 stone 3·64 × 6·73 m. (the whole); 0·50 × 1·00 m. (detail)
Conques, Ste Foy (west portal)
The dating most widely accepted is 1125–30 or later. However, if it is agreed that the two capitals with the story of Ste Foy in the Chapel of Ste Foy in the choir of Santiago de Compostela (*c.* 1105) and the relief of the Flagellation (before 1117) in the Puerta de las Platerías, in Santiago, derive stylistically and iconographically from the two capitals with the story of the Saint in the nave of Ste Foy at Conques, then the sculpture in the interior of the church must belong to the early years of the 12th century. Bernoulli's contention that one group in the church was completed as early as 1085 is, however, unacceptable· It must further be noted that the sculptures of the tympanum, though possibly a little later in date, also closely resemble the capitals referred to above (in particular the devil figures). They seem, nevertheless, to be later than the sculptures on the Tomb of the Abbot Bego III (1107),

and must, therefore, have been completed in about 1110. Much of the subject-matter is taken from the *Book of the Miracles of Ste Foy*. The mood is tranquil and sober, the style rustic, and the composition owes much to the substantial plasticity of Romano-Gallic sculpture.
Bréhier, *RAChr.*, 1912. Aubert, *Congrès Archéol. Clermont*, 1924. Aubert 1946, 114. Craplet, *Auvergne Romane*, 1958, 82.

ROBERT
124 *The Original Sin*, detail of capital *c.* 1150 0·65 m. (the figures)
Clermont-Ferrand, Notre-Dame-du-Port (choir)
One of a group of four capitals, another of which is inscribed ROBERTUS ME FECIT. These figures, sturdy and massive as they are, are nevertheless grouped in such a way as to enhance the architectural structure of the capitals. The narrative tone is realistic and imbued with rustic gravity. Although there is documentary evidence that the church was still unfinished in 1185, the style of these capitals is too close to those of Conques to admit of so late a date. There are, on the other hand, works by pupils of Robert in the church of St Nectaire, which is believed to have been built some time between 1146 and 1178. But the style of these sculptures, substantial, pictorial, with strongly delineated curves, is very close to those of St André-le-Bas in Vienne, dated 1152, and may possibly be influenced by the school of Provence.
Bréhier, *Actes Congrès histoire de l'Art*, Paris 1921. Aubert, *L'église de Conques*, 1939. Deschamps, *BMon.*, 1941. Rascol, *Le Portail de Ste-Foy*, 1947. Bousquet, *Revue du Rouergue*, 1947; *Le Jugement Dernier*, etc., 1948. Bernoulli, *Die Skulpturen der Abtei Conques-en-R.*, 1956. *Rouergue Roman*, 1963, 29.

SCHOOL OF PROVENCE

BRUNUS AND ANOTHER
125 *The Apostles John and Peter*, detail of central portal *c.* 1130

126 *The Archangel Michael c.* 1140

127 *Roman soldiers*, detail of frieze *c.* 1140

128 *Man devoured by a lion*, detail of central portal *c.* 1130
St Gilles, Abbey Church (façade)
Variously ascribed by scholars as between 1116 and 1120 and the first half of the 13th century, but the most generally accepted date is 1160–70, owing to the arbitrary identification of Brunus – whose

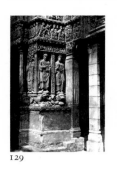

130

131

132

135

129

133 134

136

signature appears on the base of the statues of St Matthew and St Bartholomew, on the left of the central portal, and whose workmanship is plainly recognizable in the portal figures, St John (125) and St Paul – with one Petrus Brunus, a sculptor whose name is recorded in 1171 at St Gilles, and in 1186 at Nîmes. It is, however, much more likely that the façade was built and decorated between 1125 and 1145. The School of St Gilles, the oldest of the Provençal Romanesque schools of sculpture, was founded on the most strictly Classical concepts of the School of Languedoc (Gilabertus, 92), and inspired by aspects of Romano-Gallic sculpture. Brunus's figures possess an architectural grandeur and a vital power that finds expression in the grand composition of the heavy draperies, following a decidedly statuesque conception of sculpture. In the reliefs on the frieze, inspired by Roman and Early Christian sarcophagi, the robust carvings are enlivened by a remarkable pictorial intensity. They are conceived in an epic style imbued with pathos. At the same time, the mystic exaltation deriving from the sculptures of Toulouse is interpreted (e.g. in the St Michael) in terms of intense and heroic vitality, as in the case of the lions on the bases of the columns, where the beasts are much fiercer and more fancifully conceived than their Roman prototypes.

Vöge 1894, 130. Lasteyrie, *Mon. Piot*, 1902, 80. Porter 1923, 273. Hamann, *BM*, 1934, 19. Schapiro, *AB*, 1935, 415. Horn, *Die Fassade von St Gilles*, 1937. Aubert 1946, 146. Deschamps 1947, 117. Gouron, *Congrès Archéol. Montpellier* 1950 (1951) 104. Francovich 1952, 45. Hamann 1956. Salvini 1963, 87.

129 *St Peter and St John*, detail of portal *c.* 1150–8 stone lifesize

130 *Head of St Trophime*, detail of square pillar *c.* 1145–50 stone lifesize

131 *Joseph's dream*, detail of capital *c.* 1160–70 stone *c.* 0·33 m.
Arles, St Trophime (cloister, east side)
There has been much disagreement among scholars regarding the dating of the Arles sculptures in relation to those of St Gilles. Nevertheless, all are agreed that the Arles ones are later than those of St Gilles. The date 1188, mentioned in Jourdain's epitaph in the cloister, has usually been taken as the earliest possible date by those favouring a later date. It must, however, be taken as the last possible date for the construction of the cloister since it is inconceivable that church dignitaries should have been buried in the cloister before its completion. In fact, the portal sculptures must have been erected at some time between 1150 and 1158, since their influence can be seen in the pulpit of Cagliari, which was built between 1159 and 1162 (138–9). There is no trace in the Cagliari pulpit, however, of the influence of capitals

on the east side of the cloister, which are undoubtedly earlier than Antelami's *The Descent from the Cross* in Parma, dated 1178 (148–9), and therefore probably date from *c.* 1160–70. As to the sculptures on the north side of the cloister, these are probably somewhat earlier than those on the façade. Their affinities with the sculptures of St Gilles and their exceptional artistic merits place them *c.* 1145–50. In 130 the vitality deriving from the St Gilles sculptures is already more restrained. The definition is no less sharp, but the mood is more serene. There is a feeling of contained power and solemnity, which irradiates the faces. The façade figures (129), decorative and noble in form though they are, lack the depth of inspiration of the St Gilles statues and reliefs. The capitals of the east side of the cloister (131) exhibit, in their compactness, an underlying tension anticipating the works of Antelami. As 125–28. Add: Sanpaolesi, *RIASA*, 1956–67, 337.

132 *The Expulsion from Paradise*, detail of frieze *c.* 1150
Nîmes, Cathedral
This work is clearly indebted to the frieze of St Gilles (127) and also, to some extent, to the sculptures of Vienne, 1152. Arising from the necessity of adapting the design to the spatial limitations, the figures are portrayed in a crouching position, but these limitations, far from detracting from the merits of the work, are exploited by the artist to give an extra touch of liveliness to the narrative.
Hamann 1956, 323. Salvini 1963, 23.

PROVENÇAL INFLUENCE IN ITALY

133 *A Prophet*, apse window *c.* 1175 green serpentine 1·16 m.
Val di Susa (Piedmont), Sagra di S. Michele, Abbey
Although badly worn, the figures of four Prophets on either side of the apse window, and the four Apostles, originally part of a pulpit or rood-screen in the choir, are recognizable as the work of the sculptor of Castellarquato (135)
Salvini, *AAM.*, 1959. Bernardi 1962, 34, pl. v. Verzár 1968, 108, 123, 133.

134 *Atlas-figure*, external gallery *c.* 1150–60 stone 0·40 m. (the head)
Piacenza, Cathedral
This figure, like those above the arcades of the nave, belongs to the first phase of the school of Piacenza, which harks back to the works of Niccolò and his pupils (93–5), while also owing something to the Provençal school, rather than to the sculptures of the Île-de-France, as some scholars have suggested.

137

138

139

140

141

142

Francovich 1952, 25. Salvini, *RA*, 1954, 214; *AAM*, 1959. Verzár 1968, 137.

135 *The Prophet Isaiah c.* 1170
Castellarquato (Piacenza), Collegiate Church (ambo)
Clearly the work of the same master as that of 135, although possibly a little earlier, since the influence of Niccolò is stronger, and the piece is less outstanding in quality than the figures in the Sagra.
Krautheimer-Hess, *MJKw*, 1928, 293. Francovich 1952, 29. Salvini, *AAM*, 1959.

136 *Caryatid*, detail of rood screen *c.* 1178
Chur (Grisons), Cathedral (crypt)
This and the other figures in the group originally supported the rood-screen and thus their date is that of the consecration of the choir. These figures closely resemble those on the rood-screen in Modena, which are known to have been carved by Lombard craftsmen from Campione, and this indicates that the Chur figures also are the work of Campione sculptors using traditional Lombard motifs, modified by the influence of the sculptures of Arles.
Lindner, *Die Baseler Galluspforte*, etc., 1899, 12. Gantner, *Kunstgesch. d. Schweiz* I, 1936, 222. Francovich 1952, 74. Doberer, *Zeitschr. f. schweiz. Arch.*, 1959, 17.

137 *Caryatid*, detail of rood screen *c.* 1170 marble 0·52 × 0·25 m.
Modena, Cathedral
It is clear, from a document dated 1244, that the Campione workshops had started to work in Modena at least three generations earlier. Similarities between these sculptures and the latest of those at Arles, as well as some of the capitals of the Ghirlandina tower built about 1180, strongly suggest that the cathedral rood-screen was completed *c.* 1170. A sense of concentrated power arises from the compact geometry of these monumental forms.
Vöge, *RKw*, 1902, 409. Venturi 1905, III, 260. Toesca 1927, 770. Francovich 1952, 47. Salvini 1966, 155.

GUGLIELMO
138 *The Annunciation; the Nativity; the three Marys at the Holy Sepulchre*, detail of ambo 1159–62 marble

139 *Lion fighting with a dragon*, detail of ambo 1159–62 marble
Brought from Pisa Cathedral, 1311
Cagliari, Cathedral

The artist's signature, dated, has been obliterated, but is mentioned in reliable sources. Though clearly much influenced by the Provençal school in the statuary conception of the form and in the pictorial intensity of the modelling, Guglielmo did not lack originality. His style is low-keyed and serious, creating an impression of elevated reflection, warmed by a touch of pathos. The magnificent lion, inspired by those of St Gilles, derives its strength from the contrast between vigorous modelling and the geometric austerity of the composition.
Brunelli, *A*, 1901, 67. Biehl 1910, 3. Toesca 1927, 808. Salmi 1928, 77. Francovich 1952, *passim*. Salvini 1963, 98.

BONANUS PISANUS
140 *Adam and Eve after the Expulsion*, detail of door 1185 bronze 7·80 × 3·70 m. (the whole); 0·65 × 0·65 m. (the detail)
Monreale (Sicily), Cathedral (west portal)

141 *The Journey of the Magi c.* 1190–5 bronze 4·70 × 3·02 m. (the whole); 0·70 × 0·70 m. (the detail)
Pisa, Cathedral (Porta di S. Ranieri)

142 *Three Prophets*, detail *c.* 1190–5 bronze *c.* 0·70 × 0·70 m.
Pisa. Cathedral (Porta di S. Ranieri)
The Monreale portal bears the artist's signature and the date 1186, ind. III according to the Pisan calendar, i.e. a period from 25 March to 24 September 1185, according to the Roman calendar. Eve is bringing refreshments to the toil-worn man: the emotional significance of the occasion, softened by an air of sadness, is expressed in the bowed figure of Adam and Eve's lowered head and drooping shoulders. The curve of the palm tree echoes and exalts this theme, a pictorial device which seems even more poignant in conjunction with the surrounding empty spaces. Bonanus was acquainted with the musical harmonies of Byzantine art (ivories), but was steeped in the Western idiom of the school of Guglielmo, so that his narrative style was 'popular', as the title of this work, EVA SERVE A ADA[M] indicates, since it is one of the earliest recorded examples of written Italian. The Pisa portal, though unsigned and undated, must be a later work, in view of the greater maturity of style and the influence of Byzantine neo-Hellenism, which began to show in Pisan sculpture and painting towards the end of the century. In *The Journey of the Magi* (and *The Original Sin*), the pictorial sensibility of the modelling and the harmonious curve of the steep hill refer poetically to the wide and windswept spaces across which the Wise Men must pursue their long and weary journey. The

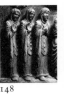

143
144
145
146
147
148
149
150

Prophets sheltering under the waving palms are bathed in brilliant light, which evokes the luxuriant landscape of an oasis.

Graeven, *A*, 1899, 314. Biehl 1926, 56. Toesca 1927, 812. Salmi 1928, 99. Bottari, *Le Arti*, 1939, 565. Martinelli, *Belle A.*, 1948, 272. Salvini 1962, 231. Martinelli, *Bonanno Pisano*, 1966.

143 *Atlas-figures*, detail of tomb of Roger II *c.* 1155 marble
Palermo (Sicily), Cathedral
Roger II, King of Sicily, of Norman stock, died in 1154, and the tomb must have been completed soon after this date. These eight powerful Atlas-figures, with their statuesque conception of the form and the pictorial treatment of their 'wet' garments, proclaim the influence of Provence, and mark the beginning of Sicilian Romanesque sculpture. These magnificent figures represent the revival of Classicism, epitomized in the exalted, heroic style of the work.

Salvini, *Kunstgesch. Studien f. H. Kauffmann*, 1956, 67. Deér, *The Dynastic Porphyry Tombs*, etc., 1959, 3, 86. Salvini 1962, 19. Cochetti Pratesi, *Comm.*, 1967, 127.

144 *The Presentation in the Temple*, detail of capital *c.* 1175–89 marble
0·34 m.
Monreale (Sicily), Cathedral (cloister)
Completed during the reign of William II, who is recorded as having commissioned the cathedral and the attached Benedictine monastery. The lively, pictorial style of the modelling and sinuous curves of the composition imbue the figures with warmth and eloquent poignancy, reminiscent of the Provençal school.

Sheppard, *AB*, 1949, 159; *GBA*, 1949, 401; *AB*, 1952, 35. Cochetti Pratesi, *Comm.*, 1958, 81. Salvini 1962, 135, 154.

145 *Capital with Atlas-figures c.* 1160 marble
Cefalù (Sicily), Cathedral
The date of this work can be fairly accurately determined by reference to the records of the building of the cathedral, and this is further strengthened by its close resemblance to the sculptures of Vienne, known to have been executed between 1150 and 1152. Probably by the same sculptor as that of 143.

Biagi, *A*, 1932, 452. Samonà, *Il Duomo di C.*, 1959; *Atti VII Congr. Storia Archit. Palermo*, 1950, 1956, 156. Salvini 1962, 28, 40. Krönig, *Cefalù*, 1963, 24. Cochetti Pratesi, *Comm.*, 1967, 137.

146 *Figures supporting lectern in ambo c.* 1180 marble
Salerno, Cathedral

The date, 1180, inscribed on a fragment of the choir screen, may also refer to the two ambos. A magnificent work, executed with great precision, luminously Classical in style. It has been erroneously supposed that works of this kind are examples of a 'Hellenistic revival' in Campania; in fact, they reflect the influence of the School of Arles.

Sheppard, *AB*, 1950, 319. Bologna, 1955, 18. Cochetti, *Comm.*, 1956, 9. Salvini 1962, 27, 204.

147 *Scenes from the Life of Christ*, detail of door *c.* 1190 bronze
Benevento, Cathedral
A pre-1939 photograph. The door, though preserved, is now in fragments. Previously thought to date from the 13th century, and believed to be inspired by Byzantine art, although, except in terms of iconography, there is no resemblance. Rather, it is an example of the influence of the Provençal school in Campania. A highly original work, full of dramatic tension and pictorial vivacity, attained by means of an exceedingly articulate and energetic style, and a warm appreciation of the value of scenic effects.

Toesca 1927, 859. Della Pergola, *A*, 1937, 90. Salvini 1963, 102.

BENEDETTO ANTELAMI

148–9 *The Descent from the Cross*, details 1178 marble
Parma, Cathedral
Originally part of the rood-screen, destroyed in 1566. This work is signed and dated. An early masterpiece of this great sculptor, it owes much to the sculptures of Arles. But, in addition to its affinities with Provençal Classicism, there are also echoes of Byzantium. Although the work is deeply imbued with the intimate lyricism of religious contemplation, it also strikes a note of human tenderness.

Venturi 1904, III. Toesca 1927, 773. Quintavalle 1947, 10. Francovich 1952, 113.

BENEDETTO ANTELAMI

150 *The Prophet David c.* 1185–90
Borgo S. Donnino (Fidenza), Cathedral
Here again the Provençal origins of Antelami's art are apparent. Compared to the relief at Parma, this and the companion figure of Ezekiel have more concentrated power and are altogether harsher. The figure, in its narrow enclosure, looks round anxiously, driven by some powerful inner compulsion. The date suggested above seems more convincing than that of 1216–20 favoured by other scholars, since, while the Provençal influence is still strong, there is, as yet, no sign of the influence of Chartres.

151

152

153

154

155

156

156

157

Toesca 1927, 781. Quintavalle 1947, 25. Francovich 1952, 317. Salvini, *RA*, 1954, 221.

BENEDETTO ANTELAMI

151 *Two works of Mercy*, detail of portal *c.* 1196–1200 marble
Parma, Baptistry (west portal, right door jamb)
These reliefs, evidently carved after the sculptor had seen some of the earliest carvings at Chartres, are among the most delicate of all the works of this great master.
Toesca 1927, 777. Jullian 1945. Francovich 1952, 205, 252.

BENEDETTO ANTELAMI

152 *The Presentation in the Temple*, detail of lunette *c.* 1200–10
Parma, Baptistry (south portal, interior)
The figures, sharp in outline and detail, stand out from the background, but are beautifully adapted to the shape of the tympanum. The sharp definition of the draperies accentuate the graceful proportions of the figures and endow them with tremendous if contained emotion. The Provençal influence has by now been left far behind, but there are echoes of the early sculptures of Chartres, and of La-Charité-sur-Loire.
Toesca 1927, 774. Jullian 1945. Quintavalle 1947, 18. Francovich 1952, 227, 254.

153 *March and April c.* 1230 stone 0·93 × 0·50 m.
Ferrara, Museo dell'Opera del Duomo
From the Portale dei Mesi, on the south side, destroyed in 1736. A work of great distinction, by a pupil of Antelami during his Vercelli phase (1220–30). Sharpness and exactness of definition are matched by remarkable pictorial subtlety. The naturalistic detail combined with the stately rhythm of the composition presents a serene and detached vision of human labour.
Schmarsow 1890, 240. Venturi, *A*, 1898, 495. Toesca 1927, 783. Giglioli, *La Cattedrale di Ferrara*, 1935, 185. Jullian 1945, 282. Francovich 1952, 450.

BENEDETTO ANTELAMI

154 *King Solomon*, detail *c.* 1200 marble
Parma, Baptistry (exterior)
Companion piece to the Queen of Sheba. The figure of Solomon stands out in striking contrast to the bare flatness of the façade. The vitality of the figure arises from the dialectic contrast between the inertness of the mass and the subtle vibration of the modelling. This contrast is enhanced by the delicate modulation of the planes, by the

quivering of the thin folds and by the disguised presence of an oblique movement arising out of a slight swerve from the frontal position. Inspired by the early statues of Chartres, the master affords us here in understated terms a new perception of the inner life.
Toesca 1927, 777. Jullian 1945. Quintavalle 1947, 17. Francovich 1952, 198, 260.

155 *The Podestà Oldrado da Tresseno* 1233 marble three-quarters lifesize
Milan, Palazzo della Ragione
Originally attributed to Antelami himself. This statue, which is dated, reflects his style but is more formal and less strikingly expressive than the equestrian statue at Lucca (156), also the work of a follower of Antelami.
Venturi 1904, III, 340. Baroni 1944, 167. Jullian 1945, 247. Quintavalle 1947, 27. Francovich 1952, 439.

156 *St Martin sharing his mantle with the beggar c.* 1210–20 marble *c.* 1·80 × 1·60 m. (the group)
Formerly on the façade, moved to the interior in 1945
Lucca, Cathedral
A work formerly attributed to Guido of Como and Guidetto, or thought to derive from the elegant neo-Hellenistic sculptures of the Baptistry at Pisa (*c.* 1190–1200). Stylistic evidence, however, suggests that it is the work of a follower of Antelami, and that although the equestrian figure of the Saint is portrayed in the stiff, full-face attitude reminiscent of Byzantine art, the work is nevertheless more indebted to the Late Antique than to the Byzantine tradition proper. The tall figure of the beggar expresses with lively simplicity a feeling of humility and trustful solicitation; this is more in key with Early Gothic than with Byzantine art.
Schmarsow 1890, 168. Venturi 1904, III, 978. Swarzenski, *RJKw*, 1905, 165. Toesca 1927, 819. Salmi 1928, 104. Salvini 1963, 97.

157 *January and February*, detail of soffit of arch *c.* 1235–40 marble 1·75 m.
Venice, St Mark's (main portal)
Certainly earlier than 1240, when these sculptures were copied at Traù by craftsmen who had worked on the portal of St Mark's. Though formally they have much in common with the work of Antelami, they are much more richly decorated. With a subtle deployment of pictorial detail, these distinguished and expressive figures, surrounded by foliage, seem endowed with the freshness of nature itself.
Ongania, *La Ducale Basilica di S. M.*, 1886, 249. Gabelentz, *Mittelalterl.*

331

158 159 160 161 162 163 164

Plastik in Venedig, 1903, 174. Venturi 1904, III, 359. Toesca 1927, 795. Pallucchini, *I Mesi marciani*, 1944. Jullian 1945, 291 Demus, *The Church of S. M. in Venice*, 1960, 153.

RADOVAN AND ASSISTANTS

158 *Allegories of the Months* 1240 marble
Traù (Trogir), Dalmatia, Cathedral (main portal)
Signed and dated. Only the figure of the man tending the cooking-pot, representing one of the winter months, is certainly the work of the master. The other two, the centre one possibly representing February and the lower one early spring, are by a pupil.
Venturi 1904, III, 350. Toesca 1927, 798, 897. Jullian 1945, 297. Fisković, *Radovan, Portal Katedrale u Trogiru*, 1951. Demus 1960, 156. Fisković, *Radovan*, 1965.

ÎLE-DE-FRANCE AND RADIATIONS

159 *The Adoration of the Magi c.* 1145 1·27 m. wide
La-Charité-sur-Loire, Ste Croix (lintel of south portal in north tower)
Probably an early work (and not a late one as is sometimes suggested) by the earliest master of Chartres. In fact, in addition to the pictorial softness and linear delicacy associated with the Burgundian tradition, there is a greater pictorial intensity (cf. the 'wet' draperies enveloping the figures) which can only derive from Provence, and almost entirely disappears at Chartres (160).
Lasteyrie, *Mon. Piot*, 1902, 78. Porter 1923, 128. Lefrançois-Pillion, *Beaux-Arts*, 1924, 214. 65. Beenken, *ASt*, 1928, 145. Beaussart, *L'Église Bénédictine La-Ch.-L.*, 1929, Aubert 1929, 23. Medding, *RKw*, 1931, 82. Aubert 1946, 108. Mâle 1948, 30. Francovich 1952, 285.

160 *The Presentation in the Temple c.* 1145–50 stone
Chartres, Cathedral (lintel of right doorway in the Royal Portal)
The approximate date can be deduced from the sequence of the construction, and also from the figure of the Madonna in the tympanum above, which may be the one commissioned by Archdeacon Richer. The figures are designed to fit neatly into predetermined rectangular spaces, but the rigour of this archaic spatial principle is softened by the way in which the figures are variously carved in full face, profile, and three-quarter face. The impression created by this means is of withdrawal into deep meditation, so that there is no sense of activity or urgency, but only an atmosphere of detached and distant ritual symbolism.

Porter 1923, 384. Priest, *ASt*, 1923, 40. Hamann, *MJKw*, 1925–6, 84; 1927, 101. Aubert, *BAFr*, 1928, 209; 1929, 85; 1946, 239. Aubert, *BMon*, 1941, 177. Aubert 1946, 176. Mâle 1948, 23. Francovich 1952, 284. Katzenellenbogen 1959.

161 *The Annunciation to the Shepherds c.* 1150 stone 0·90 m.
From the Parish Church of Gustorf
Bonn, Rheinisches Landesmuseum
Originally part of the choir screen or of the Shrine of the Holy Sepulchre. A work of some refinement in the charm of its pictorial detail and the studied poses of the figures, both reminiscent of the Burgundian School. The influence of the early sculptures of Chartres is clear, suggesting a date in mid-century rather than, as some have claimed, the 1130s or the second half of the century.
Clemen, *ZBK*, 1903, 97. Klein, *Roman. Steinplastik des Niederrheins*, 1916, 67. Lüthgen 1923, 71, 151. Beenken, *JKw*, 1923, 131. Beenken 1924, 162. Francovich 1952, 41. Feulner-Müller 1953, 50. Steingräber 1961, 14. Weigert 1961, XXIII.

162 *Column statue with crossed legs c.* 1150–5 stone

163 *The Months and Signs of the Zodiac c.* 1150–5 stone

164 *Column statues c.* 1150–5 stone

165 *Christ's entry into Jerusalem c.* 1150–5 stone
Chartres, Cathedral (Royal Portal)
Nos 162 and 163 from left door, 164 from central door, 165 from right door.
The work of master-craftsmen from various places, Burgundy in particular, but all very much under the control of the great sculptor who was in charge of the whole operation. The narrative scenes on the capitals and the allegorical subjects on the archivolts develop the still archaic style of the lintels of the door on the right (160) towards more complex treatment, already showing signs of Gothic animation. Of the column statues, 162, which preserves echoes of the school of Toulouse, is more archaic in style than those of the central door, 164, executed by the same sculptor with greater freedom. Such figures are known as 'column statues', not in the sense that they would replace the columns in the manner of caryatids but because they are merged with the column: they are, in fact, attached to them, standing out no more than is necessary to have a distinct volume of their own, and thus sharing the timeless solemnity of the actual columns. The delicate folds

165

166

167

168

169

170

171

of the drapery form the finest possible embroidery, with an indefinable suggestion of music, and seem to enfold the figures in a distant, secret world of their own, so that they appear humble and serene, only remotely aware of the turmoil of human emotions.

Vöge 1894. Lasteyrie, *Mon. Piot*, 1902. Porter 1923, 285. Priest, *ASt*, 1923, 28. Focillon 1931 (ed. 1964, 260). Aubert, *BM*, 1941, 177; 1946, 239. Goldscheider, *Bull. Mus. de France*, 1946, 22. Mâle 1948. Giesau 1950, 119. Sauerländer, *Kstchr.*, 1956, 155. Kidson 1958. Grodecki, *BM*, 1959, 285. Katzenellenbogen 1959, 29. Lapeyre 1960. Salvini 1963, 104. Kerber 1966, 47.

166 *Fiddle-player c.* 1210 stone 0·84 × 0·46 m.
Probably from the choir screen of the old cathedral
Cologne, Schnütgen Museum
Attributed, along with fragments of a dancing figure, to the 'Master of the Samson from Maria Laach', a sculptor whose works are also to be seen at Cologne (St Pantaleon), Bonn (choir stalls), and Andernach (portal). The Classical spirit, proper to the 'Hohenstaufen Renaissance', is combined with the gracious reticence of the Late Romanesque sculpture of Cologne (St Plectrude, tomb, St Maria im Kapitol; the Madonna of Siegburg; the tympanums of St Cecilia, St Pantaleon, etc.). Strongly influenced by the sculptures of Chartres and possibly of Rheims also, this work is virtually a northern version of the Classicism of southern Italy in the time of Frederick II.

Klein 1916, 102. Bader, *Bonner Jb.*, 1929, 172. Frey, *ZDVKw*, 1935, 496. Verbeek, *WRJ*, 1938, 30. Appel, *ZKG*, 1938, 69. Wirth, *ZKG*, 1957, 25. Verbeek, *Festschr. Neuss*, 1960, 366. Steingräber 1961, 17. *Das Schnütgen Mus. Kat.*, 1961, n° 54.

167 *Trumeau figure c.* 1170–5 stone 1·90 × 0·30 m. (the whole figure)
St Loup-de-Naud, St Loup (west portal)
This portal was built as the result of an endowment by the Comte Henri le Liberal, in 1167. The style of the column statues of Chartres is here translated into a language of greater realism, strengthened by a powerful sense of mass, with echoes of Burgundian art.

Salet, *BMon.*, 1933, 156. Aubert 1946, 197. Kerber 1966, 63.

168 *King Solomon c.* 1180–90 stone 2·28 m.

169 *Queen of Sheba c.* 1180–90 stone 2·38 m.
From Notre-Dame-de-Corbeil (portal)
Paris, Louvre.
It has been suggested that this portal was built in 1150–60, at the same

time as the church, the argument being that the style, although faithful to the Chartres tradition, is profoundly different from that of Senlis. It is, however, difficult to reconcile this view with documentary evidence of the purchase for demolition, in 1180, of three adjacent houses which were blocking the entrance to the church. It must also be noted that, though admittedly deriving from Chartres, the manner here is over-subtle, precious, indeed almost decadent, which suggests that these figures represent, in their excessive technical refinement, the very last phase of the art of Chartres.

Vöge 1894. Salet, *Bull. Mon.*, 1941, 81. Aubert 1946, 202. Kerber 1966, 68.

170 *Mary mourning c.* 1210–20 painted wood c. 2·20 m.
From the Crucifixion Group on the triumphal beam
Halberstadt, Cathedral
One of the most beautiful pieces among the so-called 'Triumphal Crosses' of Saxony. The stylistic origins of such groups have never been satisfactorily explained, though it seems clear that we are confronted by the fusing of a precious archaism of Byzantine origin with the already 'proto-Gothic' expressionism of Late Romanesque German sculpture, evolving under French influence.

Goldschmidt, *JPKslg*, 1900, 225. Panofsky 1924, 104. Feulner-Müller 1953, 77. Steingräber 1961, 17. Weigert 1961, XVIII.

171 *The Descent from the Cross c.* 1150 stone 5·00 m. (the whole); figures lifesize
Horn, carved in the rock at the entrance to the sanctuary
Hitherto, the generally accepted date has been 1115, which is that of the consecration of the chapel, but doubt has recently been cast upon this opinion. The suggestion that this relief is a copy, on a monumental scale, of minor works such as ivories in the Byzantine tradition does not stand up to close scrutiny. The sharp detail of the carving may possibly derive from ivory-carvings, but against this must be set powerful affinities with local Ottonian sculpture, a foreshadowing of the style of the triumphal crosses of Saxony, and some knowledge of the sculptures of western France (e.g. Poitiers, 106, 109). What is undeniable is the powerfully expressive and visionary character of the work. By the use of curve and counter-curve, the artist achieves a controlled dramatic tension, which portrays in elegiac terms the catharsis of intense suffering.

Panofsky 1924, 84. Beenken 1924, 96. Fuchs, *Im Streit um die Externsteine*, 1934. Schmitt, *Beiträge f. G. Swarzenski*, 1951, 26. Feulner-Müller 1953, 42. Gaul, *Westfalen*, 1954, 141. Steingräber 1961, 14.

172 173 174 175 176 177

Weigert 1961, XX. Salvini 1963, 83. Badenheuer-Thümmler, *Romanik in Westfalen*, 1964, 17, pl. 46.

172 *The four Evangelists*, lectern *c.* 1150 painted wood 1·37 m. (the whole); 1·20 m. (the figures). Possibly from Monastery of Alpirsbach Freudenstadt (Black Forest), Parish Church
A masterpiece which it is difficult to classify stylistically. It is highly abstract in spirit and geometric in form and colour. It may be regarded as a severely neo-Archaic interpretation of Byzantine models, if not a product of French (Chartres?) or Lombard influences.
Panofsky 1924, 98. Beenken 1924, 120. Francovich 1943, 20. Feulner-Müller 1953, 52. Steingräber 1961, 14. Weigert 1961, XIX.

BRITISH ROMANESQUE

173 *The Sisters Lamenting*, detail of the Raising of Lazarus *c.* 1150 stone 1·05 m.
Chichester, Cathedral
Detail of one of the two reliefs (the other one portraying Christ with Martha and Mary) moved in 1829 from the piers of the crossing and sometimes attributed, on insufficient evidence, to two different sculptors. Because of some vague resemblance to Ottonian works, they have received various pre-Conquest datings, or were dated about 1075. It is more likely, however, that they date from the middle of the 12th century in view of their affinities with the miniatures of the St Alban's Psalter. Any resemblance between these reliefs and Ottonian sculpture can be attributed to the influence of Saxon art (171) whose Romanesque character was still imbued with nostalgia for the great Ottonian past. The faces are deeply furrowed with grief, an effect achieved by the artist with a few vigorous strokes, suggesting a prolonged, almost liturgical lament.
Stephens, *Memorial of the . . . church of C.*, 1876, 31. De Gray Birch, *BAAJnl.*, 1886, 255. Prior-Gardner 1912, 139. Porter 1923, 55. Clapham 1930, 138. Gardner 1935, 52. Kendrick 1938, 52. Zarnecki 1951, 24. Talbot Rice 1952, 110, 172. Saxl-Swarzenski 1953, 32. Stone 1955, 65. Salvini 1963, 85.

174 *Vine tendrils, snakes, and warriors*, detail of jamb *c.* 1150 stone *c.* 0·82 m.
Kilpeck, St Mary and St David (south doorway)
A masterpiece of the Herefordshire school, the earliest works of which were in the now demolished church of Shobdon, commissioned about 1140 by Oliver de Merlimond to commemorate his pilgrimage to

Compostela by way of France. This fact explains the close affinities between the work of this school and of those of Poitou and Anjou. The French-inspired motifs, however, are treated in a spirit of mathematical abstraction deriving from the Norman tradition.
Prior and Gardner 1912. Clapham 1934, 142. Jónsdóttir, *AB*, 1950, 171. Zarnecki 1953, 10. Boase 1953, 81–84. Stone 1955, 68.

175 *Cain and Abel tilling the fields c.* 1145–8 stone *c.* 0·69 m.

176 *Noah building the Ark*, detail *c.* 1145–8 stone *c.* 1·05 m.
Lincoln, Cathedral (west front)
The fact that two of the reliefs on the frieze are unfinished suggests (Zarnecki) that the frieze was originally erected where it now stands. It follows that the work was completed as part of the restoration promoted by Bishop Alexander (d. 1148), after the fire of 1141. Moreover, these reliefs are very much in the style of the Bishop's seal. These works, though original in style, owe much to the sculptures of St Denis (1137–40). This points to the presence of a master-craftsman steeped in Emilian sculpture, a fact which explains the affinities, in terms of overall composition, with the Wiligelmo frieze at Modena (71 and 72). Thus 175 recalls the tender cadences of Burgundian sculpture, but in a simplified form. Work proceeds in a tranquil and alternating rhythm while the harmony between the soft, luminous volume of the figures and the gentle curves of their contours infuse the scene with a Virgilian spirit. Romanesque solidity is enlivened here and there with pre-Gothic vitality, as in the Noah sculpture (176), where the figure can be seen resignedly carrying out his allotted task, with an expression of prophetic, almost visionary zeal, so that his labours seem illuminated by religious faith.
James, *Proceed. Cambridge Antiq. Soc.*, 1898–1903, 148. Kendrick, *The Cathedral Church of L.*, 1899. Gardner 1935, 49. Saxl-Swarzenski 1952, 45. Zarnecki 1953, 20. Stone 1955, 73. Salvini 1963, 110. Zarnecki *Romanesque Sculpture at L. Cathedral*, 1963.

177 *Caryatid*, originally supporting the rib of a vault *c.* 1140 stone 1·18 m.
Durham, Cathedral.
One of the four caryatids which originally supported the roof of the chapter-house, built 1133–40 and demolished in the late 18th century. These works, said to have much in common with those on the capitals of the crypt of Canterbury (usually dated *c.* 1120, though they are probably later) recall, in their sculptural vigour and fluidity of line, the sculptures of western France and also, perhaps, here and there, the work of Niccolò.

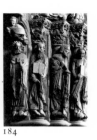

178

179

180

181

182

183

184

Prior and Gardner 1912, 218. Gardner 1935, 97. Saxl-Swarzenski 1953, 64. Zarnecki 1953, 34. Stone 1955, 76.

78 *An Apostle*, south porch *c.* 1165–75 stone *c.* 1·55 m.

79 *The Sacrifice of Isaac*, outer doorway of church *c.* 1165–75 stone 0·42 m.
Malmesbury (Wiltshire) Abbey Church
The church was consecrated in 1163, but the portico and portal may be later, possibly nearer to 1175, the date of completion. Miniatures of the period (Shaftesbury Psalter, 1161–73) provide supporting evidence for this dating. The debt to the sculptures of western France (Aulnay) and of Chartres (Apostles) is very evident, especially in the portal medallions. The figures are cut in almost flat surfaces applied as it were to the plane and delimited by sinuous outlines; on these surfaces the folds of the draperies are carved like a mysterious hieroglyph. The decorative and at the same time expressionist energy of the linear texture gives utterance, both in the scenes on the medallions and in the great figures of the Apostles, to a dialogue both fervid and detached: in fact, we experience here something like a re-creation of the abstract expressionism of Anglo-Saxon miniatures.
Bagnall Oakely, *Bristol and Gloucester Arch. Soc.* 1891, 132. Prior-Gardner 1912, 188. Porter 1923, 132. James, *Abbeys*, 1925, 28. Keyser, *A List of Norman Tympana*, 1927, XXXIX. Clapham 1934, 86. Gardner 1935, 85. Zarnecki 1953, 40. Saxl-Swarzenski 1953, 57. Stone 1955, 83. Salvini 1963, 111. Zarnecki, *Acts 20th Intern. Congress Hist. of Art*, 1963, 153.

80 *The Judgement of Solomon*, capital *c.* 1150 stone *c.* 0·26 m.
London, Westminster Abbey
Capitals used in the triforium. Some fancied resemblance to the Bayeux tapestry has led certain authorities to ascribe these capitals to the beginning of the 12th century. However, it seems more likely that, in spite of the roughness of the carving, these sculptures were inspired by the reliefs of St Denis, with which, for all their primitiveness, they have many features in common, especially in the portraiture (e.g. Solomon cross-legged, shown in full face, and with disproportionately large hands).
Zarnecki 1953, 8.
Stone 1955, 50.

LATE ROMANESQUE SCULPTURE IN SPAIN

181 *St Vincent and the two sisters led to their execution*, detail of St Vincent's tomb *c.* 1170 marble
Ávila, S. Vicente
The work of the sculptor of the west portal (possibly Fruchel), strongly influenced by the sculptures of Chartres and Burgundy (Vézelay, Autun), if not directly by the earlier portal of Sangüesa in Navarre. The Burgundian influence is especially strong in the detail illustrated here, where the nude is treated with great delicacy and tenderness.
Porter 1923, 264; 1928. Gudiol Ricart-Gaya Nuño 1948, 324. Pita Andrade 1955, 16. Durliat 1962, 42, 77.

182 *Two Apostles c.* 1180
Oviedo, Camara Santa (Capilla San Miguel)
Opinion is divided as to whether this group of Apostles is the work of a predecessor or a pupil of Master Mateo (184). The former is certainly the more likely. At all events, the theory, no sooner considered than rejected by Porter, that this is an early work by Mateo would not be untenable. The spiritual solemnity of St Denis and Chartres is fused with the imaginative fervour of Burgundy and Languedoc to express in terms of ineffable pathos and poetry the emergent spirit of dialectical passion characteristic of Scholasticism.
Buschbeck 1919, 48. Porter 1923, 261; 1928. Mayer, *Skulpt. d. Cámara Santa in Oviedo*, 1926. Gudiol Ricart-Gaya Nuño 1948, 327. Pita Andrade 1955. Durliat 1962, 42, 84. Salvini 1963, 109. Palol-Hirmer 1965, 119.

183 *St Paul the Apostle c.* 1140
Oviedo, Cathedral (cloister)
This powerful sculpture, like its companion figure, St Peter, inspired by the pioneer work of Gilabertus of Toulouse (92), exploits the full potential of the earlier techniques.
Gómez Moreno 1934. Gaillard 1938. Durliat 1962, 33, 84.

MATEO
184 *Four Apostles* 1188 granite 1·93 m. (St Peter, far left)
Santiago de Compostela, Portico de la Gloria (central door, right jamb)
This work, which is signed and dated, represents the final triumphant

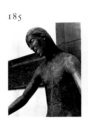
185

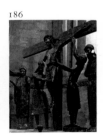
186

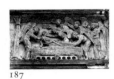

187

188

189

190

191

phase of Spanish Romanesque art, and ushers in the Gothic era. These four debating Apostles, though imbued with the same spirit as those of the Cámara Santa of Oviedo, are more animated, robust, and full-blooded.

Buschbeck 1919. Porter 1923, 261; 1928. Vidal Rodriguez, *El Portico de la Gloria*, 1926. Weise 1927. Gómez Moreno 1934, 114. Gudiol Ricart-Gaya Nuño 1948, 346. Pita Andrade, *Cuad. estudios gallegos*, 1950, 131. Pita Andrade 1955. Gaillard, *CCM*, 1958, 465. Durliat 1962, 40, 86. Salvini 1963, 110. Mellini, *Maestro Mateo a Santiago*, 1967.

LATE ROMANESQUE SCULPTURES IN WOOD

185 *The Descent from the Cross*, detail *c.* 1210–20 painted wood
From St Peter's
Tivoli, Cathedral
One of the most beautiful wooden groups among the many examples to be found in Central Italy. The influence of Antelami is clear: it probably reached the region by way of Arezzo, where several works of his school in stone still survive, as well as through the Marches where a number of wooden Crucifixes of Antelamesque origin are preserved. In any event, Antelami's influence blends here with a Byzantine pictorial delicacy to strike a note of intimate lyricism.
Hermanin, *D*, 1920, 217; 1921, 79. Francovich, *BA*, 1929. Francovich 1943 11. Carli *Scultura lignea italiana*, 1960, 30.

186 *The Descent from the Cross* 1251 wood 3·17 m. (the Cross); 1·70 m. (the figure of Christ)
S. Juan de las Abadesas, Monastery
The date of the consecration of this group is on record. While there is evidence here of some second-hand knowledge of Late Romanesque and pre-Gothic French sculpture, these sculptures appear older than those of Tahull and Erill-la-Vall – although the latter have generally been held to be of an earlier date – by virtue of the Romanesque reticence which exercises a firm control over the undoubted pathos of the scene.
Puig y Cadafalch, *RAChr*, 1914, 17. Porter 1928, 12. Francovich, *Boll. Stor. Lucchesse*, 1936, 3. Spencer Cook-Gudiol Ricart 1950, 308. *Catalogue Romane*, 11, 1961, 270. Durliat 1962, 57. Palol-Hirmer 1965, 125.

GOTHIC SCULPTURE
FRENCH 13TH CENTURY

187 *The Assumption of the Virgin*, detail of lintel *c.* 1175 stone 0·88 × 2.20 m.
Senlis, Cathedral (west portal)
This is the earliest known *Assumption* where the Virgin is awakened by a company of angels. This iconographic innovation coincides with the intensification of the cult of the Virgin Mary, which can fairly be regarded as an early manifestation of Gothic art. In place of the dream-like quality of the Chartres group (160) – the unforgettable forerunner – there is here, in the vibrant, free-flowing lines of the piece, a sense of urgency, a marvellously fresh expression of anxious haste. The building of the church was begun some time after 1153, and completed in 1191. The dating of the portal (*c.* 1175, Sauerländer) is probably based on its stylistic affinities with those of Mantes (*c.* 1180) and Laon (*c.* 1190).
Vöge 1894. Aubert, *Cathédrale de S.*, 1910. Pillion (1911), 27, 93. Mâle 1919, 300. Muratoff 1931, 32. Aubert 1946, 206. Sauerländer, *WRJ*, 1958, 115. Katzenellenbogen 1959, 58, 97.

188 *Allegory*, detail of jamb *c.* 1210 stone 0·38 × 0·28 m.
Paris, Notre-Dame (left portal)
The series of twelve reliefs on the jambs have been variously interpreted as representing the Months, the Seasons of the Year, or Stages in the Life of Man. This figure, therefore, may represent either the month of April or Spring (in both cases the double figure, clothed on the one hand and naked on the other, must allude to the uncertain weather at this time of the year), or the Prime of Life, looking back towards youth and forward to old age. As compared with the sculptures of Senlis, these delicately executed figures suggest a return to Classic simplicity under the influence of Byzantine ivories, as suggested by Michel and Sauerländer, and perhaps also of Antelamesque sculptures (153, 155).
Viollet-le-Duc 1854–69. Michel 1906 (11, 1), 150. Aubert, *La Cathédrale N.-D.*, 1909 (new ed. 1944). Pillion (1911), 106. Mâle 1919, 85. Aubert, *N.-D., sa place dans l'hist.*, etc., 1929. Muratoff 1931, 41. Aubert 1946, 245. Sauerländer, *MJKw*, 1959.

189 *The Visitation*, detail of lintel *c.* 1175 stone 0·90 m.
Paris, Notre-Dame (right portal)

190 *The Virgin Enthroned: Legends of St Anne c.* 1175 stone 5·90 m. width (tympanum)

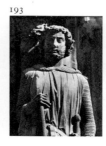

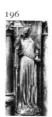

Paris, Notre-Dame (right portal, lunette and lintels)
The Portal of St Anne was reconstructed in about 1225, and some of the surrounding sculptures were added at that date. However, a great many of the sculptures from the original portal, dated 1175, were incorporated. Among these were the sculptures of the tympanum and the two architraves which are clearly influenced by the right portal in Chartres, the work of the Master of Chartres (160). Although it has been suggested that these sculptures represent a Gothic interpretation of the Late Romanesque style of Chartres, they are, in fact, transitional works, too severe and monumental in style to be regarded as strictly Gothic. The figure of King Louis VII (d. 1180) on the tympanum indicates the latest possible date for this piece.
Mâle, *R. Art*, 1897, 231. Lasteyrie, *Mém. Soc. Hist. de Paris*, 1902. Aubert, *La Cathédrale N.-D.*, 1909 (n. ed. 1944); *N.-D. de P., sa place* etc., 1929. Muratoff 1931, 31. Aubert 1946, 200. Sauerländer, *MJKw*, 1959.

191 *The Creation of Adam*, detail, north portal, *c.* 1210–25 stone, 0·50 m.

192 *Ste Modeste*, detail *c.* 1225–30 stone 3·00 m.
Chartres, Cathedral (north portal)
Both these sculptures are on the portico of the triple portal, which was added not long after the completion of the portal itself. These works are masterpieces of grace in the annals of Gothic sculpture. In the Creation of Adam, a youthful God is modelling the human form like a sculptor: the Spirit of Life seems to proceed from His delicate touch, and a feeling of loving gentleness is expressed in the sinuous curves and smoothness of form in the draperies of the Creator and in the nude figure of Adam. In Ste Modeste, the sculptor has freed himself of the conventional restrictions of the column statue form. The figure has a life of its own, independent of the architecture, while being at the same time in perfect harmony with the graceful proportions of the building as a whole.
Pillion (1911), 134. Aubert 1946, 220. Grodecki, *AB*, 1951, 156. Frankl, *AB*, 1957, 33. Grodecki, *BMon.*, 1958, 91. Kunze, *Kstchr.* 1958, 293. Sauerländer, *MJKw*, 1959.

193 *St George*, detail *c.* 1210–15 stone 3·00 m.
Chartres, Cathedral (south portal)
A magnificent figure, in crusader's armour. In spite of the realistic detail of the dress, and the naturalism of the portraiture, the spirit of this work is exalted and idealistic.
Pillion (1911), 140. Muratoff 1931, 39. Aubert 1946, 238. Grodecki, *AB*, 1951, 156. Kidson 1958, 55.

194 *October, November, December*, detail *c.* 1225–36
Amiens, Cathedral (west portal, left door)
In the decorative sculptures of the portals of Amiens Cathedral, the first phase of Gothic art can be seen in its full maturity. It has often been remarked that these works show signs of excessively mannered self-consciousness. But the panels, illustrating the Months of the Year, and those depicting the Lives of the Prophets and the Flowers of the Holy Virgin, are remarkable for their freshness and carefully observed naturalistic detail. Here the freedom and fluency of Gothic line and form are fully deployed in the interests of representational accuracy and realism.
Durand 1901–3. Pillion (1911), 150. Medding, *Die Westportale der Kath. v. Amiens*, 1930. Muratoff 1931, 44. Aubert 1946, 252.

195 *Two scenes of student life ? c.* 1260 stone 0·80 × 0·60 m (each panel)
Paris, Notre-Dame (portal of south transept)
The name of the architect (Jean de Chelles) and the date when the portal was begun (12 February 1258) are recorded in an inscription. The subject – scenes from university life, in which students are seen attending lectures, arguing, rebelling, receiving punishment, and so forth – seems too trivial for a cathedral, and it may well be that these reliefs in fact represent scenes from the life of some saint. They are, at any rate, remarkable for the freedom of their composition and their narrative vitality.
Aubert, *La Cathédrale N.-D.*, 1909 (n. ed 1944); *N.-D. de Paris, sa place*, etc., 1929. Pillion (1911), 164. Mâle 1919, 414. Muratoff 1931, 56. Aubert 1946, 263. Jalabert, *N.-D. de Paris*, 1948.

196 *Church and Synagogue c.* 1230 Grès des Vosges 1·93 m. (each figure)
Strasbourg, Cathedral (portal of south transept)

197 *Angel pillar*, detail *c.* 1230–40 sandstone grès rose 1·63 m.
Strasbourg, Cathedral (interior of transept)

198 *Caryatid c.* 1225 sandstone grès rose 1·05 m.
Strasbourg, Cathedral Museum
The allegory of Church and Synagogue (196) is here interpreted in terms of the Judgement of Solomon, of whom there is a statue on the jamb. According to an interpretation attributed to St Augustine, the Church is identified with the true mother and the Synagogue with the false claimant. Some scholars, fancying they detected the influence of Rheims (199, 201) in the work of the Strasbourg sculptor, have ascribed these pieces to a date in the middle of the century, or even

199 200 201 202 203 204 205

later. But the extremely subtle folds of the draperies may be better interpreted as a development of the style already to be seen in the north portal at Chartres, whilst the freer interplay of architecture and sculpture is linked to a secondary artistic current which had its beginnings in Sens about 1190. The remarkable boldness and virtuosity of line, giving an impression of consistent spontaneity, is allied to a Classical sense of proportion, and this rare combination brings into harmonious equilibrium the muted pride and triumph of the Church and the humbling of the Synagogue, dignified and irradiated by its own beauty. No. 198 provides clear proof of this master-sculptor's familiarity with Classical sculpture. No. 197 forms part of the very tall central pilaster of the transept (a delightful conceit, to which there is no known parallel), which renders (with Christ as Judge, four trumpeting angels and the four Evangelists) a composite image of Judgement. Franck-Oberaspach, *Der Meister der Ekkl. u. Syn.*, 1903. Schmitt, *Got. Skulpt. des Strssb. Münsters*, 1924. Jantzen 1925, 10. Kautzsch, *Oberrh. K.*, 1928, 133. Muratoff 1931, 54. Aubert 1946, 291. Weis, M. 1947–48, 65. Katzenellenbogen 1959, 69. Sauerländer, *MJKw*, 1959. Beyer, *La sculpt. méd. du Musée de l'Oeuvre N.-D.*, 1963, nº 68, Sauerlander, *Von Sens bis Strassbourg*, 1966. *Europe Gothique*, 1968, nº 40.

199 *Church* c. 1230–5
(south transept front)

200 *King Philippe Auguste* c. 1225–30
(north transept front)

201 *The Visitation* c. 1230–5
(central portal of west façade)

202 *The Resurrection of the Dead*, detail c. 1230–5
Rheims, Cathedral (north transept front)
A recent thorough reinvestigation of the complex and intricate history of French cathedral sculpture has led to a repudiation of the formerly held view that the work was not completed until as late as c. 1250–60. Moreover, because of the strong Classical influence apparent in all of them, the carvings of Rheims are among the most appealing of all French Gothic sculptures. This is especially true of the balanced and dignified figure of the Church, the heroic portrait of the young king, and the grandiose Visitation group, in which the air of learned nobility of Roman figures, which might also be works of the Augustan era is reflected, so that all these sculptures, so gentle in their appeal, evoke a direct emotional response. The Resurrection of the Dead is one of the most beautiful of all the many interpretations of this recurring theme,

through the powerful realism and the Classical solidity of the nude bodies, while their spiritual aspect is expressed by the complicated yet contrasting rhythms which combine to create the compositional unity of the Last Judgement.
Demaison, *BMon.*, 1902. Vitry 1915–19. Muratoff 1931, 45. Aubert 1946, 264. Säuerländer, *ZKG*, 1956, 1. Grodecki, *BMon.*, 1957, 125. Aubert, *EUA*, VI (1960), 394. Schmidt, *MJBK*, 1960. Branner, *ZKG*, 1961, 220.

203 *The Nativity*, rood-screen fragment, c. 1230–40 stone 0·93 × 1·31 m.
Chartres, Cathedral
The magnificent reliefs of this screen, now preserved in fragments, are the work of several different sculptors, and have much in common with those of the transept portals of Chartres, and the sculptures of about 1230 in Notre-Dame in Paris. The tender intimacy of the scene and the prevailing atmosphere of pensive serenity are expressed in the harmonious interplay of curves determining the outlines of the figures, and movement of the thin folds of the draperies, as well as the softly rounded volume of the bodies.
Delaporte, *Mém. Soc. archéol. Eure-et-Loire*, 1937, 191. Jusselin, *ibid.* 1940, 205. Bunjès, *WRJ*, 1943, 70. Aubert 1946, 239. Sauerländer *ZKG*, 1956, 1. Mallion, *Chartres; le jubé*, 1964. Villette, *Mém. Soc. archéol. Eure-et-Loire*, 1965, 127. *Europe Gothique*, 1968, nº 36.

204 *The Dance of Salome*, detail of tympanum c. 1250–60 stone 2·10 m.
Rouen, Cathedral (façade, left doorway)
On the right is shown the Martyrdom of St John the Baptist and, above it, the rarely treated subject of the mysterious death of St John the Evangelist (both scenes lie outside the limits of this illustration). The figures move freely in the clearly determined space of the 'stage'. This underlines the dramatic conception of the narrative conveyed, not without a certain elegance, by the tension of the line and by the dashing movements of the figures.
Pillion, *RAChr.*, 1904, 181. Aubert 1946, 293.

205 *The Last Judgement*, detail c. 1250–5 stone c. 2·55 × 3·40 m.
Bourges, Cathedral (central doorway)
This work exhibits every refinement to be found in the late sculptures of Rheims and Amiens, but the sculptor here is working in a popular idiom to create scenes at once dramatic and grotesque with an almost neo-Romanesque flavour.
Pillion (1911), 187. Boinet, *Les Sculpt, de la cath. de B.*, 1912. Mâle 1919, 444. Aubert 1946, 281. Gauchery-Grodecki, *St-Etienne de Bourges*, 1959, 107. Branner, *La Cathédrale de B.*, 1962.

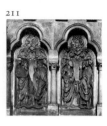

206 207 208 209 210 211

206 *The Descent from the Cross c.* 1250 coloured stone 1·10 m.
From Bourges, Cathedral (fragments of the *jubé*)
Paris, Louvre
These extraordinarily beautiful reliefs, formerly ascribed to the second
half or the end of the century, have recently been reassessed (Gnudi)
as precursors of the works of Nicola Pisano, and ascribed to an earlier
date. They are outstanding among French Gothic sculptures –
especially the fragment illustrated here – for the depth of the modelling,
executed with great freshness and vigour, which is expressive of a
passionately dramatic view of life and a profound humanity.
Bunjes, *WRJ*, 1934, 93. Aubert 1946, 323. Gauchery, *St-Etienne de
Bourges*, 1959, 28. Bottari, *AAM*, 1962, 75. Sauerländer, *Kstchr*, 1962,
225; *Art de Fr.*, 1963, 219. Gnudi, *RArt*, 1969, n⁰ 3, 18.

207 *The Vision of John the Hermit*, detail of King Dagobert's tomb *c.* 1263–4
stone 1·50 m.
St Denis, Abbey Church
At the very same hour as the death in 638 of King Dagobert, legendary
founder of the abbey, John the Hermit had a dream, in which St
Dionysus appeared to him and called upon him to pray for the soul of
the King. The King's soul meanwhile had been seized by agents of the
Devil, with a view to transporting it by boat to Hell (lower panel). In
response to John's intercession, the soul was set free by St Maurice and
St Martin, and in the uppermost panel (not illustrated here) can be
seen ascending to Heaven. This tomb belongs, in fact, to the series of
tombs of the ancestors of Louis IX, executed under the supervision of
the architect Pierre de Montreuil and placed in the church in 1263–4.
These reliefs, full of vitality and realistic narrative detail, make free and
fresh use of naturalism. The style is earthy and popular, and perhaps
derives from the neo-Romanesque character of the Bourges *Last
Judgement* (205).
Vitry-Brière, *L'Église abb. de St.-D.*, 1925. Aubert 1946, 297. Crosby,
L'Abbaye Royale de St.-D., 1953, 64.

208 *The Smiling Angel c.* 1250
Rheims, Cathedral (west front, left doorway)
Intended originally as a companion piece to the Annunciation on the
centre portal, this figure was, in the event, erected beside that of S.
Nicaise (?) on the left doorway. This is a work of the third school of
Rheims. The famous smile, which has often been compared to those of
ancient Greek statues, does no more than express the mood of the
whole work, which achieves a perfect harmony between the rounded

outlines, accentuated by the soft folds of the skirt, and the shape of the
body beneath the clinging garment. There is a feeling here of timeless
joy, as though what Dante called 'the laughter of the universe' were
reflected in the face of the Angel.
Demaison, *BMon.*, 1902. Pillion (1911), 181. Vitry 1915–19. Muratoff
1931, 52. Aubert 1946, 272. Reinhardt. *La Cathédrale de R.*, 1963.
Branner, *AB*, 1963, 375.

209 *The Golden Virgin c.* 1260
Amiens, Cathedral (south front, *trumeau* of portal)
The archetype of this statue is the Madonna of the Portal of the Virgin
on the west front of Notre-Dame in Paris, but the style shows the
influence of the third school of Rheims (208). The spirit of this work,
however, is entirely different. In harmony with the greater realism of
the garments, furrowed by the deep-cut folds which follow the *élan*
of the slightly swaying figure, even the Virgin's smile loses every
accent of universality: it becomes an element in the frame of the
preciousness and worldly gracefulness which gave this image its
famous name: '*Vierge Dorée*'.
Durand 1901–3. Pillion (1911), 168. Muratoff 1931, 62. Aubert 1946,
255.

210 *St Thomas at an Indian marriage feast*, detail of tympanum *c.* 1250
Semur-en-Auxois (Côte d'Or), Collegiate Church (north portal)
The tympanum, in three sections, one above the other, illustrates an
apocryphal incident in the life of St Thomas the Apostle. While a
marriage feast is in progress, a dog enters, carrying in its mouth the
hand of the major-domo who has been savaged by a lion, as a divine
punishment, for having slapped St Thomas because he listened to the
Hebrew song of the girl dancer and flautist. The bride and bridegroom
are asking for baptism. Burgundian Gothic sculpture has reached an
unusual degree of plastic solidity. Both these elements are skilfully
exploited here to imbue the composition with dramatic tension, which
is, perhaps, reminiscent of German sculpture.
Mâle 1919, 357. Aubert 1946, 294.

GERMAN 13TH CENTURY

211 *Four Prophets c.* 1225 stone *c.* 1·00 m.
Bamberg, Cathedral (St George's Choir)
The reconstruction of Bamberg Cathedral, apparently begun in 1218
with the east side, was substantially completed by 1237, the year of the
consecration. St George's Choir, belonging to the eastern part of

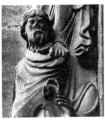

213

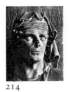

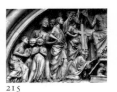

214

215

217

216

212

216

the church, was built at an early stage, soon after the completion of the Portal of Grace, the sculptures of which seem to afford a Gothic interpretation of Provençal Romanesque ideas. This was the point of departure for the two sculptors of the choir screen, one of whom was responsible for most of the Prophets and some of the Apostles, and the other for most of the Apostles. Both are slightly influenced by South German book-painting, but the Master of the Prophets is an artist of major significance. The garments enfolding the solid and immobile bodies are endowed with a vitality expressive of the intense spiritual life of the Prophets: the taut, rugged linear texture of the folds rises to poetic expression the dialectic acuteness and heat of the dispute, which are psychologically illustrated in the sharply defined profiles of the faces.

Vöge, *RKw*, 1899, 94; 1901, 195. Weese, *Bamb. Domskulpturen*, 1897 and 1914. Hamann 1922, I, 94. Dehio, *Bamb. Dom.*, 1924. Panofsky 1924, 131. Jantzen 1925, 72. Noack, *Der Dom zu B.*, 1925. Beenken, *Bildwerke d. Bamb. Doms*, 1925. Pinder, *Bamb. Dom u. seine Bildwerke*, 1927. Möhle, *Die roman. Bildhauersch. d. Bamb. Doms u. ihre Beziehungen zur Malerei*, 1927. Lutze, *MJBK*, 1932, 339. Reitzenstein, *MJBK*, 1934, 113. Feulner-Müller 1953, 79. Boeck, *Der Bamberger Meister*, 1960.

212 *A Prophet*, detail. *c.* 1230 stone 0·75 m.
Bamberg, Cathedral (Fürstenportal, left embrasure)
In the embrasures on either side of this portal are to be seen figures of Prophets, with Apostles standing on their shoulders, signifying that the New Testament was founded upon and superseded the Old. While the figures in the embrasure on the right are the work of disciples of the Master of Bamberg (*see* below), those in the left embrasure are by a craftsman of considerable, albeit rough and indeed almost barbaric power, whose work has much in common with that of the sculptor of St George's Choir.
As 211.

213–14 *The Synagogue and St Elizabeth c.* 1235 stone 1·88 × 1·90 m. (the whole figure)
Bamberg, Cathedral (interior)
On the piers in the interior – probably not in their original position – are the figures representing Church and Synagogue, and those of Mary and Elizabeth. These are certainly the work of the Master of Bamberg, a great artist who undoubtedly travelled in France and was familiar with the sculptures of Rheims, in particular the celebrated Visitation group (201). Combining powerful modelling with great linear freedom, the master endowed his figures with intense yet controlled

vitality. This is apparent both in the almost sensual warmth of the Synagogue figure, naked under her draperies, and in the powerfully expressive face of St Elizabeth, which breathes the very essence of prophetic emotion.
As 211. Weise, *Deutsche u. Franz. Kunst im Zeitalter der Staufer*, 1948, 17.

215 *The Blessed*, detail of The Last Judgement *c.* 1235 stone 1·44 × 2·90 m. (whole tympanum)
Bamberg, Cathedral, (Fürstenportal, tympanum)
The work of a number of craftsmen, some of them recalling work of the first school, from a design by the Master of Bamberg. It is fascinating to note here, in the ingenuous realism of the portraiture, elements of primitive psychology, in which character is superimposed on the face like a theatrical mask.
As 211, and 214.

216 *The Rider of Bamberg c.* 1235 stone 2·33 m.
Bamberg, Cathedral (interior)
This famous, though somewhat enigmatic knight (St Stephen? Henry II? Constantine? Frederick II? One of the Magi?), who bears some resemblance to the young King at Rheims (200), is conceived in the tradition of Late Romanesque equestrian statuary, of which 155 and 156 are examples. But this, the work of the celebrated Master of Bamberg, is far superior to any of its predecessors, chiefly in the striking contrast between the stolidity of the horse and the energy of the rider, with head resolutely turned towards his goal and eyes fixed on distant horizons.
As 211. Add: Hartig, *D. Bamb. Reiter u. sein Geheimnis*, 1939. Von Simson, *Review of Religion*, 1939–40. Steuerwald, *Das Rätsel um d. Bamb. Reiter*, 1953. Valentiner, *The Bamb. Rider*, 1956. Jantzen, *D. Bamb. Reiter*, 1964. Von Einem, *Festschr.Müller*, 1965, 55.

217 *Fortitude and Prudence*, detail of tomb of Pope Clement II *c.* 1240 marble 0·41 × 1·99 m.
Bamberg, Cathedral
Clement II (d. 1047), who retained the bishopric of Bamberg during his tenure of the Papacy, was buried in the old cathedral. A measure of pictorial refinement present in these reliefs, and unusual in 13th-century sculpture, may be due to the stylistic influence of the original Ottonian tomb, though in other respects the reliefs have much in common with the figure of the Church, and those of the Fürstenportal. This work, therefore, is by a disciple of the Master of Bamberg,

218

220

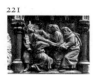

221

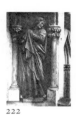

222

219

working to a design by the master himself, and not, as has often been suggested, an 18th-century copy of a lost original.

Schmitt, *StJ*, 1921, 109. Schmitz, *Kunstwanderer*, 1921, 123. Noack, *Kstchr.* 1921–22, 478. Beenken, *Kstchr*, 1921–22, 602. Jantzen 1925, 173. Reitzenstein, *MJBK*, 1929, 216. Hamann, *ZDVKw*, 1934, 162. Feulner-Müller 1953, 106. Boeck, *Der Bamberger Meister*, 1960, 16, 136, 146. Müller, *Abh. d. Bayer. Akad. d. Wiss., Phil.-Hist. Kl.*, 1961.

218 *St Peter, Adam and Eve c.* 1235–40 stone *c.* 1·70 m. (each figure)
Bamberg, Cathedral (Adam Portal)
The portal was erected in the early stages of the building of the cathedral, and is Romanesque-Norman in style. The figures were added later to harmonize with the other (Gothic) portals. The iconographic scheme is original, representing the first man and woman, the first pope (St Peter), the first patrons of the original cathedral (the one built before the existing one), Henry II and Kunigunde, and the first martyr (St Stephen). The idea of flanking a portal with figures of the Father and Mother of the Human Race has, however, a Romanesque precedent in Lodi Cathedral, and a Gothic one in the church of Mont-devant-Sassey, in Lorraine. The figure of Eve, so strikingly similar to that of the Synagogue, is the work of the Master of Bamberg. Here, as in the Synagogue figure, the sensuality of nudity, though present, is only very subtly hinted at. Adam and the other figures are the work of minor craftsmen, influenced to some extent by the work of the first school of Bamberg.
As 211.

219 *A Foolish Virgin c.* 1240–5 stone 1·25 m.
Magdeburg, Cathedral (north transept, doorway)
One of a group portraying five Wise Virgins and five Foolish Virgins, erected in the embrasure of a portal, which was later subjected to a series of alterations. These figures, though clearly derived from the Bamberg sculptures, are works of great distinction. They are linked together in a rhythmical movement as if enacting a ritual lament, and emotion is stamped on their faces as though they were masks. The figures can be dated by reference to that of the Knight of Magdeburg in the Market Place, which they closely resemble, and which can itself be dated by the style of the canopy.

Goldschmidt, *Studien z. Gesch. d. sächsischen Skulptur*, 1902, 51. Hamann-Rosenfeld, *Magdeb. Dom*, 1910, 128. Giesau, *Der Dom zu M.*, *s.d.* Lehmann, *Die Parabel d. klugen u. torichten Jungf.*, 1916. Meier,

JPKslg, 1924, 29. Kunze, *Geschichtsblätter Magdeb.*, 1924, 163. Jantzen 1925, 180. Greischel, *Magdeb. Dom.*, 1929. Feulner-Müller 1953, 113.

220–1 *The Last Supper and The Arrest of Christ c.* 1240–2 stone
Naumburg, Cathedral (choir screen)
Two of six reliefs (there were eight originally, but two were destroyed and later, in the 18th century, were replaced by wood-carvings), which adorn the balustrade of the west choir screen. They are masterpieces of the celebrated Master of Naumburg, who served his apprenticeship in France (notably at Rheims), and worked at Noyon and Mainz and possibly in Metz before coming to Naumburg. Nevertheless, these highly original works are conceived in the realistic tradition of German sculpture (Freiberg and, especially, Bamberg). The composition is compact, dynamic, and self-contained, the figures boldly modelled, full of strength and plebeian vitality, the scene portrayed with great dramatic power. Hitherto, these sculptures have been ascribed to a period following 1249, the date of Bishop Dietrich's and the Chapter's proclamation concerning the raising of funds for building works in the cathedral, but historical evidence suggests (Schlesinger) that the building and decoration of the choir was at least begun in the time of Dietrich's predecessor, Bishop Engelhard (1207–42), who attended the Diet of Mainz in 1235, when the Master of Naumburg was at work on the choir of Mainz Cathedral (consecrated in 1239), the surviving fragments of which closely resemble the reliefs of Naumburg.

Schmarsow, *Die Bildwerke des N. Domes*, 1892. Dehio 1919, 339. Panofsky 1924, 146. Jantzen 1925, 208. Hege-Pinder, *Der N. Dom u. seine Bildwerke*, 1925. Giesau, *Der Dom zu N.*, 1927. Küas, *Die N. Werkstatt*, 1937. Beenken, *Der Meister von N.*, 1939. Metz, *Der Stifterchor des N. Doms*, 1947. Schlesinger, *Meissner Dom. u. N. Westchor*, 1952. Feulner-Müller 1953, 119.

222 *St John the Evangelist c.* 1245–50 stone
Naumburg, Cathedral (choir screen, doorway)
The double doorway of the west choir portrays Christ on the Cross, formed by the central pillar and architrave. The Christ is flanked on either side of the doors by figures of Mary and John. This is a work of intense dramatic power, recalling the later sculptures of Giovanni Pisano, especially in the folds of the draperies, which rotate round the sides and are drawn out into long diagonal lines across the chest. In comparison with the balustrade reliefs, however, this work is less intense, softer and gentler in tone, as borne out by the sentimental expression of the face. This is clearly an original interpretation, by

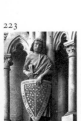
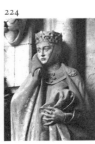

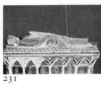

a fellow craftsman, of the powerful style of the Master of Naumburg. The style suggests that these figures are earlier than those of the Founders (223, 224).
As 220–1.

223–4 *Timo de Kistericz and Marchioness Uta c.* 1248–50 stone lifesize
Naumburg, Cathedral (west choir)
Two of the twelve statues of the founders of the See of Naumburg in 1028, controversially erected here to reaffirm the rights of Naumburg, long challenged by the Church of Zeitz, the episcopal centre until the end of 1028. As not all of these statues are of the founders as named in Bishop Dietrich's proclamation of 1249, it is plain that some of them, at least, were completed after that date. These are among the first and most remarkable of the sculptures of the Master of Naumburg, even though some of the work may have been done by his pupils. They are at once monumental and vibrant, expressing both spiritual resolution and uncertainty, and by making each figure distinct and individual, the artist deploys the maximum degree of realism compatible with the transcendental spirit of Medieval art.
As 220–1.

BRITISH 13TH CENTURY

225–6 *Moses and St John* details *c.* 1200–10 stone 1·85 m. (225) 1·59 m. (226)
From St Mary's Abbey
York, Museum of Yorkshire
Details of two of ten statues, originally surrounding a portal. The influence of French sculpture, particularly that of the Île-de-France, from Chartres to Laon, is plain to see, but this is not to minimize the originality of these noble figures. There are here present both a traditional feeling for mass and muscular strength, more pronounced in the Moses, and a new sense of physical co-ordination and facial expression, especially noticeable in the profoundly spiritual St John, which place these figures midway between Late Romanesque in Britain (Malmesbury) and Early Gothic sculpture.
Marcousé, *Figure Sculpture in St Mary's Abbey*, 1951. Stone 1955, 101.

227–8 *Corbel and Capitals c.* 1200–10 stone 0·38 m. (227) 0·59 m. (228)
Wells, Cathedral
These almost grotesque figures (a man with toothache, another extracting a thorn from his foot, in the capitals, and in the corbel a

hideous dragon), though traditionally Romanesque in their imaginative vitality, show signs of a sense of physical co-ordination and organic expressiveness which already belong to Gothic art.
Stone 1955, 103.

229–30 *Deacons and The Dead rising to Judgement c.* 1230–40 stone *c.* 2·13 m. (229) *c.* 0·77 m. (man on left) (230)
Wells, Cathedral (west front)
The influence of French sculpture (Paris and Amiens) is equally apparent in the statues of the deacons on the east buttress of the north façade-tower, and in the Last Judgement relief, but the former, in spite of their archaic stiffness, are distinguished by remarkable delicacy of touch, while the latter is interesting for the presence of a rocky landscape and the lively variety of the movements in the compact nudes, with their summary anatomy.
Hope-Lethaby, *Arch.*, 1904. Bilson, *Archaeol. Jnl.*, 1928, 65. Andersson, *English Influence in Norw. and Swed. Sculpture*, 1949. Stone 1955, 108.

231 *Tomb effigy of William Longespée c.* 1230–5 stone *c.* 1·90 m. (the figure)
Salisbury, Cathedral
This powerful memorial sculpture, recording a death which occurred before 1226, is related to the final phase of the school of Wells. The large number and high standard of artistry of such tombs are an indication of the power of the barons who, in the 13th century, laid the foundations of parliamentary government.
Planché, *BAAJnl.*, 1859, 125. Stone 1955, 115.

232 *Corbel figure c.* 1240 stone *c.* 0·33 × 0·44 m.
Oxford, Christ Church (Chapter-house)
Although these heads of Church dignitaries are influenced by the sculptures on the façade of Amiens, they are highly original works of art, striking a balance, as they do, between stylization and individual portraiture, and their appealing quality has its place in the history of art.
Stone 1955, 113.

233 *Fabulous beast*, corbel *c.* 1235–45 stone *c.* 0·60 m.
Lincoln, Cathedral (west front)
The imaginative fantasies of the Wells sculptures (227) are here extended to the limits of the grotesque, influenced possibly by the masks of mummers. Such grotesque figures have no parallel in French Gothic art.

232

233

234

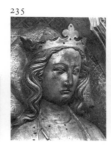
235

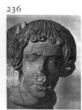
236

237

238

239

Lethaby, *Archaeol.*, 1907. Stone 1955, 113.

234 *Corbel figure c.* 1255 stone *c.* 0·37 m. across
London, Westminster Abbey (triforium of choir)
The head, indeed the entire figure, a striking example of anti-Classical perspective distortion, is carved with great self-confidence. Its remarkable vitality springs from the carefully observed psychological detail of the portraiture, suggesting a character at once crafty and good-natured. It is recorded that the rebuilding of Westminster Abbey was begun in 1245, on the initiative of Henry III, and the approximate date of the figure can be deduced from this.
Howgrave-Graham, *BAAJnl.*, 1943. Tanner, *Unknown Westm. Abbey*, 1948. Webb, *JWCI.*, 1949. Stone 1955, 119.

WILLIAM TOREL
235 *Tomb effigy of Eleanor of Castile* 1291–3 bronze 0·57 m. across (the pillow)
London, Westminster Abbey
A sumptuous work in gilt bronze, with enamel and vitreous paste decoration, commissioned by Edward I from the goldsmith Torel, as the first of a series intended to vie with those of the French kings at St Denis. That this is a work of Court patronage is apparent from the gallicized artifice and archaism of the coldly precious and self-consciously literary style, which is not matched by any profound artistic inspiration.
Lethaby, *Westm. Abbey and the King's Craftsmen*, 1906, 287. Stone 1955, 142.

236 *Head of a youth c.* 1240 stone 0·20 m.
From Clarendon Palace
Salisbury, South Wiltshire and Blackmore Museum
The building of Clarendon Palace was begun in 1236, on instructions from Henry III. This head, saved from the ruins of the palace, is executed in a spirit of nostalgia, and is delicately archaic, this effect being achieved by the subtle lines of the features within the perfect oval of the face. Thus, although the expression is soft, almost sentimental, the overall impression is of exalted idealism. 'Less noble and self-assured than the great French work, less violent and brutal than the German, this Clarendon carving is distinctively insular in its treatment, even if nearly all the elements of the style are continental derivatives.' (Stone.)
Pettigrew, *BAAJnl.*, 1859. Boremius, *BM*, 1936. Stone 1955, 118. Brieger 1957. *Europe Gothique*, 1968, 31.

WILLIAM YXEWORTH?
237 *Angel of the Annunciation and Angel with censer* 1253 Purbeck marble (the shafts) *c.* 1·85 m. (figure on left)
From the Chapter-house doorway
London, Westminster Abbey
As the account books show, the Chapter-house was completed in 1253, and a payment to William Yxeworth for two statues probably refers to these works. The debt to the Annunciation group on the façade of Amiens is obvious, but these figures are less strictly Classical and more light-hearted in style. They are more ethereal, their movements are freer, so that they appear, almost as in a dream, to be engaged in a symbolic ritual dance, and they have the same quality of insular individuality as the Wells figures.
Scott, *Gleanings from Westm. Abbey*, 1863. Lethaby, *Westm. Abbey Re-examined*, 1925. Noppen, *Antiq. Jnl.*, 1948, 147. Stone 1955, 120.

238 *Tomb effigy of a knight c.* 1295–1300 stone lifesize
Dorchester, Abbey Church
A very fine work, by one of the master-craftsmen of Abingdon Abbey. The resolute manner in which the knight is drawing his sword brings the figure powerfully to life, and the overall impression is of spiritual strength combined with almost romantic eagerness.
Jope, *Berks. Archaeol. Jnl.*, 1948–49. Stone 1955, 150

SPANISH 13TH CENTURY

239 *The White Virgin*, detail *c.* 1260 stone 2·00 m. (whole statue)
León, Cathedral (west portal)
Gothic sculpture in Spain is directly descended from that of France. The sculptor of this figure (and of the two on either side of the tympanum) was responsible, twenty years earlier, for the Puerta de la Coronería in Burgos Cathedral. The suggestion has been made that this sculptor was the French master Henri, who supervised the second stage of the building works at Burgos, and subsequently designed León Cathedral. It seems more likely, however, that the sculptor concerned was a Spaniard, since, in spite of the powerful influence of Amiens, the figures here have more substance, there is a stronger awareness of the human body and a feeling for the texture of cloth, all of which foreshadow the essentially indigenous character of later Spanish sculpture.
Mayer 1923; *El Estilo Gotico en Esp.* 1929. Weise, 1925, 1927, 69. Deknatel, *AB*, 1935. Duràn Sanpere-Ainaud de Lasarte, *Ars. Hispaniae* VIII, 1956.

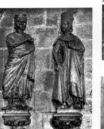

240 *Christ flanked by two Evangelists writing* c. 1240 stone
Burgos, Cathedral (Portada del Sarmental)
In spite of the archaism of the composition, reminiscent of Roman-esque, the transcendent severity of the figures identifies the piece as the work of the great French Master of the Beau-Dieu at Amiens.
As 239.

241 *King Alfonso presenting a ring to Queen Violante* c. 1260–70 stone
From the cloister of Burgos Cathedral
Burgos, Diocesan Museum
The two statues are by different sculptors. That of the King, notable for its clean, powerful lines and the strikingly dramatic effect achieved by the diagonal folds of the draperies, is probably the work of a pupil of the sculptor of the tower figures, and dates from about 1260. (There is further evidence to support this dating in a recorded gift of land in 1257, presumably the site of the cloisters.) The figure of the Queen, noble in the sweeping curves of the composition, is believed to be the work of the sculptor of 239.
As 239.

ITALIAN 13TH AND 14TH CENTURY

242 *Corbel head* c. 1240–50

243 *Corbel, Atlas-figure* c. 1240–50
Andria, Castel del Monte
Classicism, already prevalent in southern Italy since the 12th century by way of Provençal influence (146), blends happily with a sensitive feeling for line and form of French Gothic origin in this grandiose castle built by Frederick II, Emperor and King of Sicily. These two corbels are superb examples of their kind. One of them (243) – as indeed the three others in the series – has been attributed to Nicola Pisano, in his early years, though this seems improbable.
Bertaux 1904, 729. Venturi 1905, 667. Toesca 1927, 841, 906. Bottari, *AAM*, 1959, 43.

244 *Head of a poet or philosopher* c. 1240 marble 0·78 m.
From the demolished city gate
Capua, Museo Campano
One of the finest transitional sculptures of the reign of Frederick II. Here, especially in the modelling of the hair and beard, many of the features of Late Classical Roman sculpture are present, but there are signs – possibly unintentional – of incipient Humanism, which fore-

shadow the characteristics of Gothic sculpture. This head also (probably erroneously) has been taken to be an early work of Nicola Pisano.
Venturi 1904, 538. Toesca 1927, 861. Bottari, *AAM*, 1959, 43.

NICOLA PISANO
245–8 *The Adoration of the Magi: The Allegory of Hope: The Presentation in the Temple: The Crucifixion*, details of pulpit 1255–60 marble
Pisa, Baptistry
According to the inscription, which bears Pisano's signature, this work was completed in 1260 (Pisan calendar: 25/3/1259–24/3/1260). Both in the design of the pulpit and in the style of the reliefs, this piece marks a new era in Italian sculpture, and indeed Italian art generally. It not merely signals the beginning of the Gothic Age. but is one of the earliest forerunners of Renaissance art. A number of influences can be seen, notably those of Campanian Classicism in the time of Frederick II and of Campanian Roman tombs (the sarcophagus in Capua Cathedral). The artist was also plainly familiar with antique Roman sculpture in Pisa (the Roman tombs in the cemetery, and the capitals now incorporated in a modern building in the Via Dini). But the grandeur of scale and style is wholly new, and the artist turns to Classicism as the most appropriate idiom for the elevated solemnity of Biblical narrative. The artist developed as he worked. In the earliest of the reliefs. *The Adoration of the Magi*, though there are faint Gothic undertones, the Classicism is more overt and more rigorous. *The Presentation in the Temple* is larger and freer in scope, and rich in over-tones of heroism and pathos. Finally, there is *The Crucifixion*, subtler and more intimate in style, which already foreshadows the more clearly Gothic style of the Siena pulpit.
Venturi 1905. Toesca 1927, 864. Swarzenski 1926, 3. Nicco Fasola 1941. Braunfels, M., 1949, 321. Pope-Hennessy 1955. Wundram, *ZKG*, 1958, 243. Salvini, *Mélanges Alazard*, 1963, 219; *AV*, 1967, nᵒ 4, 15.

NICOLA PISANO
249–50 *The Adoration of the Magi; Virgin and Child; The Resurrection of the Dead*, detail of The Last Judgement, 1265–8 marble 1·03 × 0·83 m. (Magi); 1·90 × 0·65 m. (Virgin); 0·85 × 0·45 m. (Resurrection)
Siena, Cathedral
There are a number of documents testifying to the date and author-ship. These also provide evidence that among those who collaborated with the master were Arnolfo, Giovanni Pisano, Lapo and, in the early stages, Donato, who was in charge of the architectural and decorative work. Responsibility for the versatility and freshness of pictorial detail in the composition lies with the master himself, not with his col-

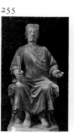
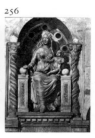

249 250 251 252 253 254 255 256

laborators. These novelties are already foreshadowed in the last reliefs of the Pisan pulpit. The composition is more picturesque and there is unusual subtlety in the line, while a much higher degree of pictorial delicacy is to be found in the modelling: all this gives the narrative new accents of warmth and human emotion. In the figure of the Virgin, more strikingly than anywhere else, a renewed awareness of French sculpture is revealed. Here and there, as in the figures of the seated Virgin and the kneeling King (249), and the second row of faces (250) in the *Judgement*, executed with great energy and expressiveness, one recognises the potent dramatic tension and powerful massing of volume associated with the work of Arnolfo. However, the standing Virgin (249), and the front row of figures (250), inspired by a Roman relief now in Siena, are clearly, in their Gothic freshness and sensuousness, among the finest works produced at this period by Nicola.
As 245–8. Carli, *Il Pulpito di Siena*, 1943.

LAPO
251 *St George and the Dragon* c. 1280 stone 1·05 × 1·20 m.
From Porta a S. Giorgio
Florence, Palazzo Vecchio
This relief has only recently been identified as the work of Lapo. Comparison with 252, the portraiture in particular, clearly bears this out. Hitherto it had been variously ascribed to a Pisan or Florentine sculptor influenced by Nicola, of c. 1285, or 1300–24, and also to Arnolfo. Swarzenski, *ZBK*, 1904, 99. Middeldorf-Paatz, *MKIF.*, 1932, 511. Carli, *Boll. Stor. Pis.*, 1936, n⁰ 3. Toesca 1951, 218. Salvini, *Festschr. Heydenreich*, 1964, 266.

LAPO
252 *The Liberal Arts*, detail of pulpit 1265–8 marble 0·70 × 0·55 m.
Siena, Cathedral
The seven figures of the Liberal Arts surrounding the base of Nicola's pulpit are clearly recognizable as the work of Lapo, as distinct from that of Nicola, Arnolfo, and Giovanni. From these figures, it has been possible to identify the hand of Lapo in much of the sculpture on the Arca di San Domenico in Bologna, and elsewhere, including the sculpture illustrated in 251. Lapo was a faithful disciple of Nicola, but there is less pathos in his work, and his treatment of Classical forms is more decorative than Nicola's.
As 246–8. Gnudi, 1948, 49.

NICOLA and GIOVANNI PISANO
253 *Augusta Perusia* 1278 marble 0·79 m.

254 *Female figures and griffons* 1278 bronze 1·25 m. (female figures) 0·51 m. (griffons)
Perugia, Piazza fountain
On the evidence of documents and an inscription, this monumental fountain, erected over a conduit which was begun in 1254, was built in 1277–78 by Nicola Pisano and his son Giovanni. It includes fifty reliefs and twenty-four marble statuettes, arranged in two basins, one above the other, with a bronze group crowning the whole (254). The entire work is devoted to scenes from the history of the town – an offshoot of Rome – interwoven with scenes of wider reference, relating to the history of man and Christian civilization. It is not always easy to distinguish between the work of Nicola and that of Giovanni, largely because so many of the statues are badly eroded. 253, an allegorical figure representing the City of Perugia, appears, by virtue of its powerful linear tension, to be the work of Giovanni, who also probably sculpted the lions and griffons shown in 254. The three bronze figures of girls (254), remarkable for Classical purity of line and delicately lyrical intimacy of style, are the work of Nicola, though it has often been claimed that they are by Giovanni, or even Arnolfo.
As 246–8. Nicco Fasola, *La Fontana di Perugia*, 1951. Toesca 1951, 226. Francovich, *Comm.*, 1953, 67.

ARNOLFO
255 *King Charles of Anjou* c. 1275–8 marble 2·10 m.
Rome, Museo Capitolino
Though sometimes attributed to pupils of Arnolfo, or to some unknown Roman sculptor, this statue, commissioned by the King of Naples who, from 1268 to 1278, was Senator of Rome, ranks with the finest work of Arnolfo, and is undoubtedly by the master himself. There is ample internal evidence for this attribution, in the massive, geometrical solidity of the composition, the angular folds of the draperies, and the forcefulness and tension of the facial expression.
Wickhoff, *ZBK*, 1889, 109. Venturi 1905, 109. Keller, *JPKslg*, 1934, 205. Salmi, *RA*, 1940, 134. Mariani, *Arnolfo*, 1943, 8. Toesca 1951, 212. Weinberger, *Festschr. Müller*, 1965, 63.

ARNOLFO
256 *Virgin and Child* c. 1282 marble 1·16 m.
Detail of the tomb of Cardinal de Braye
Orvieto, S. Domenico
The monumental tomb of Cardinal de Braye (d. 1282), which bears Arnolfo's signature, shows a different aspect of his work. Here, finding inspiration in an ancient marble monument, and possibly also in

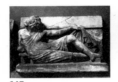

257

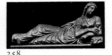

258

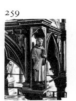

259

260

261

262

263

Etruscan sculpture, he reveals himself as a disciple of Nicola. Nevertheless, the piece is more massive and sharper in outline than any strictly Classical work, and the solemnity of mood is expressed in terms of exalted abstraction.

Venturi 1906, 99. Keller, *JPKslg*, 1934, 205. Salmi, *RA*, 1940, 134. Mariani, *Arnofo*, 1943, 12. Gnudi 1948, 111. Toesca 1951, 205.

ARNOLFO

257 *Male figure*, fragment of fountain 1277 marble 0·35 × 0·54 m.
Perugia, National Gallery of Umbria

In 1277, Charles of Anjou, in whose service Arnolfo was retained in Rome, agreed to release him, at the request of the civic authorities in Perugia, to work on a fountain in that city. This cannot have been the Great Fountain, which bears an inscription attributing it to Nicola and Giovanni alone, but another and smaller one, at the lower end of the piazza, of which 257 and two other fragments with figures probably formed part. A wonderful figure, where the massiveness of form, inspired by Etruscan sculpture, is firmly controlled in an almost neo-Romanesque spirit by compressing the figure between two parallel planes, though it is expressed with a new, intensely expressive vitality.

As 256. Mariani, *Gli 'Assetati' di A.*, 1939.

ARNOLFO

258 *The Virgin of the Nativity* c. 1296–1300 marble 0·81 × 1·71 m.
From the old façade of the cathedral
Florence, Museo dell' Opera del Duomo

A celebrated and solemn document attests that, in 1296, Arnolfo was called upon to design and build a new cathedral in Florence. This and other figures formed part of the façade, which was destroyed in 1598. A comparison with 257 indicates that, in his final creative phase – he died sometime before 1310 – Arnolfo turned back, in a somewhat critical spirit, to the Virgin of the Nativity on Nicola's pulpit in Siena, and disciplined the ebullient richness of the fountain figure of Perugia within a strictly geometrical framework. Moreover, in the contrast between the stiff pose and the indrawn breath and anxious face of the Virgin, he added a new depth of poetic expression.

As 256. Schottmüller, *JPKslg*, 1909, 291. Rathe, *Der figurale Schmuck der alten Domfass. in F.*, 1910. Becherucci, *D*, 1928, 719. Metz, *PKslg*, 1938, 121.

ARNOLFO

259 *St Benedict* 1285 marble 1·17 m.
Rome, S. Paolo fuori le Mura (ciborium)
Signed, and dated 1285, the ciborium is rich in magnificent reliefs and

statuettes, of which this is a fine example, in its noble simplicity of composition and the powerfully expressive face of the Saint.
As 256.

ARNOLFO

260 *St Tiburtius* 1293 marble
Rome, Sta Cecilia in Trastevere (ciborium)

An extraordinarily bold piece of sculpture, in which the figure of the knight on horseback juts out, foreshortened, from its niche. The sculptor brilliantly overcomes the problem of clearly defined spatial limitation (note the bent head of the horse, which prevents the piece from projecting too far), and thus foreshadows Giotto's use of the confines of a stage setting.

As 256. Bottari, *Belle A.*, 1946, 5.

ARNOLFO

261 *Draped figure* 1296–1300 marble 2·00 m.
Florence, Casa Buonarroti

This magnificent figure, part of a collection of classical sculpture assembled by Michelangelo's descendants, has recently been identified by Salmi as a work by Arnolfo, originally on the cathedral façade.
Salmi, *Comm.*, 1965, 17.

262 *Virgin and Child* c. 1295–1300 ivory 0·406 m.
London, Victoria and Albert Museum

An exquisite work of the French school, in which the natural curve of the elephant's tusk is exploited to enhance the lively swirl of the draperies, and the grace and joyfulness of the figures. Giovanni Pisano undoubtedly saw ivories of this kind, and was much influenced by them.

Koechlin 1924. Grodecki 1947. Freeden, *Scult. Gotica*, 1962, pl. 6.

GIOVANNI PISANO

263 *Virgin and Child* 1298 ivory 0·53 m.
Pisa, Tesoro del Duomo

In spite of Toesca's claim for an earlier date, this piece must be identical with the Virgin and Child belonging to an ivory panel with scenes from the Passion, which, according to documentary evidence, Giovanni Pisano was to complete by the Easter of 1298 (1299 in the Pisan calendar). The original inspiration, possibly known to Giovanni through an ivory copy, is the Virgin on the north portal of Notre-Dame in Paris. There remains something of the grace of the French original in Giovanni's ivory figure, but the dramatic tension, expressed

264

265

266

267

268

269

270

271

in the diagonal folds of the draperies, is wholly his own. The head of the Infant and the right hand of the Virgin were renewed in 1634.
Sauerlandt, *Die Bildwerke des G. P.*, 1904. Venturi, *G. P.*, 1928. Francovich, *Le Arti*, 1942, 195. Toesca 1951, 219. Pope-Hennessy 1955 (in general on G. P.). Supino, *Arte Pisana*, 1904, 136. Vöge, *JPKslg*, 1908, 218. Weinberger, *ZBK*, 1930–31, 6. Ragghianti, *CA*, 1954. Pope-Hennessy 1955. Barsotti, *CA*, 1957, 47. *Europe Gothique*, 1968, 229 (in particular on this work).

GIOVANNI PISANO
4–5 *Maria di Mosè and Habakkuk c.* 1284–96 marble 1·90 m. (both)
From the Cathedral
Siena, Museo dell'Opera del Duomo
Giovanni Pisano was engaged upon architectural and sculptural work in Siena Cathedral from 1284 to 1296. These are two of his magnificent façade sculptures, full of vigour and dramatic power. The carving is extremely sharp, the composition dynamic, but, at the same time, the subtly modulated planes create an atmosphere which might almost be described as idyllic.
As 263. Add: Keller, *KJBH*, 1937, 141. Carli, *Sculture del Duomo di S.*, 1941, 39. Bacci, *Le Arti*, 1942, 184. Carli, Acts (*20th Congress Hist. of Art*), 1963, 183.

BARTOLOMÉ DE GERONA
266 *Virgin and Child c.* 1280 marble
Tarragona, Cathedral (main portal)
Documentary evidence shows that the Master Bartolomé (or Bartomeu) was working on the façade of the cathedral from 1277 to 1282. In this masterpiece, Classical delicacy is combined with Gothic grace, but added to these is a new element of dramatic tension. Scholars have till now only vaguely hinted at Italian influences on this great Catalan master. It is, however, probable that he obtained some knowledge of Nicola's Sienese phase as well as of Giovanni's early art when the latter was travelling, as it may be supposed, through Europe before working on the fountain of Perugia.
Duràn, *La Escultura medieval catalana*, 1927. Gómez Moreno, *Breve hist. de la escult. espa.*, 1951. Duràn Sanpere-Ainaud de Lasarte, *Ars Hispaniae* VIII, 1956, 181.

GIOVANNI PISANO
267 *A Sybil*, detail of pulpit 1298–1301 marble
Pistoia, S. Andrea
Where Nicola placed figures of the Virtues on his pulpit, Giovanni, on his, placed Sybils carved almost wholly in the round, interspersed

with reliefs of the Prophets. This is an allegorical reference to the Coming Christ, as foreshadowed in the utterances of the seers of the pagan and Jewish peoples, a theme to be taken up by Michelangelo in the Sistine Chapel. Even in purely formal terms, these contorted Gothic figures, bowed under their own weight, achieve an effect of *contrapposto* which gives them a claim to be considered as the earliest forerunners of Michelangelo's Sybils.
As 263.

GIOVANNI PISANO
268 *The Massacre of the Innocents*, detail of pulpit 1298–1301 marble
Pistoia, S. Andrea
Even in his narrative reliefs, Giovanni's style is very different from that of Nicola. His chisel bites deep into the marble, and the boldly rough-hewn, almost unfinished figures, contorted and violent, reveal the artist's coruscating dramatic instinct, which reminds one of the modern Expressionists.
As 263.

GIOVANNI PISANO
269–70 *The Nativity and the Flight into Egypt*, detail of pulpit 1302–10 marble
Pisa, Cathedral
Those parts of the Pisan pulpit which were not carved by assistants re-create, in a more deeply tragic vein, the dramatic themes of the Pistoia pulpit; witness the intensity of expression with which the Virgin is bending over to adjust the wrappings of the Holy Child, and, in *the Flight into Egypt*, the pictorial intensity, the sharp chiselling, and use of counterpoint in the composition.
As 263, in addition to: Bacci, *La ricostruzione del pergamo del Duomo di P.*, 1926. Fried, *Strzygowski Festschrift*, 1932, 130. Weinberger, *BM*, 1937, 4. Von Einem, *Das Stützengeschoss der Pisaner Domkanzel*, 1962. Jászai, *Die Pisaner Domkanzel*, 1968.

TINO DI CAMAINO
271 *Draped figure of Angel c.* 1321–3 marble
Florence, Museo della Fondazione Romano in S. Spirito
This piece may have come from the tomb of Bishop Orso which, though partly dismantled, still stands in Florence Cathedral. Tino di Camaino of Siena, a disciple of Giovanni Pisano, was also influenced by Sienese painting, and in his work the style of the master is modified by fresh overtones of gentleness, tenderness, and sensuousness, creating an overall impression of profound and lyrical serenity.
Valentiner, *Tino di C.*, 1935, 65. Brunetti, *Comm.*, 1952, 102. Pope-Hennessy 1955.

347

272 273 274 275 276 277 278 279

GIOVANNI PISANO

272 *Temperance*, detail *c.* 1302–10 marble
Pisa, Cathedral (pulpit caryatid)
This statue represents Temperance (von Einem) whose modest gestures temper the fiery lusting flesh, according to St Ambrose. This magnificent work, clearly inspired by the Medici Venus, does honour in the dramatic idiom of Gothic art to one of the masterpieces of Classical Antiquity.
As 269–70.

273 *The Descent from the Cross c.* 1260–70 ivory 0·29 × 0.24 m.
Paris, Louvre
The carving of ivory statuettes and groups began in the second half of the 13th century, and as this intricate and delicate craft evolved, a vein of lyricism was introduced, deriving from monumental sculpture, which reached its highest expression in the statues of the Sainte-Chapelle in Paris. The gently curving lines of both composition and drapery, originally highlighted in brilliant colour (traces of gilding and polychrome remain), imbue this French masterpiece with intimate tenderness.
Molinier, *Mon. Piot* III, 1896, 121. Koechlin 1924, I, 59; II, nº 19. Grodecki 1947, 84. *Europe Gothique*, 1968, 227.

274 *Virgin and Child c.* 1290 ivory 0·25 m.
Assisi, Tesoro di S. Francesco
A remarkable French ivory, well preserved, even the colours. In spite of a certain rhythmic gracefulness, some tension is apparent in the diverging lines of the two figures and in the elastic outline which might well have inspired Giovanni Pisano – if, as is quite possible, he knew the work.
Venturi, A., 1906. Kleinschmidt, *Die Basilika S. F. in A.,* 1915. Marinangeli, *Misc. Franc.,* 1915. Gnoli, *BA,* 1919; *D,* 1921. Zocca, *Catal. Assisi,* 1936, 153.

ANDREA PISANO

275–6 *The Disciples visiting St John the Baptist in prison*, detail, *and The Burial of St John the Baptist* 1330 bronze
Florence, Baptistry (south door)
The door is dated 1330, and signed, but the casting and burnishing were not completed until 1335. Andrea is without doubt the greatest Italian sculptor of the 14th century. He was not greatly influenced by the works of Nicola and Giovanni, but was familiar with French 13th-century sculpture, especially the more Classical aspects, and with Giotto's paintings. The simplicity of the composition and the dramatic

clarity of the narrative are reminiscent of Giotto, as are the ritual solemnity of the composition (cf. 275) and the ample curves of the draperies, whereas the fluid Gothic line and subtle interplay of light and shade add mellowness to the dramatic theme, and create an overall impression of profoundly serene and meditative resignation.
Weinberger, *AB,* 1937, 58. Falk, *Studien zu A. P.,* 1940. Falk-Lányi, *AB,* 1943, 132. Ilaria Toesca 1950, 11. P. Toesca 1951, 306. Weinberger, *AB,* 1953, 243. Pope-Hennessey 1955. Becherucci 1965.

ANDREA PISANO

277–8 *Medicine and Agriculture c.* 1334–7 marble 0·79 m. and 0·80 m.
Florence, Cathedral (base of Campanile)
The attribution is supported by the sources; the dating of these reliefs, illustrating the Creation, the labours of men, human endeavours in science, arts, and crafts, is given by their location in the base of the tower, started by Giotto in 1334. According to the sources, Giotto prepared drawings but the work was clearly carried out by Andrea (278) and his assistants (277). While 277 is remarkable for the lively representation of a Medieval apothecary's shop, 278 is a major masterpiece of 14th-century sculpture. Four diverging lines start from the 'giottesque' bush in the centre, lending to the composition a dynamic tension; thus a heroic accent falls on the toil of the man and his oxen, sounding the first note of a hymn to the sanctity of manual labour.
As 275–6. Schlosser, *JKslgW,* 1896, 53. Becherucci, *MKIF,* 1965, 227. Becherucci 1965.

279 *La Belle Madone c.* 1320–5 painted stone 1·57 m.
From the Church of La Celle (S. et M.)
Paris, Louvre
Among the many figures of the Virgin and Child, in stone, marble, wood, and metal, of the first half of the 14th century, to be found in the Île-de-France region, this work – attributed to the sculptor of the Virgin of Rampillon – is supreme 'in the relaxed attitude of the figure, its refinement and elegance, and the expression of tender anxiety on the face of the Virgin, so subtly suggested, all without altering the harmonious and measured style of similar works in the 13th century' (Michèle Beaulieu). The date can be deduced from the greater austerity of the piece compared with the more mannered style of such works as the silver-gilt Madonna in the Louvre, and the marble Madonna (now in the church of Magny-en-Vexin), given, in 1339 and 1340 respectively, by Queen Jeanne d'Evreux, to the Abbey of St Denis.
Michel, *Musées et Mon. de France,* 1906, 5. Vitry, *RAAM,* 1908, 100; *Les Arts,* 1909, nº 98, 26. Michel, *Mon. Piot,* 1911, 118. Aubert 1946, 329. Aubert-Beaulieu, *Cat. Louvre,* 1950, nº 201.

280

281

282

283

284

285

280 *Virgin and Child c.* 1320–5 stone *c.* 1·52 m.
Troyes, Cathedral
Stylistically, this work has much in common with 279, but the lines are fuller and freer. Andrea Pisano was familiar with statues of this kind, and they also probably influenced the earlier works of Nino.
Koechlin, *Congrès archéol. de Fr., Troyes Provins,* 1902, 251. Forsyth, *AB,* 1957.

ANDREA AND NINO PISANO
281 *Virgin with the Holy Child at her breast c.* 1345–50? marble 0·91 m.
From Sta Maria della Spina
Pisa, Museo Nazionale di S. Matteo
Vasari's attribution to Nino is accepted only by some modern scholars while others suggest Andrea or Nino and Andrea in co-operation, or even an unknown Pisan sculptor. There is much uncertainty as to the chronology of Nino's sculptures, but 281 and 282 may be transitional works between his *juvenilia* (e.g. the Saltarelli tomb (1342) in Sta Caterina in Pisa), which were strongly influenced by French sculpture, and his late period, represented by the signed works in Florence (S. Maria Novella) and in Venice (S. Zanipolo): the likelihood is that both works were designed by Andrea and executed in part by Nino. A subtle interweaving of line, form, and colour is introduced into the quiet yet sinuous melody of the overall composition, creating an impression of gracious tranquillity, very faintly flavoured with sensuous pleasure.
Valentiner, *Art Am.,* 1927, 195. Carli, *A,* 1934, 189. Weinberger, *AB,* 1937, 58; 1953, 243. Valentiner, *AQ,* 1947, 163. Becherucci, *BM,* 1947, 68. I. Toesca 1950, 50. Toesca 1951, 327. Pope-Hennessy 1955, 26, 194. Becherucci, *MKIF,* 1965, 227.

ANDREA AND NINO PISANO
282 *The Virgin in Majesty c.* 1346–8 marble 0·85 m.
Orvieto, Museo dell'Opera del Duomo
This work can be identified as the Virgin in Majesty flanked by two angels which, according to the records, Andrea brought from Pisa in September 1347, and which were erected in 1348 on the postern door of Orvieto Cathedral. Scholars disagree as to whether they are the work of Andrea or Nino. The contrast between the statuesque volume of the figures and the rich Gothic fluidity of the draperies creates an impression of subtle grace and transcendent serenity. The likelihood is that this work was designed and supervised by Andrea, and carried out in part by Nino.

As 281. Schmarsow, *Festschr. Kunsthist. Inst. Florenz,* 1897. Lànyi, *A,* 1933, 204. Cellini, *RA,* 1933, 1.

283 *The Creation of Man c.* 1310 stone 0·72 × 0·62 m.
Auxerre, Cathedral (base of left portal in façade)
These magnificent bas-reliefs, showing strict analogies in style with Île-de-France sculptures, have often been assigned to the last quarter of the 13th century. They are, however, more likely to date from about 1310, slightly earlier than the reliefs on the exterior of the north chapel of Notre-Dame in Paris. By virtue of its fluency of line and delicate pictorial modelling, the narrative, free from dramatic tension, is imbued with lyrical tenderness. In the act of creation, God is bringing to life the newly moulded body of Adam, and this is reminiscent of the finishing touches, anxious and loving, given by a sculptor to the work of his hands.
Aubert 1946, 319. Oursel 1953, 104. Lefrançois Pillion 1954, 61.

LORENZO MAITANI (*c.* 1275–1330)
284 *The Creation of Woman c.* 1320 marble
Orvieto, Cathedral (façade, left portal)
Lorenzo Maitani came to Orvietoe in 1308, and was – from 1310 to 1330 – master-mason in charge of the building of the cathedral. It therefore seems logical to regard him as responsible for the design of the whole fabric and for the execution of the finest of the reliefs, where the stylistic taste of the master's home-town, Siena, is more easily detectable. But, in addition to affinities with the Sienese paintings of the time, there is also evidence that the artist was familiar with French works such as the reliefs of Auxerre (283) and those in the north chapel of Notre-Dame. Everywhere, the gently undulating linear composition blends harmoniously with the softly rounded shapes of the figures and objects, the delicately moulded nudes, the transparent garments, and the rippling surfaces of the background, subtly suggesting a landscape. The scene is imbued with a sense of the idyllic relationship between man and nature, as though the artist's imagination had truly recreated the Garden of Eden before the Fall.
Schmarsow, *RKw,* 1926, 119. Valentiner, *AB,* 1927, 178. Francovich, *BA,* 1927, 339. Cellini, *RA,* 1939, 229; Par 1958, nº 99, 3. Carli, *Le Sculture del Duomo di O.,* 1947. Toesca 1951, 278. Weinberger, *AB,* 1952, 60. Pope-Hennessy 1955, 21, 190. White, *JWCI,* 1959, 254.

ANDREA ORCAGNA (*c.* 1310–68)
285 *The Annunciation,* detail of shrine *c.* 1355–9 marble
Florence, Or San Michele

286

287

288

289

290

291

Work on the shrine, which bears the completion date 1359, was already under way in 1355. Orcagna certainly had in mind the Campanile reliefs (277–8), but his attitude was somewhat archaic in the attempt to recover a 'giottesque' spirit of synthesis. As a result, his work, while robust and imbued with simple dignity, lacks genuine inspiration.

Venturi 1906, IV, 638. Steinweg, *A. Orc.*, 1929, 7. Gronau, *A. Orc. u. Nardo di C.*, 1937, 20. Valentiner, *AQ*, 1949, 48. Meiss, *Paint. in Flor. a. Siena after the Black Death*, 1951, 2nd ed. 1964, 30. Toesca 1951, 342. Pope-Hennessy 1955, 27, 196.

GIOVANNI DI BALDUCCIO (active 1317–49)

286 *Justice and Temperance*, detail 1335–49 marble

Milan, S. Eustorgio (shrine of St Peter Martyr)

This shrine, signed by the Pisan sculptor, and dated 1349, was begun as early as 1335. Giovanni di Balduccio, a colleague of Tino di Camaino, can perhaps fairly be said to have purified the dramatic sculptures of Giovanni Pisano in order to achieve simplicity of composition, so that, in his work, the tension characteristic of Gothic sculpture is contained within sharp, clear outlines, creating an impression of luminous clarity.

Venturi 1906, IV, 540. Vigezzi, *ASL*, 1933, 223. Bellone, *RA*, 1940, 130. Baroni 1944, 63. Toesca 1951, 268. Pope-Hennessy 1955, 29, 199.

ALBERTO ARNOLDI (active 1351–64/79)

287 *The Eucharist c.* 1351 marble 0·87 m.

Florence, Campanile of the Cathedral

This relief, on the upper storey of the Campanile, is one of a series portraying the Sacraments, and Arnoldi is known to have been working on the upper-storey windows in 1351. Because of the almost neo-Romanesque flavour of his style, he has been presumed Lombard by origin, although he was certainly also affected by Andrea Pisano. The firm, almost 'giottesque' volume of the server and the candle rising tall and straight, viewed from below, form a prelude to the compact, solemn gesture of the celebrant priest. Thus an impression of deep religious emotion is added to the realistic and almost photographic aspect of the scene.

Becherucci, *A*, 1927, 214. Toesca 1951, 334. Pope-Hennessy 1955, 28, 198.

UGO DA CAMPIONE?

288 *St Stephen*, detail (after 1351?) marble 1·65 m. (whole figure)

Milan, Loggia degli Osii

One of nine statues in niches above the gallery, commissioned in 1316 by Matteo Visconti, to be used for the proclamation of edicts. The style has much in common with the sculptures of Giovanni da Campione in the Baptistry of Sta Maria Maggiore at Bergamo, though it is somewhat more archaic – hence the attribution to Giovanni's father, Ugo, though no known sculptures exist which can be ascribed to him with certainty. This is a very powerful work, in which neo-Romanesque strength is combined with the realistic characterization common to so much 14th and 15th-century sculpture in the Lombard tradition.

Carotti, *A*, 1903, 179. Bellone, *RA*, 1941, 186. Baroni 1944, 41; *Storia di Mil.*, V, 1955, 748. Toesca 1951, 384. *Arte Lombarda dai Visconti agli Sforza*, 1959, 40.

BONINO DA CAMPIONE

289 *Votive relief* 1360 marble 0·80 × 0·65 m.

Cremona, S. Agostino

A modest work in the Gothic style, though unusually restrained. The overall impression is of serene naturalism in the Lombard manner, though there are traces also of the influence of the sculptures of Pisa and northern Italy.

Bellone, *RA*, 1941, 166. Baroni 1944; *Storia di Milano*, 1955. Toesca 1951, 390.

FRENCH 14TH CENTURY

290 *Ornamental hairpin c.* 1360 ivory 0·24 × 0·03 m.

Modena, Museo Estense

A rare and hitherto unpublished hair ornament, with three carved figures. Two iconographic themes are combined here: that of the standing pair of lovers and that of the 'Offrande du cœur', elaborated by the motif of Cupid transfixing the heart with an arrow. Close in style to the hairpin with Tristan and Isolde in the Museo Civico at Turin (Koechlin, no. 1137), and also to the Virgin and Child in the National Museum, Munich (Koechlin, no. 660), it is a superb and charming example in the so-called 'minor arts' of French sculpture from the mid 14th century onwards.

NORTHERN ITALIAN 14TH CENTURY

291 *Equestrian memorial statue of Cangrande della Scala c.* 1330 marble

Verona, Museo di Castelvecchio

There is considerable disagreement regarding the date of this work,

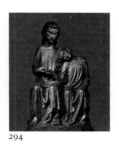
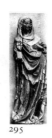

292 293 294 295

some scholars suggesting that it was erected some considerable time after the death of the knight (1329). The authorship is also in dispute, being variously ascribed to some unknown master from Campione, Verona, or Tuscany. Those in favour of a Tuscan artist draw attention to the strikingly similar pose of Guidoriccio in Simone Martini's fresco at Siena, and to the multi-lobed frames of the tomb reliefs (the latter still in their original place whereas the knight has been taken to the museum for conservation). But this resemblance may be due merely to the inspiration of French Gothic sculpture, common to both, especially as the boldly executed vitality of the figure and the acutely observed portraiture have no parallel in Tuscan art. This work is, in fact, one of the outstanding masterpieces of 14th-century art. Both horse and rider are drawn from life, as can be seen in the broad, satisfied, and good-humoured smile of the knight, who looks down on the city spread out below at his feet, in the detail of his armour, and in the trappings of the horse. But this realistic study of horse and rider, resulting from close and detailed observation, is miraculously transfigured into a dazzling apparition conceived in the poetic language of heraldry. This effect the artist achieves by means of simple, almost emblematic composition, in which the figures, pulsating with vitality, are contained within long, sharp, taut lines.

Baroni 1944, 60. Toesca 1951, 431. De Maffei, *Le Arche Scaligere*, 1955, 37. Fiocco, *AVen*, 1955, 227. Pope-Hennessy 1955, 31. Arslan, *Studi in onore di F. M. Mistrorigo*, 1957.

GERMAN 14TH CENTURY

292 *The Virgin* from an Annunciation or a Visitation group *c.* 1300 lime-wood 1·95 m.
Munich, Bayerisches Nationalmuseum
This beautiful statue, on which the merest traces of the original colouring remain, came originally from Regensburg (Ratisbon). A superb figure, in which extreme subtlety and economy of line express both majesty and humble modesty, it appears to have something in common with a group of Danubian sculptures, notably the wood-carving of St Florian in the Museum of the Covent of St Florian, near Linz. It is, indeed, much closer to this group than to the charming French-influenced stone statues in the old chapel and cathedral at Regensburg.
Schinnerer, *Got. Plastik in Regensburg*, 1918. Halm-Lill, *Bayer. Nationalmus. Bildwerke* I, 1924. Karlinger, *Bayer, Kunstgeschichte*, 1928. Müller 1950, 11.

SPANISH 14TH CENTURY

JAIME CASCALLS (active 1345–77)
293 *Charlemagne c.* 1350 alabaster 0·85 m.
Gerona, Cathedral
This magnificent work was possibly inspired by sculptures of the school of Giovanni Pisano – which the Catalan sculptor must have known, at least through the Tomb of St Eulalia in the crypt of Barcelona Cathedral. It is remarkable for its energy, which is generated by a highly original combination of linear tension and robust four-squareness of bulk.
Durán, *Escult. medieval catalana*, 1927. Gómez Moreno, *Breve historia de la escult. espanola*, 1951. Duràn Sanpere Lasarte, *Ars Hisp.* III, 1956.

GERMAN 14TH CENTURY

294 *Christ and St John c.* 1320 painted wood 0·89 m.
Berlin, Staatliche Museen
In the sculptures of southern Germany the figures of Christ with St John's head resting on His shoulder are detached from the other participants in the Last Supper to form a Holy Group erected in the shadowy gloom of a church, to be discreetly and silently worshipped by the Faithful. The oldest of all such wood-carvings is that of Katharinental am Bodensee (Antwerp, Museum Mayer van den Bergh), dating from about 1300–10, and attributed to Henry of Constance. The figure here illustrated, originally from Sigmaringen, appears to be of slightly later date. In this masterpiece of lyric tenderness, composition, modelling, and line combine to create a mood of muted exaltation.
Demmler, *Bildwerke des Deutschen Museums* III, 1930. Wentzel, *Die Christus-Johannes Gruppen*, 1944. Feulner-Müller 1953.

295 *The Virgin Annunciate c.* 1315–20 painted stone *c.* 2·00 m.
Cologne, Cathedral (choir)
One of a group erected on the pilasters of the choir, consecrated in 1322, representing Christ, the Virgin, and the twelve Apostles. To this group should be added the wood-carving known as the 'Madonna of Milan'. These sculptures are all the work of a single master, to whom the Virgin on the interior of the cathedral portal in Freiburg is also attributed. These figures, clearly influenced by French sculpture, are imbued with a new spirit of sensuousness. Set against the taut, soaring

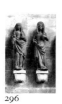

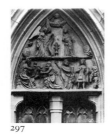

299

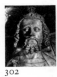

296

297

298

300

301

302

lines of the pilasters, the sumptuous curves of the figures, stressed and reiterated, ripple and flow with infinite grace, and, enhanced by the vivid colouring, they create an effect at once mannered, spiritual, and sensuous.

Pinder, *Deutsche Plastik des 14. Jhrhs.*, 1925. Beenken, *Bildhauer des 14. Jhrhs. am Rhein*, 1927. Clemen-Neu-Witte, *Der Dom zu Köln*, 1938, 150. Feulner-Müller 1953, 166.

296 *Two Foolish Virgins c.* 1350 stone 1·40 m. (right-hand figure)
From the north portal
Schwäbisch-Gmünd, Kreutzkirche
These pieces were carved under the supervision of Heinrich Parler, who was summoned from Cologne to build the grandiose choir of this church, while shortly after this his son Peter was summoned, in 1356, by Charles IV to work for him in Prague. In their decorative function, they recall their forerunners of the end of the 13th century in Strasbourg and Freiburg but, in the use of contemporary costume and in the new plastic solidity, they already show signs of a bourgeois realism which was to be developed by the Parlers during their prolonged period of activity in Prague.
Nägele, *Die Heilig-Kreuz Kirche in S.-G.*, 1925. Schmitt, *Festschrift D. Frey*, 1943, 234; *Das Heiligkreuz Münster in S.-G.*, 1951. Feulner-Müller 1953, 205.

297 *The Annunciation and Adoration of the Magi c.* 1340 stone 2·05 × 2·20 m.
Rottweil (Swabia), Kapellenturm (tympanum of north portal)
The tradition of the richly decorated portals of Strasbourg and Freiburg is echoed here, though in a typically German interpretation of the French premisses. All traces of naturalism have vanished, and the dramatic significance of the Biblical story is expressed in terms of exalted fantasy and richly exuberant decoration.
Pinder, *Deutsche Plastik des 14 Jhrhs.*, 1925. Beenken, *Bildhauer des 14 Jhrhs. am Rhein u. in Schwaben*, 1927. Feulner-Müller 1953, 156. Weise 1956, 77.

298 *The sleeping guard* detail *c.* 1330–40 stone *c.* 0·30 m. (the head)
Freiburg i. B., Münster (Easter Sepulchre)
The work of a notable sculptor, trained in France, who a few years later executed sculptures for the Chapel of St Catherine in Strasbourg Cathedral. All the figures, the dead Christ in the tomb, the angels, mourners, and guards, are delineated with a sharpness of outline which makes them appear emaciated, indeed almost skeletal. Their faces are drawn, and expressive of extraordinary bitterness.

Schmitt, *Gotische Skulpturen des Freiburger Münsters*, 1926. Jantzen, *Das Münster zu Freiburg*, 1929. Bauch, *Freiburg i. B.*, 1953. Feulner-Müller 1953, 154.

299 *A Prophet*, detail *c.* 1330 red sandstone *c.* 2·95 m.
From the tower octagon
Freiburg i. B., Cathedral Museum
One of a group of Prophets which, until 1958, stood under canopies near the top of the tower. These figures are attributed to the master-sculptor of Christ in the Holy Sepulchre. This attribution is borne out by the style of these masterpieces, in which dramatic severity and high-minded austerity are emphasized by tense, sharp outlines, so that the very flesh of the figures seems consumed by fiery anger.
I. and R. Oertel, *Festschrift Noack*, 1958, 33.

BRITISH 14TH CENTURY

300 *Tomb of Aymer de Valence*, detail of canopy *c.* 1325 stone
London, Westminster Abbey
The lively figure of the horseman (with traces of paint) on the canopy of the alabaster tomb of the Earl of Pembroke (*d.* 1324), a cousin of Edward II, is one of the finest examples of the new style, restless and imaginative, which emerged in England in the third decade of the century, and in which decorative elegance and great energy of movement are blended.
Stone 1955, 159.

301 *Man playing the bagpipes*, detail of altar screen *c.* 1335 stone *c.* 0·40 × 0·30 m.
Beverley (Yorkshire), Minster.
This work was near completion in 1334. The pictorial vividness of the modelling and the striking rotundity of the outlines are expressive of a vigorous and sanguine earthiness. This is a splendid example of the imaginative grotesques born of this robustness. Among the forerunners of this style are the heavily restored sculptures of the Chapter-house of York Minster, carved between 1290 and 1308.
Bilson, *Arch Rev.*, 1898, 251. Stone 1955, 171.

302 *Effigy of Edward II*, detail *c.* 1330–5 alabaster *c.* 0·25 m. (face)
Gloucester, Cathedral
This memorial tomb was ordered by Edward III, son of Edward II, shortly after the *coup d'état* which placed him on the throne. The

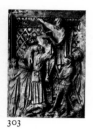

303 304 305 306 307 308

intention was to counteract the cult of the rebel, Thomas, Earl of Leicester, which had grown up after his execution by Edward II. This is an interesting example of Court sculpture, in which expressive power derives from the harmonious contrast between the precious stylization of the curls in the hair and beard, and the sensuous vitality of the face, which is achieved by means of subtle modulations of the highly polished alabaster surfaces.
Stone 1955, 160.

303 *The Descent from the Cross* c. 1380 alabaster 0·55 × 0·38 m.
London, Victoria and Albert Museum
In the second half of the century, small alabaster reliefs were produced in quantity as sacred objects to be kept in the home. Indeed, they were produced almost on an industrial scale, much to the detriment of their artistic merit. This tablet, however, dated on the internal evidence of the accoutrements of the soldier on the right, has considerable artistic merit. Somewhat influenced by French ivories, this work has a wholly individual quality of ingenuous, popular dramatic feeling, which is stressed by the firm lines of the carving and the strictly vertical folds of the draperies.
Hildburgh, *BM*, 1925. Stone 1955, 190.

304 *The Virgin Annunciate* c. 1350–60 wood c. 1·95 m.
Wells, Somerset, Hall of the Vicar's Choral
The hall, begun as early as 1348, was completed well before 1363. This figure, from the Annunciation group, far from deserving the stigma of vulgarity attached to it by some critics, is a fair example of the secularization of Divine Persons, widely practised in the latter half of the century. Though strongly influenced by French refinement of taste, the style is distinctly indigenous, combining tension and fastidiousness of line to create an impression of near-seductiveness.
Parker, *The Architect. Antiquities of the City of Wells*, 1866, 31.
Stone 1955, 187.

NICHOLAS BROKER AND GODFREY PREST
305 *Effigy of Richard II* 1394–6 copper gilt
London, Westminster Abbey
Part of the memorial tomb of Richard II and Anne of Bohemia, commissioned by Richard in 1394 from Henry Yevele and Stephen Lote
The artists' preoccupation with accurate portraiture does not exclude a strong vein of idealism, and the extremely subtle delineation of the features combines with the gently curving planes of the face to create an underlying feeling of melancholy.

Rymer, *Foedera*, 1729, 795. Devon, *Issues of the Exchequer*, 1837, 263. Westlake, *Westm. Abbey* II, 1923, 470. Stone 1955, 193.

INTERNATIONAL GOTHIC

PETER PARLER AND ASSISTANTS
306 *Effigy of Ottokar I* c. 1370–5 arenaceous marl 1·96 × 0·82 m.
Prague, Cathedral of St Vitus (centre chapel of choir)
The massive and powerful bulk of the figure, the realistic detail of the clothes, the keenly observed portraiture, though an imaginary conception of the King, are innovations which, in one respect, look forward to the International Gothic style. The traditional undulations of the Gothic line seem to conflict, especially in the remarkably powerful head, with the solid bulk of the form, creating an impression of human, and at the same time almost animal strength, overshadowed by profound suffering.
Six, *KgJZK*, 1908, 69. Kletzl, *WRJ*, 1933–4, 126. Pinder 1937, 92. Swoboda, *Peter Parler*, 1940. Feulner-Müller 1953, 206. Matejcek, *Umeni*, 1954, 1. Kutal, *České gotické socharstvi*, 1350–1450, 1962.

HEINRICH PARLER
307 *Statue of St Wenceslas* 1373 stone 2·10 m.
Prague, Cathedral of St Vitus (choir)
There is documentary evidence that this work was executed by Heinrich, son of Peter Parler. The style, in spite of the careful and detailed accuracy of the clothes, indicates a revival of interest in idealistic portraiture, with added elements of pure decoration, foreshadowing some of the distinctively novel features of International Gothic art.
As 306.

PETER PARLER AND ASSISTANTS
308 *Bust of Anna von Schweidnitz* c. 1379–85 stone 0·49 m. (wide)
Prague, Cathedral of St Vitus (choir)
One of twenty-one busts of members of the royal family in the triforium of the choir. These vary in quality. The one illustrated here is among the finest. Although there are echoes of an earlier Gothic style, the figure, modelled with great pictorial sensibility, is imbued with a fresh, almost sensual vitality.
As 306.

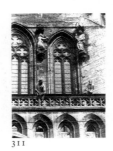

309 310 311 312 313 314

ANDRÉ BEAUNEVEU

309 *Recumbent figure of Charles V* 1364 marble 2·50 m.
St Denis, Abbey Church
The King, while still a very young man (he died in 1380), com-
missioned Beauneveu in 1364 to build this tomb, as well as those of
Philip VI (d. 1350), and John II, known as the Good (d. 1364); most
of the work was carried out by the master himself. The powerful
individuality of the portraiture is evidence of a poetic realism, akin to
that of the Parlers, though the artist is limited by the convention, well
established by this time, of idealized portraiture. More important than
its artistic merits is the historical significance of this work as the fore-
runner of a long tradition of courtly art.
Champeaux and Gauchery, *Travaux d'art éxécutés pour Jean de France*,
1894, 93. Lefrançois Pillion 1954, 88. Aubert 1946, 345. Crosby, *Abbaye
Royale de Saint-Denis*, 1953, pl. 102. Meiss, *French Painting in the time
of Jean de Berry*, 1967, 147.

310 *Recumbent figure of Catherine d'Alençon* 1412-13 marble 1·80 m.
Paris, Louvre
This work, with its companion piece, the tomb figure of Pierre
d'Evreux (d. 1412), son of Charles II, King of Navarre, was originally
in the Carthusian monastery in Paris. Since Catherine – who in 1413
took as her second husband the Duke of Bavaria-Ingolstadt, and lived
until 1462 – is wearing a widow's cap, it is plain that her tomb also
was commissioned and executed immediately after the death of her
first husband. This work, by an unknown Parisian sculptor, is remark-
able for the liveliness and freshness of the portraiture, and the perfect
fusion of naturalism and mannerism, through fluidity of line com-
bined with great pictorial delicacy.
Millin, *Antiquités nat.*, V Chartreuse de P., 18. Aubert 1946, 355. Aubert-
Beaulieu, *Louvre Sculptures Moyen-Age*, 1950, n⁰ 282. *Europäische
Kunst um 1400*, Vienna 1962, n⁰ 366. Müller 1966, 47.

311 *Charles IV leaning over the balcony* c. 1380 stone with traces of paint
Mühlhausen (Thuringia), Marienkirche (transept doorway)
The Emperor and Empress, attended by a knight and lady-in-waiting,
are leaning over a balcony to wave to the crowds. Here we have a rare
example of *trompe-l'œil* combined with the naturalism of northern
Gothic sculpture, deriving from Cologne and Bohemia. But the
artist's daring is justified by the studied control of the proportions of
the figures, which fits them harmoniously into the soaring framework
of the architecture.
Longhi, *Romanitá e Germanesimo*, 1941, 222. Feulner-Müller 1953, 225.

HEINRICH BEHEIM AND ASSISTANTS

312 *Three Royal Electors and the hero, Godefroy de Bouillon* 1385-96 stone
1·20 m. (the figures)
From the Schönen Brunnen
Nuremberg, Germanisches Nationalmuseum
Heinrich Beheim, the architect of the fountain, was closely associated
with the Parlers. He was undoubtedly overseer and possibly designer
of the work of the sculptors (the masters who created the Prophets and
the Heroes). These statues, full of vitality, power, and realism, not
least in the portraiture, have an air of aristocratic refinement in
harmony with the rich Gothic decoration of the panels.
Pinder, 1937, 113. Feulner-Müller 1953, 217.

313 *The 'Beautiful Madonna'* c. 1400 calcarea stone with traces of poly-
chrome 1·12 m.
From Cesky Krumlov (Krumau, Bohemia)
Vienna, Kunsthistorisches Museum
One of the oldest and most famous of the 'schöne Madonnen' of
Central Europe. This statue, variously dated c. 1385-90 and c. 1400,
is certainly the work of the Court school of Prague, which is thus
established as the source of this enchanting tradition which, neverthe-
less, owes much to earlier Western sculpture. This is a work of the very
highest quality. The curving outlines and broad sweep of the draperies,
fresh and free in execution, are also rich in refinement of pictorial
detail.
Ernst, *KgJZK*, 1917, 109. Pinder, *JPKslg*, 1923, 147. Wiegand, *JPKslg*,
1938, 76. Feulner, *ZDVKw*, 1943, 19. Clasen, *Die Schönen Madonnen*,
etc., 1952. Paatz 1956, 27. Grossmann, *OeZKDpf*, 1960, 103. Müller,
Europ. Kunst um 1400 (catalogue), 1962, 307.

314 *Self-portrait of an architect or sculptor?* c. 1400-10 stone 0·55 m.
Regensburg, St Peter's Cathedral (main portal)
A magnificent work, in the Parler tradition. The graceful lines flow
untrammelled in a ceaseless rhythm thus conveying, in full harmony
with the ageing and furrowed face, an expression of world-wariness.
Schinnerer, *Die gotische Plastik in Regensburg*, 1918. Endres, *Beiträge z.
Kunst-u. Kulturgeschichte d. mittelalt. Regensburg*, 1924. Müller 1950, 14,
31. Müller 1966, 43.

315 *The Pietà of Seeon* c. 1400 calcarea stone with traces of polychrome
0·75 m.
From the Monastery of Seeon
Munich, Bayerisches Nationalmuseum

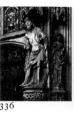

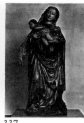

329 330 331 332 333 334 335 336 337

detail, executed with loving care, is designed to extract the maximum effect from the play of light and shade on the carving. The sinuous curves of the composition and stressed linear harmonies are Gothic in origin, and are used as a means of clothing reality in the ritual trappings of legend. In the figures carved after the Shrine of St Dominic, there are echoes of Florentine sculpture, and the terracotta *Pietà* (329), a still later work – it cannot surely be the one mentioned in a document of 1463 – has affinities with the realism of Guido Mazzoni of Modena and the harsh expressionism of the paintings of the Ferrara school, the latter style having been brought to Bologna after 1470 by two great masters, Cossa and Ercole de'Roberti.
Gnudi, *N. dell'Arca*, 1942. Toesca, *AQ*, 1956, 271. Bottari, *L'Arca di S. Domenico*, 1964, 56. Novelli, *N. dell'Arca*, 1966.

15TH CENTURY NATURALISM AND LATE GOTHIC

JACQUES MOREL
331 *Tomb of Agnes of Burgundy and Charles I of Bourbon* 1453 marble 1·95 m. (length – woman) 2·14 m. (length – man)
Souvigny, Parish Church
Originally this tomb, like that of Philip the Bold (325–6), was surrounded by figures of mourners. Although the influence of Sluter is undeniable, this work of Morel's, more contrived and deliberately pictorial than Sluter's, is highly original in style.
Aubert 1946, 375. Müller 1966, 55.

JOHN MASSINGHAM
332 *Tomb of Richard, Earl of Warwick* 1450 copper gilt
Warwick, St Mary's
This tomb was apparently designed by a painter by the name of Clare. Massingham, while working on it, enlisted the services of the Earl's physician, as well as those of a founder and a goldsmith. These facts are significant as indicating the artist's determination to create, as far as possible, a perfect likeness, and to ensure the highest standard of craftsmanship in the execution of the work.
Nichols, *Descr. of the Church of St Mary*, 1838. Stone 1955, 209.

333 *The Virgin Annunciate c.* 1441–50 stone *c.* 1·00 × 0·60 m.
From Henry V's Chantry
London, Westminster Abbey

While the style of much Gothic memorial sculpture is prosaically realistic and imitative, this beautiful Virgin, by an unknown artist, inspired by Flemish paintings, is a distinguished example of pictorial naturalism.
Stone 1955, 206.

HANS MULTSCHER
334 *The Virgin Enthroned c.* 1430–5 painted wood 0·58 m.
Munich, Bayerisches Nationalmuseum

335 *St Florian* 1456–8 painted wood, less than lifesize
Vipiteno (Sterzing), South Tyrol, Civic Museum

336 *The Man of Sorrows* 1429 stone
Ulm, Cathedral
Hans Multscher, painter (see the Wurzach altarpiece in Berlin) and sculptor, was born in Allgäu. After a period of travel in Burgundy and Flanders, where he must have seen the works of Sluter and the Master of Flemalle, he settled in Ulm. Traces of Gothic influence remain in the linear harmonies of his work, but these are overwhelmed by the powerful tension and substantial plasticity of his modelling. In the Christ at Ulm (336), an early work, there is only the faintest echo of the curving lines of Gothic sculpture, here superseded by a staccato linear rhythm and a feeling of muscular tension, which create the impression that the figure is on the point of stepping down from its niche. Thus sculpture of this period is seen emerging from Gothic idealism into the real world, and this transition is marked by a new eloquence of gesture and expression. The Munich Virgin (334), compactly modelled, and remarkable for the elaborate use of divergent folds in the carvings of the draperies, is full of a sense of proud majesty. In the later figure of St Florian (335, from the dismantled *Schnitzaltar* of the Parish Church of Vipiteno), the traditional Gothic undulation is transformed into the tension of a line sharply defining the volume and dynamically relating the figure to space. In other words, these figures emerge into the light of the real world, retaining no more than a faint trace of the courtly and knightly graces of the Gothic tradition.
Bossert, *Der ehem. Hochaltar . . . zu Sterzing*, 1914. Gerstenberg, *H. Multscher*, 1928. Salvini, *Le Arti* I, 1939, 404. Feulner-Müller 1953, 246. Paatz 1956, 74. Rasmo, *Der Multscher-Altar in Sterzing*, 1963. Müller 1966, 73.

JAKOB KASCHAUER
337 *Virgin and Child* 1443 painted wood 1·75 m.
Munich, Bayerisches Nationalmuseum

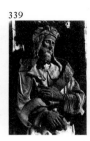
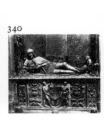
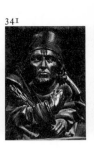
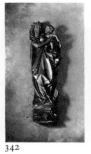

338 339 340 341 342 343 344

From an altarpiece with carved panels (*Schnitzaltar*) commissioned in 1443 by the Bishop of Freising (Bavaria). The sculptor was a Viennese, and has been identified by some scholars as the painter known as the 'Master of the Albrecht Altar'. Kaschauer was certainly familiar with and influenced by the early work of Multscher, and in his work, as in Multscher's, there remains a faint Gothic echo in his sturdily modelled, naturalistic, fleshly figures.

Oettinger 1939, 13. Garzarolli v. Thurnlack, *Mittelalter. Plastik in Steiermark*, 1941, 61. Müller 1950, 18. Feulner-Müller 1953, 236. Paatz 1956, 82. Müller 1966, 76.

NICOLAUS GERHAERT

338 *Self-portrait? c.* 1467 stone
Strasbourg, Musée de l'Oeuvre de Notre-Dame
The Dutchman Nicolaus Gerhaert was little influenced by Sluter. His style derives rather from the paintings of Roger van der Weyden and from Netherlandish sculpture, of which little remains, which seems to have depended on van der Weyden. In the portrait here illustrated, the eloquent pose of the figure and the expressive lines of the face are realistic, yet there is something of expressionism in the work, and great spiritual intensity. In this masterpiece, the artist, in an entirely original way, makes it appear as though the surrounding space were irradiated by the spiritual energy of the image. Through his vast output, examples of which are to be found throughout the old Holy Roman Empire in towns as far apart as Strasbourg and Vienna, Nicolaus was to exercise a profound influence on German sculpture in the second half of the century.

Wertheimer, *Nic. Gerhaert*, 1929. Feulner-Müller 1953, 284. Paatz, *Heidelberger Jhb*. III, 1959, 68. Sommer, *Kstchr*. XIII 1960, 284. Müller 1966, 80.

SCHOOL OF JUAN GUAS

339 *St James the Apostle*, detail *c.* 1490 stone
Toledo, S. Juan de los Reyes
Spanish sculpture in the 15th century was strongly influenced by Flemish art. However, this statue – one of a large number in this church, itself designed by Juan Guas and built under his direction – shows the influence of Nicolaus Gerhaert, transmitted by way of German sculpture. Flemish naturalism, however, undergoes a spiritualizing process through a new sensibility of line, and a tendency towards abstraction in the modelling, thus attaining, as here, a pronounced effect of intimate lyricism.

Duràn Sanpere-Lasarte 1956, 320. Müller 1966, 145.

340 *Tomb of Martin Vazquez de Arce, called 'El Doncel', c.* 1488 alabaster
Sigüenza, Cathedral
A magnificent example of Early Renaissance sculpture, notable for the simplicity and balance of its composition, in which naturalism is subordinated to geometric form, no doubt under the influence of Italian art. In this work, pictorial delicacy is combined with a brilliant use of light and shade, so that the figures appear to undergo an almost magical transfiguration.

Duràn Sanpere-Lasarte 1956, 338. Müller 1966, 146

JÖRG SYRLIN

341 *Virgil* 1469–74 wood
Ulm, Cathedral (choir stall)
Here in the choir stalls of Ulm Cathedral, side by side with sacred characters from the Old and New Testaments, are to be found the sybils, philosophers and poets of the ancient world. With this Medieval convention, the Humanists of the 15th century felt themselves strongly in sympathy. A flavour of Humanism may also be detected in these portraits: they are, in fact, highly individual likenesses, that of Virgil in particular, so full of power and dignity, so confidently dominating its surroundings that it might almost be a self-portrait. The broad sweep of the arm, while serving to anchor the figure in its spatial context, endows it at the same time with intense spiritual energy.

Baum, *Ulmer Plastik um 1500*, 1911. Otto, *Ulmer Plastik d. Spätgotik*, 1927. Vöge, *J. Syrlin*, 1950. Feulner-Müller 1953, 306. Müller 1966, 113.

342 *The Virgin standing on the sickle moon c.* 1475 stone
Trier, Cathedral (cloister)
This figure, for a time believed to be an early work of Nicolaus Gerhaert, has now been identified as the one presented to the cathedral by the dean Edmund von Malberg (*d.* 1478). It is the work of a very distinguished pupil of Nicolaus, among whose other works is the group in stone of the Virgin and St Anne in the Berlin Museum, which was also formerly believed to be by Nicolaus. This is an enchanting work, in which the abstract geometry of the draperies, fanning out in front as the Virgin holds her robe together to prevent it from falling open, is in contrast with the freshness and naturalism of the portraiture.

Schmoll Eisenwerth, *JHKslg* III, 1958, 59. Müller 1966, 102.

ERASMUS GRASSER

343 *A Morris dancer* 1480 painted wood 0·64 m.
Munich, Münchner Stadtmuseum

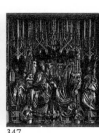

345 346 347 348 349 350 351 352 353

One of a group of figures originally in the Council Chamber of the old Town Hall of Munich. The versatility and freedom of Gothic linear composition can be seen, in this delightful figure, to have finally liberated sculpture from the restraints of surrounding decoration. Indeed, this group of figures, linked in the performance of a genial and graceful burlesque, appears to have conquered both time and space. As 344.

ERASMUS GRASSER

344 *St John c.* 1480 painted wood 1·22 m.
Munich, Bayerisches Nationalmuseum
This figure and another of the Virgin originally formed part of a Crucifixion group, in the church of nearby Pipping, built between 1478 and 1480. The figure is slim and elongated in the Gothic manner, but there is a new element of self-containment in the oval contour of the robe, which evokes a sense of ineluctable lyric intensity.
Halm, *E. Grasser*, 1928, 37. Hasse, *JPKslg* LX, 1930, 52. Müller 1950, 21. Feulner-Müller 1953, 330. Müller 1966, 117.

MICHEL ERHART

345 *The Merciful Madonna c.* 1480 painted wood 1·35 m.
Berlin, Staatliche Museen
This figure, along with two reliefs, comes from Ravensburg and was formerly ascribed, on the basis of an apocryphal document, to Friedrich Schramm. The Madonna and reliefs are today attributed to Michel Erhart of Ulm, who is known to have executed the lost figures of Syrlin's wooden altarpiece in the cathedral. The new attribution is founded upon their close affinity with the Crucifix at Schwäbisch Hall, signed and dated 1494, and with the altarpiece of Blaubeuren, built in 1493–94 in collaboration with the sculptor's son, Gregor. The Swabian earthiness and intensity of portraiture to be found in the Syrlin stalls (341) is here mitigated: a mood of lyrical astonishment is achieved by enclosing the intensely human faces and the powerfully modelled figure of the Virgin within the firm lines and broad sweep of her cloak.
Demmler, *Bildw. d. Deutschen Mus.*, 1930, 206. Otto, *JPKslg*, 1943, 17. Feulner-Müller 1953, 310. Paatz 1963, 27. Müller 1966, 116.

MICHAEL PACHER

346 *St Michael slaying the dragon*, detail of altarpiece 1471–75 painted wood 1·85 m.
Bolzano-Gries, Parish Church

347–9 *Coronation of the Virgin: St Wolfgang: St Florian*, details of altarpiece *c.* 1481 painted wood 3·90 × 3·16 m. (the case 347)
St Wolfgang am Abersee, Parish Church
Michael Pacher of Bruneck, in the south Tyrol was one of the greatest wood sculptors (as well as one of the greatest painters) of the German school in the 15th century. He was greatly influenced by Swabian sculpture, by Multscher (334–6), by the school of Nicolaus Gerhaert (338 and 342), and by Jakob Kaschauer (337), as well as by the drawings of the Master E. S. As a painter he was, above all, profoundly influenced by the school of Padua, in particular the work of Mantegna, from which he derived an entirely new awareness of spatial relationships, and the intense dramatic energy with which all his figures are imbued. The altarpiece of St Wolfgang shows him at the height of his powers. The figures are deployed like orchestral harmonies to create a grandiose composition on the heroic scale.
Stiassny, *M. P.s St. Wolfganger Altar*, 1919. Hempel, *M. P.*, 1931. Schwabik, *M. P.s Grieser Altar*, 1933. Salvini, *Arch. Alto Adige*, 1937, 5. Rasmo, *Arte medioevale nell'Alto Adige*, 1949, 32; *Cultura Atesina*, 1950. Feulner-Müller 1953, 341. Paatz 1963, 27. Müller 1966, 120. Rusmo, *M.P.*, 1969.

TILMAN RIEMENSCHNEIDER

350–1 *Adam and Eve* 1491–3 sandstone 1·89 and 1·86 m.
Würzburg, Mainfränkisches Museum

352 *The Last Supper*, detail 1501–4 wood *c.* 1·00 m. (the figures)
Rothenburg, St Jakobskirche (Altar of the Sacred Blood)

353 *The Virgin and Child*, detail *c.* 1510 wood
Berlin, ehem. Staatliche Museen
Tilman Riemenschneider, of Osterode in the Harz Mountains, became a citizen of Würzburg in 1483. Though his sculptures owe much to other works of the period (Flemish school, Nicolaus Gerhaert, school of Ulm), he is nevertheless a highly original artist. Even his earliest work, such as the exquisitely delicate statues formerly flanking the portal of the Marienkapelle in Würzburg (350–1), is imbued with intense sensibility. In the altarpieces at Rothenburg (352) this sensibility is manifested in terms of profound religious contemplation and intimate personal suffering. In the magnificent Madonnas of his maturity (353), it is seen in the tense and strangely anxious lines of the faces. All Riemenschneider's work, indeed, reflects the sensitive and introspective temperament of the artist, as well as the high drama of the Reformation.
Bier, *T. R.*, 1925, 1930. Gundermann-Demmler, *Die Meisterwerke*

354

355

356

357

358

359

360

T. R.s, 1936. Feulner-Müller 1953, 385. Freeden-Hege, T. R., 1959. Gerstenberg, T. R., 1962. Müller 1966, 177.

BERNT NOTKE

354 *St George and the dragon* 1483–9 oak
Stockholm, Storkyrka
This monumental piece, much larger than lifesize, is a memorial to the liberation of Sweden from the Danish yoke in 1471. The sculptor – who was also a notable painter – though born in Pomerania, lived and worked in Lübeck. This is a work rich in fantasy, a notable example of the neo-Gothic style, in the irrepressible dynamism of the whole composition as well as in the illusion of thrusting motion, which is in perfect harmony with the Gothic architecture of the church.
Roosval, *Riddar St Göran*, etc., 1919; *Nya St Görans Studier*, 1924. Heise, *Lübecker Plastik*, 1926, 10. Paatz, *B. N. u. sein Kreis*, 1939. Feulner-Müller 1953, 422. Müller 1966, 130.

ADAM KRAFT

355 *Self-portrait*, detail of the Shrine of the Sacrament 1493–6 stone 0·89 m.
Nuremberg, St Lorenzkirche
One of three figures supporting this towering shrine. The use of Atlas-figures to support an architectural structure harks back to Medieval times, but here the style is very different. The composition, with great strength expressed in terms of squared masses and planes, constrains the linear flow within hard, tense outlines, to create that feeling of energetic yet sober realism which was to become the hallmark of the age of Albrecht Dürer.
Feulner-Müller 1953, 370. Schwemmer, *A. Kraft*, 1958. Müller 1966, 184.

VEIT STOSS

356 *The Dormition of the Virgin*, detail 1477–89 painted wood 2·80 m. (maximum height of the figures)
Cracow, St Mary's
The central panel of a monumental carved altarpiece, commissioned from the master, a citizen of Nuremberg, by the German community of Cracow. Influenced by the interrelationship of space and figures conceived by Nicolaus Gerhaert, the sculptor combines grandeur, pathos and intensity in this beautifully balanced composition, which, in its expression of intense anguish, looks forward to the Renaissance.
Lutze, *V. S.*, 1938. Dobrowolski-Dutkiewicz, *Wit Stwosz, Oltarz Krakowski*, 1953. Feulner-Müller 1953, 362. Dettloff, *W. S.*, 1961. Müller 1966, 126.

VEIT STOSS

357 *St Roch c.* 1505 wood 1·70 × 0·70 m.
Florence, SS. Annunziata
It is not known how this work came to Florence, but it is recorded in the church in 1523. It was later praised by Vasari as an outstanding example of wood sculpture attributed to a master-craftsman 'Janni Franzese'. The strong modelling of the figure and its firm and clear situation in space create a powerful impression of human dignity. The entangled and whirling draperies, which strike a note of anguished pathos, serve to enhance this impression.
Voss, *JPKslg*, 1908, 20. Dami, *D*, 1920, 418. Feulner-Müller 1953, 368. Lutze, *P*, 1957, 183.

VEIT STOSS

358 *The Annunciation c.* 1517–19 painted wood 3·20 m. (wide)
Nuremberg, St Lorenzkirche
The two principal figures, magnificently carved in the round, are much enhanced by the spatial significance of the gorgeously coloured oval frame, surmounted by God the Father, and decorated at intervals with carved medallions, and winged cherubim in flight. The broad display of plastic fullness in the figures and the ampleness of the surrounding space melt in the splendour of light and colour; the entire composition is imbued with a feeling of transfiguring pathos.
Lutze, *V. S.*, 1938.

VEIT STOSS

359 *The Virgin and Child c.* 1515–20 wood
London, Victoria and Albert Museum
Very close to 358, though on a much smaller scale. The triumphal luxuriance of 358 turns here to a more collected and intimate expression: the spiritual excitement conveyed by the grandiose and contrasted movement of the draperies is ultimately translated into a radiant energy, culminating in the smiling tranquillity of the Virgin's face.
Lutze, *V. S.*, 1938.

360 *Eve c.* 1500 stone 1·30 m.
Albi, Cathedral (choir screen)
Traces of the influence of Sluter are still discernible in this work, but the Gothic elements have given place to an awareness of the flesh, in which there is no hint of transcendental spirituality. Instead, the keynote is naturalism, expressing with entirely secular frankness the vital power of the human body.
Aubert 1946, 405.

BIBLIOGRAPHY

Each bibliographical reference to a sculpture appears under the relevant note. Titles of books and periodicals quoted more than once are abbreviated as follows:

JOURNALS

A – L'Arte
AB – Art Bulletin
AAM – Arte Antica e Moderna
AE – Archivo Español
AEA – Archivo Español de Arte
AL – Arte Lombarda
AMDSPM – Atti e Memorie della Deputazione di Storia Patria per le provincie modenesi
Ant – Antiquity
AP – Arts Plastiques
Apl – Apollo
AQ – Art Quarterly
Arch – Archaeology
Arch Rev – Archaeological Review
Arch Rom – Archivum Romanicum
Art Am – Art in America and elsewhere
ASL – Archivio Storico Lombardo
ASt – Art Studies
AV – Antichità Viva
AVen – Arte Veneta
BA – Bollettino d'Arte
BAA Jnl – British Archaeological Association Journal
BAFr – Bulletin de la Société Nationale des Antiquaires de France
Belle A – Belle Arti
Belv – Belvedere
BIzLUJA – Bulletin Instituta za likovne myetnosti Jug. Akademije
BM – Burlington Magazine
BMon – Bulletin Monumental
Bull Arch – Bulletin Archéologique
CA – Critica d'Arte
CCM – Cahiers de Civilization Médiévale
Comm – Commentari
CRAIBL – Comptes Rendus des Inscriptions et Belles Lettres
D – Dedalo
EUA – Enciclopedia Universale dell'Arte
GA – Gazette Archéologique
GBA – Gazette des Beaux-Arts
JBM – Jahrbuch der Berliner Museen
JHKslg – Jahrbuch der Hamburger Kunstsammlungen
JKslgW – Jahrbuch der kunsthistorischen Sammlungen (des a.h. Kaiserhauses) in Wien
JKw – Jahrbuch für Kunstwissenschaft
JPKslg – Jahrbuch der Preussischen Kunstsammlungen
JWCI – Journal of the Warburg and Courtauld Institutes
KDb – Kölner Domblatt
KgJZK – Kunstgeschichtliches Jahrbuch der Zentral-Kommission in Wien
KJBH – Kunstgeschichtliches Jahrbuch der Bibliotheca Hertziana
Kstchr – Kunstchronik

M – Das Münster
MhKw – Monatshefte für Kunstwissenschaft
MJBK – Münchner Jahrbuch der bildenden Kunst
MJKw – Marburger Jahrbuch für Kunstwissenschaft
MKIF – Mitteilungen des Kunsthistorischen Institutes in Florenz
Mon Piot – Fondation Eugène Piot Monuments et Mémoires
MSFg – Memorie Storiche Forogiuliesi
OberrhK – Oberrheinische Kunst
OeZKDpf – Oesterreichische Zeitschrift für Kunst und Denkmalspflege
P – Pantheon
Pall – Palladio
Par – Paragone
RA – Rivista d'Arte
RAs – Revue des Arts
RAC – Rivista di Archeologia Cristiana
RAChr – Revue d'Art Chrétien
RAAM – Revue de L'Art Ancien et Moderne
RArt – Revue de l'Art
RBAHA – Revue belge d'Archéologie et histoire de l'art
RIASA – Rivista dell'Istituto Nazionale di Archeologia e Storia dell'Arte
RJKg – Romisches Jahrbuch für Kunstgeschichte
RKw – Repertorium für Kunstwissenschaft
StJ – Städel Jahrbuch
Spec – Speculum
WRJ – Wallraf-Richartz Museum, Jahrbuch
ZBK – Zeitschrift für bildende Kunst
ZChrK – Zeitschrift für christliche Kunst
ZDVKw – Zeitschrift des deutschen Vereins für Kunstwissenschaft
ZGA – Zeitschrift für Geschichte der Architektur
ZKG – Zeitschrift für Kunstgeschichte
ZKW – Zeitschrift für Kunstwissenschaft

BOOKS

Arslan 1943 – La Scultura e la Pittura Veronese dal secolo VIII al XIII. Milan
Arslan 1954 – La Scultura Romanica, in Storia di Milano, III, pp. 525 sgg
Art Roman 1961 – L'Art Roman en France, by M. Aubert, G. Gaillard, M. de Bouard, R. Crozet, M. Durliat, M. Thibout, J. Vallery-Radot, F. Benoit. Paris
Aubert 1929 – La Sculpture Française au début de l'Époque Gothique. Paris
Aubert 1946 – La Sculpture Française au Moyen-Age. Paris
Baroni 1944 – La Scultura Gotica Lombarda. Bergamo
Becherucci 1965 – Andrea Pisano nel Campanile del Duomo. Florence

Beckwith 1964 – Early Medieval Art. London
Beenken 1924 – Romanische Skulptur in Deutschland. Leipzig
Bernardi 1962 – Tre Abbazie del Piemonte
Bertaux 1904 – L'Art dans l'Italie Méridionale. Paris
Bertoni 1921 – Atlante Storico-Artistico del Duomo di Modena. Modena
Biehl 1910 – Das Toskanische Relief im XII–XIV Jahrhundert. Bonn
Biehl 1926 – Toskanische Plastik im frühen und hohen Mittelalter. Leipzig
Boase 1953 – English Art 1100–1216. Oxford
Bologna 1955 – Opere d'Arte nel Salernitano dal XII al XVIII secolo. Naples
Braunfels 1965 – Karl der Grosse (Ausstellungskatalog). Aachen
Brieger 1957 – English Art 1216–1307. Oxford
Brown 1921 – The Arts in Early England, vol. v
Buschbeck 1919 – Der Portico de la Gloria
Canestro Chiovenda 1955 – L'Ambone dell' Isola di San Giulio. Rome
Cecchelli 1932 – Zara. Catalogo delle cose d'antichità e d'arte. Rome
Cecchelli 1943 – I Monumenti del Friuli, vol. I. Milan
Clapham 1930 – English Romanesque Architecture before the Conquest. Oxford
Clapham 1934 – English Romanesque Architecture after the Conquest. Oxford
Crozet 1948 – L'Art Roman en Poitou
Debidour 1961 – Le Bestiaire Sculpté en France. Paris
Dehio 1919 – Geschichte der Deutschen Kunst, vol. I
Demus 1960 – The Church of San Marco in Venice. Washington
Deschamps 1947 – La Sculpture Française. Epoque Romane. Paris
Duràn 1927 – La Escultura Medieval Catalana. Barcelona
Durand 1901–3 – Monographie de l'Église N.-D. Cathédrale d'Amiens
Durliat 1954 – Le Maître de Cabestany. La Sculpture Romane en Roussillon, vol. IV. Perpignan
Durliat 1958 – Roussillon Roman. La-Pierrequi-vire, Yonne ('Zodiaque')
Durliat 1962 – L'Art Roman en Espagne. Paris
Feulner-Müller 1953 – Geschichte der Deutschen Plastik. Munich
Focillon 1931 (1964) – L'Art des Sculpteurs Romans. Paris (2nd ed. 1964)
Francovich 1943 – Scultura Medievale in Legno. Rome
Francovich 1952 – Benedetto Antelami e l'Arte del suo tempo. Milan-Florence

Francovich 1961 – *Studi in Onore di M. Salmi*, vol. i. Rome

Gaillard 1938 – *Les Débuts de la Sculpture Romane Espagnole*. Paris

Gardner 1935 – *Handbook of English Medieval Sculpture*. London

Giesau 1950 – Stand der Forschung über das Figurenportal des Mittelalters, in *Beiträge zur Kunst des Mittelalters*. Deutsche Kunsthistorikertagung in Schloss Brühl (1948). Berlin

Gnudi 1948 – *Nicola Arnolfo Lapo. L'Arca di S. Domenico a Bologna*. Florence

Goldschmidt 1914 – *Die Elfenbeinskulpturen aus der Zeit der Karolingischen und Sächsischen Kaiser*, vier Bände (1914–26)

Goldschmidt 1926 – *Die Deutschen Bronzetüren des Frühen Mittelalters*

Gómez Moreno 1934 – *El Arte Romanico Español*. Madrid

Gómez Moreno 1951 – *Breve Historia de la Escultura Española*. Madrid

Grodecki 1947 – *Ivoires Français*. Paris

Gudiol Ricart-Gaya Nuño 1948 – *Ars Hispaniae*, vol. v. Madrid

Hamann 1922 – *Deutsche und Französische Kunst im Mittelalter*. Marburg

Hamann 1956 – *Saint-Gilles und ihre Künstlerische Nachfolge*

Haseloff 1930 – *La Scultura Preromanica in Italia*. Bologna

Henry 1965 – *Irish Art in the Early Christian Period*. London

Jantzen 1925 – *Deutsche Bildhauer des 13 Jahrhunderts*. Leipzig

Jantzen 1947 – *Ottonische Kunst*. Munich

Jullian 1945 – *L'Eveil de la Sculpture Italienne*. Paris

Katzenellenbogen 1959 – *The Sculptural Programs of Chartres Cathedral*. Baltimore, Maryland

Kendrick 1938 – *Anglo-Saxon Art to A.D. 900*

Kendrick 1949 – *Late Saxon and Viking Art*

Kerber 1966 – *Burgund und die Entwicklung der Französischen Kathedralskulptur im 12. Jahrhundert*. Recklinghausen

Kidson 1958 – *Sculpture at Chartres*. London

Klein 1916 – *Die Romanische Steinplastik des Niederrheins*. Strasbourg

Koechlin 1924 – *Les Ivoires Gothiques Français*. Paris

Lafargue 1940 – *Les Chapiteaux du Cloître de N.-D.-la-Daurade*. Paris

Lapeyre 1960 – *Des Façades Occidentales de St.-Denis et de Chartres aux Portails de Laon*. Paris

Lefrançois Pillion 1954 – *L'Art du XIV^e Siècle en France*. Paris

Leisinger 1956 – *Bronzi Romanici*. Zürich-Milan

Lüthgen 1923 – *Romanische Plastik in Deutschland*. Bonn and Leipzig

Magagnato 1962 – *Arte e Civiltà del Medioevo veronese*. Verona

Mäle 1919 – *L'Art religieux du 13^e Siècle en France*. Paris

Mäle 1922 – *L'Art Religieux au 12^e Siècle en France*. Paris

Mäle 1948 – *Notre-Dame de Chartres*. Paris

Marioni-Mutinelli 1958 – *Cividale. Guida storico-artistica*. Udine

Mayer 1923 – *Mittelalterliche Plastik in Spanien*. Munich

Mesplé 1961 – *Toulouse. Musée des Augustins: les Sculptures Romanes*. Paris

Messerer 1964 – *Romanische Plastik in Frankreich*. Cologne

Müller 1950 – *Alte Bairische Bildhauer*. Munich

Müller 1966 – *Sculpture in the Netherlands, Germany, France, Spain 1400–1500*. Harmondsworth, Middlesex

Muratoff 1931 – *La Sculpture Gothique*. Paris

Nicco Fasola 1941 – *Nicola Pisano*. Rome

Oakeshott 1959 – *Classical Inspiration in Medieval Art*. London

Oettinger 1939 – *Altdeutsche Bildschnitzer in der Ostmark*. Vienna

Oursel 1928 – *L'Art Roman de Bourgogne*. Dijon

Oursel 1953 – *L'Art de Bourgogne*. Paris-Grenoble

Paatz 1956 – *Prolegomena* (Abr. Heidelberger Akad. Wiss.)

Paatz 1963 – *Süddeutsche Schnitzaltäre*

Palol-Hirmer 1965 – *Spanien. Kunst des frühen Mittelalters vom Westgotenreich bis zum Ende der Romanik*. Munich

Panofsky 1924 – *Die Deutsche Plastik des 11.–13. Jahrhunderts*. Munich

Pillion 1911 – *Les Sculpteurs Français du XIII^e Siècle*. Paris

Pinder 1937 – *Die Kunst der ersten Bürgerzeit*. Leipzig

Pita Andrade 1955 – *Los Maestros de Oviedo y Avila*. Madrid

Pope-Hennessy 1955 – *Italian Gothic Sculpture*. London

Porter 1917 – *Lombard Architecture*. New Haven, Connecticut

Porter 1923 – *Romanesque Sculpture of the Pilgrimage Roads*. Boston, Massachusetts

Porter 1928 – *Romanische Plastik in Spanien*. Florence-Munich

Prior-Gardner 1912 – *An Account of Medieval Figure-sculpture in England*. Cambridge

Puig y Cadafalch 1957 – *L'Escultura Monumental*, in *L'Art Català*, i

Quintavalle (A.O.) 1947 – *Antelami Sculptor*. Milan

Quintavalle (A.C.) 1964–5 – *La Cattedrale di Modena*. Modena

Rachou 1934 – *Pierre Romanes Toulousaines*

Ragghianti 1968 – *L'Arte in Italia*, vol. ii. Rome

Rey 1936 – *La Sculpture Romane Languedocienne*. Paris-Toulouse

Rivoira 1908 – *Le Origini dell'Architettura Lombarda*. Milan

Salmi 1928 – *La Scultura Romanica in Toscana*. Florence

Salvini 1952 – *Lineamenti di Stora dell'Arte*, vol. i. Florence

Salvini 1954 – *La Pittura dal secolo XI al XIII*, in *Storia di Milano*, iii, pp. 603 sgg.

Salvini 1956 – *Wiligelmo e le Origini della Scultura Romanica*. Milan

Salvini 1962 – *Il Chostro di Montreale e la Scultura Romanica in Sicilia*. Palermo

Salvini 1963 – *La Scultura Romanica in Europa*, 2° ed. Milan

Salvini 1966 – *Il Duomo di Modena e il Romanico nel Modenese*. Modena

Santangelo 1936 – *Cividale. Catalogo*. Rome

Saxl-Swarzenski 1953 – *English Sculptures of the twelfth Century*. London

Schmarsow 1890 – *St.-Martin von Lucca*. Breslau

Spencer Cook-Gudiol Ricart 1950 – *Ars Hispaniae*, vol. vi

Steingräber 1961 – *Deutsche Plastik der Frühzeit*. Königstein im Taunus

Stoll 1967 – *Architecture and Sculpture in Early Britain*. London

Stone 1955 – *Sculpture in Britain: The Middle Ages* (Penguin Books)

Swarzenski 1926 – *Niccolo Pisano*. Frankfurt a.M.

Swarzenski 1967 – *Monuments of Romanesque Art* (2nd ed.). Chicago-London

Talbot Rice 1952 – *English Art 871–1100*. Oxford

Toesca 1912–66 – *La Pittura e la Miniatura nella Lombardia* (new ed. 1966). Turin

Toesca 1927 – *Il Medioevo*. Turin

Toesca (I.) 1950 – *Andrea e Nino Pisani*. Rome

Toesca 1951 – *Il Trecento*. Turin

Tschan 1951 – *Saint Bernward of Hildesheim*, vol. ii. Notre-Dame, Ind.

Venturi – *Storia dell'Arte Italiana*. Milan

Verzár 1968 – *Die Romanischen Skulpturen der Abtei Sagra di San Michele*. Basle

Viollet-le-Duc 1854–69 – *Dictionnaire Raisonné de l'Architecture*. Paris

Vitry 1915–19 – *Reims*

Vöge 1894 – *Die Anfänge des monumentalen Stils im Mittelalter*

Volbach 1968 – *L'Impero Carolingis*. Milan

Volbach 1968 – *Hubert-Porcher-Volbach – L'Impero Carolingio*. Milan

Wackernagel 1912 – *Die Plastik des 12. und 13. Jahrhunderts in Apulien*. Leipzig

Weigert 1961 – *Romanische Plastik in Europa*. Frankfurt

Weise 1925 – *Spanische Plastik aus sieben Jahrhunderten*, vol. i. Reutlingen

Weise 1927 – *Spanische Plastik aus sieben Jahrhunderten*, vol. ii. Reutlingen

Weise 1956 – *L'Italia e il Mondo Gotico*. Florence

Wesenberg 1957 – *Bernwardinische Plastik*. Berlin

Zarnecki 1951 – *English Romanesque Sculpture, 1066–1140*. London

Zarnecki 1953 – *Later English Romanesque Sculpture, 1140–1210*

Zeller 1907 – *Die Kunstdenkmäler der Provinz*. Hannover

INDEX

The Index includes sculptures, entered under title and subject, artists, periods and styles. The numbers refer to the illustrations.

GUIDE TO LOCATION